D0516229

REMINGTON & RUSSELL
AND THE
ART OF THE AMERICAN WEST

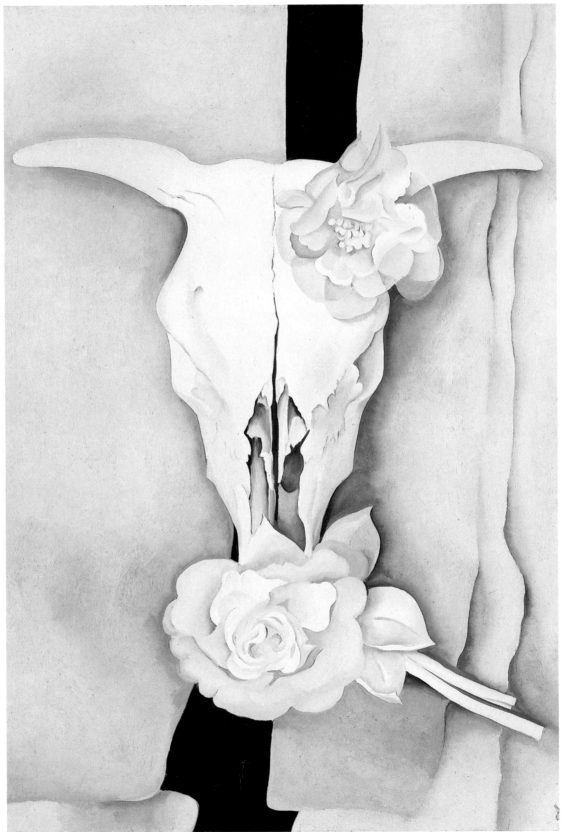

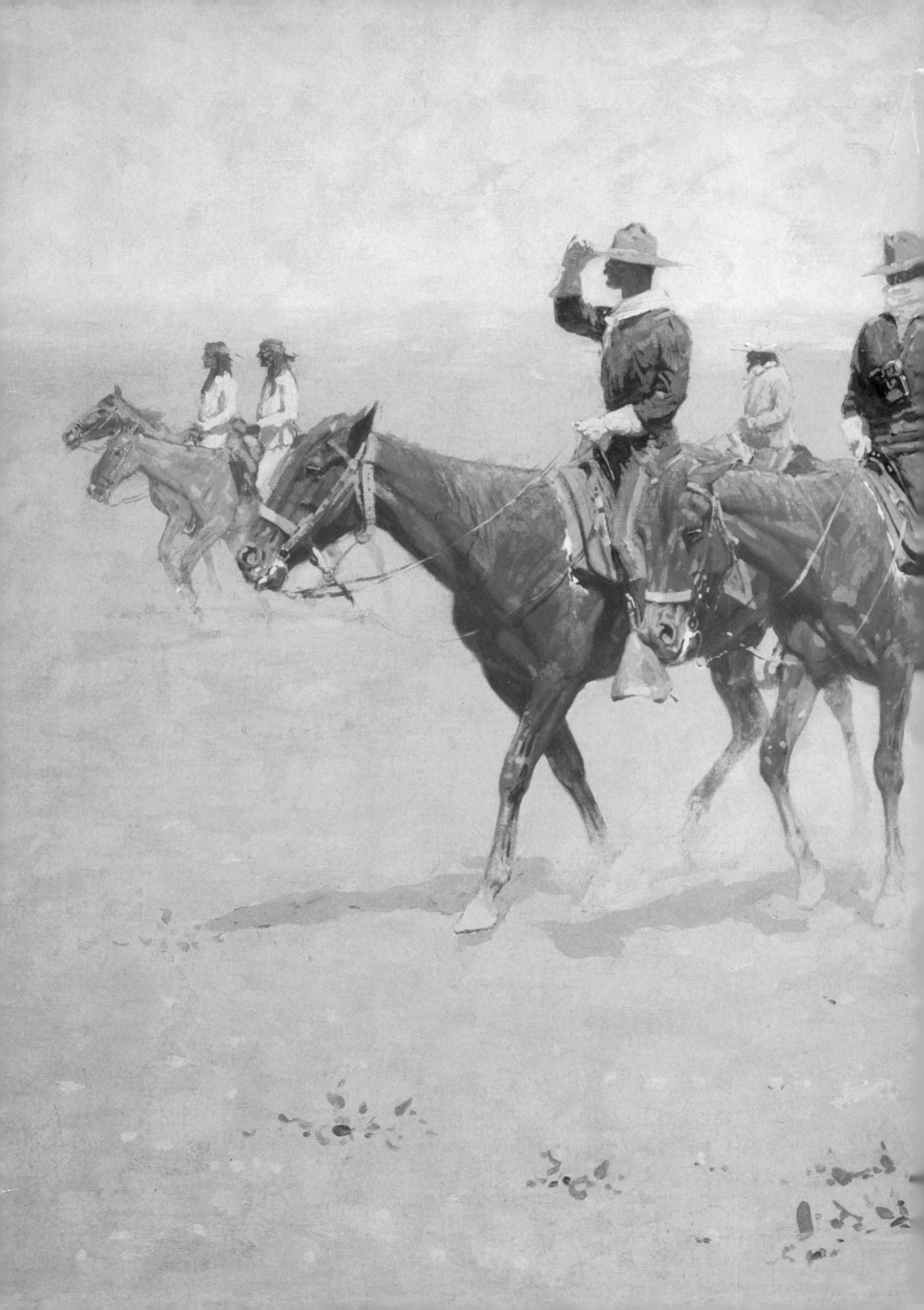

REMINGTON & RUSSELL
AND THE
ART OF THE AMERICAN WEST

Kate F. Jennings

SMITHMARK

Frederic Remington

Copyright © 1993 Brompton Books Corp.

All rights reserved. No part of this publication may
be reproduced, stored in a retrieval system or
transmitted in any form by any means, electronic,
mechanical, photocopying or otherwise, without
first obtaining written permission of the copyright
owner.

This edition published in 1993
by SMITHMARK Publishers Inc.,
16 East 32nd Street
New York, New York 10016.

SMITHMARK books are available for bulk purchase
for sales promotion and premium use. For details
write or telephone the Manager of Special Sales,
SMITHMARK Publishers Inc., 16 East 32nd Street,
New York, NY 10016. (212) 532-6600.

Produced by Brompton Books Corp.,
15 Sherwood Place,
Greenwich, CT 06830.

ISBN 0-8317-5161-4

Printed in Italy

10 9 8 7 6 5 4 3 2 1

Fol
ND
237
.J46
1993

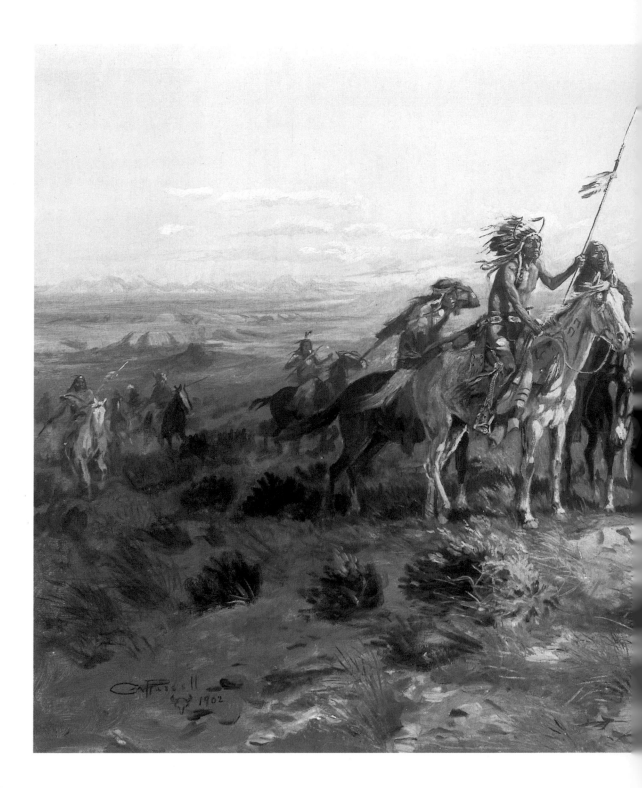

Page 1:
GEORGIA O'KEEFFE
Cow's Skull with Calico Roses,
1932
Oil on canvas
35.8 × 24 in.
The Art Institute of Chicago,
Chicago, IL
Gift of Georgia O'Keeffe, 1947 (1947.712)

Pages 2-3:
FREDERIC REMINGTON
The Quest, c. 1902
Oil on canvas
26 × 39½ in.
The Anschutz Collection

These pages:
CHARLES M. RUSSELL
The Scouts, 1902
Oil on canvas
24 × 36 in.
The Anschutz Collection

Contents

CONCORDIA COLLEGE LIBRARY
2811 NE HOLMAN ST.
PORTLAND, OR 97211-6099

Introduction

Whenever people speak of "Western Art" the first names most likely to be mentioned are those of Frederic Remington and Charles Russell. Understandably so, for not only were they both, in their different ways, superbly talented artists, but between them they contrived to touch on virtually all the basic subject matter we have come to associate with the art of the Old West – cowboys, Indians, cavalrymen and outlaws, as well as (though more incidentally) exotic landscapes, pioneers and animal life.

At least as important as the way their work summarized the content of Western art was the spirit in which they approached that content. By the early twentieth century, when both men were doing their most mature work, the West they had known in their youth had already largely vanished. Regretting this (as Russell put it, "When I backtrack memory's grand trail, it seems all the best camps are behind."), they deliberately set about memorializing their partly-remembered, partly-imagined Old West in painting and sculpture. Perhaps inevitably, nostalgia led them to romanticize – even mythologize – their subjects, and we have come to accept this, too, as an essential characteristic of Western art.

Yet if Remington and Russell may be said to epitomize Western art, they certainly neither invented it nor put an end to its evolution. Like today's Western artists, they were, in fact, heirs to an old and rich tradition, and the full magnitude of their accomplishment can be appreciated only in the context both of that tradition and of the colorful history from which it sprang.

The American West has a past to match the grandeur of its mountains and seemingly infinite plains. Even before it was claimed as part of the United States, artists were drawn to its territories by the lure of adventure and the promise of fortune. Though some were defeated by natural disasters, mortal enemies and the rigors of the West's uncivilized state, many were thrilled beyond expectations with the beauty of its landscapes and with the Indian tribes who roamed across its expanse.

We have few pictorial records of the West before the nineteenth century. The Louisiana Purchase, negotiated by President Thomas Jefferson in 1803, was the beginning of the Yankee era in this region from which 13 of the 50 United States would evolve.

In that year Jefferson requisitioned Congress for $2500 "to send intelligent officers with 10 or 12 men to explore even to the Western Ocean." In May of 1804 Meriwether Lewis, Jefferson's private secretary, and William Clark, along with Sacajawea, an Indian guide, and 45 men set out northwest across the continent from St. Louis.

Soon thereafter, in 1805 an Army officer, Lieutenant Zebulon Pike, headed north past the entry to the Minnesota River and chose the future site for Fort Snelling. During the next year Pike also challenged the Rockies, and a snow-covered mountain, Pike's Peak, was named after him. He later followed the Red River south and by accident crossed the Rio Grande into the hostile Spanish domain of Mexico, where he was captured and imprisoned. When he was finally released, Pike glowingly described the rich Spanish empire in North America.

These government-sponsored expeditions were fact-finding missions. Their goal was to determine the scope and geography of the land, as well as both the friendliness of the local Indian tribes and the customs of these patronizingly-called "children of the forest." And this they did very well. By 1806, when 14 members of the Lewis and Clark expedition returned to St. Louis, they brought with them a storehouse of data on the geology, zoology and especially on the Indian tribes of the West. It appeared that the character and activities of these tribes were highly varied.

On the plains were the nomadic and savage Sioux, as well as other aggressive nations such as the Cheyenne, Blackfeet, Kiowa and Comanche. The sedentary and more peaceful farmers belonging to the Pawnee, Arikara, Mandan and Kidatsa tribes lived along riverbanks. In the desert southwest, where men plowed arid acres and women wove beautiful textiles and made pottery, lived the Hopi, Acoma, Jemez, Zuni and Pueblo Indians, though some more pugnacious Navaho and Apache natives were scattered across this region as well. The Shoshoni resided in the Great Basin and on the plateau, and to the north and the east were the Utes and the Nez Perce.

The Indians, whom Frederic Remington called "men with the bark on" were extraordinarily resilient people. Indeed, they needed to be, for over the course of the next 100 years they would face increasing encroachments upon their land and customs from soldiers, railroaders, ranchers and farmers. A significant influence upon their culture had been the Spanish, whose most important contribution to the Indian lifestyle was .he horse. This enabled them to hunt buffalo more proficiently, as well as to ward off, or escape from, their foes.

The dependence of many Indians upon migratory herds of buffalo leant a certain transience to their existence. A clan would go to the plains to hunt and then retreat, always prepared for con-

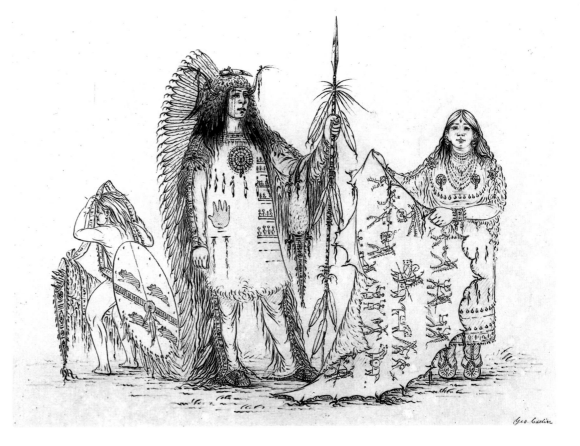

Left bottom: *Mandan*, an ethnographically priceless sketch by George Catlin.

Below: Sacajawea, a Shoshoni girl, helped to guide the Lewis and Clark expedition of 1804-06.

Bottom: Buying furs from Indians laid the basis for John Jacob Astor's immense fortune.

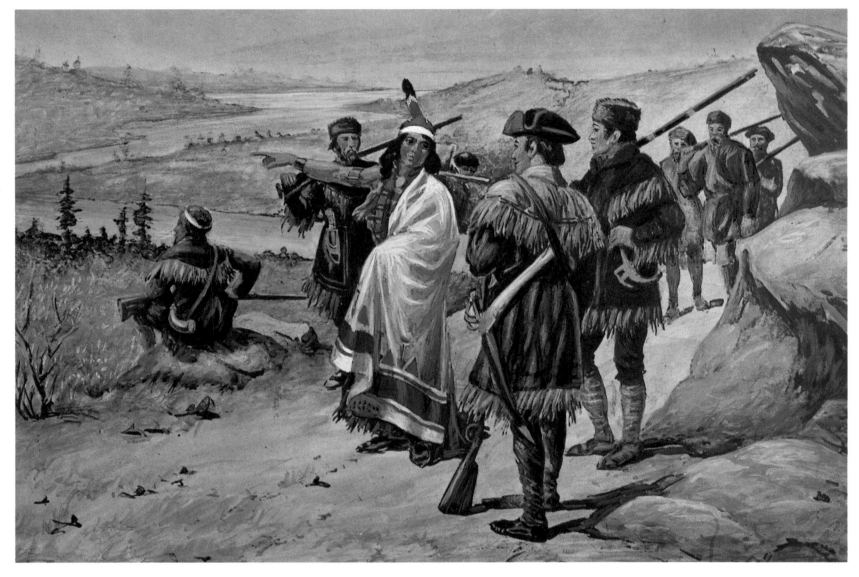

flict with another tribe, since each group considered the buffalo their own. Not surprisingly, their rites, dances, meetings, chores and trade revolved to a large degree around the hunt.

There were other early Western explorers beside military men. Trappers had already penetrated deep into remote territories whose rivers supplied abundant beaver pelts, along with muskrat, otter, mink and fox, for the Eastern and European markets. Among the first French explorers of the Northwest were Pierre Radisson and Médart Groseilliers, who voyaged far west of the Great Lakes in 1633, traveling by canoe into Sioux country to extend their fur trade.

A fur trader named Manuel Lisa had also been a member of the Lewis and Clark expedition. Upon his return he went into the upper Missouri vicinity and established a trading post in Mandan, North Dakota. Appointed to be an Indian agent for the barter of animal skins and furs by Governor William Clark of Missouri, Lisa was the only regular trader in these parts for the next 10 years.

John Jacob Astor acquired a vast fortune by extending the operations of his American Fur Company in 1811 up the Columbia River from St. Louis into a region called "Astoria." Astor's business was sanctioned by the government, and he

created constellations of smaller trading posts inland, selling the company to the British Northwest Fur Company in 1813. This firm merged with the Hudson Bay Company in 1821, whose chain of operations then spanned from the Hudson River to the Pacific Ocean.

The trapper, trader or mountain man typically rode small, lean, nimble-footed horses. He wore fringed deerskin clothes made by and purchased from Indian squaws, as well as a signature beaver

hat. A well-equipped hunter carried an Indian knife and slung a half-stock flintlock rifle, along with a powder horn and bag, over his shoulder. The trap he carried on his Indian-style saddle was prepared for game such as deer, antelope, coyotes, bear, wolves and mountain lions.

These men lived apart from society, surviving upon the skills of their trade and their knowledge of the woods and waterways. The artist Alfred Jacob Miller fluently described their character:

The astonishing detail that George Catlin was able to put into his finished canvases is well illustrated in his *Keokuk on Horseback*.

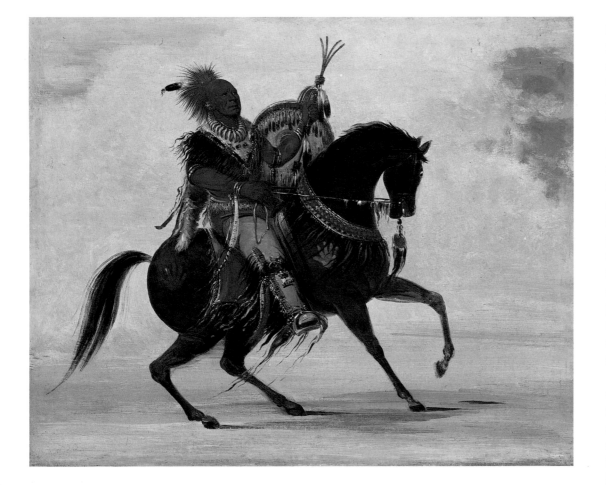

From the Canadas in the North to California in the South, from the Mississippi East to the Pacific West, every river and mountain stream in all probability have been at one time or another visited and inspected by them . . . Adventurous, hardy and self-reliant, always exposed to constant danger from hostile Indians and extremes of cold and hunger, they penetrate the wilderness in all directions in pursuit of their calling.

Although the information procured by Lewis and Clark made a compelling and factual narrative, it lacked illustrations to flesh out its verbal account of the land and peoples of the West. Without a graphic dimension, the details could seem flat and, sometimes, incomplete. To ensure more comprehensive reporting on subsequent forays, Congress began to use its resources to employ artists to accompany its military enterprises.

In 1819 Major Stephen Long embarked on a mission beginning at Pittsburgh and continuing by riverboat to St. Louis, west up the Missouri River to the Yellowstone River and beyond to the Platte River. Long then followed the South Platte to the foothills of the Rockies, went south to the banks of the Arkansas and traveled this river downstream to meet the Canadian River in what is now Oklahoma.

Scientific aspects of the exploration were analyzed and written up by expedition members, who included a botanist, a mineralogist and a geologist. A landscape artist from Philadelphia, Samuel Seymour, along with the painter Titian Peale, son of Charles Peale, founder of the Phil-

adelphia Academy of Art, went with Major Long. Over 150 landscapes and Western images, including council meetings, scalp dances, pagan ceremonies and feats of horsemanship were published in the atlas and journal that resulted from this journey.

An emphasis on European draftsmanship and technique was very much a part of their style. (Charles Peale's affection for the classical European tradition is shown by his sons' names: along with Titian were Raphael, Rembrandt and Rubens Peale.) Their renderings seem rather stiff and academic compared with later canvases, yet they greatly enhanced the scientific value of the expedition's reports and inspired a demand for additional pictorial representations of the West.

In 1823 Seymour also followed Major Long on a second expedition that traveled 4500 miles north as far as Lake Winnipeg. This time Long departed from Fort Snelling, at the juncture of the Mississippi and Minnesota rivers, and headed north to the Red River, finally reaching the 49th parallel and the Canadian border.

With the increasing interest in Western life, not only did artists venture into the wilderness, but Indians were brought back east to be portrayed by artists-in-residence in Baltimore, Philadelphia and Washington, D.C. The Superintendant of Indian Trade, Thomas H. McKenney, brought tribal chiefs to these cities in a gesture of friendship, to impress them with white man's culture, and to negotiate treaties. Flattering portraits of the visitors were painted by skilled artists such as Charles Bird King, who

had studied in London with Benjamin West. King captured the likenesses of over 100 Indians selected from 200 tribes. At least 89 of these would be collected for the Indian Gallery at the Smithsonian. (Unfortunately, a fire destroyed all but three of King's paintings in 1865.)

A series of important council meetings between US government officers and the chiefs of the more established tribes began in 1925. The first was at Prairie du Chien, where the Wisconsin River empties into the Mississippi. Fort Crawford was located here, and members of the Chippewa, Sauk, Fox, Pottawatonnie and Winnebago nations conferred to reach peaceful accords with the visitors. Powerful leaders such as Keokuk, chief of the Sauk nation, smoked the calumet, or peace pipe, with the white men. The purpose of the meeting was the purchase of 20,000,000 acres from the Indians, for which the United States was offering less than 10 cents an acre.

In 1826 Governor Cass of Michigan met with the Chippewa at Fond du Lac, the trading post of the American Fur Company located on the western end of Lake Superior, where US commissioners arrived by canoe. Another meeting was held in 1827, but although some agreements may have been reached during these powwows, war chiefs such as Red Bird, head of the Winnebago, privately prepared his tribe for battle. Ultimately, they would be defeated and he would be taken to prison.

James Otto Lewis, an artist on hand to sketch these events, recalled his frustrations in the preface to his *Aboriginal Portfolio* of 1835:

When it is recollected that the time for holding Indian treaties is generally very limited . . . together with the rapidity with which the artist is obliged to labour, he confidently believes . . . that whatever imperfections may be discoverable will be kindly ascribed to the proper and inevitable cause.

On occasion members of the military were also accomplished artists. Seth Eastman was such "a soldier with a sketchbook," a graduate of West Point and a second lieutenant when he arrived at Fort Crawford in 1829. Eastman kept copious notes and drawings of council meetings and took topographical reconnaissance trips to surrounding areas. Eastman's wife, Dorothy, was a writer whose text accompanied Eastman's 1849 picture portfolio of the Sioux who lived near Fort Snelling. She described the fort's architectural features, ". . . constructed of stone . . . one of the strongest forts in the United States . . . placed on a commanding bluff, with somewhat the appearance of an old German castle." Her lyrical chronicles of the Indians would be a source of inspiration for Henry Wadsworth Longfellow's celebrated poem "The Song of Hiawatha."

Legislative intrusions upon the red man's right

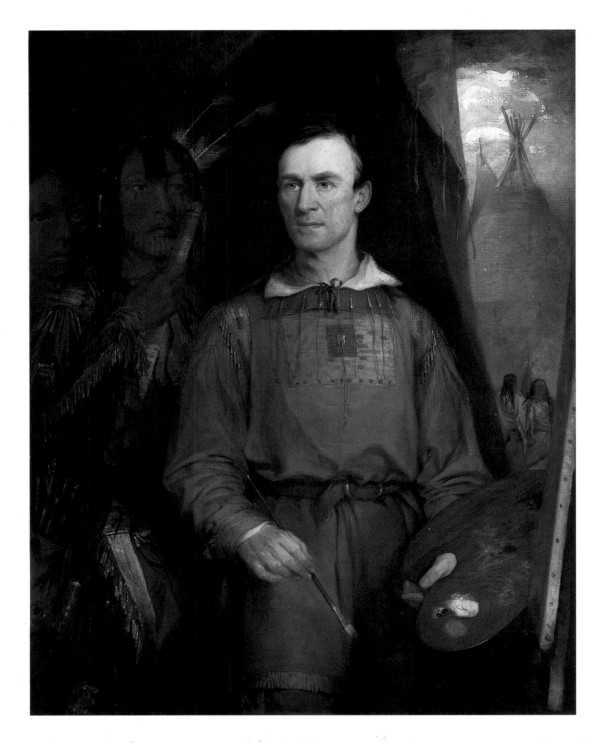

Left: A portrait of George Catlin painted in 1849 by William Fisk.

Below: A Catlin sketch shows Sioux disguised as coyotes stalking buffalo.

to his land began during Andrew Jackson's presidential term. The Indian Removal Act was ratified in 1830, and in 1834 the Commissioner of Indian Affairs announced that all areas west of the Mississippi, with the exception of Louisiana, Missouri and Arkansas, would thenceforth be designated "Indian Territory" for the resettlement of the vanquished eastern tribes. It was at about this time that some awareness of the Indian's plight and unique characteristics first began to emerge among scholars and painters.

One of the most famous, prolific and sympathetic Indian artists, George Catlin, was commissioned in 1832 by New York governor De Witt Clinton to travel to Fort Union, the farthest outpost of the American Fur Company, located at the mouth of the Yellowstone River. Like Charles King, Catlin had painted images of Indian chiefs in the East, but now he possessed a new goal. He would journey . . .

Over the almost boundless prairies and through the Rocky Mountains with a light heart, inspired with an enthusiastic hope and reliance that I could meet and overcome all the hazards and privations of a life devoted to the production of a literal and graphic delineation of the living manners, customs, and character of an interesting race of people who are rapidly passing away from the face of the Earth.

Catlin journeyed from St. Louis on the riverboat *Yellowstone*, sketching the Sioux and

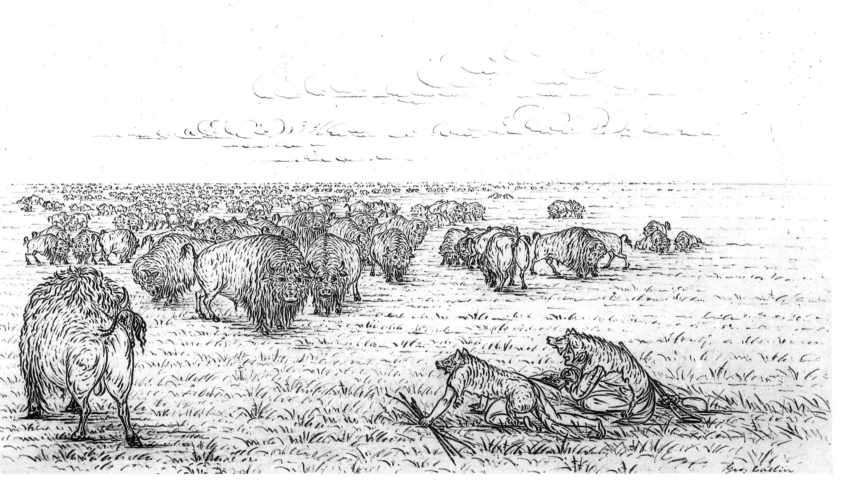

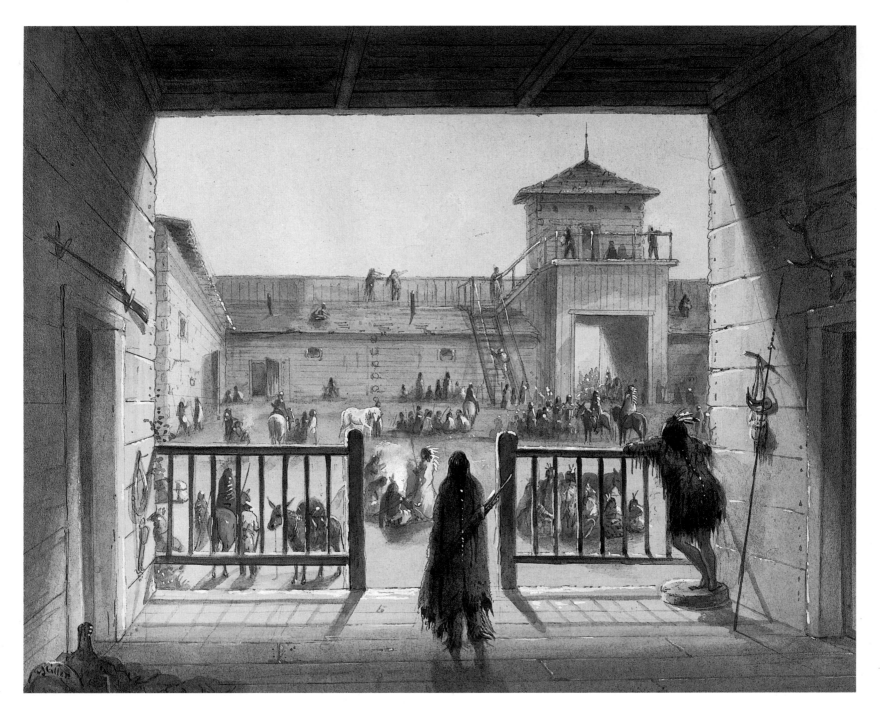

Cheyenne at Fort Pierre en route. While at Fort Union he painted many portraits of the Blackfeet and Crow nations, whom he called "the most independent and happiest races I have met with: they are all entirely in the state of primitive wildness, and consequently are picturesque and handsome, almost beyond description."

Catlin noted that the Crow lodges were made large enough for 40 men to dine under, constructed of 30 poles of pine, covered with buffalo hide and rising some 25 feet high. A string of dewclaws from deer or buffalo were hung at the entrance to announce visitors, and an opening at the top was carefully designed as a vent to allow smoke to escape and prevent it from being blown back into the living quarters.

Catlin also depicted the Osage, Kiowa, Comanche and Wichita tribes, yet the people who most fascinated him were the placid Mandans, who lived on the Upper Missouri near Bismarck, North Dakota. Catlin reached their villages by canoe in the company of two fur traders and soon rigged up his easel to capture likenesses of the settings and ceremonies he witnessed.

The most remarkable rite was the "Okeepa," a torture initiation to which young men subjected themselves to win favor from the gods and ensure a good buffalo hunt. Skewers were thrust through their chest muscles, and ropes attached

to these skewers were then hauled taut over rafters, leaving the braves to dangle until they lost consciousness and were cut down by fellow tribesmen. It was a savage enough ceremony to remind Catlin of the perilousness of his own position in depending upon the good will of a race with a growing distrust of Anglo-Saxons, yet he professed his determination: "Nothing short of the loss of my life shall prevent me from . . . becoming their historian."

Europeans were as intrigued by tales of the West as were the citizens of the East. Several wealthy members of the Old World aristocracy sallied forth from the Continent to explore and document its wonders. Prince Maximilian Alexander Philip zu Wied of Prussia was a naturalist who wished to publish a narrative atlas of the western United States. He brought with him a young Swiss draftsman named Karl Bodmer.

In March of 1833 they rode up the Missouri from St. Louis on board the same steamship that had borne George Catlin the year before. Bodmer had seen Catlin's sketches in St. Louis, whetting his interest in the adventure before him. The river route went past Mandan villages to Fort Union and then continued 500 miles to Fort McKenzie. Here a fierce battle broke out between a party of Assiniboins and Crees and some Blackfeet. Prince Maximilian joined in the fray, shoot-

ing from atop the fort's parapets and later claiming to have slain an Assiniboin brave. Bodmer, meanwhile, furiously made sketches of the action as it developed.

On the American Fur Company's second steamer, the *Assiniboin*, Maximilian and Bodmer went back down the Missouri in September 1833 to Fort Clark, where they stayed for the winter. Bodmer accumulated 81 pictures that would be published in the Prince's 1839 two-volume atlas entitled "Travels in the Interior of North America."

Bodmer's technical manner had a more scientific emphasis than Catlin's, perhaps to suit the requirements of his employer and reflecting the European academic tradition. His detail was extraordinarily explicit, and in some ways more ethnologically precise than the work of George Catlin, yet it could not match the emotional, personal attachment to the tribesmen that added such fervor to Catlin's style.

River travel was accomplished by several different types of boats. There were canoes and keelboats, which were shallow-draft vessels with a mast and sail and a set of oars; they were also equipped with long poles to help guide them through shallow streams. Bull-boats had an Indian basket frame covered with buffalo hides, and they too were used for shallows and down-

stream voyages. But the most common transportation on the erratic Missouri was the steamboat, an exceedingly slow vehicle that required many stops for refueling with wood. Its arrival was an occasion for parties and rejoicing at the lonely outposts of the military.

A steamer usually carried 30-40 passengers, including soldiers, traders, Indians, government surveyors and a few unclassifiables. There were constant risks of striking against tree turnks swept into the river during storms and the ever-present hazard of Indian ambushes: indeed, when traveling through Indian territory the steamships would normally come to by dropping anchor at the center of the river rather than risk trying to moor at its banks. When the tedium of life aboard a languid steamer grew too pronounced, wayfarers could stop and visit a military post or break up the journey by riding overland to meet the ship farther along.

Garrisons like Fort Benton, founded in 1834 by two brothers, Charles and William Bent, on

the Arkansas River, were both oases for steamer passengers and supply points along the Santa Fe trail. Fort Benton was made of adobe and held approximately 200 people. Items for trade at "Bent's Fort" included kettles, blankets, knives, tobacco and beads, as well as food supplies of sugar, flour and coffee. During the warmer months as many as 20,000 Indians might camp nearby to swap hides for these staples and trinkets. Gymkhanas, horse races and rifle matches were held for the troops. Entertainment other than reading consisted of card games, gambling, dances with the Indians and playing banjos, bugles and cracked fiddles.

When George Catlin rode along with the mounted cavalry, it was with the First United States Dragoons, organized in 1833 to curb the aggression of the Comanche, Kiowa and Apache tribes. Its leaders were Colonel Henry Dodge, Lieutenant Colonel Stephen W. Kearny and (eventually to be the most famous of the three) Adjutant Jefferson Davis. Their mission was to

gallop forth "to scour the prairies, to astonish the natives, and to satisfy them that further hostilities will lead to their destruction." And this they did with a will, completing one campaign of nearly 700 miles across scorchingly hot plains during the summer of 1834. Clearly, artists wishing to accompany such expeditions were practically required to be horsemen: most of them wound up carrying provisions in one saddlebag and sketchbooks and brushes in another.

Overland travel for settlers in the early to mid-1800s was often achieved by means of the Conestoga wagon, or prairie schooner, named after its place of origin in the Conestoga Valley of Pennsylvania circa 1755. Three-horse teams, yokes of oxen or teams of mules pulled these huge vehicles, which covered an average distance of 12 to 15 miles a day. Caravans composed of 100 wagons or so could leave St. Louis in the spring and arrive in Santa Fe by July, the optimum time for setting up trade markets.

The standard northwestern route went from

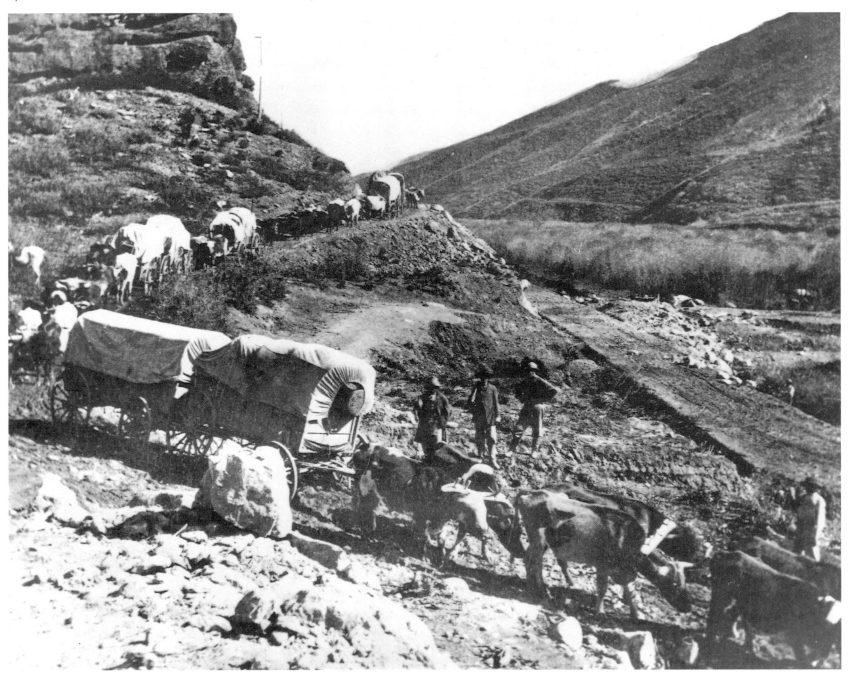

Right: A photographic portrait of landscape painter Albert Bierstadt taken *c.* 1859.

Below: A photograph of a Shoshoni brave taken in 1859 by one of the Bierstadt brothers, Albert, Charles or Edward.

Missouri through Kansas to Fort Kearny on the Platte River, then to Chimney Rock and on past Council Bluffs, Iowa. At a rate of 15 miles a day, a wagon could reach Fort Laramie on the Oregon Trail in 45 days. One foreign traveler who chose this course was a Scottish captain named Sir William Drummond Stewart.

Stewart had become enamored of the West while hunting elk and large game in Wyoming in 1836. He returned in the following spring, bringing with him a young artist from Baltimore named Alfred Jacob Miller, whose job it was to supply paintings for Stewart's Scottish hunting lodge, "Murthly Castle," located in Perthshire. The two men and their party, assisted by a half-breed guide and hunter named Antoine Clement, made their pilgrimage with a caravan belonging to the American Fur Company. For most of the way the group was obliged to subsist on meat alone.

Miller, trained at the École des Beaux-Arts in Paris, eventually furnished the Scotsman with over 167 watercolor sketches and more than 30 canvases of buffalo hunts, Indians of the Snake and Sioux tribes, elk and antelope, grizzly bears, prairie fires and frontier life in general. They were works of exceptional merit.

Miller's sympathetic attitude towards his Indian subjects was far from conventional in the

1830s. The official view is well expressed in McKenney and James's 1837 document *History of Indian Tribes in North America*:

Nor do we believe at all that migrating tribes, small in number and of very unsettled habits of life, have any right to appropriate to themselves as hunting grounds, and battle fields, those large domains which God designed to be reclaimed from the wilderness and which under the culture of civilised man, are adapted to support millions of human beings and to be made subservient to the noblest purposes of human thought and industry.

Alfred Jacob Miller, however, was able to see things from the Indians' perspective:

It is a question whether with all our boasted civilization, we enjoy more real happiness than these children of the prairies, on whom we exhaust a deal of superfluous sympathy. They would certainly not be willing, or in a hurry, to exchange with us – and are at least contented with their lot. We (generally speaking) never are.

Missionaries, determined to transform both Indian savages and wayward trappers into Christian devotees, were among the early pioneers who headed west. Between 1820 and 1860

approximately 70 missions were founded, and their ministers adapted to the rough and ready frontier culture by sometimes delivering sermons in saloons.

But the real pioneers, the people who truly opened the West, were ordinary settlers. Fourteen wagons crossed the Continental Divide in 1841. In 1842 Elijah White sponsored 18 wagonloads of goods and 130 emigrants to the Northwest. John C. Frémont, christened "the Pathfinder" by his followers, led a large group through Nevada in 1843, crossing the Sierras into California and then finally pressing on to Oregon: 100,000 copies of his vivid description of the American Promised Land were printed and distributed by Congress. In 1847 Brigham Young brought the Mormons to Salt Lake.

Journeys began during the good grass season for animals, and wagons would stop mid-day for two hours of grazing. The route to California departed from the Oregon Trail at the Snake River and continued down to the Humbolt River in western Nevada. The desert beyond was treacherous, and the Sierra Nevadas daunting. After this, the rushing, rocky Truckee River led through the formidable Donner Pass and finally reached the California Trail, which met the San Joaquin and Sacramento valleys.

As the westward migration swelled, so did the demand for wagons. While Conestoga wagons continued to sell well, new, larger models – squarer, sturdier and more box-like in design – were also being produced by companies with names such as Jackson, Murphy or Studebaker. These wagons weighed a ton, stood 6 feet to 8 feet high and could carry 4000 pounds, which meant that heavy manufactured goods such as bar mirrors and fixtures, safes, machinery and materials for home and store building could now be carried west.

In 1855 a freighting firm founded by Alexander Majors and two men named Russell and Waddell operated 300-350 wagons on the Santa Fe Trail. By 1860 they owned 3000 wagons, 40,000 oxen and a thousand mules. Freighting centers were located at Leavenworth, Omaha, Nebraska City, Independence and Atchison, Kansas.

Pack trains and wagon caravans were essential to the development of mining in California. California had been ceded to the United States in 1848 by Mexico after the Mexican-American War, and gold was discovered near Sutter's Fort in the region of Sacramento in the same year. In the next 12 months some 81,000 Americans and foreigners poured into the region. And in their wake were many artists, one of whom was Albert Bierstadt.

Born in Düsseldorf, Germany, in 1830, Bierstadt emigrated with his family to the United States as a child. He returned to Düsseldorf for his art education and studied there under an American, Worthington Whittredge, who had been a member of the Hudson River School of landscape painters. Bierstadt returned to the United States and two years later joined the wagon train of General Frederick Lander on a military expedition that left Fort Laramie, Wyoming, in 1858 to find a passage to the Pacific

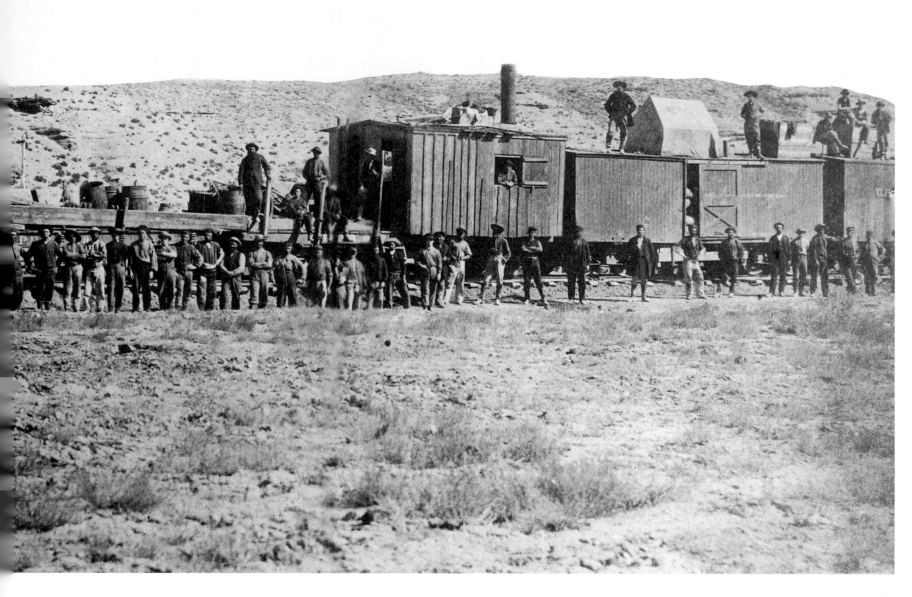

Coast. This experience would set Bierstadt on a road that would end with his becoming the most famous Western landscape painter of his century.

Bierstadt's most celebrated canvases emphasized the beautiful, romantic and breathtaking aspects of the Rocky Mountains. In his work their peaks were always dramatically lit, heroic and rugged, contrasting with lower foregrounds that were quiet, shaded and serene. His aim was less to report on the West than to glorify it, and to this end he often resorted to lighting effects that were visually awe inspiring, but in fact unnatural, and to exaggerations of scale wherein men and animals appeared minute compared with the forests, skies and mountain ranges surrounding them. Some critics objected to Bierstadt's theatricality, but the public loved it and paid top prices for his canvases.

Bierstadt's old mentor, Worthington Whittredge, also ventured west, riding 2000 miles on horseback with General John Pope's troops in 1866. Their odyssey followed along the Platte River, the Rio Grande and the Cimarron Trail. By this time, however, stagecoach travel, far faster than the wagon train, was also being used for carrying mail and passengers without household belongings. The Concord model, first manufactured in New Hampshire, was highly ornamental but swayed so vigorously that Mark Twain dubbed it "a cradle on wheels."

The coach rested on leather straps attached to braces fastened to the front and rear axles. Inside were comfortable, upholstered seats that would carry nine passengers, while a dozen or more rode outside on top. Under the driver's feet would be a box with bullion and valuables. The coaches also carried mail and issued bills of exchange.

In 1860 the freighting firm of Russell, Majors and Waddell began the weekly overland mail service known as "The Pony Express." An advertisement in the San Francisco papers in March of 1860 stated the employee requirements: "Wanted: young, skinny wiry fellows. Not over eighteen. Must be expert riders willing to risk death daily. Wages $25 per week." This was considered a very good salary but the job was as hazardous as the ad promised. Snow drifts, fires, storms and bands of marauding Indians were only some of the dangers that awaited these daring riders.

They traveled at a full gallop in relays averaging 50 to 100 miles in length, with a change of horses every 20 miles. The ponies stood about 14 to 14.2 hands high, and the preferred weight of their riders was between 125 and 135 pounds. Riders were expected to change saddles and tack in two minutes at changeovers. When the transcontinental telegraph was finally connected in October 1861 the Pony Express was disbanded,

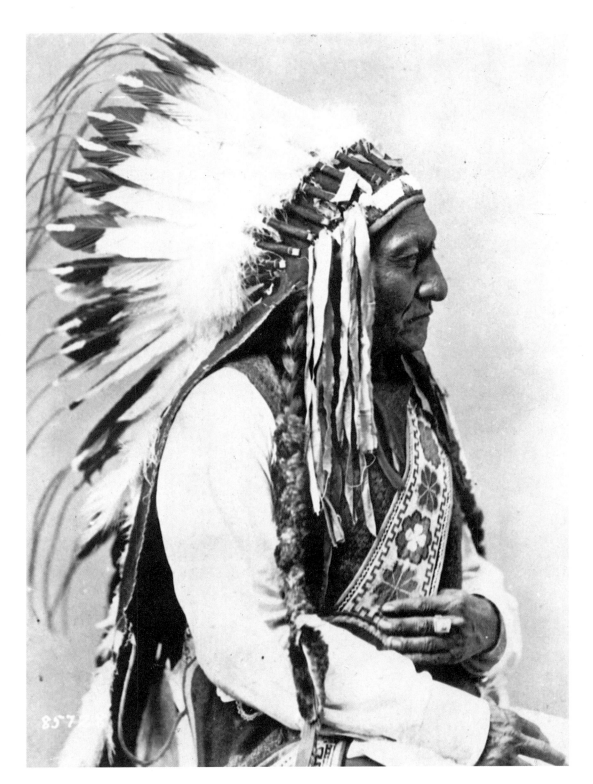

yet the legend of its fearless men lives on to this day in canvases by Frederic Remington, Frank Tenney Johnson and N.C. Wyeth.

In time, Conestoga wagons, river steamers, stage coaches and virtually all other forms of transport would fall victim to the iron horse. The decades between 1830 and 1855 were the most active in railroad construction in the US history. In 1827 the nation's first major rail line, the Baltimore and Ohio, received its charter, and by 1848 its western terminus was Cincinnati, Ohio. John Mix Stanley, an Indian portraitist who had visited both Fort Snelling and Fort Gibson in Arkansas in the 1840s, was the draftsman designated to outline topography, tribes and animal life as a member of the northwestern railway survey in 1853. By 1855 the first reports planning the most practical route to the Pacific were being issued by the government.

The building of a transcontinental railroad was only slightly impeded by the onset of the Civil War, since President Lincoln readily perceived its strategic value in maintaining Union control over the northwestern territories. A federally-sponsored Union Pacific line, starting west

from Omaha, Nebraska, was approved in 1862, and in the same year a California-sponsored Central Pacific line began to push east from Sacramento. The two lines would finally meet on May 10, 1869, at Promontory, Utah, and the history of Western settlement would be forever changed. But the completion of this intercontinental rail link would be accomplished only at a vast expense of blood and treasure, and its existence would precipitate severe new crises in white-Indian relations.

The two greatest dangers to the completion of the rail lines, and to overland travel in general, were the Indians and herds of buffalo. As Grenville Dodge wrote in *How We Built the Union Pacific Railway*, "Every mile of road had to be surveyed, graded, tied and bridged under military protection."

Though virtually all Indians were hostile to the building of the Western railroads, the biggest practical threat was posed by the Great Plains Sioux, the powerful and bellicose nation led by such great war chiefs as Sitting Bull, Crazy Horse and Kicking Bear. The tribe, also known as the Western Dakota, was organized into seven divi-

Left: The famous Hunkpapa Sioux medicine man and war leader Sitting Bull (Tatankya Iyotake).

Below: General George Crook fights the Sioux at the Battle of Rosebud, an inconclusive engagement that took place eight days before Custer's defeat at the Little Big Horn.

sions, including the Oglala, the Brule, the Without Bows and the Hunkpapa. Each division appointed its own council heads and its own battle leaders.

Elders, consisting of priests, hunters and warriors of renown, were at the top of the hierarchy, followed by Nacas, who were the executives, and the Shirt wearers, braves dressed in hair shirts who served middle-level administrators.

Warfare was an integral part of Sioux culture. Whether or not it was undertaken might depend on dreams, cloud visions or atmospheric signs, but once the Sioux were on the warpath they were formidable – as General George Armstrong Custer would discover in a skirmish that has become the most written-about (and painted) battle in American history.

In June of 1876, America's centennial year, Custer left the Yellowstone River to ride along the Rosebud River with the goal of reconnoitering the positions of a large party of hostile Sioux camped nearby. He brought with him 31 officers, 585 troopers, 20 civilians (mainly packers and guides) and 40 Crow and Arikara Indian scouts.

On June 25th, from a ridge overlooking the valley of the Little Bighorn River, the scouts saw smoke and assumed that it came from a small Sioux encampment. Custer decided to attack, dividing his force in three: one battalion under Major Reno, one under Captain Benteen and the remainder – 215 men – under his own command. Benteen was ordered to scout to the south while Custer and Reno flushed the hostiles from the small campsite. This was easily done, and Reno was directed to continue pursuing the survivors. But as he was doing so he was set upon by Chief Gall and an overwhelming force of Sioux braves. Custer, meantime, had stumbled upon an encampment of 12,000 Sioux, one-third of whom were warriors. Incredibly, he decided to attack it, and his entire cavalry contingent was massacred within an hour. Reno's and Benteen's commands were able to retreat, but suffered heavy losses.

It was not a major battle, and Custer had handled it badly, but perhaps in part because there were so few witnesses to report the facts, Custer and his men were heralded as heroes, the event was sensationalized as an epic of bravery and "Custer's Last Stand" would eventually become the subject of some 800 paintings, some by such well-known artists as Cassily Adams, Frederic Remington, Charles Russell, Joseph Sharp, W. Herbert Dunton, N.C. Wyeth and Walt Kuhn. The lithograph of Cassily Adams' canvas produced by Anheuser-Busch hung behind the bar in countless American saloons, possibly the most influential of all the icons of the Wild West.

In the end, of course, the Indians could not prevail: they had neither the resources nor the numbers (a government census issued in 1870 counted only 287,640 Indians). Their fate was presaged in these words written by Thomas McKenney:

It has chiefly been when we have chafed them to madness by incessant and unnecessary encroachment, and by unjust treaties . . . that they have been so unwise as to provoke our resentment with open hostility. These wars have uniformly terminated in new demands on our part . . . until the small reservations which they have been permitted to retain in the bosom of our territory are scarcely large enough to support the living, or hide the dead, of these miserable remnants of once powerful tribes.

Unlike the Indians, the bison, incorrectly but commonly called buffalo, *were* a problem because of their numbers. An 1830s estimate of their herds was 60 million animals. Grenville Dodge described a drove that confronted the railroad survey. It was 25 miles wide and 50 miles deep and took "about 5 days in passing a given point." Notes from an exhibit catalogue by wildlife artist William Jacob Hays in the 1860s proclaim: "They form a solid column, led by the strongest and most courageous bulls, and nothing in the form of natural obstacles seems to deter their onward march."

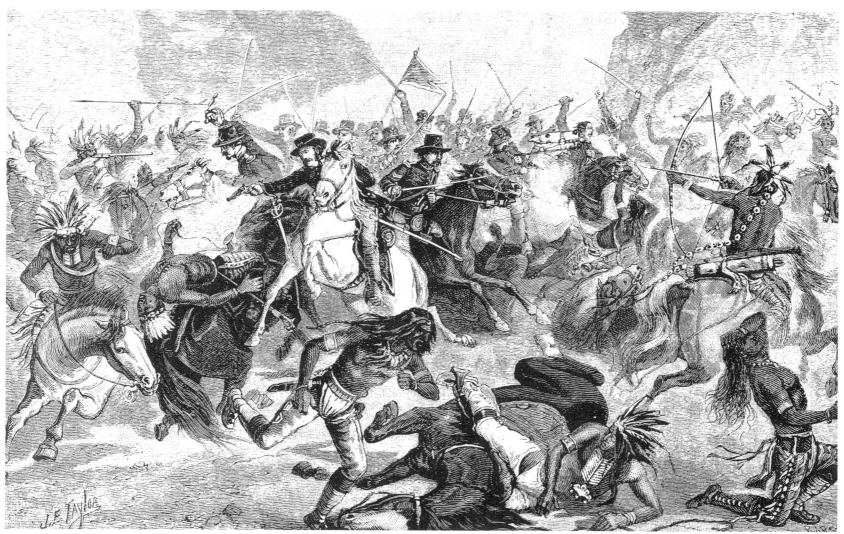

Below: A portrait of the landscapist Thomas Moran by Howard Russell Butler.

Bottom: Showman Buffalo Bill poses with some Indian members of his Wild West Show troupe.

Mature bison stood six feet tall at the shoulder and weighed from 1800 to 2000 pounds. Hunters called them "walking gold pieces." Shooting by professionals was done from 300 yards with heavy guns, and wagons loaded with three to four tons of skins were regularly driven to markets such as Dodge City, Kansas. Each hide could be sold for between $2 and $3, and hunters might earn as much as $4000 a year.

Legislation was proposed for the bison's protection in the Senate as early as 1872, but it was defeated. Though by the late 1880s laws finally were enacted, by and large they were unenforceable. An estimate of the buffalo in 1887 counted only 1091 head of the animal, an incredible record of the rapacious plunder of this once-plentiful species.

During the course of railroad expansion great deposits of coal and iron ore were discovered in the Rockies and surrounding region. Two hundred tons of coal a day were extracted from a lode near Carbon Station near the Continental Divide. Geological exploration received increasing attention during President Ulysses Grant's administration, and it was in 1871 that a geologist, Dr. Ferdinand Hayden, embarked, along with a pioneer photographer William Jackson and an English-born artist, trained at the Pennsylvania Academy of Art, named Thomas Moran, on a notable government expedition to explore the Yellowstone region.

Thomas Moran was enthralled by the Yellowstone Falls and rendered so many different

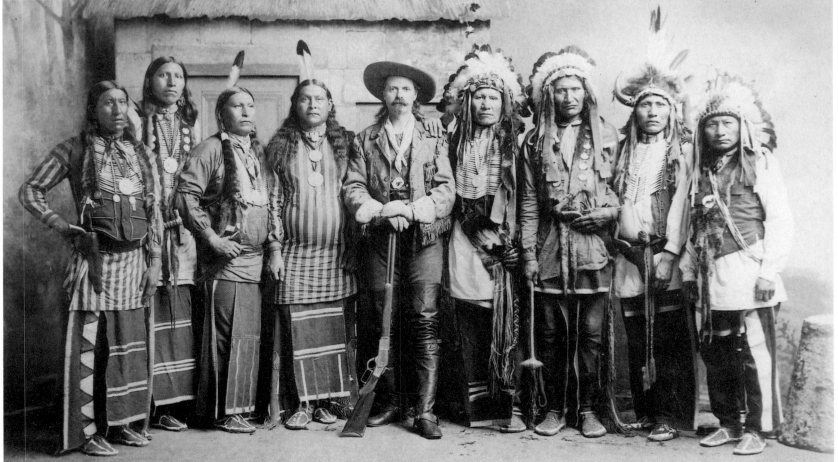

Below: An 1878 poster invites Tennessee blacks to move west and homestead in Kansas.

canvases of its steaming channels that he was nicknamed "T. Yellowstone Moran." In 1872 Congress purchased Moran's 7-foot by 12-foot mural *The Grand Canyon of Yellowstone*. The artist was a primary force in the establishment of Yellowstone as a national park in the same year.

Moran's rapture at the sights before him is disclosed in a letter he wrote to Dr. Hayden on March 11, 1872: "I have always held that the grandest, most beautiful or wonderful in Nature would, in capable hands, make the grandest, most beautiful or wonderful pictures, and that the business of a great painter should be the representation of great scenes in Nature."

The artist Thomas Hill went west for a more personal reason: to seek the warm, dry climates of Arizona and California as a cure for his tuberculosis. But in the end he, like Moran, was overwhelmed by the natural beauty he found and ultimately became the foremost painter of the Yosemite Valley. He had been a member of the Hudson River School and had traded paintings of the White Mountains for room and board there. Now he became known as the fastest brush in the West: he could finish six 18-inch by 24-inch paintings in nine hours. He was also fond of large canvases. One, *The Driving of the Last Spike*, a commemorative mural commissioned by Governor Leland Stanford to celebrate the joining of the Union Pacific and Central Pacific tracks, measured 8 feet by 12 feet. Stanford, unfortunately, never got around to paying for it.

With the extension of various railroad lines throughout the West came the profitable possibility of shipping cattle back east and the emergence of the cowboy. The Union Pacific-Central Pacific link to the California coast was soon supplemented by other lines such as the Northern Pacific, Great Northern, Santa Fe, Southern Pacific and Milwaukee railroads, and cow towns quickly sprang up to take advantage of this explosion in transport.

The main shipping point for longhorn cattle from Texas was Abilene, Kansas, where tracks were laid in 1867 and stockyards with extensive dimensions were built. In 1868, 35,000 steers were shipped from Abilene, a figure that grew to 150,000 the next year. In all, between 1866 and 1880 it is estimated that 5 million head of cattle arrived in the East, most driven to railheads along trails with names like Abilene, Ellsworth, Newton, Goodnight, Dodge City and the famous Chisholm Trail.

Longhorns could be dangerous animals to herd, for they had extremely sharp horns that sometimes measured 6 feet from tip to tip. They were "more tail than beef," bred for muscle, stamina and speed and for enduring the harsh Western winters. The drivers were rowdy, noisy and brave, ever vigilant for a stampede that might be caused by a coyote yelp, the rattling of pots in

Ho for Kansas!

Brethren, Friends, & Fellow Citizens:

I feel thankful to inform you that the

REAL ESTATE

AND

Homestead Association,

Will Leave Here the

15th of April, 1878,

In pursuit of Homes in the Southwestern Lands of America, at Transportation Rates, cheaper than ever was known before.

For full information inquire of

Benj. Singleton, better known as old Pap,

NO. 5 NORTH FRONT STREET.

Beware of Speculators and Adventurers, as it is a dangerous thing to fall in their hands.

Nashville, Tenn., March 18, 1878.

the chuckwagon or a sudden bolt of lightning. Almost anything could send the longhorns into a headlong panic – a panic that required superb horsemanship, feats of daring and fine roping skills to subdue.

The American cowboy was first and foremost a horseman, and much of his equipment, lingo and manner of living had evolved from his predecessors, the Spanish vaqueros, who had formerly worked on the ranchlands of California. The Western saddle, with its high pommel, fancy stitching and stirrup covers called "taps" (from tapadero), the suede chaps, the lariat (from "la reata"), the mustang (from "mesteno," meaning wild) and the rodeo are all derived from a Spanish heritage.

A cowboy might be in the saddle 12 or more hours a day, always taking care to move the cattle without running the beef off them or tiring out his horse. The horse was usually ridden with a hackamore bridle, which lacked a bit and had a cotton rope throat-latch to make the bridle into a halter. The reins were tied together, ending in a quirt, a braided lash that could be used as a whip.

In the early decades of the 1860s and 1870s a rancher had only to register his cattle brand and claim the extent of his range for his herd. The most valuable commodity for his territory was water. Though he had no formal title to the land he claimed, he enforced his turf with arms. The most popular gun was the .45-caliber Colt six-shooter, usually carried in open holsters or

Right: The great Apache war chief Geronimo.

Below: A Frederic Remington watercolor of his father, Seth Pierpont Remington, wearing his Civil War cavalry uniform.

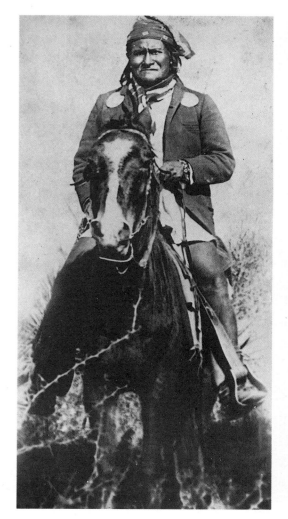

tucked into waistbands. Most men, and even boys, carried weapons of some kind.

Steers were branded on the left side of their rumps. There were numerous rustlers, known as "rewrite artists," who would change the brands and abscond with their booty. Cattlemen often notched the ears of their beasts to avoid this looting and registered both their brands and ear notches. Expedient roping and throwing of calves was a desirable talent for cowboys and a source of keen competition at rodeos. It was also the theme of many artists' sketches and canvases.

Around 1875 barbed wire came into increasing use to divide and limit properties. This was largely initiated by the railroads, which sectioned off parcels of acreage for sale. Many of the cowboys resented this intrusion into their freedom and open spaces, and stockmen particularly disliked agricultural farmers, whose plowing of the soil earned them the moniker "sodbuster." On the other hand, barbed-wire fencing did help the ranchers to conduct breeding programs, which eventually produced such new strains as shorthorns and Herefords.

The two most notable of the many artists who proclaimed the virtues and heroism of the Western cowboy were Frederic Remington and Charles Russell. The exploits and activities of wranglers and rodeo men were captured in exquisite detail and with humor and insight by these two legendary painters.

Frederic Remington was born on October 1, 1861, in Canton, New York, not far from the Canadian border. His early interest in horses was perhaps inherited, for his father had been a member of the New York Cavalry in the Civil War. Young Frederic was sent off to Highland Military Academy in Worcester, Massachusetts, to learn discipline along with his equestrian skills. While there, he found that another of his talents, an aptitude for sketching, could be a military asset.

He particularly enjoyed drawing soldiers and battle scenes, and in his correspondence with a boyhood friend and fellow artist Remington demanded: "Don't send me any more women or any more dudes. Send me Indians, cowboys, villains or toughs, those are what I want." Remington was exhilarated by the idea of a life of violence and seemed convinced that the best place to find it was in the West, but at this point, any journey to the Rockies or beyond was just an adolescent dream. Upon graduation from Highland Academy, Remington enrolled at Yale to study art at the university level.

During Remington's sophomore year at Yale his father died, leaving him a modest inheritance which suddenly made possible his long-planned trip to the West. He left college and briefly went home to Canton, where he met his future bride, Eva Adele Caten. He was smitten and wished to

marry her at once, but her father doubted his financial prospects. He vowed to go west, make his fortune and come back to claim Eva.

Remington roamed the badlands of Dakota and wandered into Wyoming, Kansas and Montana, following the Oregon and Santa Fe Trails at different times over his 2½-month stay. He returned to New York with a sizeable portfolio of sketches, and he sold his first published illustration to *Harper's Weekly* for its February 25, 1882, issue. When he received the remainder of his inheritance on his 21st birthday he again headed west, this time to Peabody, Kansas, where he bought a sheep ranch. But he was ill-suited to animal husbandry and sold the ranch just two years later, investing the proceeds into a saloon. Unfortunately, his partners swindled him, and he was forced to travel east once more, poor and apparently with few prospects.

Nevertheless, his passion and loyalty to Eva was rewarded by her father's granting her hand

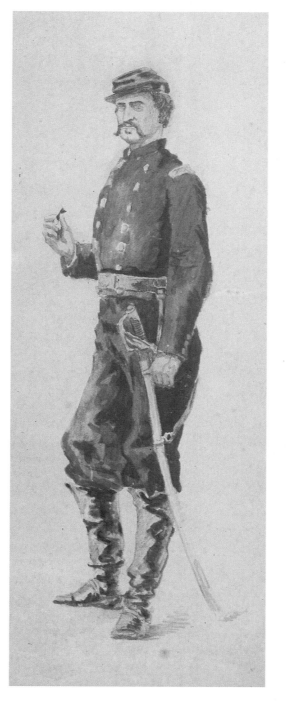

in marriage, and the young couple soon thereafter left for Kansas City, Missouri. By this time Remington had recognized that his true vocation was that of an artist, yet he was frustrated in his attempts to market more of his illustrations. Eva grew homesick for New York and weary of the unpredictability of her husband's ambitions. She returned to the East while Remington set off with a group of gold prospectors into the Arizona Territory.

The Arizona Territory at this time was still filled with hostile Apaches. One evening while sitting around a campfire discussing the military's plans for capturing the great Apache war leader, Geronimo, Remington and his companions were startled to see that sitting on the other side of the campfire from them were three Apache braves. At first they were convinced that they were facing Geronimo himself, but the tribesmen signalled they were simply hungry. Remington candidly described the event. "I mused over the occurence. For a while it brought no more serious consequences than the loss of some odd pounds of bacon and flour. Yet there was a warning in the way those Apaches could usurp the prerogatives of ghosts."

Remington also spent a period of time in the north among the Comanches, whose talent with horses impressed him and inspired a variety of drawings and canvases. Not long after this sojourn Remington went back to Eva and New York, where he enrolled in the Art Students League. After 1885 he never again lived in the West, though he would return several times on assignment for various publications.

But his experiences provided him with a wealth of material. The cover for *Harper's Weekly*'s January 9, 1886, issue was a reproduction of his *The Apache War – Indian Scouts on Geronimo's*

Right: Frederic Remington in his studio. The work in progress is *The Buffalo Horse*.

Below: Remington's friend, future president Teddy Roosevelt, poses with some of his Rough Riders on San Juan Hill in 1898.

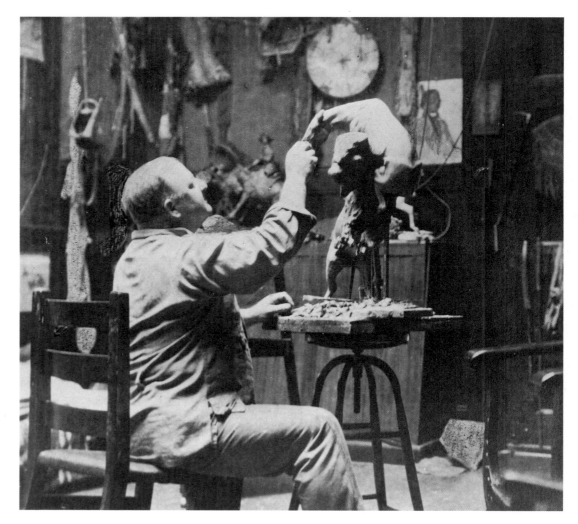

Trail. He also contributed illustrations to *St. Nicholas* magazine, but his biggest break came when he was reunited with his Yale classmate, Poultney Bigelow. Then the editor of *Outing Magazine*, Bigelow bought Remington's entire collection of Western drawings and kept the artist occupied with orders that would present his work in every one of the magazine's issues for the next two or three years. To find fresh material to meet the rising demand for his work, in June of 1886 Remington accompanied the US Army on an expedition against the warring Apaches in Arizona. This adventure would furnish him with research for the genre that would in time make him world famous: cavalry paintings.

Remington's reputation soared in the next few years. In 1888 his canvas *Return of a Blackfoot War Party* won two prizes at the National Academy of Design's annual exhibit. He placed 54 illustrations in *Harper's Weekly*, 32 in *Outing Magazine*, 27 in *Youth's Companion* and 64 in

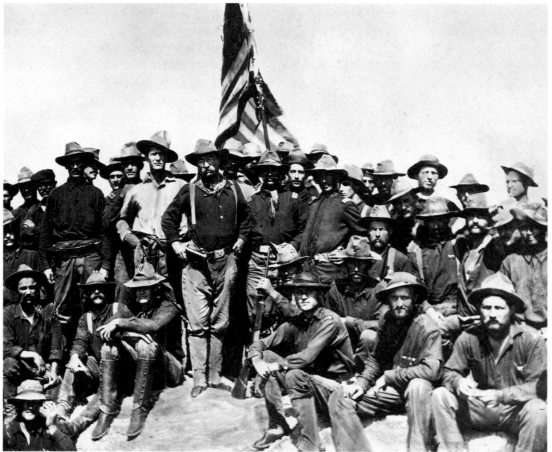

Century Magazine. Several of the pieces he completed for *Century* were intended for a series of articles written by Theodore Roosevelt, another unabashed aficionado of the West who would shortly become Remington's close friend and patron: 99 illustrations by Remington would later appear in Roosevelt's 1907 book *Ranch Life and the Hunting Trail*. In 1890 he illustrated Longfellow's "Song of Hiawatha," and in 1892 Francis Parkman's frontier classic *The Oregon Trail*.

While Remington was in New York City his

life was relatively comfortable. His apartment overlooking Central Park was filled with memorabilia from his adventures: Indian trinkets, saddles, chaps, bugles and bridles. He rode horseback through the park in the afternoons. Though a large man, weighing nearly 230 pounds, he remained athletic.

But life in New York could not satisfy him entirely. Thus when Remington was informed of forthcoming skirmishes with the Sioux, he eagerly joined a scouting party sent to search for their leader, Chief Sitting Bull. They scoured the

Badlands of South Dakota, and though Remington left for New York before Sitting Bull's discovery and subsequent defeat, he gathered many sketches and notes which he would use to embellish his canvas of the massacre that took place at Wounded Knee on December 29, 1890.

Upon his return, Frederic and Eva moved to the suburb of New Rochelle, New York, where Remington had a separate studio and private stable in addition to a capacious home. He wrote and illustrated a book of his experiences entitled *Pony Tracks* in 1895 and also began sculpting in bronze at this time. He would finish 23 pieces in his lifetime, almost all of which were equestrian. His desire to see combat firsthand, along with a commission from publisher William Randolph Hearst, took him to Cuba in 1898 to observe the Spanish-American War. A subsequent result, his canvas *The Charge of the Rough Riders at San Juan Hill*, is testimony to his enduring admiration for Teddy Roosevelt, who led the brigade. Remington rarely painted public figures, but Roosevelt was then in the midst of a tough gubernatorial campaign, and the artist lent his support with this heroic painting.

By the turn of the century Remington was all too well aware that the West he was so fond of portraying had, for the most part, ceased to exist. "The West is no longer the West of picturesque and stirring events. Romance and adventure have been beaten down in the rush of civilization . . . My West passed out of existence so long ago as to make it merely a dream."

In 1903 *Collier's Weekly* began reproducing Remington's canvases directly, rather than requesting specific illustrations. At least two or three a month were printed in the magazine. The effects of Impressionism and the sensibility of Monet can be perceived in these later works,

Far left: Charles Russell in Indian garb.

Left: Russell poses in a cowboy outfit.

Below: Russell at work in his studio.

the Louisiana Territory and later the Chief Justice of the Supreme Court of the Missouri Territory. His great-uncle was William Bent, the pioneer fur trapper who built the first trading post on the Arkansas River in 1832 and who rode with the famous scout Kit Carson.

As a youth Russell was an indifferent student but showed a predilection for art at an early age. He carried beeswax in his pocket to model animals such as horses and bears, and he won a blue ribbon for drawing at the St. Louis County Fair when he was 12. His parents took him to exhibits of well-known Western artists such as George Catlin, Karl Bodmer and Alfred Jacob Miller. Like Remington, Russell was packed off to a military school, but this was his last brush with formal education. He left the academy in New Jersey at 16, in 1880, and headed west to central Montana with a family friend, Pike Miller.

The pair boarded the Utah and Northern Railroad, then took a stagecoach to Helena. After this

which convey the West with a more romantic, looser brushwork and shimmering horizons. The art critic for the *New York Herald Tribune* declared, "The mark of the illustrator disappeared and that of the painter took its place."

For refuge from public demands upon his time, Remington took journeys to his island retreat "Inglenook" on the St. Lawrence River, not far from his place of birth. He hunted, fished and canoed there, an antidote to his gourmandizing in society settings. In 1909 the Remingtons moved from New Rochelle to Ridgefield, Connecticut. In early December of the same year he had a one-man exhibit at Knoedler's Gallery in New York, where a reviewer raved: "Remington's work is splendid in its technique, epic in its imaginative qualities, and historically important in its prominent contributions to the most romantic epoch in the making of the West."

Three weeks later Remington was gone. He died of appendicitis the day after Christmas at the age of 48. Theodore Roosevelt's final tribute to his genius proclaimed: "The soldier, the cowboy and rancher, the Indian, the horses and cattle of the plains, will live in his pictures and bronzes, I verily believe, for all time."

Though Remington often depicted cowboys in his paintings and sculptures, they are not the dominant theme of his work. The artist who is most closely associated with the cowboy, and who described their exploits and diversions with the greatest fidelity and insight, was himself an ex-cowboy: Charles Russell.

Though Russell was born a member of a well-established family in Oak Hill, Missouri, on March 19, 1864, it would not be long before the legacy of his pioneer forefathers would affect him with a restless, adventuresome spirit. His great grandfather, Silas Bent, was the chief surveyor of

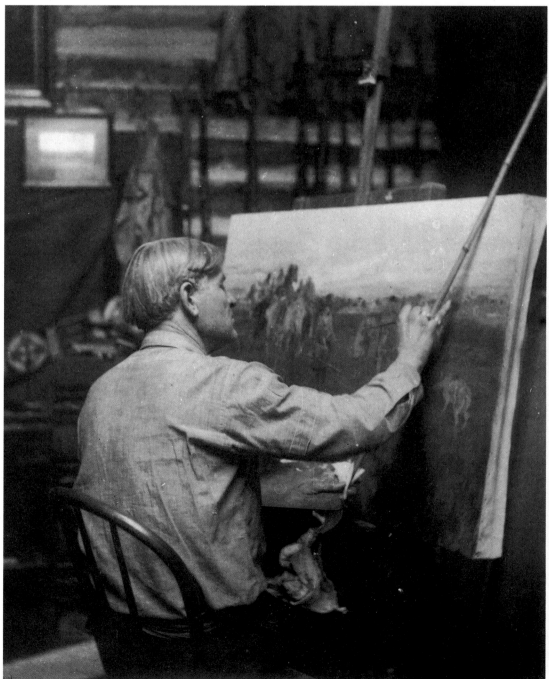

"THE COWBOY ARTIST."

COPYRIGHT 1902 BY CHARLES GIES, GREAT FALLS, MONT.

Left: Russell, depicted by an admiring Montana painter as "The Cowboy Artist."

Below left: On horseback, Russell poses with his beloved adopted son, Jack.

they hired a wagon and some saddle horses and after an arduous monthlong trek arrived at a sheep ranch in the basin of the Judith River. The nearest settlement was Helena, then a gold-mining camp of 4000 souls.

Russell's description of his sojourn at the sheep ranch is terse: "I did not stay long as the sheep and I did not get along well, but I do not think my employer missed me much as I was considered pretty ornery." After this, Russell took up with a hunter and trapper named Jake Hoover, an independent life that suited Russell's temperament. They had six horses, a saddle horse apiece and pack animals as well, Russell's pony being a pinto named "Monty."

Following his travels with Hoover, Russell got a job outside Billings, Montana, as a night hawk guarding horses till dawn for a cow outfit. He then joined a roundup of 75 riders to corral 400 horses in the Judith Basin. Then he was hired again as a night herder. During these years Russell drew or painted on anything handy – the back of envelopes, birchbark, buckskin or card-board. These sketches were done mainly for his private pleasure, and he gave away most of what he produced.

Russell's recollections of a cattle drive to Miles City, Montana, give an idea of some of the stresses of cowboy life. The herd was supposed to meet the railroad at Miles City for shipment east via the Northern Pacific, but construction was behind schedule and the tracks were not yet laid. Russell had to chivy the herd on for another 125 miles to Glendive, the next station. Along the way Indians tried to extract a toll of $1 per head of cattle, and when his trail boss refused, they threatened to stampede the herd.

One of the worst winters ever endured by the cattle ranchers was the blizzard of 1886-1887.

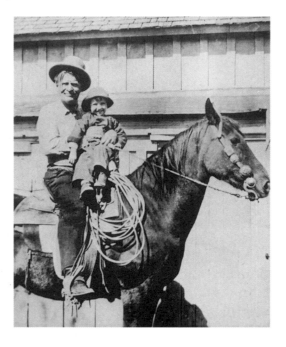

Russell rendered a poignant sketch of a starving steer from the Kaufman herd with the inscription "waiting for a chinook," the latter a warm, dry wind that descends the eastern slope of the Rockies. Temperatures that year dropped to 50 degrees below zero, and thousands of cattle either starved or froze to death. Teddy Roosevelt's herd of Dakota was almost completely exterminated by these desperate conditions.

It was about this time that Charles Russell was first called "the cowboy artist" – by a Helena newspaper, *The Independent* – for Russell was now beginning to sell as few pictures locally. His first bona fide commission was for a saloon-keeper in Utica, Montana, for whom the artist painted a picture on a slab of wood to be hung behind the bar.

Russell lived six months with the Blood Indians in the Northwest Territory in 1888. They adopted the artist as one of their own and called Charlie "Ah Wah Cous," or antelope. His time with them was probably on his mind when he later remarked: "I've known some bad Injuns, but for every bad one I kin match 'em with ten worse white men . . . When he's a good friend, he's the best friend in the world."

Living with the Bloods was not the only memorable thing that happened to Russell in 1888. In May he sold his first illustration to *Harper's Weekly*. His success was by no means now assured, but this was an auspicious sale for a self-taught artist. Not long after, Lewistown, Montana, was the scene of another welcome commission when Russell composed a Western mural on the iron door of a local bank.

The first important patron who supported Russell's efforts was a prosperous St. Louis hardware store owner named Niedringhaus. He had invested his profits in a Texas longhorn ranch in Montana where Russell worked as a hand. Niedringhaus left the subjects and prices up to Russell and provided sufficient income and commissions for him to devote his attention full-time to painting.

On a visit to see his brother in Cascade, Montana, Russell met Nancy Cooper, whom he married in 1896. He was 31 and she was only 17, but she was a business-minded young woman who at once set about promoting his work. It seems fitting that Russell expressed his warm feelings for "Mame" (as he called her) with an equine image: "The lady I trotted in double harness was the best booster an' pardner a man ever had." To help the young couple establish themselves, Charlie's father, a wealthy man with assets in coal mining and vineyards, purchased a house in Great Falls for them.

Russell built his own log cabin studio out of telephone poles stacked one upon another and furnished it with such rough-hewn furniture as a buffalo horn chair. It was packed with Indian blankets, headdresses, moccasins, saddles and hunting trophies. A bleached bull skull, Russell's logo, still hangs above the stone fireplace today.

The demand for Russell's canvases and bronzes increased. One of his paintings appeared at the Louisiana Purchase Exposition in St. Louis in 1903, and he traveled to New York to sell his illustrations to magazines. On his second trip there he met Will Rogers, who became a lifelong friend, and persuaded Tiffany's to sell his bronzes.

One of the happiest moments of his lifetime was when Charlie and Mame adopted a son, Jack, " . . . a little two-month slickear when we put our brand on him." They had longed for a child and now could afford to raise one comfortably. Jack would soon be joining his father in riding horses and doing chores.

In 1911 Russell received a prestigious commission for a canvas to be displayed in the House of

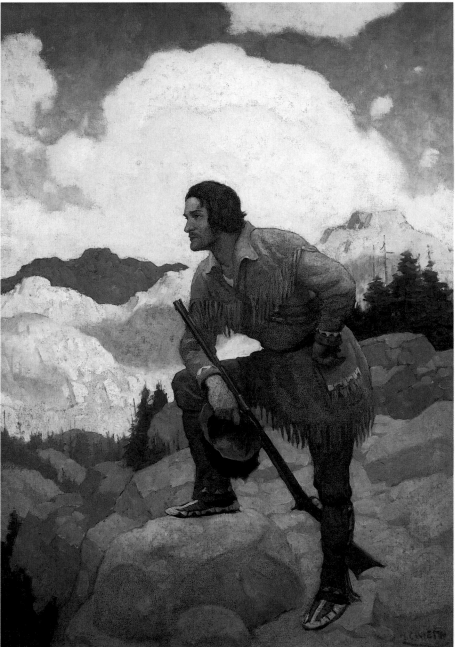

Representatives at the State Capitol in Montana. It was a dynamic narrative of Lewis and Clark's meeting with the Ootlashoot Indians. The palette of Russell's later work had deepened, and the influence of Charles Wimar, whose paintings he greatly admired, grew more evident. Prairie colors of yellow, grey, russet, mauve and green were used, along with late afternoon skies of a rich purple-blue cast.

Between 1914 and 1920 Russell exhibited in London, New York and Los Angeles, and his international reputation reached its zenith. His canvases now sold for up to $20,000, a sum that led him to make the awed remark, "Those are dead men's prices."

Russell died on October 24, 1926, knowing he had lived his life according to his own simple tastes. He was always amazed that he had made money at a craft he so much enjoyed. He knew that the West he had loved was now civilized beyond recognition, but he also felt its beauty would endure: "When I backtrack memory's grand trail, it seems all the best camps are behind . . . but in spite of gasoline, the biggest part of the Rocky Mountains belongs to God."

As the nineteenth century progressed into the twentieth century both the subject matter and the styles of Western artists gradually changed. The trapper, trader and Indian fighter were replaced by the ranger, the cattleman and the law-

man. After the Battle of Wounded Knee in 1890 the Indian was no longer a threat to the white man's civilization. With the disappearance of the buffalo the mountain man and buffalo hunter were eclipsed by railroad and mining interests.

By the early twentieth century many Western artists were turning to commercial illustration, and for this reason much of their work was both realist and narrative in nature. Like Remington and Russell, many of them were sent West by Eastern magazines on specific assignments.

N.C. Wyeth is probably the best known member of a group of celebrated illustrators trained by Howard Pyle in Wilmington, Delaware. Early in his career Wyeth was drawn to the challenges of the Rockies. The first painting he sold to the *Saturday Evening Post* in 1903 was called *The Bronco Buster*. In 1904 this magazine and *Scribner's* sponsored a trip west for Wyeth. He was an excellent rider and, like Russell, lived the life he portrayed in his commercial advertisements and narrative compositions. During his stay in the West, Wyeth worked as a range rider, mail carrier and stage driver and suffered through blizzards and storms, as well as the theft of all of his earnings.

Harold Von Schmidt was a second-generation Pyle illustrator – he studied with a classmate of Wyeth's, Harvey Dunn, in 1924. Von Schmidt's illustrations appeared in *Liberty, Cosmopolitan*

and the *Saturday Evening Post*, and in 1970 he designed a stamp for the US Post Office commemorating the Pony Express.

The venue for the largest association of both Western illustrators and fine artists was Taos, New Mexico. The Taos Valley is located at 7000 feet above sea level and is surrounded by mountains on three sides. The Sangre de Cristo range is in the north, the Picuris lies in the east and the Jemez and Nacimiento mountains arise in the west. There are endless views of earth and sky and a sense of infinite space. The surrounding fields are fertile, and the varied topography includes mesas, deserts and canyons, along with the mountains and fields. Dazzling sunshine creates brilliant colors and deep shadows, and the light and atmosphere have almost magical qualities.

Three distinct cultures converge in Taos: the Pueblo Indians, the Spanish and the Anglos. Resident artists thus not only had an immense variety of landscape to work with but a rich diversity of ethnological material as well.

The spiritual father of the Taos Society of Artists was Joseph Henry Sharp, who had attended the McKicken School of Design in Cincinnati and had followed this with study in Belgium. His first trip to Taos was in 1893, and he returned there with a commission from *Harper's Weekly* in 1894. During a period of study in Paris

Far left: N.C. Wyeth's *The Prospector*.

Left: An N.C. Wyeth illustration for Francis Parkman's *The Oregon Trail*.

Below: Some Taos Society of Artists members in 1927: (l. to r., front row) B. G. Phillips, E. Blumenschein; (middle row) J. H. Sharp, E. M. Hennings, E. I. Couse, O. Berninghaus; (back row) W. Ufer, W. H. Dunton, V. Higgins, K. M. Adams.

in 1895 he met Ernest Blumenschein and Bert Geer Phillips, whom he encouraged to visit Taos.

In 1912 Sharp moved to Taos permanently and founded the Taos Society of Artists, which had six original members. It soon expanded to a group known as the Taos Ten: Sharp, Ernest Blumenschein, Bert Phillips, Walter Ufer, W. Herbert Dunton, E.I. Couse, Oscar Berninghaus, Kenneth Adams, Victor Higgins and E. Martin Hennings.

The Society was active from 1912 to 1927. Some of its artists attempted to recreate the West of the past. Others concentrated on landscape. Still others made sympathetic portraits of Indians, village leaders and local characters.

The Taos Society itself was formed primarily to market and exhibit its members' wares. It was underwritten by the Santa Fe Railroad, and the artists' paintings were displayed in the railway's ticket offices and its company-owned Harvey Hotels. The artists supplied promotional posters and calendar illustrations for the line. In return, they were granted free passage and stayed gratis at the hotels.

W. Herbert Dunton, like Charles Russell, was fascinated by cowboy life and by historical subjects such as "Custer's Last Stand." He illustrated the Western adventure novel *Riders of the Purple Sage* by Zane Grey, as well as numerous articles for *Colliers, Recreation* and *Harper's Weekly*. He was famous for his sketches of cowgirls and female bronco riders; his model was Lillian Baron, a Brooklyn-born lass.

Though an ardent hunter, in his later days Dunton was saddened by the dwindling number of native Western animals and by the threat of extinction many species faced. He wrote "Did you ever consider what a desolate place, how like a place of death, the mountains would seem to one, were all vestige of wildlife absent?"

Oscar Berninghaus was born in St. Louis, the son of a lithograph salesman. He visited Taos in 1899 while painting a commission for the Denver and Rio Grande Railroad and moved there in 1913. Though he received only a minimum of formal training, his work was highly regarded. He focused on Pueblo Indian rituals such as rabbit hunts, harvest fiestas and corn dances, perhaps the more so because he rued the changes that took place in the Indians' lifestyle as their agriculture ceased to be productive and their ceremonies increasingly became tourist attractions. Berninghaus felt there was a special quality that distinguished the art colony in Taos, proclaiming "the canvases from Taos are definitely as American as anything can be."

There were several prominent American painters of the West who were also drawn to Taos and Santa Fe but who were never specifically associated with the Taos Society. Among these were Dorothy Brett, Marsden Hartley, Nicolai Fechin, Ila McAfee Turner, Georgia O'Keeffe and Fritz Scholder.

Right: Georgia O'Keeffe in 1931. The painting, *Life and Death*, contains two famous O'Keeffe motifs, lush flowers and an animal skull.

Georgia O'Keeffe is a titan of twentieth-century art, perhaps the first woman to be universally recognized as one of the great masters of her time. Her Western canvases are paragons of simplicity in composition and purity of light. Their forms are at once realistic and abstracted from nature, so altered in scale and symbolism that they transcend representation.

Georgia O'Keeffe was born in Sun Prairie, Wisconsin, on November 15, 1887 and raised on adventure stories about legendary heroes like Kit Carson and Billy the Kid and on the Leatherstocking tales of pioneer days. She lived in a farmhouse that looked out upon 600 acres of wheatfields. She took painting lessons as a child, inheriting some of her talent from her Irish grandmother, whose sketches of plums and roses decorated the house. By the age of 12 she had already declared to a friend that she was going to be an artist.

At 17, O'Keeffe attended the Art Institute of Chicago. Two years later, in 1907, she went to New York to take courses at the Art Students League. Her painting teacher was the American Impressionist William Chase, whose advice to the young artist was to make her work interesting. She took a class in 1912 with Amon Bement, an assistant to Arthur Dow, who at that time was exploring the realms of abstraction and modernism. This new art would speak directly to the senses, void of sentimentality or fussiness: pure light and darks and formal harmonies of pattern were keynotes of this aesthetic. That O'Keeffe was impressed is abundantly clear in her subsequent work.

Amarillo, Texas, was the next port of call for O'Keeffe, who went to its wide, windy plains to teach art. This was cattle country, where the song of lowing herds echoed in the lonely, empty spaces. She moved to another school in Canyon, Texas, in 1916, an even more remote locale and one that inspired works that had an innocent directness and flow.

She sent some of her pictures north to a friend and correspondent in New York, Anita Pollitzer. Pollitzer, in turn, took the sketches to Alfred Stieglitz, a photographer whose avant-garde 291 gallery was attracting attention from contemporary critics and drawing European and American artists to its doors. O'Keeffe had first met Stieglitz while attending the Art Students League. In 1918 she left Texas and joined Stieglitz and his circle of friends and photographers in New York. There, O'Keeffe was impressed by the work of Cubist artists, as well as by the close-up photos and cropped images she saw at 291. In 1924 she married Stieglitz and spent summers vacationing with his family in Lake George.

Though she had visited Taos in 1919, she spent her first significant summer there in 1929. She traveled in the group of Mabel Dodge Luhan,

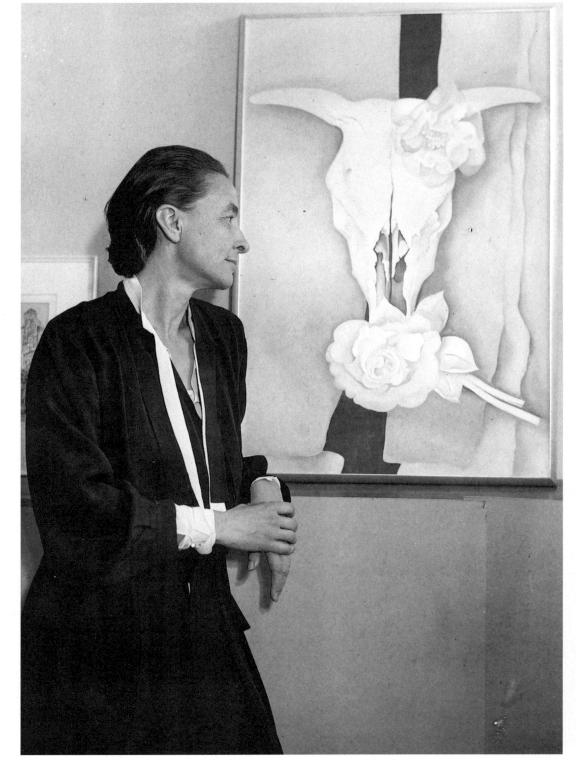

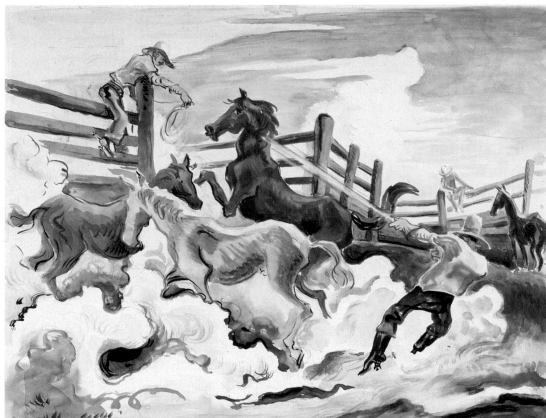

Left below: *Lassoing Horses*, a watercolor of 1931 by Thomas Hart Benton, exemplifies the crowded, swirling action Benton loved.

Below: This ink-and-chalk study, *California Cattle Herd* by Edward Borein, well shows the gritty romanticism so typical of Western art.

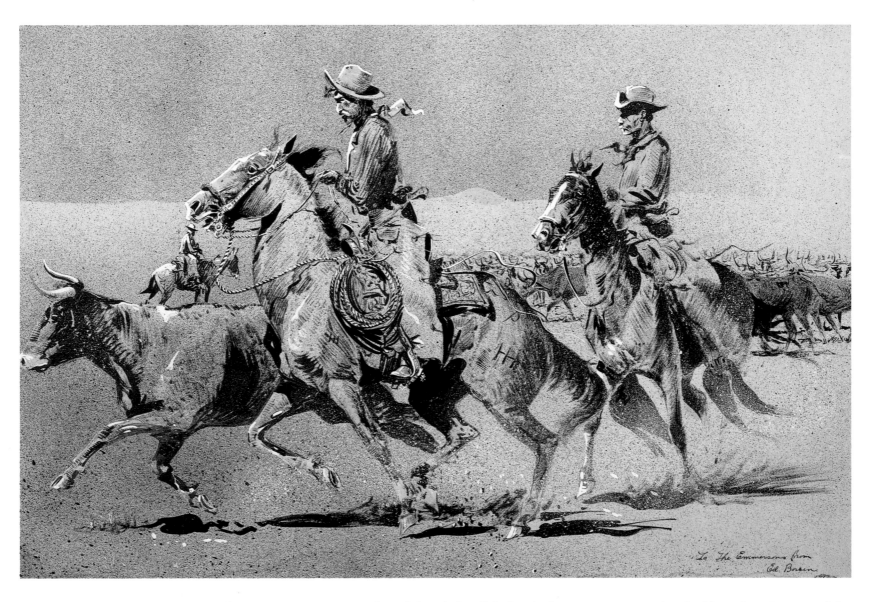

D.H. and Frieda Lawrence and Dorothy Brett. She went out to paint with watercolorist John Marin at a camp in the hinterlands, though she chose different approaches from his. The working conditions were severe: fierce winds sometimes carried off her easel, she often crawled under her car for shade from the hot sun and on some days the air turned so cold she painted wearing gloves and standing on a rug.

O'Keeffe began spending all of her summers in Taos, and after Stieglitz' death in 1946 she moved permanently to Abiquiu, New Mexico. Though she dressed in stark black clothing that conveyed a nun-like austerity, her paintings were voluptuous. Big canvases with surging curves of red hills appeared, and other landscapes which one critic described as "cleanswept as if by a strong wind." There were many studies of the skulls and pelvis bones of cows and antelopes: though reviewers might call these works macabre, for O'Keeffe they were both symbols of life and fascinating shapes. She claimed, "I am most interested in the holes in the bones – what I saw through them."

O'Keeffe had been financially secure as the result of popular demand for her work ever since the 1920s, but towards the end of her life she was extraordinarily successful. Just after she died in 1986 at 98, a legend, her *Black Hollyhock with Blue Larkspur* sold for $1 million at public auction. Her exquisite paintings of crosses, flowers and animal heads, magnified to heroic proportions, convey a uniquely personal sense of the power and mystery of the American West.

Many contemporary artists painting and sculpting the West continue to employ techniques in the tradition of Remington and Russell, and, like them, several have a strong background in commercial art. A typical example, John Clymer, began his career by providing illustrations for the Colt Firearms Company. Like his idol, N.C. Wyeth, he gravitated to Wilmington, Delaware, to learn his craft, and he later furnished covers for the *Saturday Evening Post* and *Field and Stream* that were based on his summer trips to the West. He now paints historical vistas and images of the countryside surrounding his studio in Teton Village, Wyoming.

James Boren was an illustrator who became the Art Director of the National Cowboy Hall of Fame in the late 1960s: he now paints military narratives from his ranch near Clifton, Texas. Howard Terpning is another successful New York illustrator who moved to Tucson, Arizona, confiding "I'm a cowboy at heart": he specializes in portraits of the Plains Indians. Richard Greeves sculpts highly realistic bronzes of the Indian tribes among whom he dwells on the Wind River Reservation in Wyoming. Fritz Scholder was born of Indian heritage in Minnesota and taught painting at the Institute of American Indian Arts in Santa Fe, New Mexico: his style is a confluence of traditional Western subjects and a more contemporary, sharply expressionistic idiom.

Today the popularized vision of the American West is fostered in magazine promotions for clothing by manufacturers such as Ralph Lauren, in films by Clint Eastwood, in plays such as "The Will Rogers Follies" and in novels such as those by Tom McGuane and Larry McMurtry. Yet the graphic records left us by artists of the past remind us that there are many more ways to look at the West than those that are currently conventional.

But if the ways in which Americans have viewed the West have changed over time, the enormous power that the West has exercised on the American imagination has remained remarkably constant. The paintings and sculpture shown in this book reflect a sense both of that unwavering power and of the fascinating range of responses that artists have been making to it for the better part of two centuries.

Landscape

The physical beauty of the West afforded early nineteenth-century artists a cornucopia of opportunities for dramatic canvases. A reviewer of a book on the Mississippi dating from this era exclaimed:

Nature has a deeper and richer dash of poetry in her composition. Her domain is wider and wilder; and if her attire is less trim and symmetrical, it is more opulent in color, and magnificent in drapery. She is enthroned in more queenly pomp and splendor; and the beauty and gorgeousness of her gardens, parks and pleasure-grounds, not only satisfy the senses, but feast them to satiety.

But though Western scenery was often more grandiose and memorable than scenery in other locales, the styles used by Western landscape artists varied, and by no means all were moved to portray the West solely in heroic terms.

Alfred Jacob Miller's canvases, for example, were gently romantic, capturing the ethereal mood of rivers and Indian camps with special lighting effects. The work of George Caleb Bingham is more hard-edged, but equally undramatic. The clarity of his figures poised in hazy, tranquil settings is a hallmark of the Luminist style.

The unusual native wildlife of the West, in particular the vast herds of buffalo which roamed across the open plains, provided material for painters such as William Cary and William Hays. Hays was well-known for his animal portraits, and Western species such as the grizzly bear, the pronghorn antelope, the bighorn sheep and the mountain lion provided him with memorable images for Eastern viewers.

Albert Bierstadt, Thomas Moran and Thomas Hill brought many of the devices of the Hudson River School of landscape painters to Western sites, but considerably augmented them in order to create panoramic vistas of this new natural paradise. Their landscapes were essentially devoid of human presence, revealing the grandeur of places where man had not yet intruded.

The majesties of Yellowstone Falls, the Grand Canyon and thundering storms in the Rocky Mountains were the subjects that fascinated these men, and their canvases were magnificent in size as well as theatrical in composition.

The methods of the French Impressionists can be seen in several of the late nineteenth- and early twentieth-century painters. Ralph Blakelock's mystical, almost surreal settings emphasized the fragmentary quality of late afternoon and evening light, shimmering on the Western prairies. The sweetness and delicacy of Joseph Sharp's palette clearly shows a French influence, as well as his own perception of the Indians as a gentle, thoughtful race.

The solitude and potential harshness of the Western landscape is evoked in works by W. Herbert Dunton, Walter Ufer and Maynard Dixon. Their cowboys and caravans seem minuscule as they travel through apparently infinite vistas of mesas, prairies and mountains.

The modernist spirit was brought to the region by such avant-garde painters as Marsden Hartley and Georgia O'Keeffe. Hartley dabbled in many styles, combining features of the Fauves, the Cubists and the Blue Rider and Kandinsky into his vivid, often turbulent landscapes. O'Keeffe's work is both less varied and more personal. In one sense, however, it does suggest the tremendous impact of photography upon the painting medium. Her canvases often zero in on a single element or architectural structure of the Western kaleidoscope, enlarging and simplifying its image for the viewer. She used archetypal objects such as skulls, crosses and animal bones as symbols of her own deep responses to what lay before her, and superimposed them on her stratified paintings of this empty, sun-washed land.

Contemporary illustrators and artists continue to revel in the charms of the West. Paintings by John Clymer and members of the National Academy of Western Artists are not far removed from the mythologizing of Bingham and Bierstadt. They, too, exult in the vastness and magic of this varied American domain.

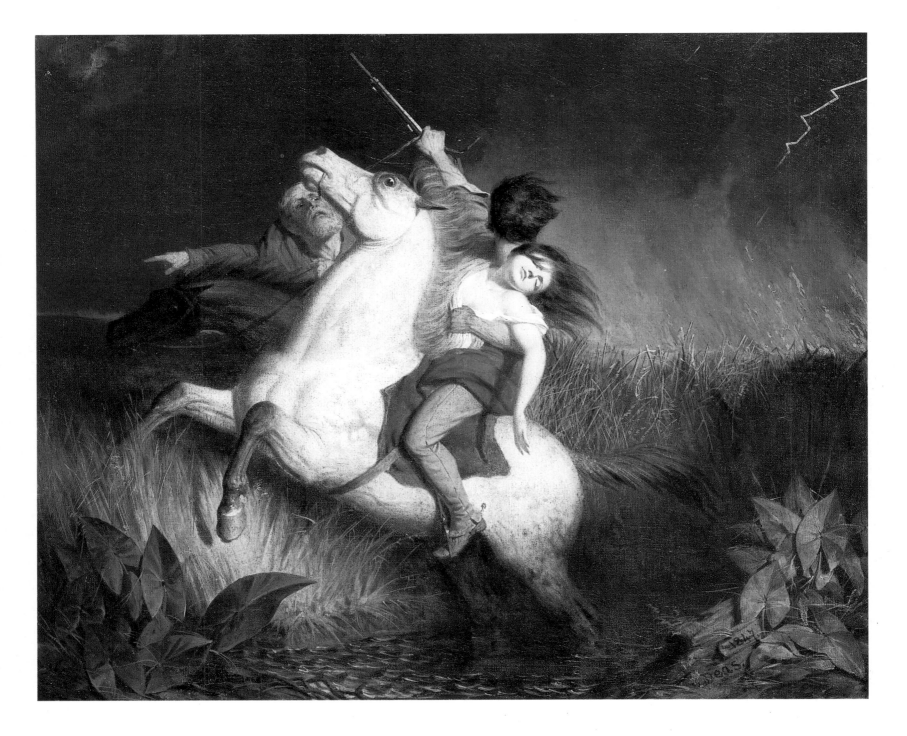

CHARLES DEAS 1818-1867
Prairie Fire, 1847
Oil on canvas
28⅞ × 36⅟₁₆ in.
The Brooklyn Museum,
Brooklyn, New York
Gift of Mr. and Mrs. Alastair
Bradley Martin (48.195)

Charles Deas was a highly regarded painter in his time though only a handful of his canvases can now be located. The son of a distinguished family, he was born in Philadelphia on December 22, 1818, and studied at the National Academy of Design, where he was elected an Associated Academician in 1840. At this time he was inspired by an exhibit of George Catlin's and headed west to visit his brother, who was an officer at Fort Crawford at Prairie du Chien. He also ventured to Fort Winnebago and Fort Snelling. He established a studio in St. Louis in 1841 and made several additional excursions west. In 1844 he went on an expedition with Major Wharton from Fort Leavenworth to the Pawnee villages on the Upper Platte River. Nicknamed "Rocky Mountains" by the soldiers, he could travel where he pleased and looked the part of a mountain trapper. He amused the Indians by speaking French to them and by his polite, almost obsequious manners. The extraordinary passion in his paintings may reflect an unbalanced mind, for he eventually went mad.

A description of a prairie fire by Lewis F. Thomas in 1841 matches the mood of this painting: ". . . flaming wisps of grass flash up, revolving and circling in the glowing

atmosphere, and lending to the imagination, a semblance of convict-spirits tossing in a lake of fire." This is a romantic canvas with melodramatic flourishes and atmospheric grandeur. Though the sense of man pitted against the elements had a basis in the artist's Western experiences, the lurid, turbulent aspects in his treatment of the subject overwhelm its narrative content.

GEORGE CALEB BINGHAM 1811-1879
Fur Traders Descending the Missouri, ca. 1845
Oil on canvas
29 × 36½ in.
The Metropolitan Museum of Art,
New York, New York
Morris K. Jessup Fund, 1933. (33.61)

Western rivers, boats and boatmen were among the favorite subjects of Missouri artist George Caleb Bingham. Born in Augusta County, Virginia, in 1811, he moved to Missouri in 1819, living on what was then the western frontier. He was apprenticed to a cabinet maker in 1827 and six years later began his independent career as a portrait painter. In 1838 he went to the Pennsylvania Academy of Art in Philadelphia.

Bingham first won national fame when the American Art Union distributed an engraving of his canvas *The Jolly Flatboatmen* to 10,000 subscribers. Bingham later became involved in politics in Missouri, serving as State Treasurer and the state's Adjutant General. In 1877 he was made a Professor of Art at the University of Missouri. He died in Kansas City in 1879.

Bingham's narrative paintings employ a Luminist technique, filled with radiant planes of light. The figures are in sharp focus compared with the hazy background beyond them, and they have a sculptural presence. The picture format in *Fur Traders* follows a standard composition principle seen in Bingham's work. The shapes are arranged in a pyramid scheme. The backs of the old trader and his son form the apex of the triangle, and the boat and river surface are its bottom line. Bingham once remarked, "Art cannot breathe into that form a living soul or endow it with speech and motion. All is silent and still." The exceptional quietness of this painting is one of its charms.

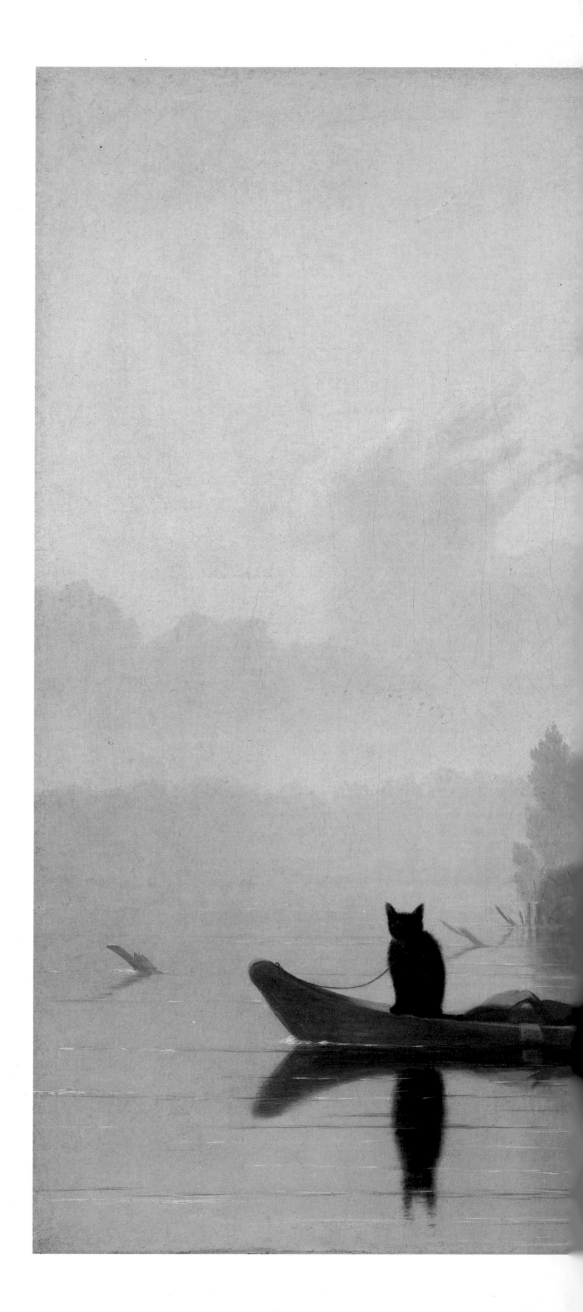

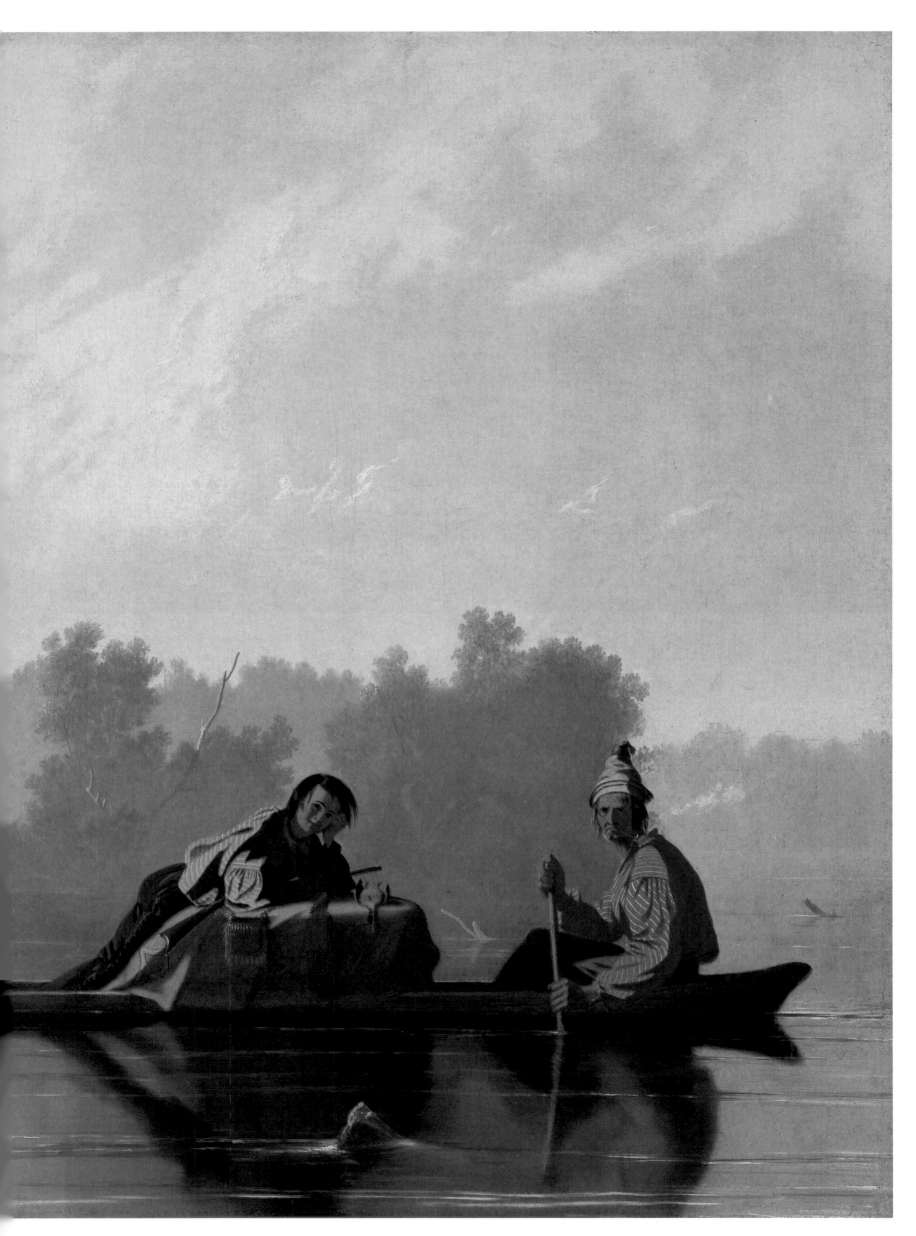

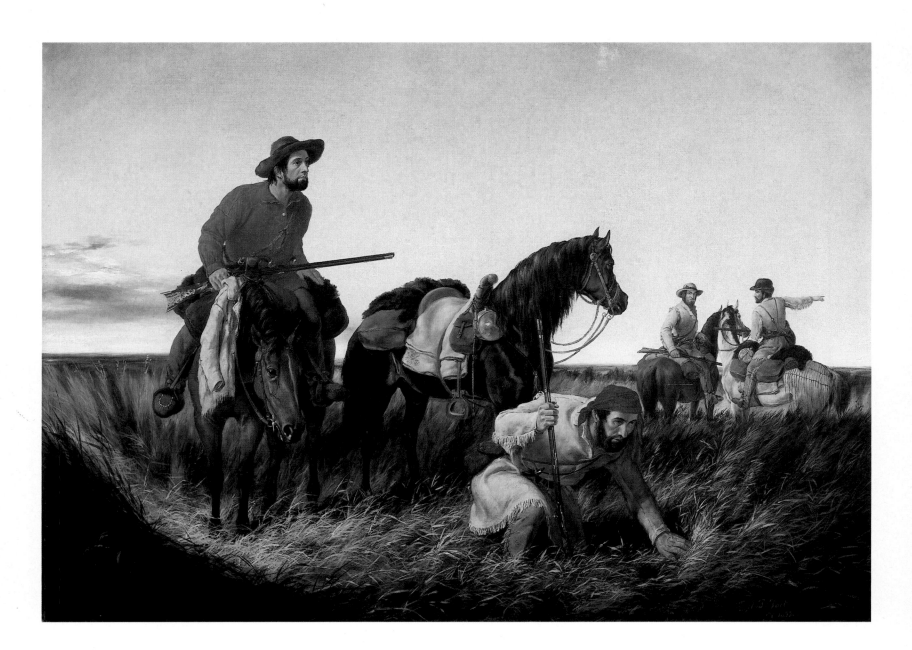

ARTHUR FITZWILLIAM TAIT 1819-1905
Trappers at Fault, Looking for Trail, 1852
Oil on canvas
36 × 50 in.
Denver Art Museum,
Denver, Colorado (1955.86)

One of the primary suppliers of hunting and animal lithographs for Currier and Ives prints, Arthur Tait was born near Liverpool, England, in 1819, and by the age of 12 he was working for an art dealer. He arrived in America in 1850, when he was 31, and he began to produce scenes of the Adirondacks. The lithographs of his paintings sold for $5 apiece, the highest price paid for such reproductions at this time. Tait assisted George Catlin with an exhibition of his Indian Gallery in 1840, and this inspired Tait to create his own Western canvases. Though he never traveled into the West, his work was very popular and widely published. He was elected a member of the National Academy of Design in 1852.

The careful detail and deliberately arranged composition of *Trappers at Fault* reflect Tait's training as a lithographer. One of the formal devices is the placement of the hunters' two guns at right angles, with the horse in the center as a focal point. The brilliant reds, a favorite color of both Indians and traders, carry one's eye across the main figures of the canvas. The direction is established at the left, and gestures and signs draw us to the right. Tait's talent as an animal portraitist is seen in the particular care given to their skin, postures and expressions of keen intelligence. The simple background never detracts from the costumes and characters in the foreground.

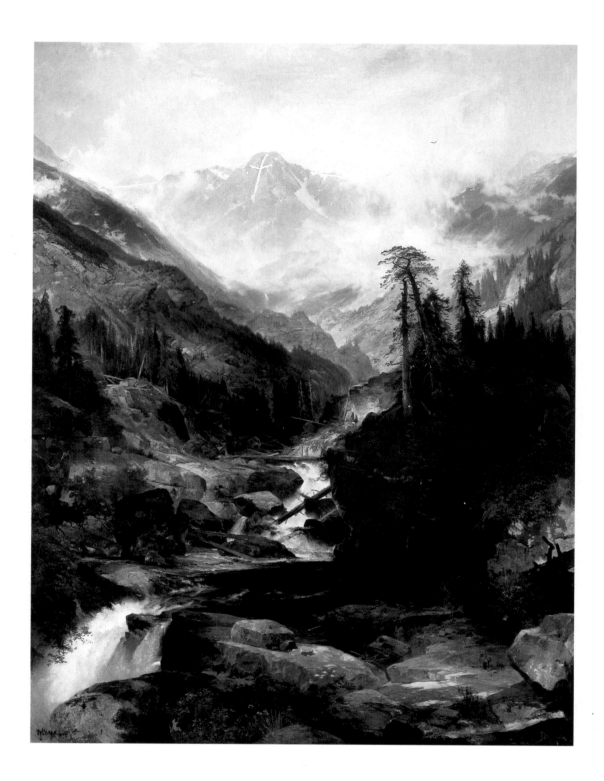

THOMAS MORAN 1837-1927
Mountain of the Holy Cross, 1876
Oil on canvas
96½ × 77⅛ in.
Gene Autry Western Heritage Museum,
Los Angeles, California
Gift of Mr. and Mrs. Gene Autry
(91.221.49)

Like Thomas Hill, Thomas Moran was also a native of England. His family arrived in Philadelphia in 1845, when Moran was eight years old, and even as an adolescent he yearned to be an artist. Essentially self-taught, he first exhibited his work at the Pennsylvania Academy of Fine Arts when he was 19. At the beginning of the Civil War, Moran returned to England, where he was impressed by the landscapes of J.M.W. Turner and introduced to the Barbizon style of Emile Corot. His brother, Edward Moran, was a talented marine painter.

Upon his return to America, Moran went west in 1871 with the survey party of Dr. Ferdinand Hayden. His enchantment with Yellowstone won him the nickname "T.

Yellowstone Moran." In 1872 Congress purchased his 7-foot by 12-foot canvas *The Grand Canyon of Yellowstone*, and Mt. Moran in the Tetons was named for him. The artist was instrumental in the establishment of Yellowstone National Park. He died at the age of 90 in 1927.

Moran felt that "An artist's business is to produce for the spectator of his picture the impression produced by nature on himself." In *Mountain of the Holy Cross* a reverential mood is transmitted. It develops from the dark, earthly regions of the foreground to the celestial, filmy peak in the distance, apparently inscribed by God's hand with a cross. The surging waterfall and massive, sharp-edged boulders are ruggedly described. Light glancing upon this splendid expanse is carefully placed to heighten our sense of awe.

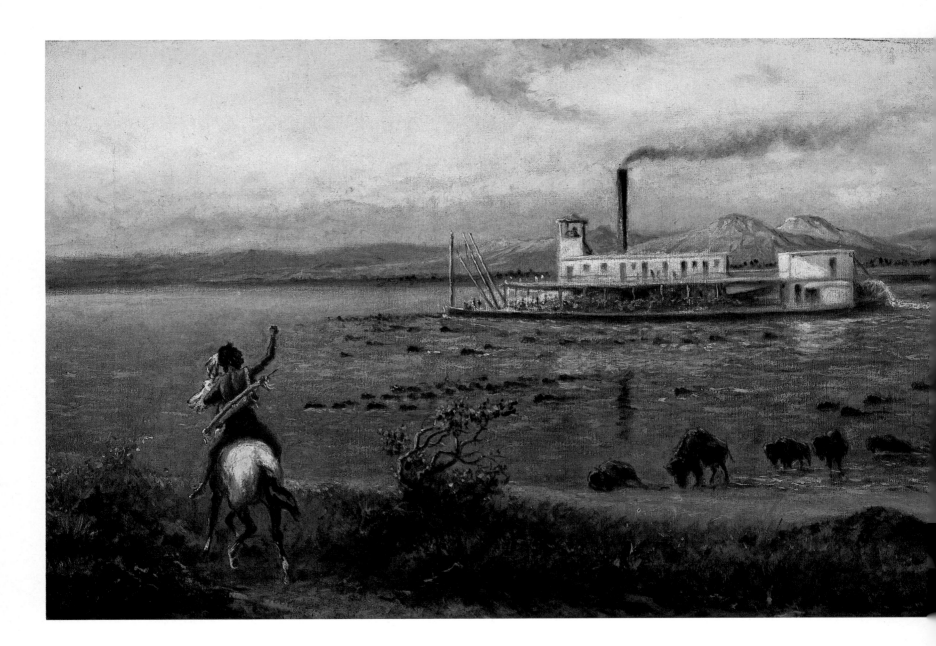

WILLIAM DE LA MONTAGUE CARY 1840-1922
Buffalo Crossing the Missouri River, n.d.
Oil on canvas
12 × 24 in.
The Thomas Gilcrease Institute of
American History and Art
Tulsa, Oklahoma (0126.1851)

Born in Tappan, New York, in 1840, William
Cary first ventured up the Missouri River in
1860 with two companions, sketching and
painting throughout his tour. At one point,
traveling overland, his wagon train was
captured by Crow Indians and later released.
He reached Portland, Oregon, and went on to
San Francisco before returning to New York.

Cary's illustrations were regularly featured in
Eastern publications such as *Harper's Weekly*
and *Leslie's Weekly* during the 1860s and
1870s. In 1874 he went west again as a
member of the Northern Boundary Survey that
explored the borders between the United States
and Canada. He later had a studio in
Manhattan and died in Brookline,
Massachusetts in 1922.

This impressionist painting *Buffalo Crossing
the Missouri River* touches upon several
narrative themes. One is a conflict between
nature, represented by the herd, and
civilization, symbolized by the steamboat that
cuts across their path. A possible confrontation

between the Indian in the foreground who
awaits the buffalos' arrival and the white men
in the steamboat is also implied.

The central placement of the steamer makes
it the focal point, and the buffalo grow more
indistinct as they recede into the distance until
they resemble trees on the far shore. The
multitude of brown flecks in the water's surface
conveys a substantial herd. It is unusual for
them to be depicted swimming rather than
stampeding or to be described in such a soft,
shimmering light.

Pages 34-35:
ALBERT BIERSTADT 1830-1902

A Storm in the Rocky Mountains–Mt. Rosalie, 1866

Oil on canvas
83 × 142¼ in.
The Brooklyn Museum,
Brooklyn, New York
Dick S. Ramsay Fund, A. Augustus Healy Fund B, Frank L. Babbott Fund, A. Augustus Healy Fund, Ella C. Woodward Memorial Funds, Gift of Daniel M. Kelly, Gift of Charles Simon, Charles Smith Memorial Fund, Caroline Pratt Fund, Frederick Loeser Fund, Augustus Graham School of Design Fund, Bequest of Mrs. William T. Brewster, Gift of Mrs W. Woodward Phelps, Gift of Seymour Barnard, Charles Stuart Smith Fund, Bequest of Laura L. Barnes, Gift of J.A.H. Bell, John B. Woodward Memorial Fund, Bequest of Mark Finley (76.79)

Albert Bierstadt, born in Düsseldorf, Germany, on January 7, 1830, became one of the most famous, popular and highly paid landscape painters of the Rocky Mountains. Though his family emigrated to the United States soon after his birth, Bierstadt eventually returned to Düsseldorf for his art education, yet while there, he studied with an American artist, Worthington Whittredge, a proponent of the Hudson River School style.

Upon his return to the US in 1857, Bierstadt joined his brother, a photographer, in the White Mountains of New Hampshire, trading landscapes for room and board. In 1858 the artist went to St. Louis, where he joined General Lander's wagon train, embarking on a route from Fort Laramie across the Rockies to the Pacific. The National Academy of Design elected Bierstadt an Academician in 1860, and he received very high prices for his large-scale works. A mural measuring 6 feet by 10 feet featuring the mountain called "Lander's Peak" sold for $25,000.

On his second trip west, in 1863, Bierstadt painted *Mt. Rosalie*, named after his future wife. The 7-foot by 12-foot canvas was bought by T.W. Kenard for $35,000. Back East, Bierstadt bought a 35-room home and studio overlooking the Palisades at Tappan Zee, New York. He received many government commissions and had many highly-placed patrons and friends. Bierstadt briefly rented a studio in San Francisco in 1872 to paint the Yosemite region. In his later life, Bierstadt's style fell out of favor, but he had succeeded far beyond many artists in his heyday.

A Storm in the Rocky Mountains is a typical epiphanous Bierstadt composition. A guide, William Byers, led the artist into the mountains near Idaho Springs, remarking, "I agreed to show him where I thought he could get all the picture he wanted." The day was gloomy and overcast, and Bierstadt was thrilled with "the grandeur and sublimity of the great gorge and the rugged amphitheatre at its head." Light pours into the painting from a heavenly source. The scale of the mountains, similar in shape and altitude to the clouds surrounding them, convey an almost supernatural majesty. The tiny deer in the foreground on the right and the tepees on the left emphasize these effects.

Pages 36-37:
ALBERT BIERSTADT

Emigrants Crossing the Plains, 1867

Oil on canvas
67 × 102 in.
National Cowboy Hall of Fame
and Western Heritage Center,
Oklahoma City, Oklahoma (A.011.1)

A brilliant sunset bursting through a grove of trees lends a somewhat surreal haze to this canvas. The figures and their caravan are deliberately dwarfed by the cliffs at the right. Their scattered procession seems inexorably drawn to the promise of the light – connoting both physical and spiritual salvation – that streams from the West, yet the delicately detailed Conestoga wagon seems to imply that this otherwise theatrical scene is rooted in reality. All in all, a very effective exercise in myth-making.

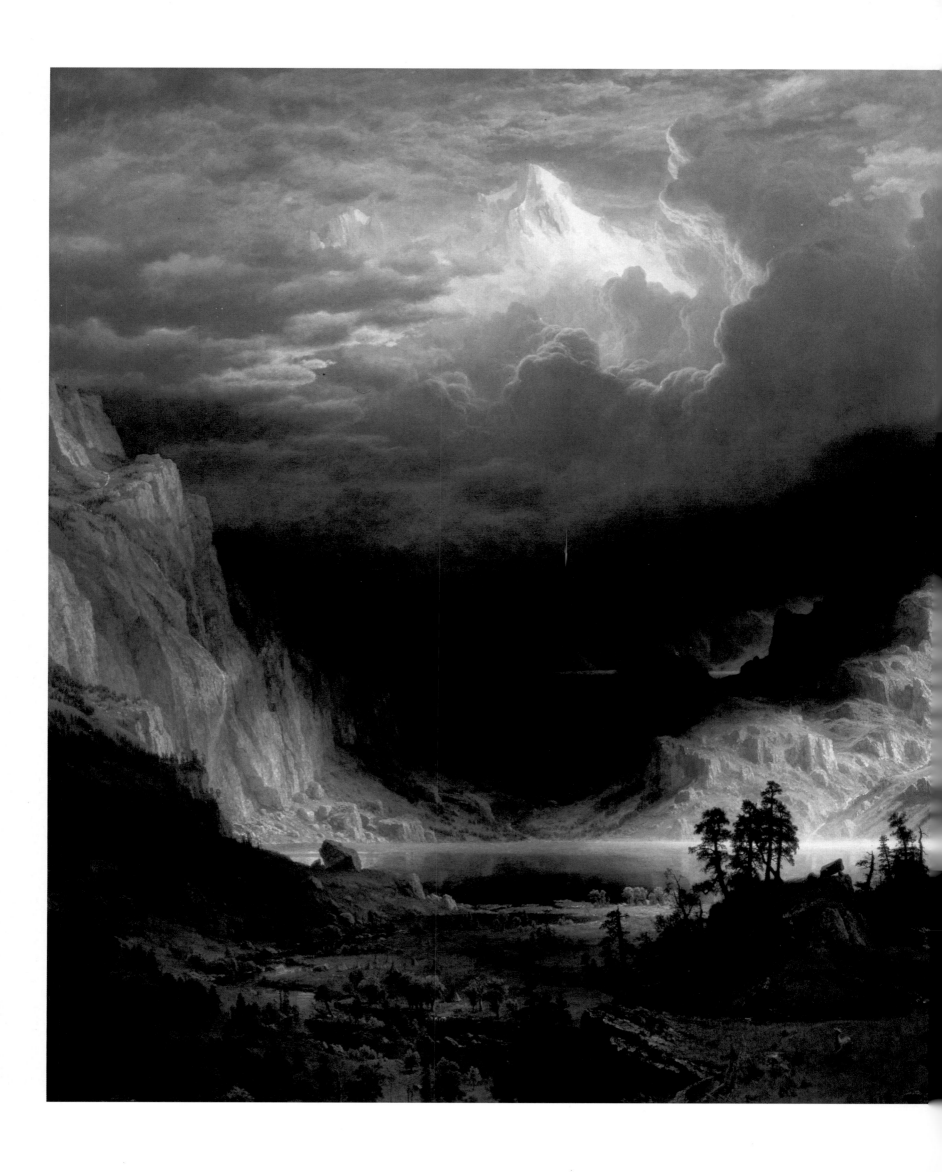

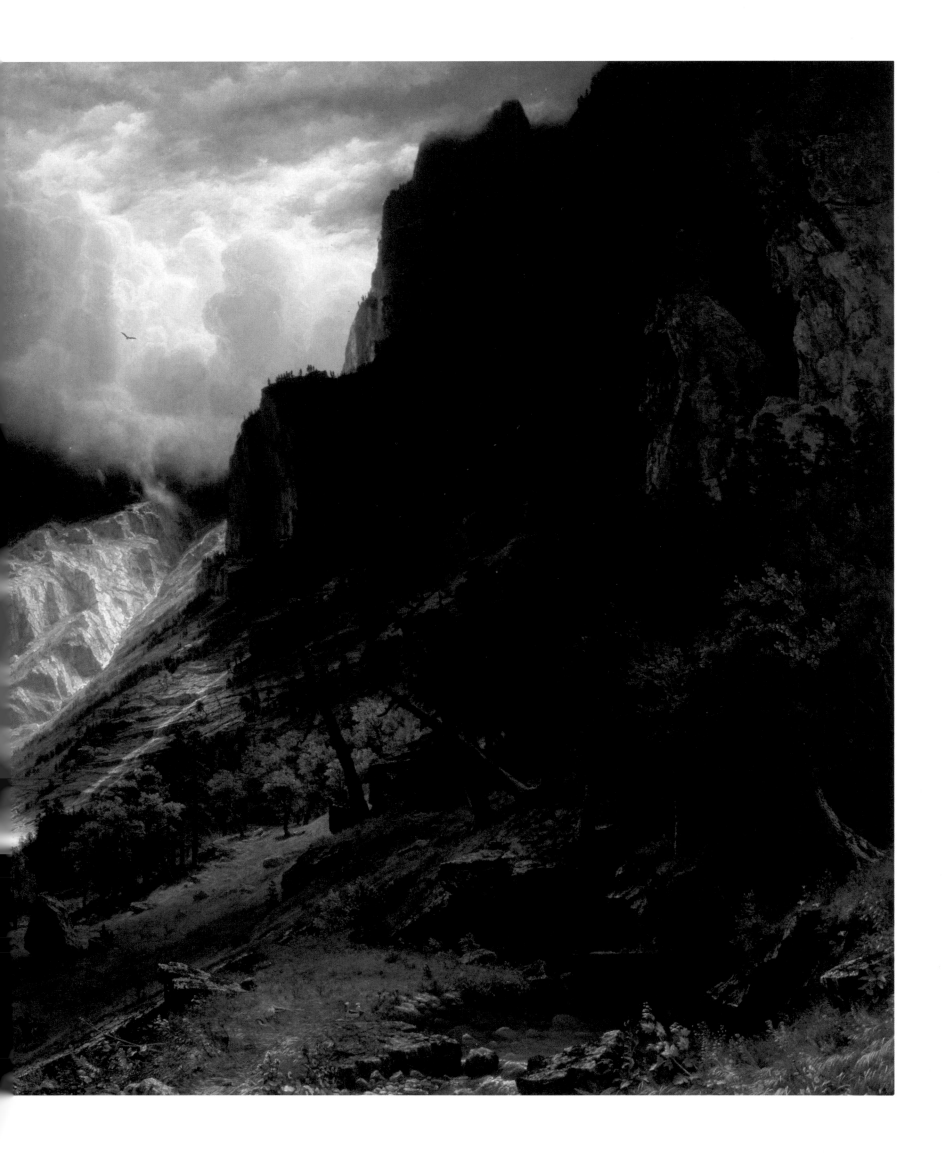

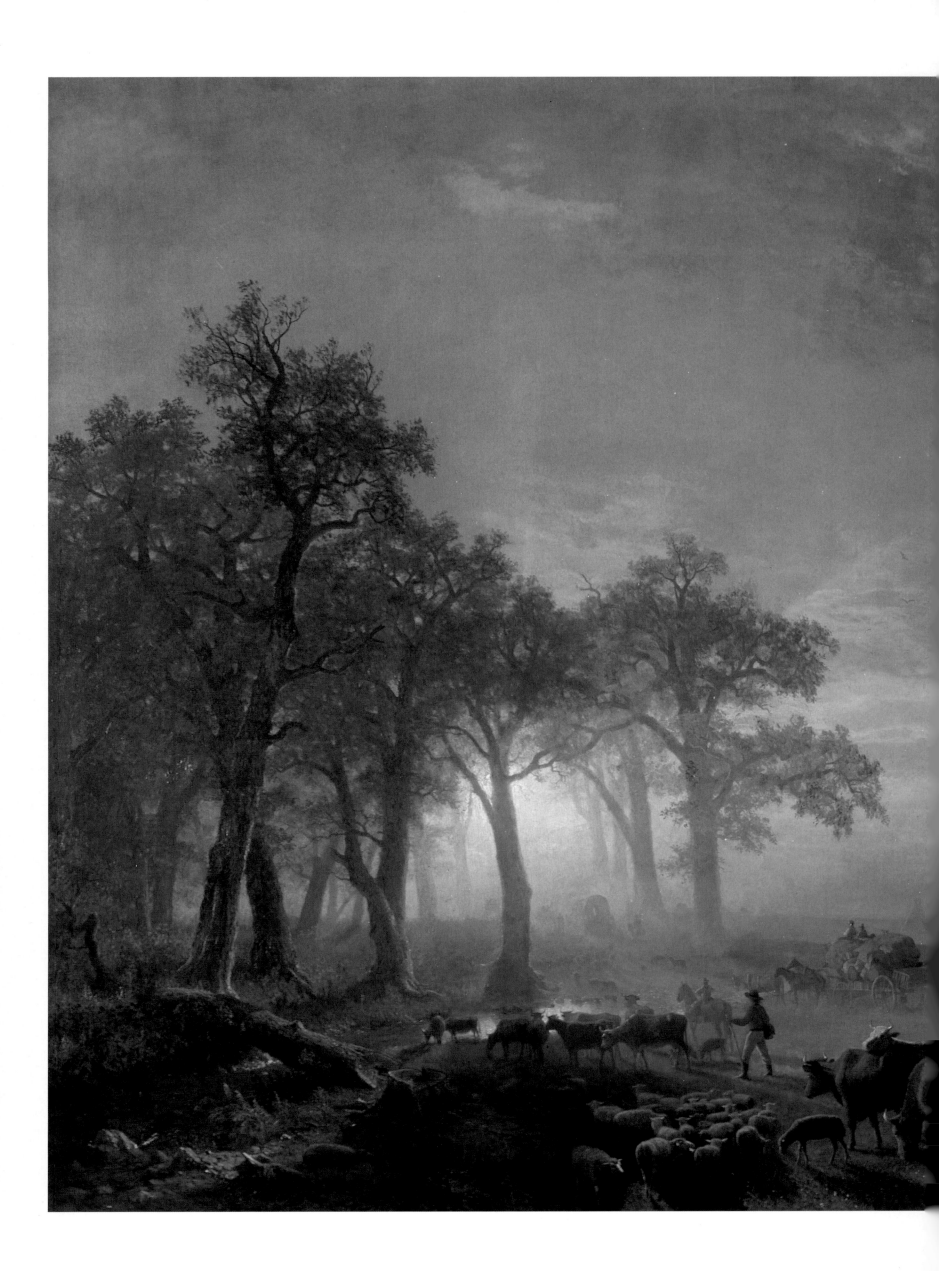

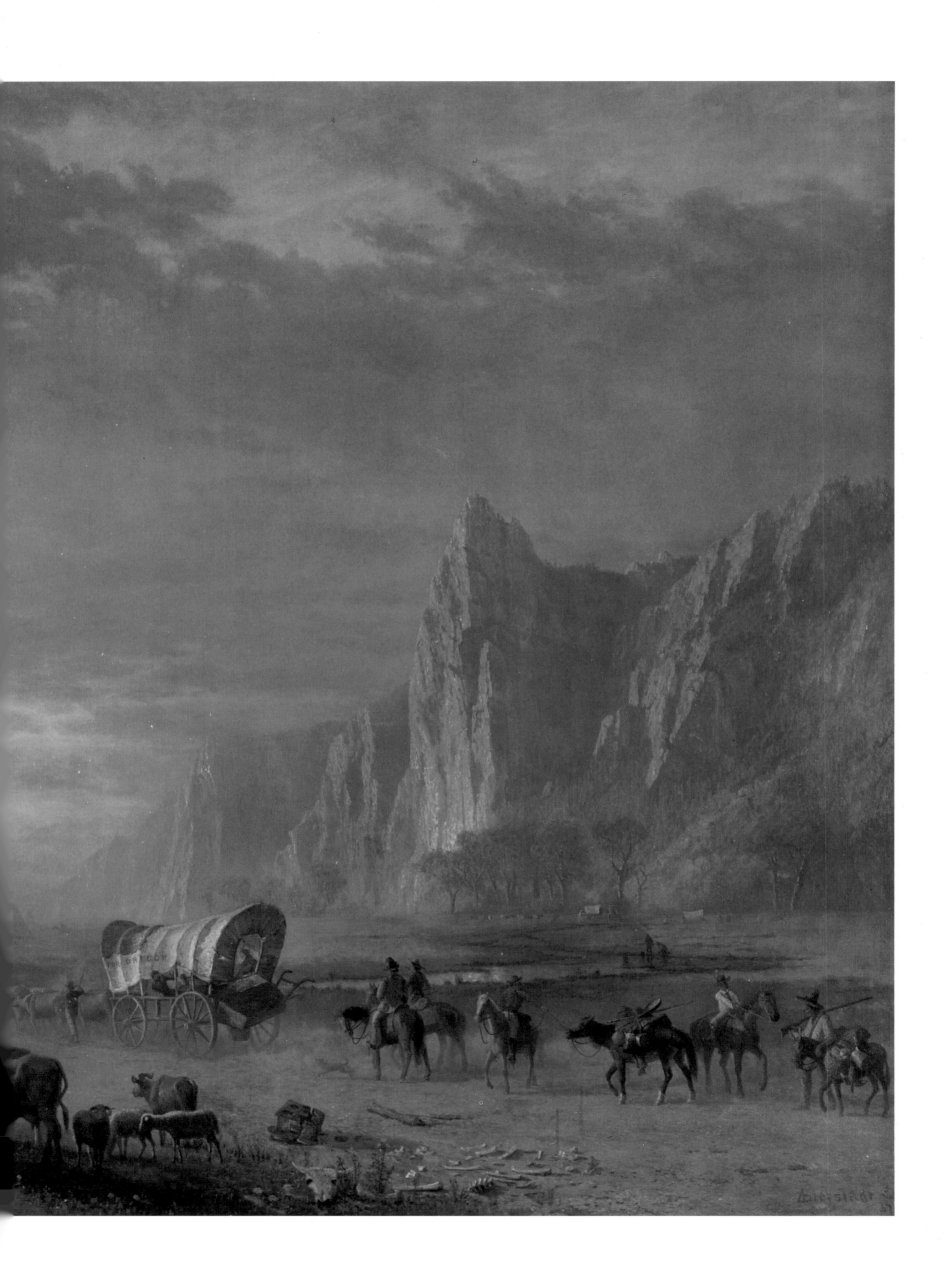

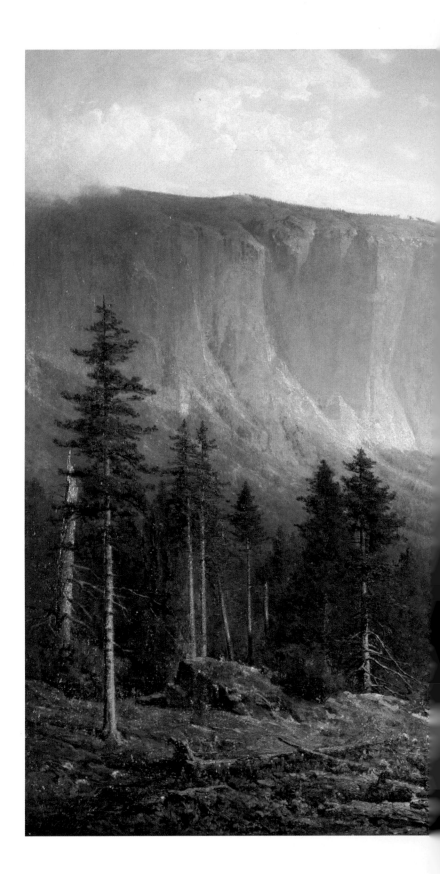

Thomas Hill 1829-1908
**_Great Canyon of the Sierras,
Yosemite,_** 1871
Oil on canvas
72 × 120 in.
Crocker Art Museum,
Sacramento, California
E. B. Crocker Collection (1872.423)

Thomas Hill was one of Albert Bierstadt's
painting companions in the White Mountains.
Born in England, the son of a tailor, he was
given his first horsehair paintbrush when he
was seven. His family soon moved to
Massachusetts, and there Hill served as an
apprentice to a carriage painter. By the time he
was 24 he was attending the Pennsylvania
Academy of Fine Arts.

After contracting tuberculosis, Hill went
west to San Francisco in 1861. He made his
first trip into the Yosemite (Indian for "grizzly
bear") in 1862, traveling up the Merced River
in the Sierra Nevada mountains. He had an
exhibit at the National Academy of Design and
later studied in Paris, where he was influenced
by the misty, poetic techniques of the Barbizon
School. His work was well-received, and he
sold a 6-foot by 10-foot canvas of the Yosemite
Valley for $10,000 in 1868. The Crocker
Brothers, of San Francisco banking fame,
bought two canvases for $15,000.

Hill was renowned for how fast he could
paint, and he liked to have friends keep him
company while he worked. When economic
boom times ended, Hill had to sell his entire
gallery to settle his debts, and he later sold his
views of the Yosemite as souvenirs.

The softness and sweetness of the
foreground details and figures in _Grand Canyon
of the Sierras, Yosemite_ is a Barbizon flourish.
While somewhat less theatrical than Bierstadt's
Rocky Mountains, these hills and cliffs have a
monumental grandeur, and the sense of
remoteness and solitude is paramount.

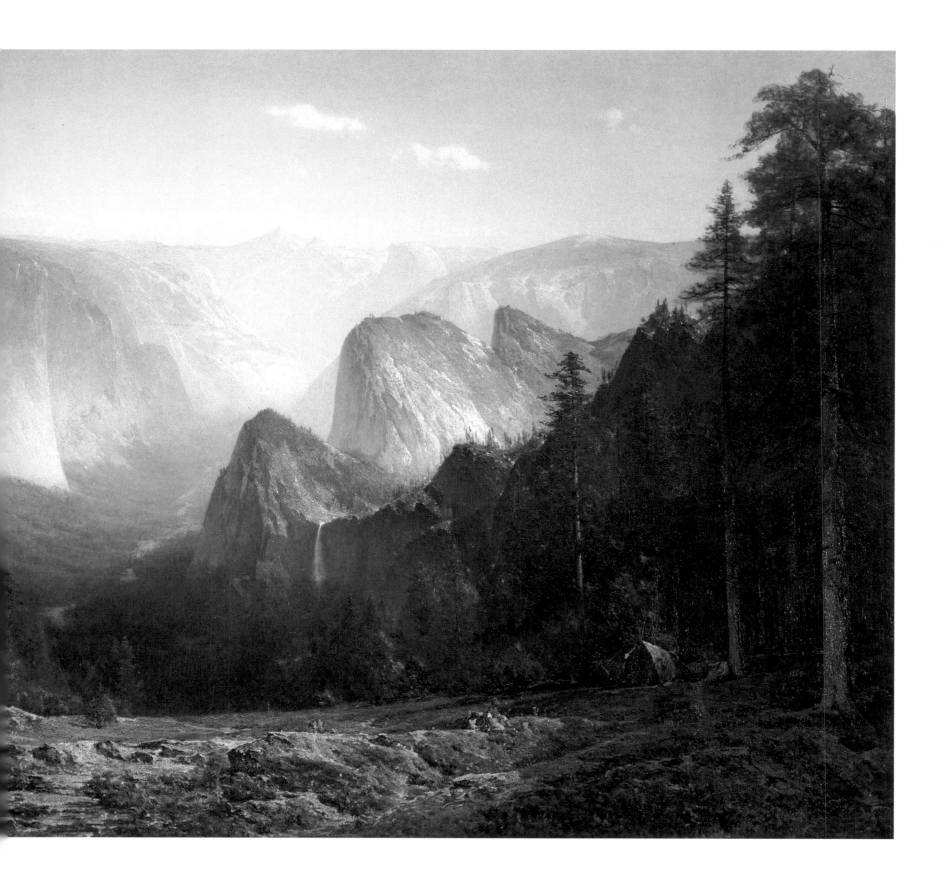

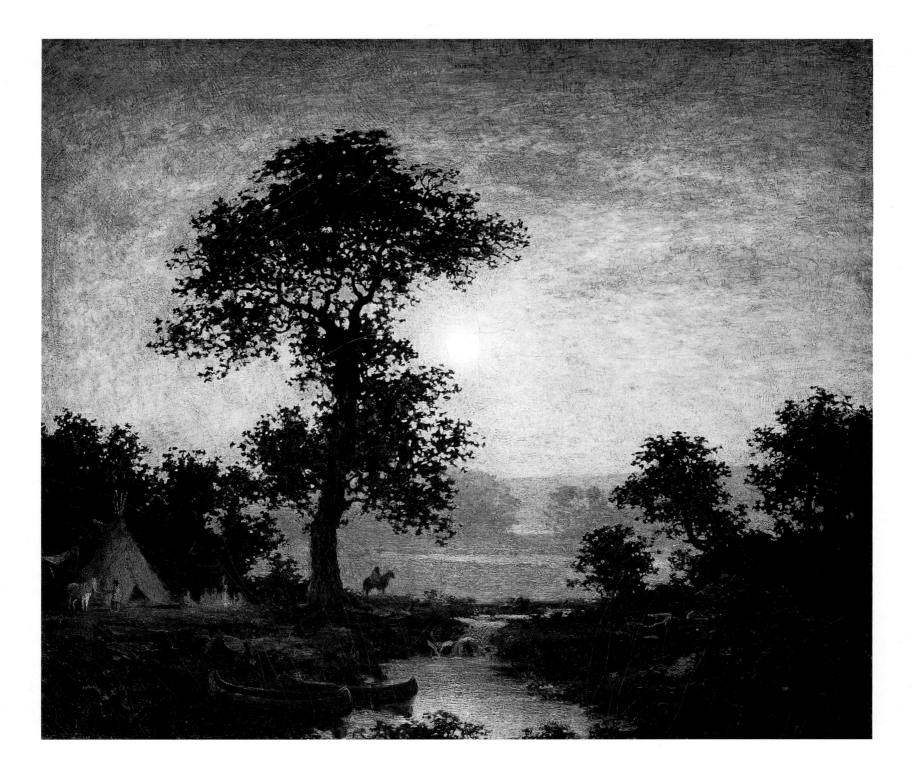

RALPH ALBERT BLAKELOCK 1847-1919
Moonlight, c. 1885-1889
Oil on canvas
27¼ × 32¼ in.
The Brooklyn Museum,
Brooklyn, New York
Dick S. Ramsay Fund (42.171)

Ralph Blakelock was born in New York City on October 15, 1847, and lived most of his life in the East. His early paintings were landscapes of Mt. Washington, the White Mountains, the Adirondacks and the resort areas of northern New Jersey. He went west in 1869 and stayed between three and seven years. The records and notes of his travels are haphazard, though he made copious sketches and watercolors. His work earned National Academy recognition when he returned to New York, but as it became more impressionistic in his later years it was excluded from Exhibits. His signature on this canvas, as on all his work, was contained within a symbolic outline of an Indian arrowhead.

Blakelock married and had nine children and lived in extreme poverty in the borough of Brooklyn. His debts and financial worries finally broke his spirit, and he died in an asylum for the insane.

Moonlight possesses a primeval, otherworldly quality achieved by using impasto overlaid with an opaque layer of paint, or scumble. The effect is highly romantic, imbuing this tranquil scene of an Indian encampment by a river with an aura of auspicious events. Color is overlooked in favor of strong contrasts of light and dark forms and haunting shadows from the full moon.

JOSEPH HENRY SHARP 1859-1953
Glacier Park, Blackfeet Reservation, Montana, n.d.
Oil on canvas
25 × 30⅛ in.
Collection of the Eiteljorg Museum of
American Indian and Western Art,
Indianapolis, Indiana
Gift of Harrison Eiteljorg

Joseph Henry Sharp was a romantic realist who was a founder of the Taos Art Society in Taos, New Mexico. Born in Bridgeport, Ohio, in 1859 to Irish immigrant parents, Sharp became deaf as a result of a near-drowning accident when he was a youth and always carried a pad to make notes and write messages. He became interested in Indians as the result of reading James Fenimore Cooper's Western novels, and attended the McKicken School of Design in Cincinnati, where Henry Farny, an Indian portraitist, was his teacher.

Sharp later studied in Belgium, Paris and Madrid, and was influenced by the work of Van Dyke and Velazquez. He first went to Santa Fe in 1882 and was sent to do illustrations on Taos by *Harper's Weekly* in 1894. A portraitist in Cincinnati during the 1890s, selling two paintings a week at $30 each, Sharp longed to make the Indian his primary subject.

Theodore Roosevelt approved Sharp's building a cabin on Crow Agency land in 1899,

and Sharp completed 79 paintings of Indians, eleven of which were bought by the Smithsonian for $800. The rest were eventually purchased by Phoebe Hearst, the mother of William Randolph Hearst, and later given to the University of California at Berkeley.

In 1912 Sharp moved to Taos permanently, founding the Taos Society of Artists. He was popular among the townspeople and among art collectors. When he died in 1953 some 500 of his paintings were in museums.

On the back of his canvas of Glacier Park, Sharp wrote "I never painted a better mountain canvas. I loved the country and the Blackfeet and spent several summers there." The softness and sweet colors of the painting, as well as the gentle detail of horses grazing in a field, reflects an Impressionist influence. The shapes of the teepees are like those of the fir trees and the distant mountains. A natural harmony is conveyed by Sharp's palette choices and commonality of forms, and his pleasure in the vista before him is evident.

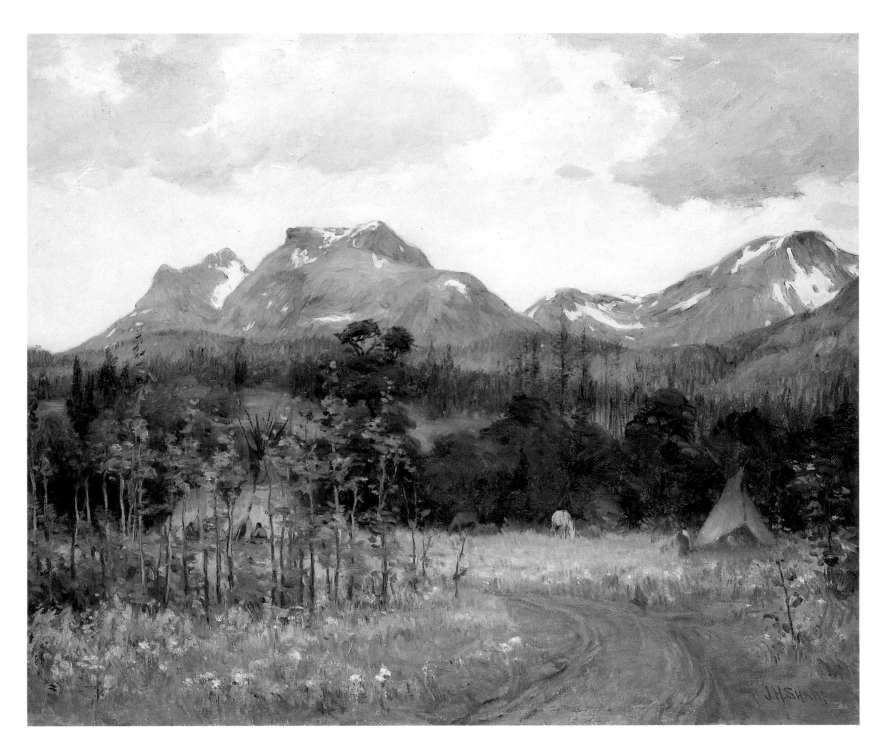

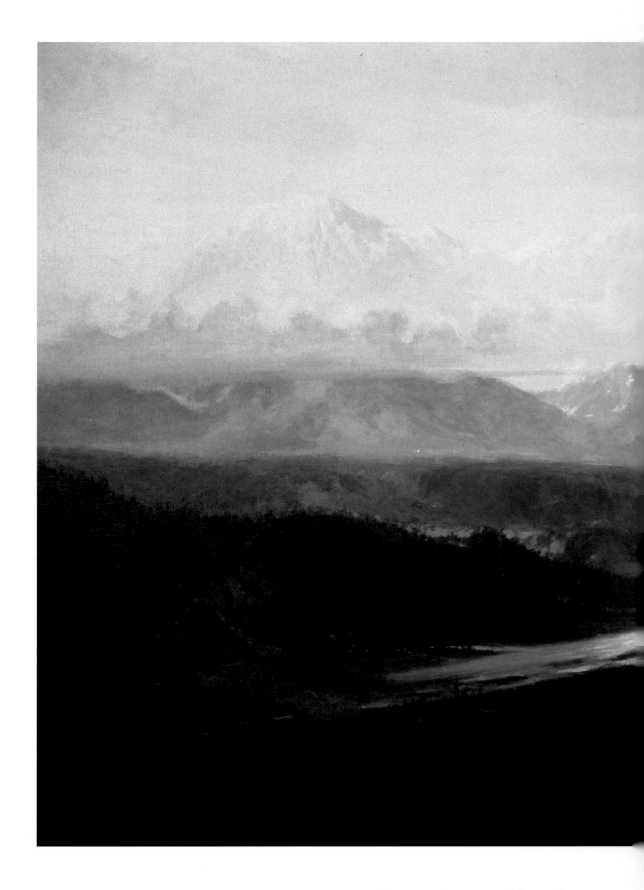

SYDNEY LAURENCE 1865-1940
Mount McKinley, 1924
Oil on canvas
72 × 132 in.
Museum of Western Art,
Denver, Colorado (7.88)

Sydney Laurence, artist and adventurer, was the first painter to depict Mt. McKinley in Alaska. He was born in Brooklyn, New York, in 1865, attended Peekskill Military Academy as a youth and later was a member of the crew on a sailing vessel. He studied at the National Academy of Design in 1886 and took classes with Edward Moran, the older brother of Thomas Moran. In 1889 he went to Paris and enrolled at the École des Beaux-Arts.

As a war correspondent and illustrator he was sent to Africa, to China to cover the Boxer Rebellion and to Cuba to cover the Spanish-American War. He got the gold bug in 1904 when new gold fields were discovered in Alaska, and for seven years he prospected and sketched in the summers and did odd jobs to survive the severe Alaskan winters.

In 1913 Laurence got his cronies from local taverns to grubstake him $10,000 for a

painting of Mt. McKinley. He set off alone with five sled dogs in May to a camp at the base of the mountain, and there he stayed for one whole summer, sending for art supplies from Seward and transforming his sled into an easel. By the fall he had 45 oil sketches, and he returned to Valdez to complete the final 6-foot by 11-foot canvas. He sold it to the Smithsonian Museum in Washington, D.C., where its exhibit supported a campaign to establish Mt. McKinley as a national park. In 1925 Laurence moved to Los Angeles. He died there in 1940.

In this idealized landscape Mt. McKinley is glowing, romantic and beckoning, looking as if it had suddenly arisen into the light above the churning, moody Tokositna River in the foreground. The purples, mauves and blues surrounding the river suggest an Impressionist palette, as do the frothy light effects on the river's currents.

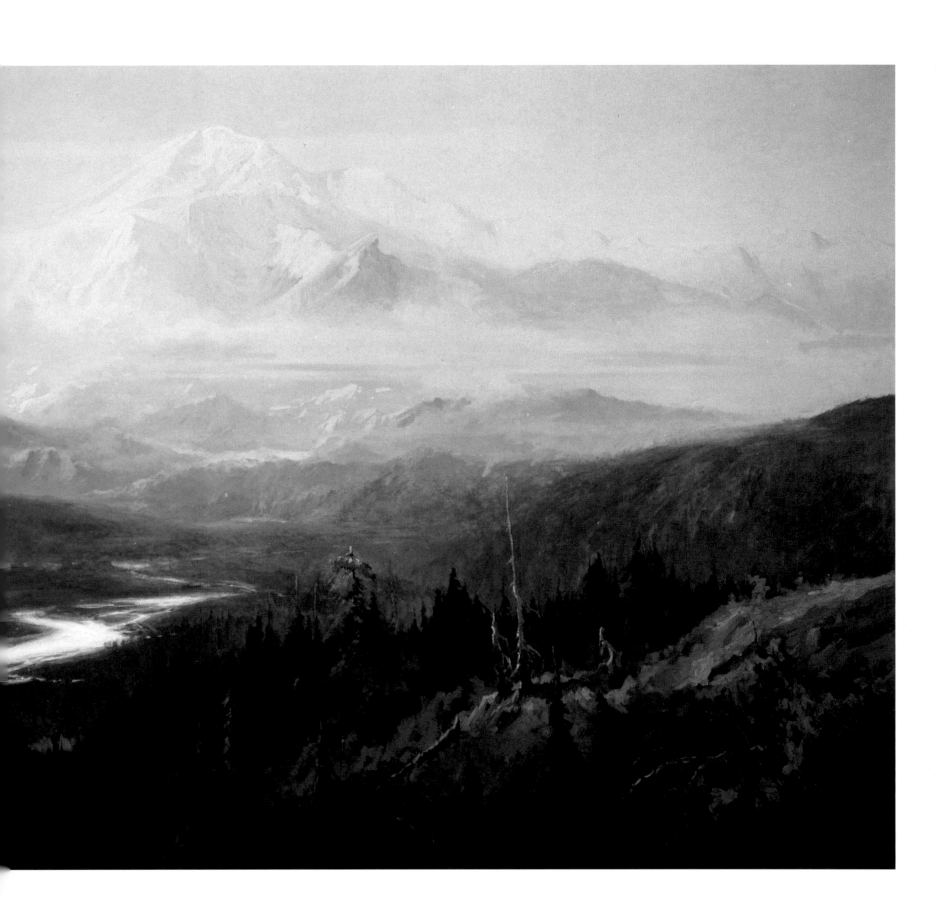

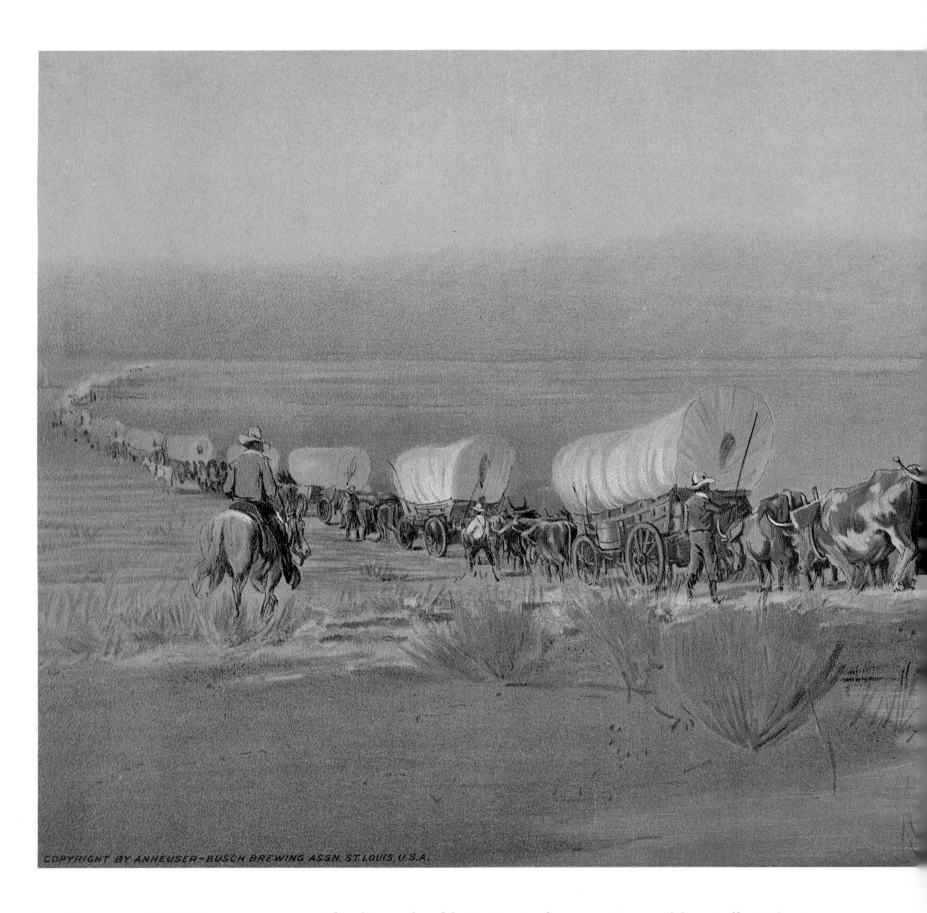

COPYRIGHT BY ANHEUSER-BUSCH BREWING ASSN. ST. LOUIS, U.S.A.

Oscar Berninghaus 1874-1952

Westward Ho!, 1910

Oil on canvas
21 × 45 in.
Anheuser-Busch Co., Inc.,
Saint Louis, Missouri

A founding member of the Taos Society of
Artists, Oscar Berninghaus was born in St.
Louis, Missouri, on October 2, 1874. His father
was a lithograph salesman. In 1893 Oscar was
apprenticed as a lithographer and in 1899
received a commission from the Denver and
Rio Grande Railroad for Western illustrations.
That year, Berninghaus made his first visit to
Taos and subsequently began living there
during the summers. Yet his primary home was
still St. Louis, and he was active in St. Louis
artistic circles and had a studio next door to
Charles Russell's.

In 1912 he moved to Taos and was one of six
original members of the Taos Society of Artists.
In 1917 he was one of five artists providing
historical decorations for the Missouri State
Capitol in Jefferson City. He also did murals
for the Federal Courthouse in Fort Scott,

Kansas, and the post office in Phoenix,
Arizona. He was a financial and critical success
during his lifetime and was made an Associate
of the National Academy of Design.

Berninghaus was fascinated by the Pueblo
Indians of Taos and their ceremonial rabbit
hunts, harvest fiestas and corn dances. He felt
that the Taos colony was special and that "the
canvases from Taos are definitely as American
as anything can be." He bought a home on the
loma, the fertile valley farmland, in 1919.
When he died of a heart attack in April 1952
the businesses of Taos all closed their doors in
his honor.

Westward Ho! has the hallowed feeling of a
pilgrimage. In this romantic perspective a
wagon train stretches across the plain until it
becomes invisible, its linear direction westward
by design. The caravan also moves from

44

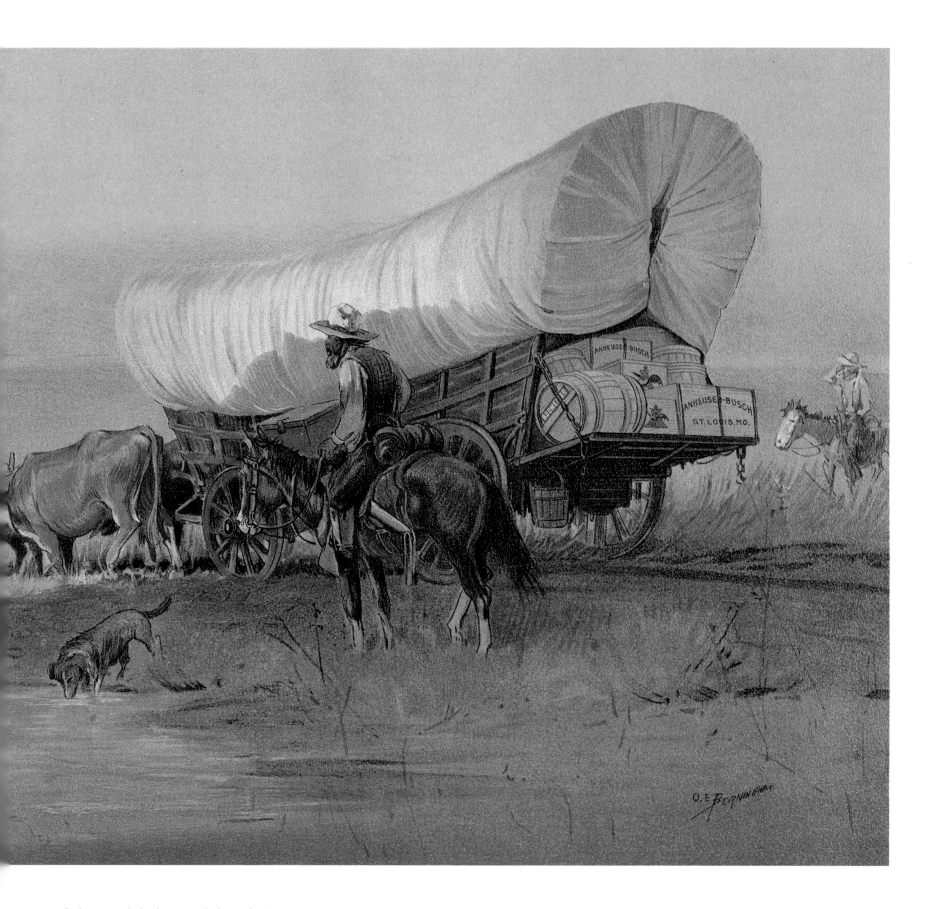

darkness and shadow into light, a device employed to sharpen details in the foreground and to imply a sense of salvation and warmth in the West. There is a certain homeliness to this painting. The covered wagons are rather awkward in shape, and the rumpled hat and slumped posture of the cowboy by the first wagon, as well as his burly sheepdog foraging in the sagebrush, lend a humble integrity to the scene. When Berninghaus first reached Taos after a 10-hour ride on a mail stagecoach, the town was filled with covered wagons.

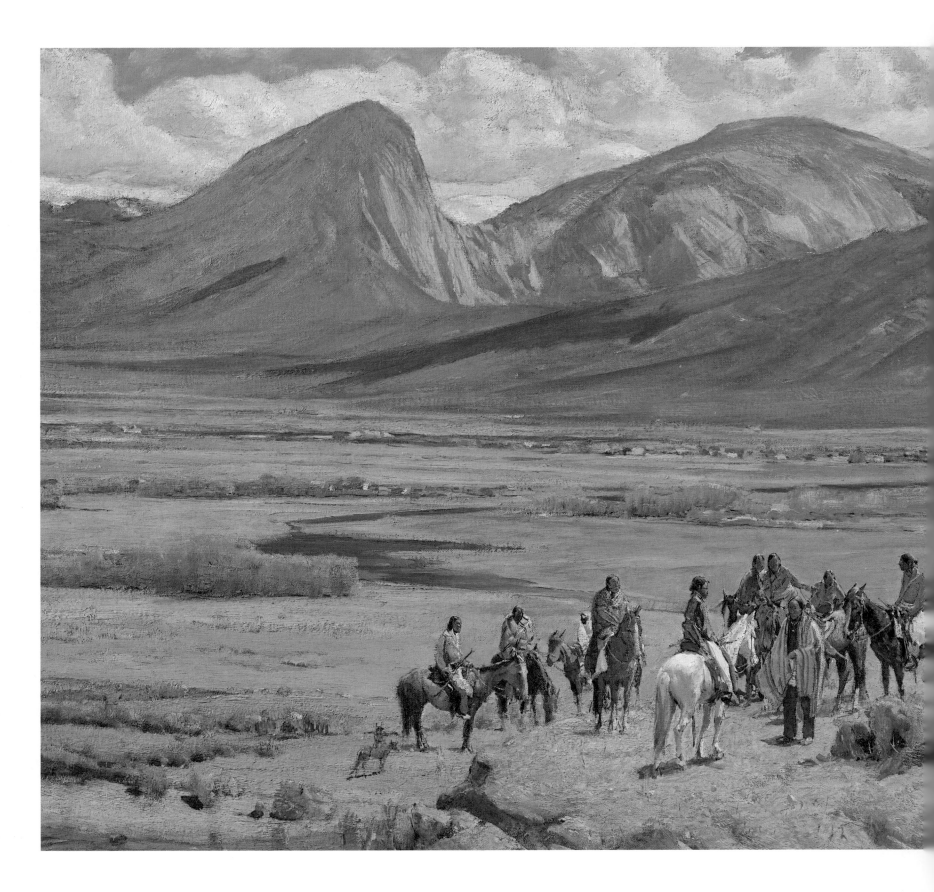

Oscar Berninghaus

Taos Country (Ready for the Rabbit Hunt), c. 1939

Oil on canvas
49 × 24 in.
Woolaroc Museum
Bartlesville, Oklahoma

The expansive topography of New Mexico is underscored in this painting: the tiny scale of the Indians and trappers convened atop a mesa emphasizes the vast fields and mountain range beyond them. No hostility is even remotely implied in this scene of Pueblos meeting to hunt together. The semicircular arrangement of the figures echoes that of the hills in the distance and helps to concentrate the viewer's focus on the otherwise diminutive central characters.

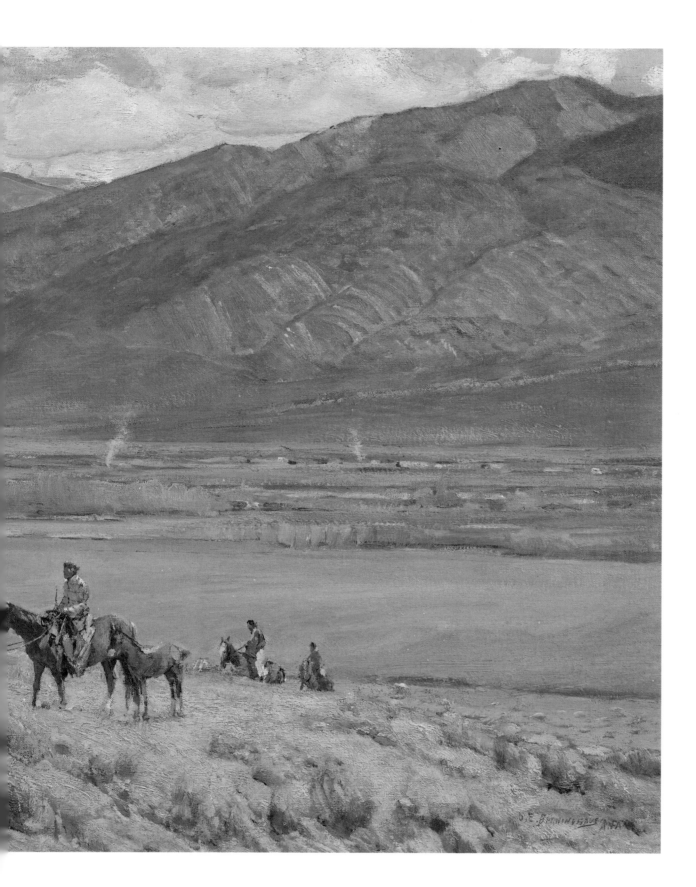

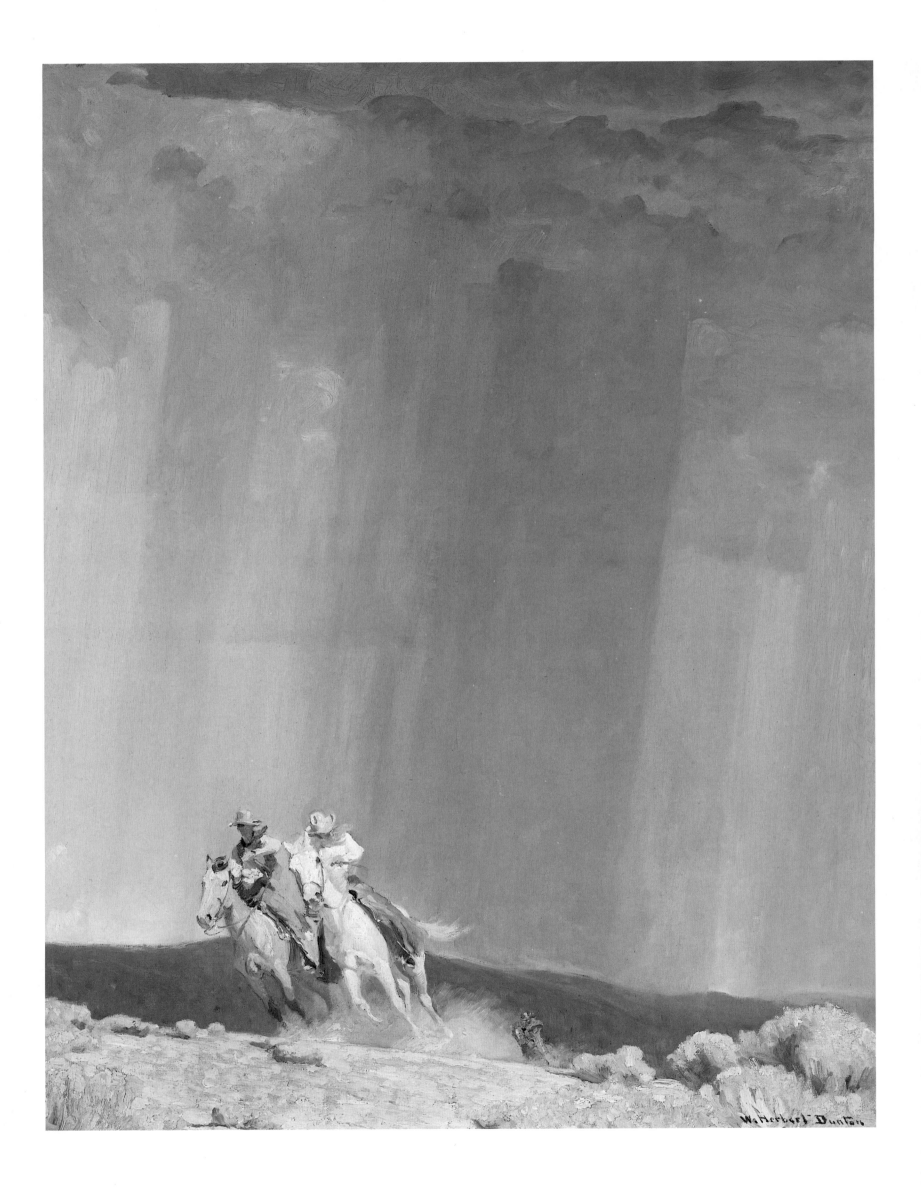

Left:
W. Herbert Dunton 1878-1936
The Shower, c. 1914
Oil on canvas
32 × 25 in.
The Anschutz Collection

W. Herbert Dunton, known as "Buck," was born in Maine, where he grew up on a farm. His schoolboy interests included hunting and drawing, and by the time he was 14 he had written and illustrated a column for *Recreation Magazine.* His first venture west was in 1896, when he took packhorse trip to Montana as an assistant to a bear hunter. He sketched in the wild, froze carcasses in order to draw them and sold four paintings from the trip for $75. Upon his return he studied at the Cowles Art School in Boston.

Dunton became a commercial illustrator in New York, working for *Collier's* and *Harper's Weekly* and furnishing drawings for Western adventure novels such as Zane Grey's *Riders of the Purple Sage.* He illustrated over 60 books during the winters and traveled west in the summers. He led this dual life for 15 years, working as a cowhand on a Texas ranch, as a vaquero in Mexico and as a hunter and guide in the Pacific Northwest.

In June 1912 he went to Taos, New Mexico. Locally known as "the cowboy," he was a founding member of the Taos Society of Artists. One of his patrons, the Stetson Hat Company, used to give him hats with his name stamped in gold on the sweatbands. He loved riding the open range, and, like Charles Russell, never lost his affection for the cowboy lifestyle.

This romantic portrayal of a cowboy and a cowgirl riding together in the midst of a rainstorm is, with its dappled light touching upon the landscape, semi-impressionistic, yet it is also so simplified in subject as to hint at abstraction. The sky is composed of shafts of blue, white and lavender, a vertical plane against the horizontal desert. The riders are tiny against this vast backdrop, which somehow seems to strengthen their bond.

Above:
Marsden Hartley 1877-1943
New Mexico, ca. 1919-1923
Oil on canvas
20 × 24 in.
Portland Museum of Art,
Portland, Maine
Hamilton Easter Field Art
Foundation Collection, Gift of
Barn Gallery Associates, Inc.,
Ogunquit, Maine, 1979 (1979.13.22)

An artist whose changing styles reflected his peripatetic life, Marsden Hartley was born in Lewiston, Maine. After moving to Cleveland, he left school at the age of 15 and attended art classes while working at a marble quarry. He later won a scholarship to the Cleveland School of Art and then studied at the New York School of Art and at the National Academy of Design.

By 1909 Hartley was exhibiting at Alfred Stieglitz' 291 gallery and traveling to Maine, New York and Boston. In 1913 he moved to Berlin, where the Blue Rider movement and the German Expressionists had an effect upon his technique, which had earlier been influenced by Matisse and Picasso. He lived there until 1916, when he returned to New York. In 1918 Hartley went to New Mexico with the coterie of Mabel Dodge Luhan and painted there for two years. Though he never truly became part of the art community there, he nevertheless found powerful inspiration for his landscape canvases.

Between 1926 and 1930 Hartley lived in Paris and Aix-en-Provence and traveled throughout Europe. He finally went home to New England in 1930 and did murals and paintings for the Works Project Administration. He lived for the most part in Gloucester, Massachusetts, with occasional visits to New York for exhibits and to Maine.

The vivid colors of the Fauves can be seen in this animated landscape of New Mexico's foothills. Hartley wrote his description of the view to Stieglitz: "great isolated altar-like forms . . . stand alone on a great mesa with immensities of blue around them and that strange Indian earth making almost unearthly foregrounds." Hartley walked long distances into the arroyos to capture his scenes. Hartley's peaks are so abstracted they look like slabs of marbleized steak, and the distant mountains seem like ocean waves. The brushwork is active, linear and almost surreal, much in the manner of the German Expressionists.

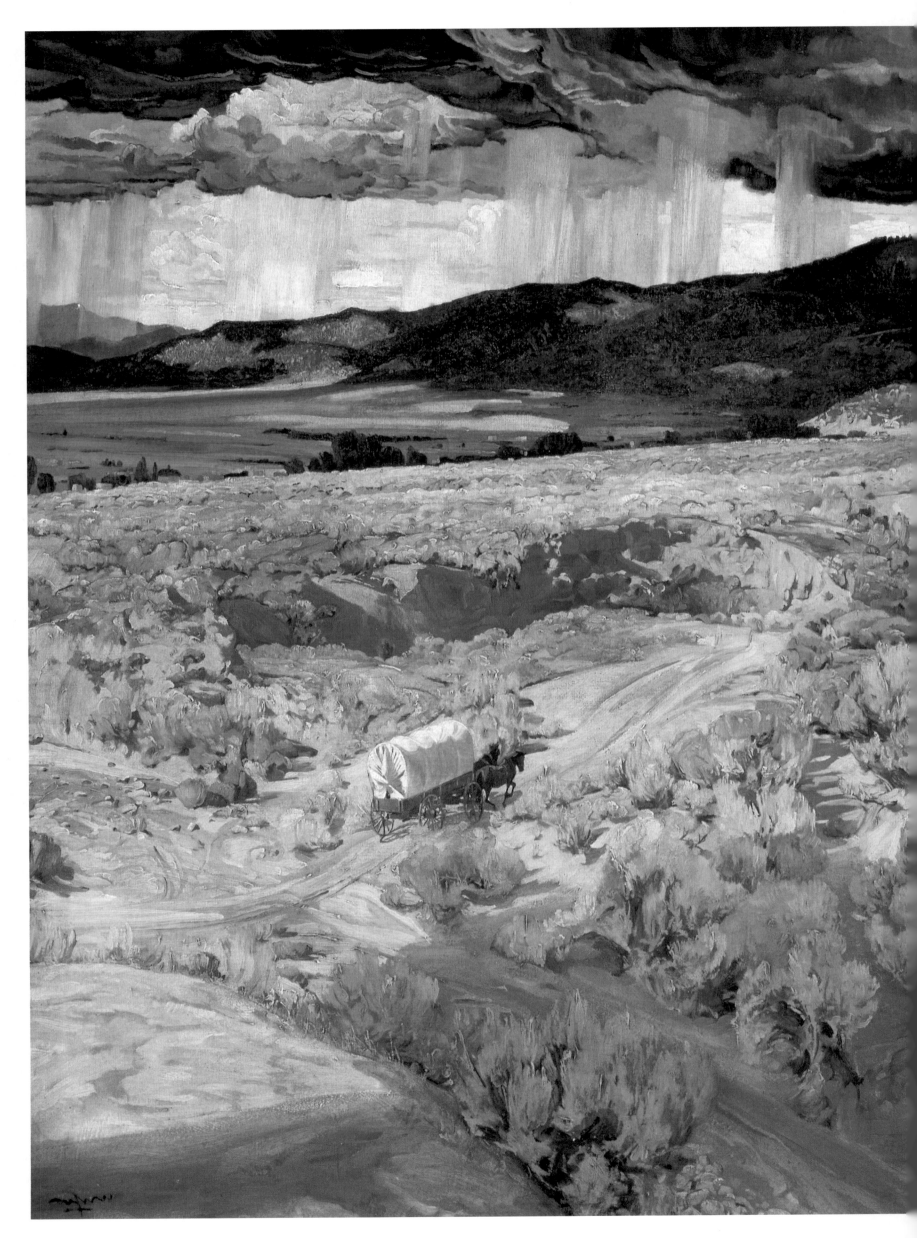

Where the Desert Meets the Mountain, 1922

Oil on canvas
36 × 40 in.
The Anschutz Collection

Walter Ufer was born July 22, 1876, in Louisville, Kentucky, to parents who had emigrated from Germany, his father having been a political radical. The young Ufer's formal art training began when his parents apprenticed him to a lithographer. He later went to Hamburg, Germany, where he attended the Royal Applied Art School and then studied at the Royal Academy in Dresden. He returned to the US in 1898 and worked in the art department of the *Louisville Courier.* He went to Chicago in 1900 and, while working for Armour and Company, attended school in the city.

Ufer found a patron in the person of Chicago's mayor, Carter Harrison, who sponsored a trip by Ufer to Taos in 1914. He was made a member of the Taos Society of Artists. Until 1920 he divided his time between Chicago and Taos, finally moving to Taos permanently. By then his work was in many major museums and collections, and in 1926 he was elected an Academician of the National Academy of Design. Despite this recognition, he remained poor and suffered from bouts of alcoholism. He died in 1936.

Ufer was known as a master draftsman with a direct and powerful style. He never painted from imagination or indoors, and his standard technique was to start at the top of a canvas and paint to the bottom, rarely pausing to make alterations. In *Where the Desert Meets the Mountain* the solitude of a lone covered wagon determinedly plodding across the great western frontier is powerfully evoked. Danger lurks in the huge crevices in the earth on each side of the road and in the squalls streaking toward the wagon through the turbulent steel grey sky.

VICTOR HIGGINS 1884-1949
Winter Funeral, 1931
Oil on canvas
46 × 60 in.
The Harwood Foundation,
Taos, New Mexico

Victor Higgins grew up on a farm in Shelbyville, Indiana, where he was born on June 28, 1884. As a youth he painted images on the insides of barns. He attended the Art Institute of Chicago and the Chicago Academy of Fine Arts, where he later taught. In 1910 he went to Paris and then Munich, where he met Walter Ufer. He saw the Armory Show in New York in 1913 and was much influenced by the Cubists, the Fauves and the Impressionists. At Thanksgiving time of that year he met his future wife, Sara, in Taos, New Mexico, and fell in love with her and the town.

In 1917 Higgins joined the Taos Society of Artists and soon began to receive considerable recognition for his work. A Museum of Modern Art opening in 1929 included one of his paintings, and he was named an Academician of the National Academy of Design in 1935. At first he focused on native Indian portraits, but later his interest in Cézanne's appreciation of

nature as a system of architectural forms became more apparent. Higgins died of a heart attack in 1949.

The watercolorist John Marin had visited Taos between 1929 and 1930, his influence is visible in the broken contour lines, tilted planes and notational scheme for the clouds, canyons and mountains in Higgins's *Winter Funeral.* Both artists were interested in the concept of "Dynamic Symmetry," the idea that all of nature had a structured spatial order. But though Higgins was enamored of theory, he never forgot that what made the work of American artists special was their unique subject matter. "To be outstanding," he once remarked, "their art should be indigenous."

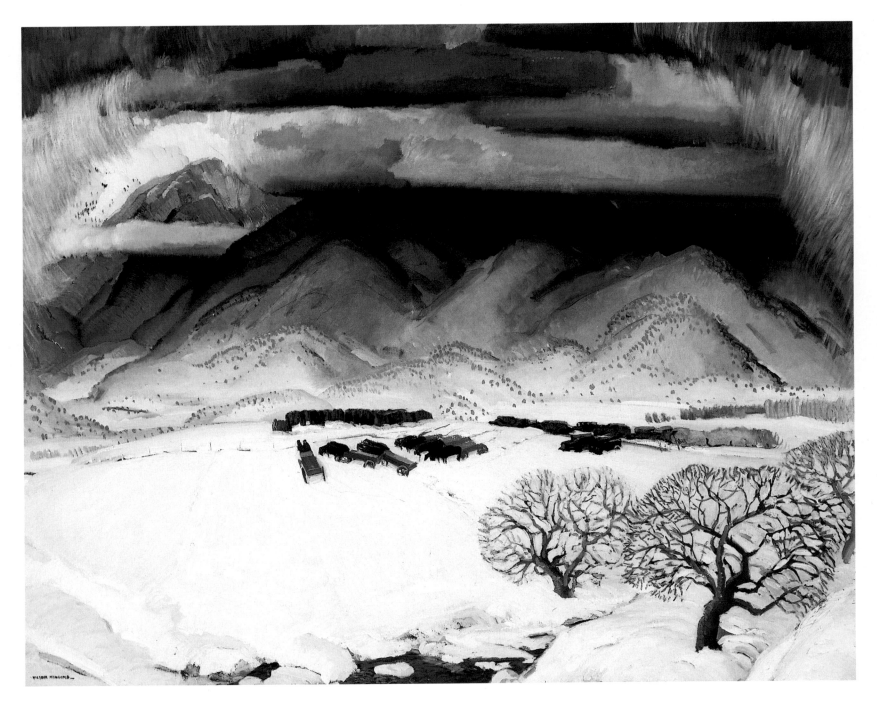

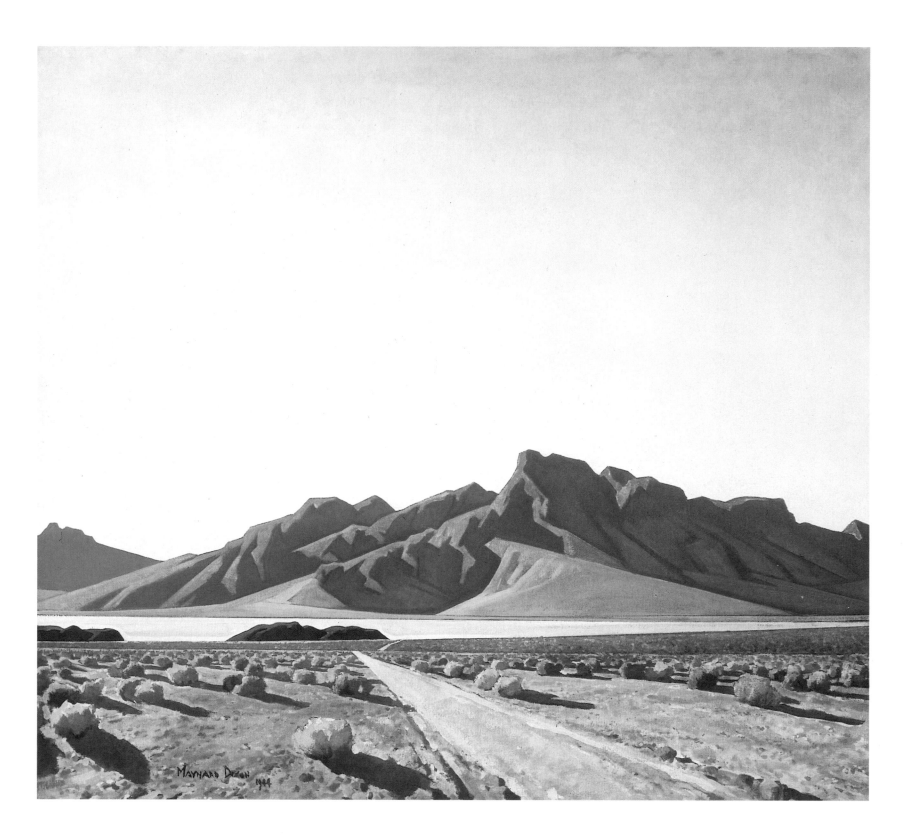

MAYNARD DIXON 1875-1946
Desert Southwest, 1944
Oil on canvas
40 × 36 in.
The Anschutz Collection

A strange character who dabbled in the occult and in bizarre religions, Maynard Dixon was born in Fresno, California, on January 24, 1875. He was asthmatic as a youth, and his father took him into the Sierras and the Yosemite Valley for a cure. Some of the sketchbooks Dixon created as a teenager he sent to his idol, Frederic Remington, for review, and Remington replied encouragingly.

In 1893 Dixon attended the San Francisco School of Design and soon thereafter began to provide illustrations for national magazines, eventually being hired as the staff artist on the *San Francisco Examiner* in 1899.

Dixon married the photographer Dorothea Lange in 1920 and became well known as a mural painter, working on WPA projects during the Depression. He lived for a while among the placid Hopi Indians and refused to paint any violent scenes even when lucrative commissions were offered. He stated his goals simply: "I aim to interpret the poetry and pathos and the life of Western people seen amid grandeur, sternness and loneliness." He died in Tucson, Arizona, in 1946.

Desert Southwest reveals Dixon's interest in abstracting geometric planes from natural elements in landscape. The mountains are broken up into cubistic forms, and there is a slightly surreal sharpness and electric energy to their blue-gray contours. The solitude of the Western expanse is underscored, and there is a harshness to the light: the beauty here is stark rather than romantic. The round, dappled sagebrush in the foreground offers a contrast in shapes, and a stretch of road recedes to lend a point of perspective.

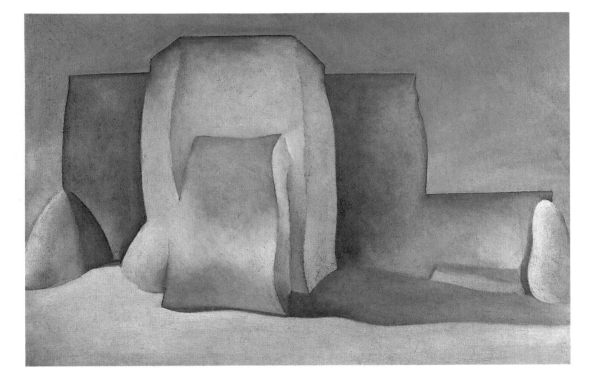

Pages 56-57:
GEORGIA O'KEEFFE
It Was Blue and Green, 1960
Oil on canvas
30 × 40 in.
Collection of Whitney Museum of
American Art, New York, New York
Lawrence H. Bloedel Bequest
(77.1.37)

This is the latest of the three O'Keeffe paintings shown here, and the most abstract. A ground line is not indicated, and the sweeping stripes that curves sinuously through the horizon might suggest Western roads dissolving into the distance – or possibly jet trails, since at this time O'Keeffe was producing canvases of clouds and skyscapes that suggested views from airplane windows.

The grey-white shadows and masses in this mindscape may have evolved from the pelvises and horns that O'Keeffe had so often painted, for their hue, scale and intricately curved forms seem related. Yet the spirit of this painting is wholly its own: there is a cleanness and pureness about it that reminds one of mountains in winter snow.

Above:
GEORGIA O'KEEFFE 1887-1986
Ranchos Church, 1929
Oil on canvas
24 × 36 in.
The Phillips Collection
Washington, D.C. (1449)

Georgia O'Keeffe was born in the farm country of Sun Prairie, Wisconsin, on November 15, 1887. When she was 12 she decided to be an artist. She went to the Art Institute of Chicago when she was 17, and she later took classes at the Art Students League in New York. She then taught art in Virginia and for several years in small towns in the flatlands of Texas.

In 1918 O'Keeffe returned to New York and joined the circle of photographer Alfred Stieglitz, who ran the avant-garde 291 gallery. She married Stieglitz in 1924 and employed some of the contemporary photographic theories of cropped images, close-up views and crisp, hard-edge forms in her paintings of flowers and still life. She was already a financial and critical success in the art world, a rare event for a woman.

O'Keeffe went to Taos in the summer of 1929 and was swept into the social and artistic coterie of Mabel Dodge Luhan, D.H. Lawrence, John Marin and others. After Stieglitz's death in 1943 she lived full-time in New Mexico at a deserted ranch in Albiquiu. Her paintings of the landscape and found objects of the Western plains combined elements of realism, symbolism and abstraction with her own unmistakable personal style. She lived and dressed as sparingly as a nun and painted some of the most passionate vistas of the West ever made. She died in 1986, 98 years old and already an acknowledged master.

Ranchos Church is portrayed with simplified volumes and a limited palette of grey and beige placed against a clear blue sky. The shapes created by the church's adobe architecture are so abstracted as to seem like the natural forms of boulders and mesas in the Southwest. The calmness of the image is paramount, and no details of windows, doors or crosses identify the building as a place of worship. Here the natural and man-made worlds are made one. The church fills the canvas completely, but there is no need to show its natural surroundings: they are all implicit in the church's contours.

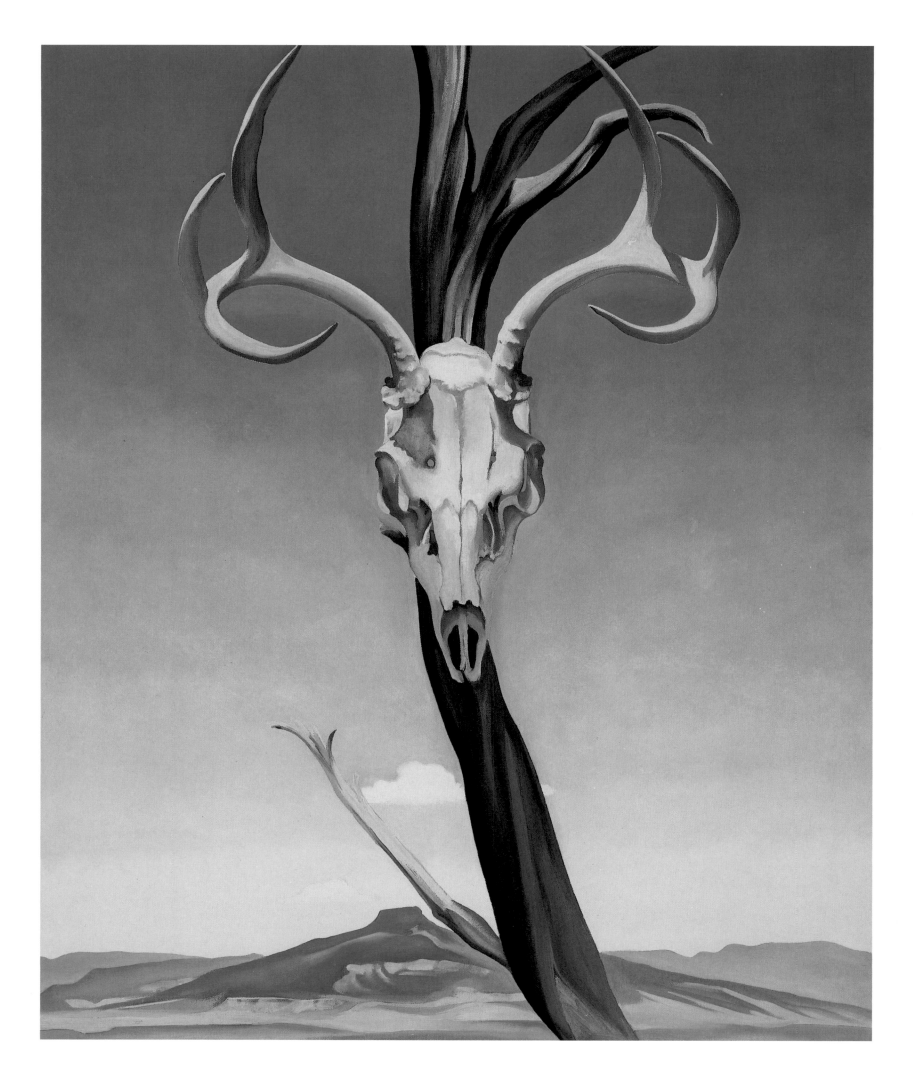

GEORGIA O'KEEFFE
Deer's Skull with Pedernal, 1936
Oil on canvas
36 × 30 in.
Courtesy of Museum of Fine Arts,
Boston, Massachusetts
Gift of the William H. Lane Foundation
(1990.432)

O'Keeffe wrote of her series of skull and pelvis-bone paintings, "I brought home the bleached bones as my symbols of the desert. They cut sharply to the center of something that is keenly alive on the desert . . . and knows no kindness with all its beauty." There is a mysterious power in this deer skull seen against the backdrop of the Pedernal, a mountain O'Keeffe viewed from her studio.

The crisp, symmetrical, close-up image of the skull is placed at the center of the canvas in a composition that probably consciously refers to modern photography. The skull rests on a black branch that heightens the interstices of its bones and sockets. The foreground objects seem especially arresting because they are seen against a gentle but vacant landscape and an equally remote clean blue sky.

JOHN CLYMER 1907-
Out of the Silence, 1976
Oil on canvas
30 × 40 in.
National Cowboy Hall of Fame and
Western Heritage Center,
Oklahoma City, Oklahoma (A.027.2)

John Clymer was born in Ellensburg,
Washington, on January 29, 1907. At the age
of 16 he sent his pen drawings of a Colt .22 to
the Colt Firearms Company, which reproduced
his work. He later moved to Vancouver, British
Columbia, where he studied at the Vancouver
School of Art. He also provided drawings for
mail-order catalogues and worked as an
illustrator for several Canadian magazines. But
he became ill and dispirited, and when he
recovered he temporarily shelved his art career
and took a job as a deckhand on a ship sailing
in the waters off Alaska.

By 1928 Clymer had returned to art and had
enrolled in the Wilmington Academy of Art in
Delaware. His idol was now N.C. Wyeth, the
most famous of the first generation of artists
produced by the Howard Pyle School in
Wilmington. Clymer married his childhood
sweetheart, Doris Schnebly, and in 1932 went
to Toronto. In 1935 he went to New York to
study with Harvey Dunn, another Howard Pyle
graduate, and soon thereafter the Clymers
moved to Westport, Connecticut. After serving
in the Marines in World War II, Clymer began
a series of over 90 covers for the *Saturday
Evening Post*, completed between 1945 and
1962. He took Western trips every summer
sponsored by *Field and Stream*, traveling the
Chisholm Trail, the Oregon Trail and the
Bozeman Trail.

Clymer embarked on a series of Western
historical paintings, whose celebrated research
and documentation was in part provided by his
wife. Like N.C. Wyeth, Clymer believes he
paints best what he knows best: his studio is
now in Teton Village, Wyoming, a Western
setting very like the Cascade Mountains where
he grew up.

There is a sense of intimacy about the scene
shown in *Out of the Silence*, an Indian and his
packhorses quietly emerging from a forest of
snowladen firs. The details of the Indian's
blanket jacket and buffalo chaps and his sturdy
dun-colored pony are photographically
accurate, attesting to Clymer's skills both as an
illustrator and an ethnographer. The icicles on
the pony's whiskers and steam from his nostrils
convey the cold, yet the sun on the field before
him promises warmth ahead. The background
is impressionistic, dappled in lavender hues,
and the huge tree trunk in the left foreground
creates scale.

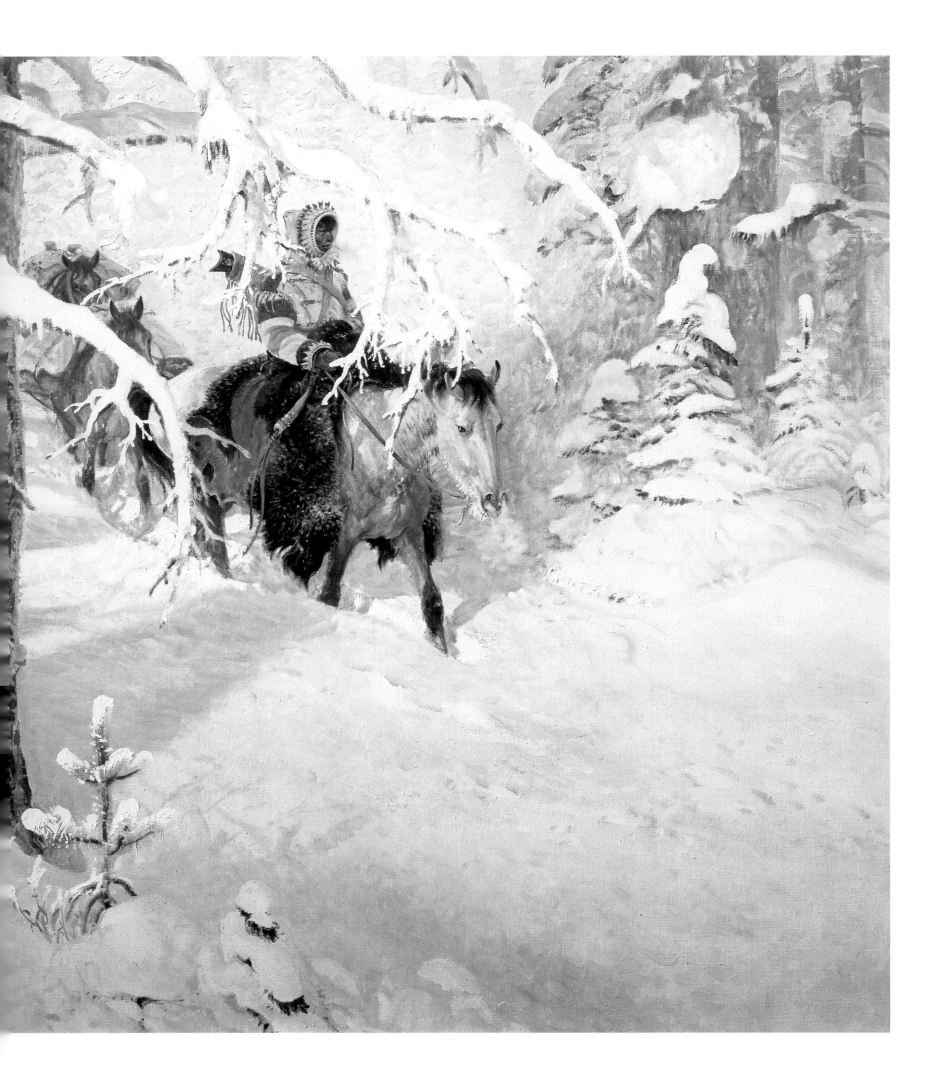

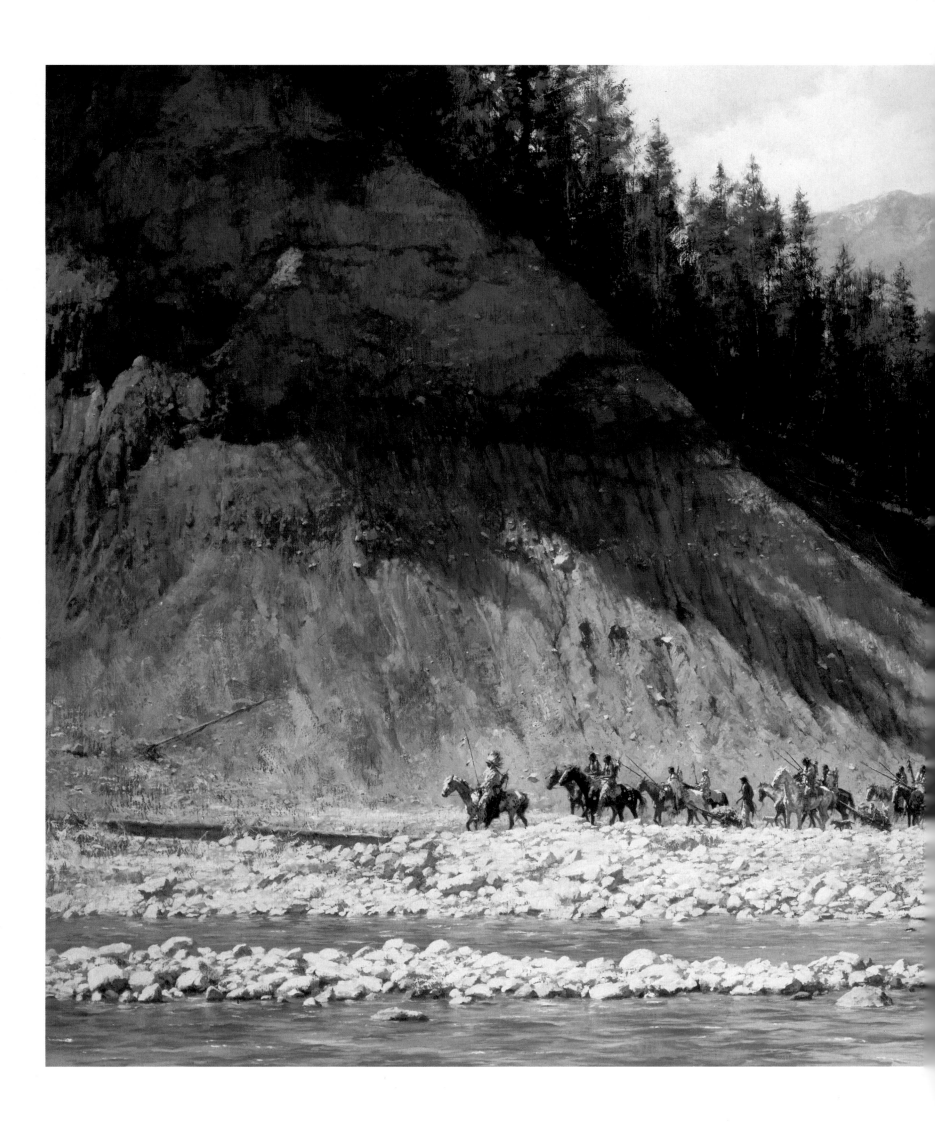

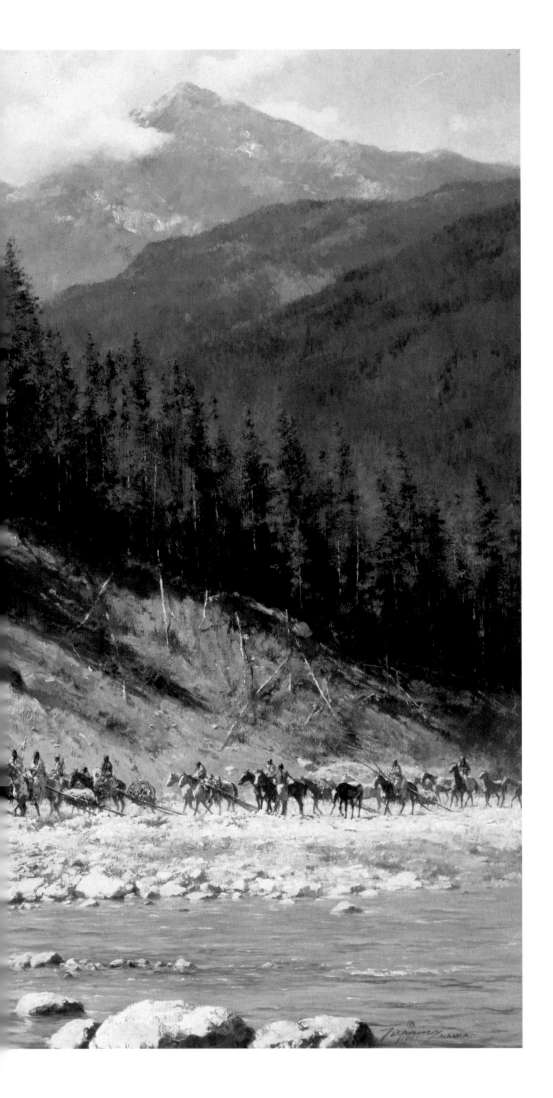

HOWARD TERPNING 1927-
Moving Day on the Flathead, 1981
Oil on canvas
40 × 58 in.
National Cowboy Hall of Fame and
Western Heritage Center,
Oklahoma City, Oklahoma (81.34)

Howard Terpning was born in Oak Park, Illinois, on November 5, 1927. For many years a successful New York illustrator, he produced covers for *Time* magazine, *Field and Stream* and *Reader's Digest*, as well as a variety of movie posters. He provided catalog drawings for the Winchester Arms Company, and during the Vietnam War he was a war artist as a member of the Marine Corps. Several of his war paintings now hang in the Pentagon.

Always excited by Western themes and horse portraits, Terpning moved his home from Wilton, Connecticut, to Tucson, Arizona, in 1977, claiming "I'm a cowboy at heart." Two years after his arrival he was accepted as a member of the National Academy of Western Art. The plains Indians are Terpning's specialty, and he has amassed a superb collection of Indian paraphernalia.

Moving Day on the Flathead won the Prix de West at the 1981 exhibit of the National Academy of Western Art. Its composition is relatively simple, and its details are beautifully executed. The smallness of the Indian tribe highlights the dramatic scale of the firs and mountain beyond them, yet they seem completely at one with their surroundings. Horizontal planes are formed by the Indians, the rocks and the river; vertical planes are established in the trees, cliff and lavender mountain. The mountain is handsome, mysterious and romantic, cloaked in a mist of fleecy white clouds.

Cowboys

The cowboy arrived in the West when cattle began to be transported back East on the newly-built railroads in the 1850s and 1860s. Rustlers, drovers and cattle wranglers were a noisy, rowdy crew, doing a job that was remote from other walks of life. They were tough, brave, independent and colorful characters, and their finest portraits were painted by men who lived among them and suffered their hardships.

Cattle had to be driven hundreds of miles between rustic outposts and railway stations during fierce snowstorms, through fires started by lightning and in periods of drought across baked prairies. Indians were a constant threat, as were cattle and horse thieves and other violent outlaws.

Charles Marion Russell was a self-taught artist who rode with a round-up crew in the Judith Basin in Montana in the 1880s and worked as a night hawk guarding herds till dawn. He sold his paintings in saloons and savored the camaraderie of his fellow ranchhands on the desolate plains. He loathed cities, claiming "If I had a winter home in Hell and a summer home in Chicago, I think I'd spend my summers at my winter home." He rode a horse named "Redbird" after a Winnebago war chief and was close friends with the legendary cowboy and entertainer, Will Rogers. Russell's popularity among his cohorts and the verisimilitude of his paintings earned him fame as "the cowboy artist" from art critics of the time.

Color, action and humor are the keynotes of Russell's style. His landscapes are laced with turquoise, lavender and maize hues, and his cowboys often wear bright red shirts and kerchiefs as they ride their chestnut and paint ponies. Steers plunge forward and lariats fly in *The Herd Quitter*, riders are unseated and calves are thrown to the ground in *A Tight Dally and a Loose Latigo*, a horse rears above the sagebrush while his cowboy rider grips his reins with one hand in the rousing bronze sculpture *Bucking Bronco*.

Russell's cowboys usually carry sidearms, for the law of the gun reigned in the West of the late nineteenth century, and the attitude of most cowboys was "shoot first and ask questions afterwards." Gunfights were frequent, and characters like Wild Bill Hickok, Buffalo Bill Cody and Jesse James were locally famous for their skill with six-shooters. N.C. Wyeth, the celebrated magazine and book illustrator from Chadds Ford, Pennsylvania, alludes to this form of hero worship in his vivid and rather sinister portrait *The James Brothers in Missouri*.

Frederic Remington, perhaps the most famous artist of the American West and a contemporary of Charles Russell, was trained at a military academy and later received formal art education at Yale University. He was particularly drawn to scenes of violent action, and his narrative canvases reflect this predisposition. Horses and cowboys are strewn about like playing cards following a territorial skirmish in the grim painting *What An Unbranded Cow Has Cost*.

Remington said he wanted his epitaph to read, "he knew the horse," and the fabled bronco of the West is the centerpiece of many of his paintings. Thus a horse fights taming with a vengeance while being broken in in *Turn Him Loose, Bill*: his mane seems almost electrified, and his eyes bulge white with fury. In contrast, a steady, fast and surefooted steed bears his rider between galloping longhorns in Remington's striking bronze *The Stampede*. Remington once said, "As a saddle animal simply, the bronco has no superior. He graces the Western landscape because he comes of the soil and has borne the heat and the burden and the vicissitudes of all that pale of romance which will cling about the Western frontier."

The rodeo, a feature of cowboy life since the days of the vaqueros, has persisted down to our own time and it is still a favorite subject of many Western artists. During the decades following the Depression the Works Progress Administration sponsored numerous murals by Western artists such as Frank Mechau, who captured the pageantry of the rodeo in a flat, semi-Cubist style in his *Wild Horse Race*. Another painter who liked rodeo subjects, W. Herbert Dunton, was one of the few Western artists to show women riders, handling their mounts as confidently as any cowboy.

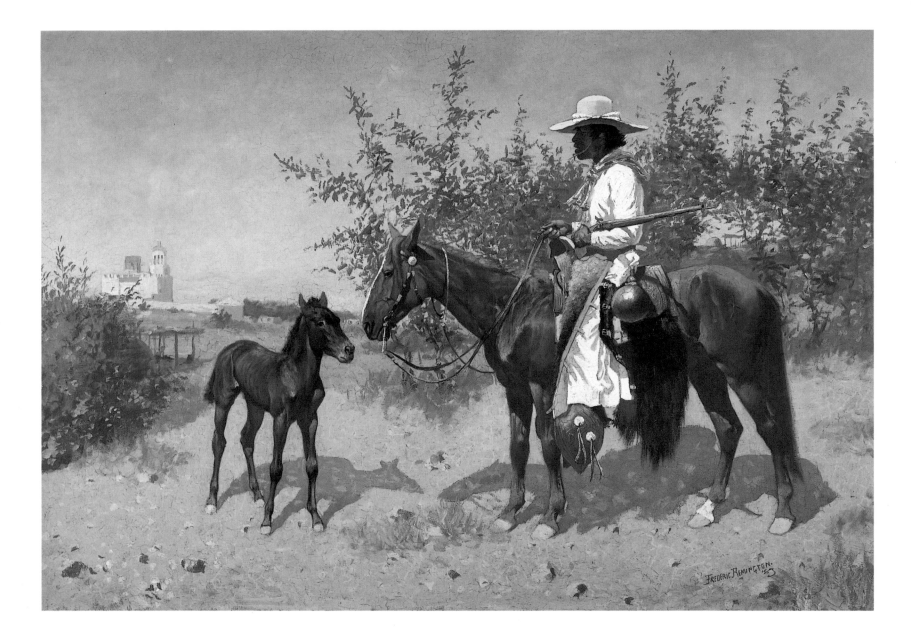

FREDERIC REMINGTON 1861-1909
The Sentinel, 1889
Oil on canvas
34 × 49 in.
Courtesy Sid Richardson
Collection of Western Art,
Fort Worth, Texas (SWR 76)

Remington is probably the best known artist of the American West, a painter with an appetite for violent scenes and passionate, action narratives. The son of a cavalry soldier, Remington was born October 1, 1861, in Canton, New York. He attended military school and studied fine art for two years at Yale University, leaving before graduation to go west. Upon his return he sold sketches to *Harper's Weekly* in New York and married his sweetheart, Eva Caten. They moved to Kansas City, Missouri, but soon thereafter she went home to New York while Remington ventured among the Apaches in Arizona and the Comanches to their north.

Remington brought his work back to New York, and his illustrations appeared in many magazines, in Western novels by Rudyard Kipling and Owen Wister, in Francis Parkman's *The Oregon Trail* and in a memoir by his friend Theodore Roosevelt. His easel painting, meanwhile, won awards at the National Academy of Design. His early style of hard-edged realism gradually gave way to a somewhat looser, semi-impressionistic approach, but he never lost his taste for scenes of explosive, action-packed narrative. He died of appendicitis at the age of 48.

The Sentinel, an early work, is a more formal and quiet portrait than is typical of Remington. The figures are slightly stiff but quite interestingly detailed. Note the explicit and fancy refinements of the Mexican cowboy's gear – his bright scarf, buffalo-skin chaps, hand-tooled saddle and the silver and gold details of his stirrup covers and the pony's bridle. The colt's awkward stance and questioning vulnerability are well-handled. The misty Spanish fort in the background adds another touch of exoticism to the canvas.

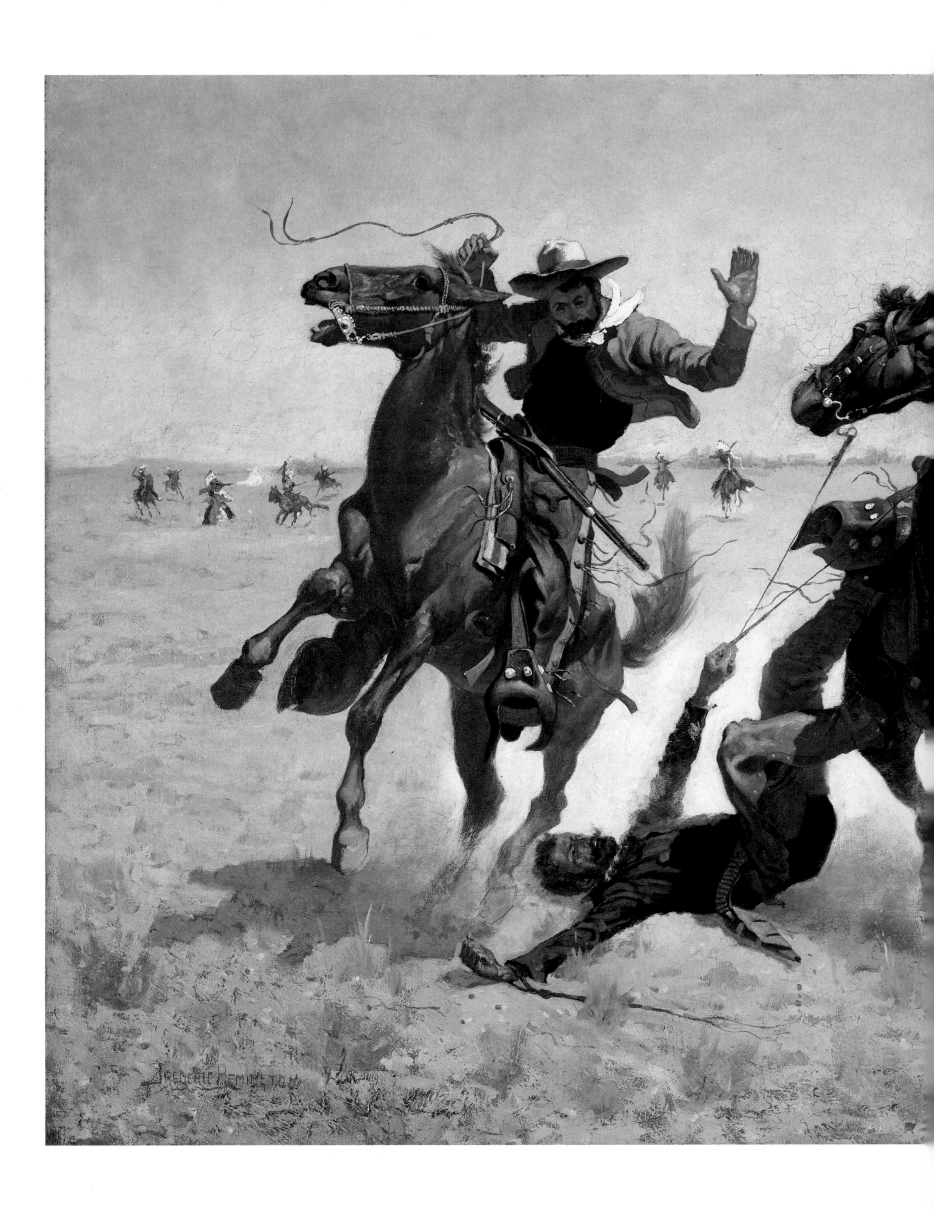

FREDERIC REMINGTON
Aiding a Comrade, ca. 1890
Oil on canvas
34⁵⁄₁₆ × 48⅛ in.
The Museum of Fine Arts,
Houston, Texas
The Hogg Brothers Collection,
Gift of Miss Ima Hogg (43.23)

Remington's love of violent dramatic action
and his skill at portraying it are well illustrated
here. The horses are galloping, rearing and
turning all at once, with angry and confused
expressions. Their legs twist into peculiar
contorted positions and are effectively
foreshortened so as to orient their momentum
directly towards the viewer. The cowboys'
postures and the grimacing features of the
fallen rider just beneath the hooves of his
comrade's mount are superbly described. The
loops of the reins and halters add lyrical, linear
designs. The background is wisely left a flurry
of chalky dust, with tiny Indians to indicate the
source of danger.

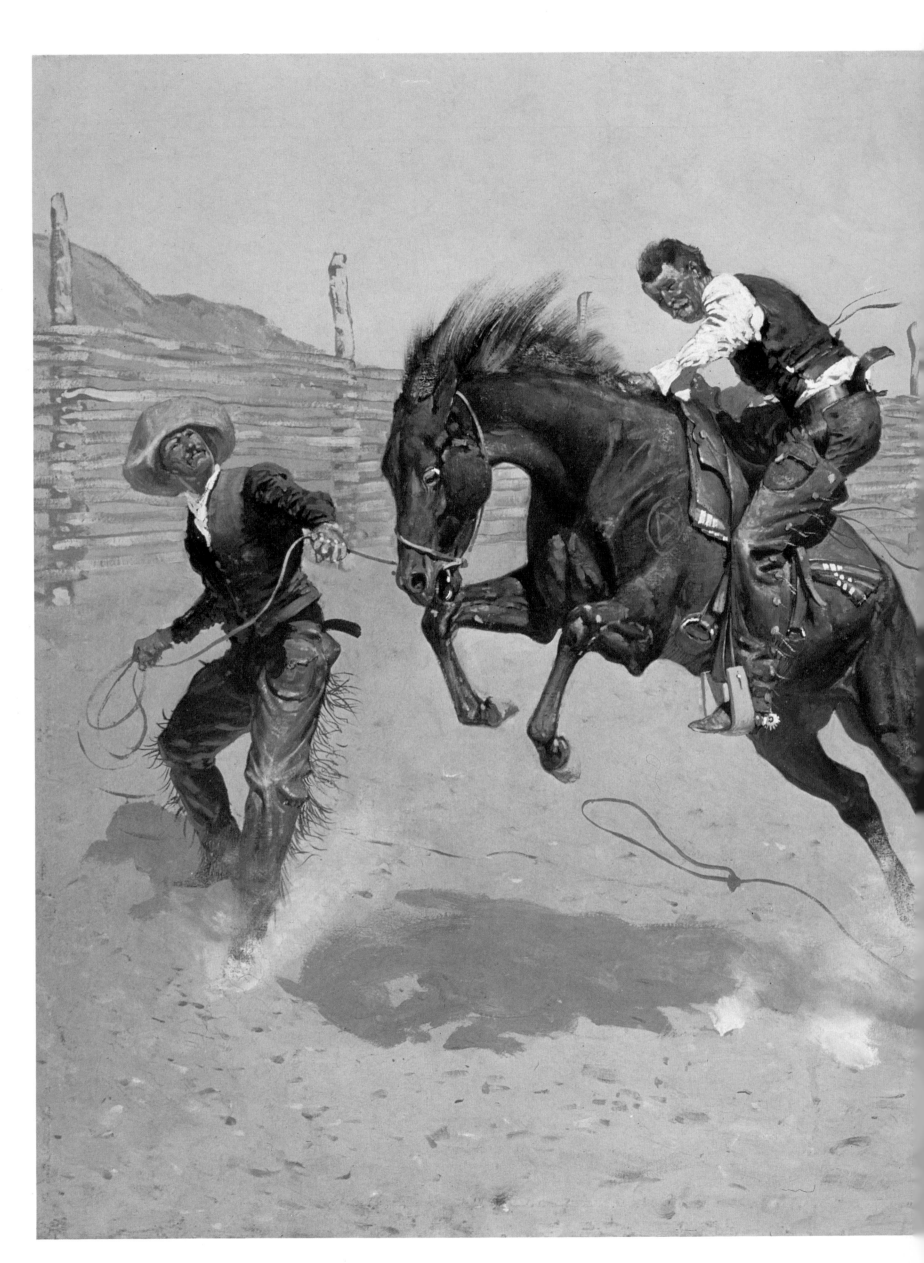

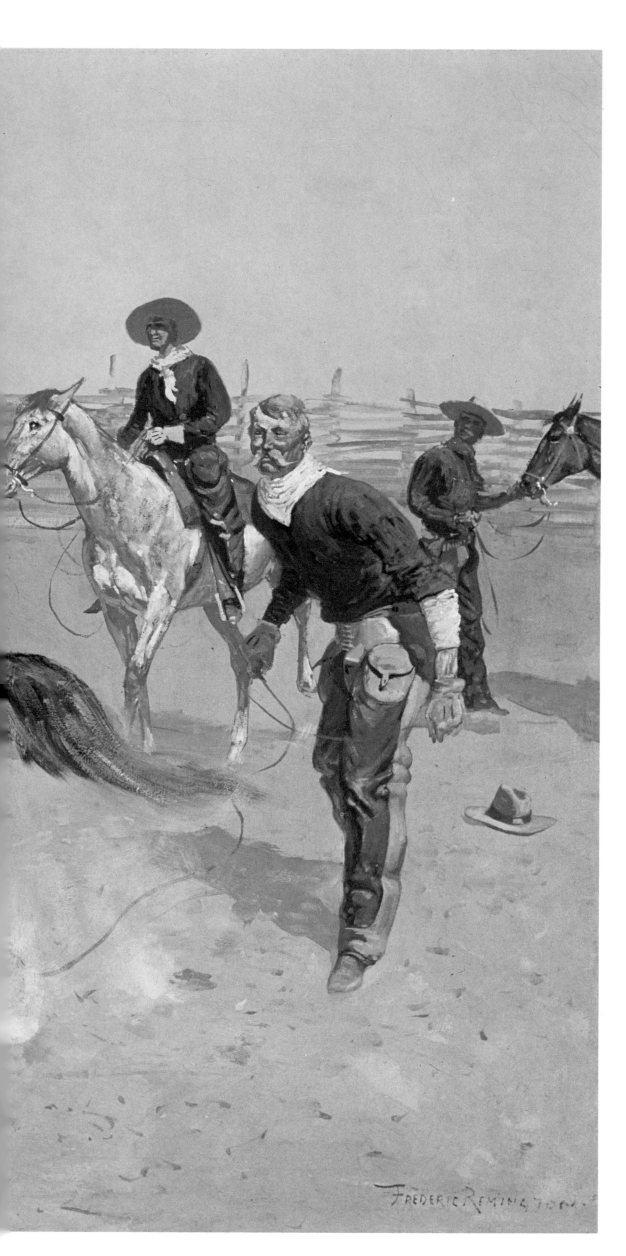

Left:

FREDERIC REMINGTON
Turn Him Loose, Bill, 1892
Oil on canvas
25 × 33 in.
The Anschutz Collection

A diagonal arrangement of forms leads to the
main attraction – a bay bronco being broken.
There is an element of humor in the
ranchhands' faces as they watch the cowboy
being tossed about. The horse is vividly and
powerfully displayed as he fights the men who
surround him. Interestingly, the features of the
bronc rider closely resemble those of Teddy
Roosevelt, a good friend of Remington and
likewise an aficionado of the Old West.

Pages 68-69:
FREDERIC REMINGTON
**What an Unbranded Cow Has
Cost,** 1895
Oil on canvas
28 1/16 × 35 1/8 in.
Yale University Art Gallery,
New Haven, Connecticut
Gift of Thomas M. Evans, B.A. 1931
(1977.114)

This painting has an eerie light, as if the color
of death were in the air. The fight between two
gangs of ranchers over which owns an
unbranded cow has resulted in a scene of
carnage, with horses and cowboys strewn on
the plains, some in the throes of dying and
some already gone. One hand still stands
defiantly, but he is outnumbered and plainly
has not long to live. The horses lend color and
pathos to a picture that is otherwise unrelieved
by any detail not essential to the implied story.

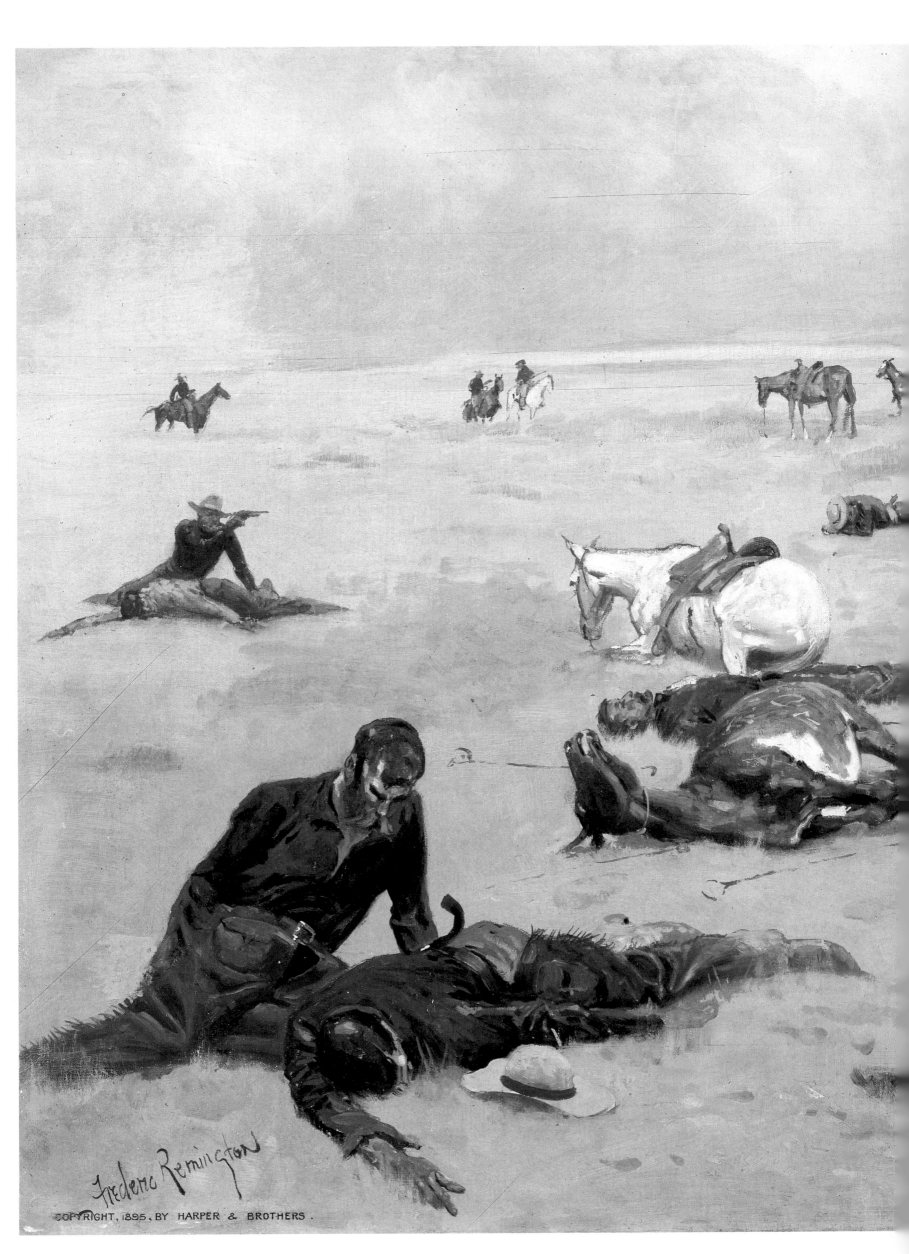

Frederic Remington

COPYRIGHT, 1895, BY HARPER & BROTHERS.

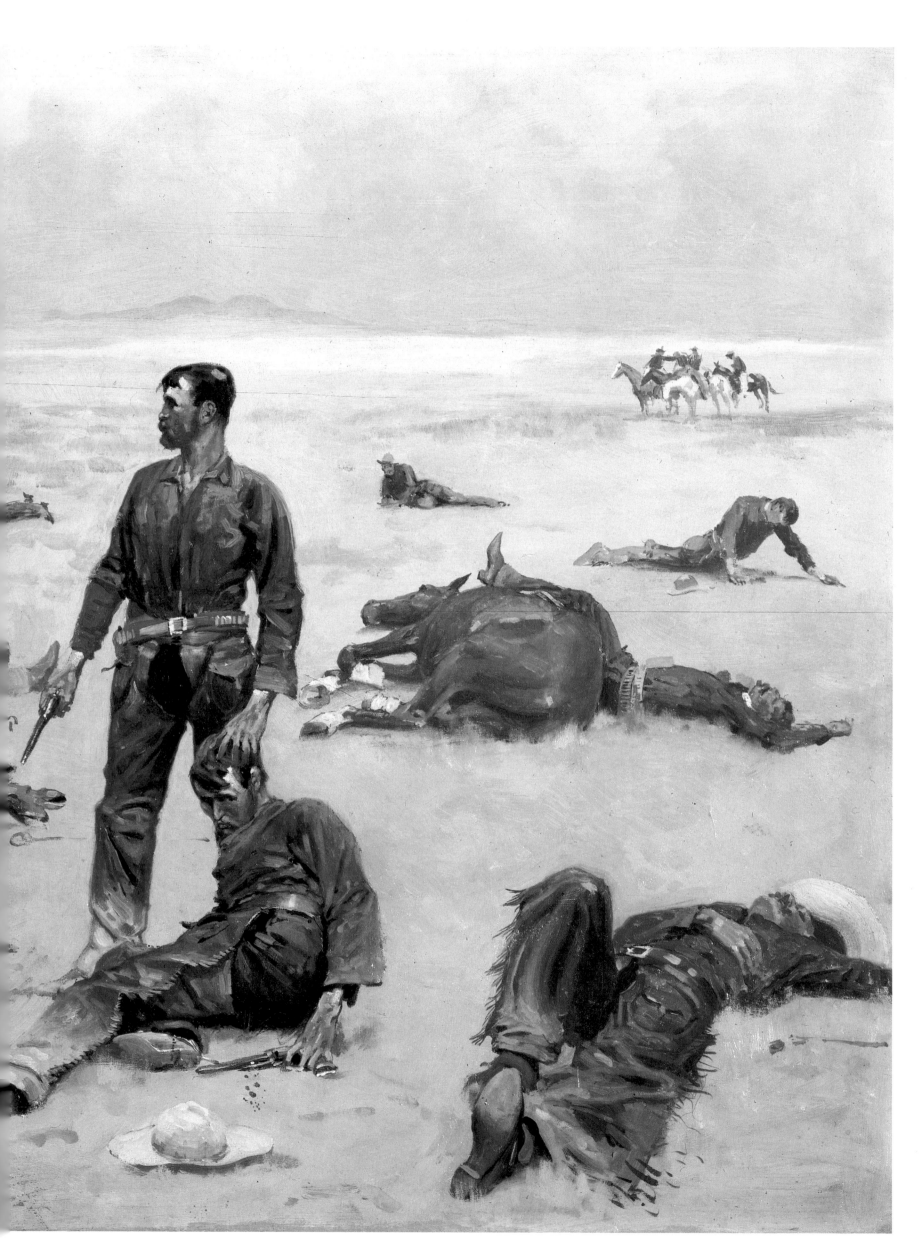

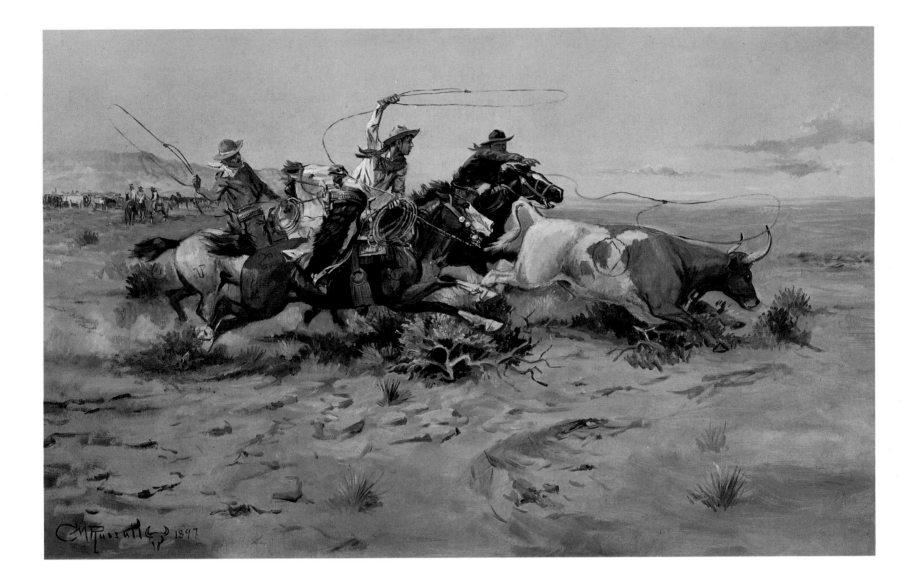

CHARLES M. RUSSELL 1864-1926
The Herd Quitter, 1897
Oil on canvas
20 × 31 in.
Courtesy of Montana Historical Society,
Helena, Montana
Gift of Colonel Wallis Huidekoper
(X52.02.01)

A member of round-up teams, a cattle drover and night herder, Charles Russell was "the cowboy artist." Born in a well-to-do family in Oak Hill, Missouri, on March 19, 1864, Russell showed an early affinity for art. He went to military school in New Jersey but left at the age of 16 and never returned, preferring the vagaries of life as a trapper, sheep rancher and wrangler in Montana. He also lived among the Blood Indians, who called him "Ah Wah Cous," or antelope.

At 31 Russell married a young girl named Nancy Cooper, whom he called Mame and who became his business manager. He sold Drawings to *Harper's Weekly* and *Recreation* magazine. He gradually earned increasing acceptance among galleries and museums, and Tiffany's in New York sold his bronzes. In 1911 he received a mural commission for the House of Representatives at Montana's State Capitol. Will Rogers, the homespun Western entertainer, was his good friend. Russell died of heart failure in October 1926.

The Herd Quitter has tremendous forward energy pulsing through its horizontal layout.

Selected details of the cowboys' gear and the lyrical, linear sweep of the lassos are superbly rendered. Note the variety of brands on the horses' flanks, the diamond in the circle brand on the steer and the fancy silverwork on the lead pony's bridle. The colors of the canvas are particularly rich, with touches of turquoise, lavender, yellow and jade streaking across the sagebrush plains and distant foothills. The cowboys have met their match in the galloping long-horned steer.

CHARLES M. RUSSELL
The Tenderfoot, 1900
Oil on canvas
14⅛ × 20⅛ in.
Courtesy Sid Richardson
Collection of Western Art,
Forth Worth, Texas (SWR 73)

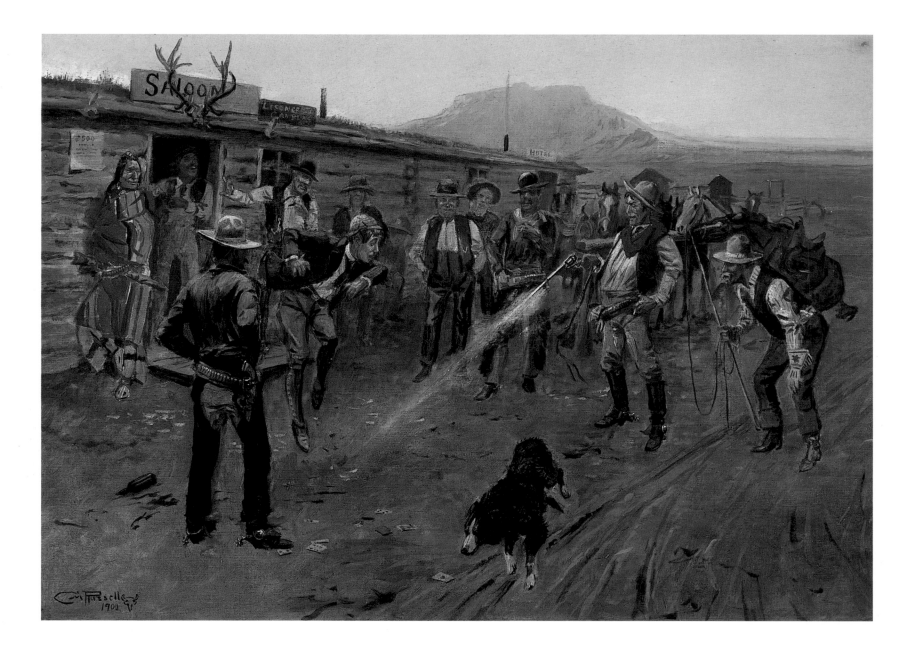

An example of the bawdy humor of the West,
this picture reveals some of the less appealing
features of cowboys folkways. After a bit too
much liquor, a cowhand entertains himself by
shooting at the feet of a city dude unfamiliar
with rowdy Western customs. But perhaps
there may be some justification for this
gunplay, for the cards strewn about hint at the
possibility of a cheating player being rewarded
for his sleight-of-hand. In any event, the
sheepdog scampering off and the blanketed
Indian add picturesque details to this
entertaining, if slightly clichéd, genre scene.

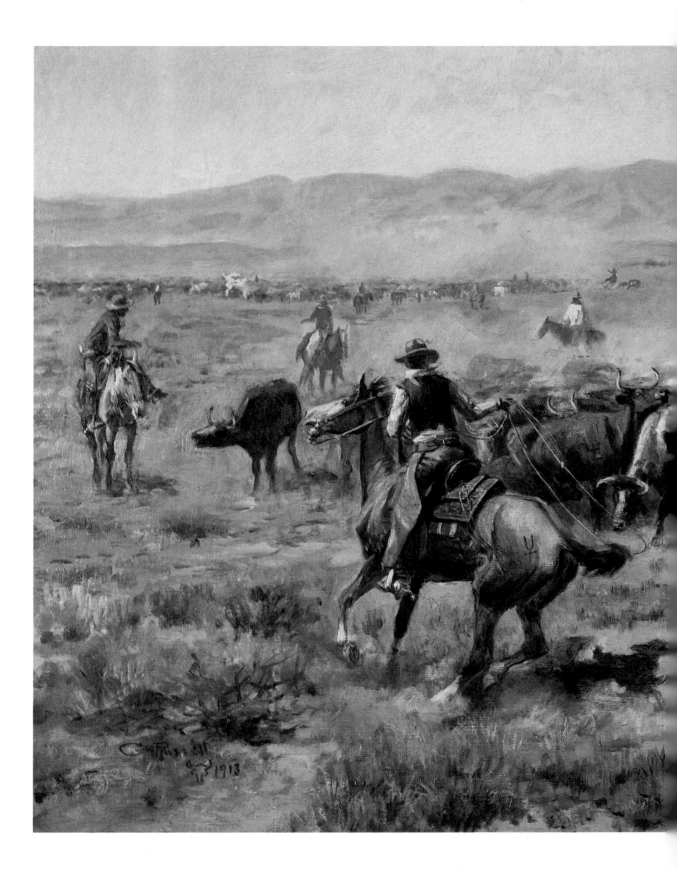

CHARLES M. RUSSELL
The Roundup #2, c. 1913
Oil on canvas
25 × 49 in.
Courtesy of Montana Historical Society,
Helena, Montana
Mackay Collection (X52.01.07)

This *Roundup* is a literal and descriptive painting, without humor or any over-dramatized action to divert our attention. With a limited palette of dark greys and browns to outline the cowboys, and with soft blue, turquoise and yellow to enhance the landscape, Russell has constructed a fine study of the quotidian chores of the cattle rancher. The horses and riders converge to form a triangle with the roping cowboy at left at the apex. This late painting effectively employs impressionistic, pastel-hued brushwork to create the effect of cowhands and herds fading in the shimmering heat of the background. The commonplace challenge of corralling longhorns is here evoked by a master.

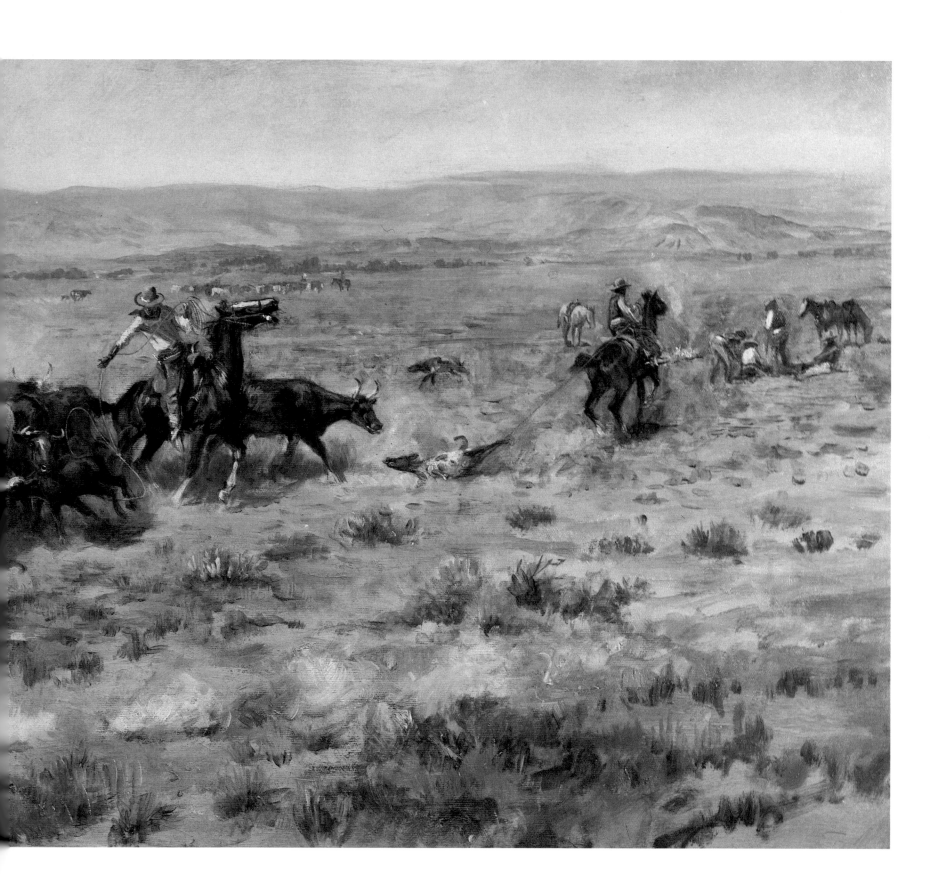

Pages 74-75:

CHARLES M. RUSSELL

Buffalo Bill's Duel with Yellow Hand, 1917

Oil on canvas

29⅞ × 47⅞ in.

Courtesy Sid Richardson
Collection of Western Art,
Fort Worth, Texas (SWR 79)

Although some authorities claim this confrontation between Buffalo Bill Cody and the Indian chief Yellow Hand never took place, it was a part of cowboy legend. William F. Cody was a colorful showman whose internationally famous Wild West Show even reenacted a buffalo hunt for the Grand Duke Alexis of Russia in 1871. This canvas, too, has a theatrical air. Buffalo Bill in his fringed jacket and suede pants plays the lead actor, turning to fire on his nemesis, Yellow Hand, who seems to have come up behind him. Yellow Hand's dying white pony makes the scene more lurid: together their bones will join the skull and skeleton of the steer in the foreground. Yet despite the theatricality of the narrative, the beauty of the setting – the maize-colored plains, heather sagebrush and periwinkle mountains – is authentic and heartfelt.

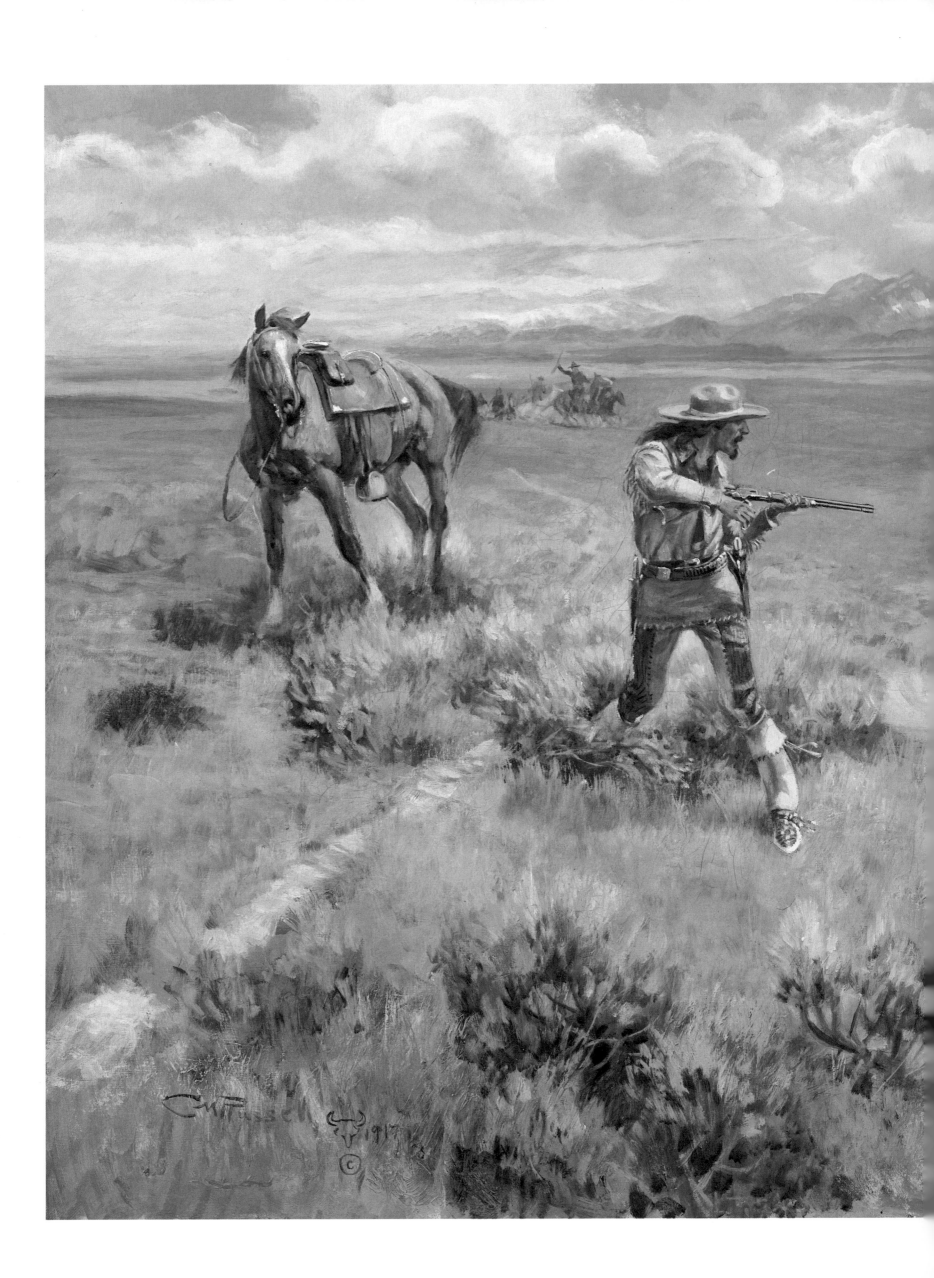

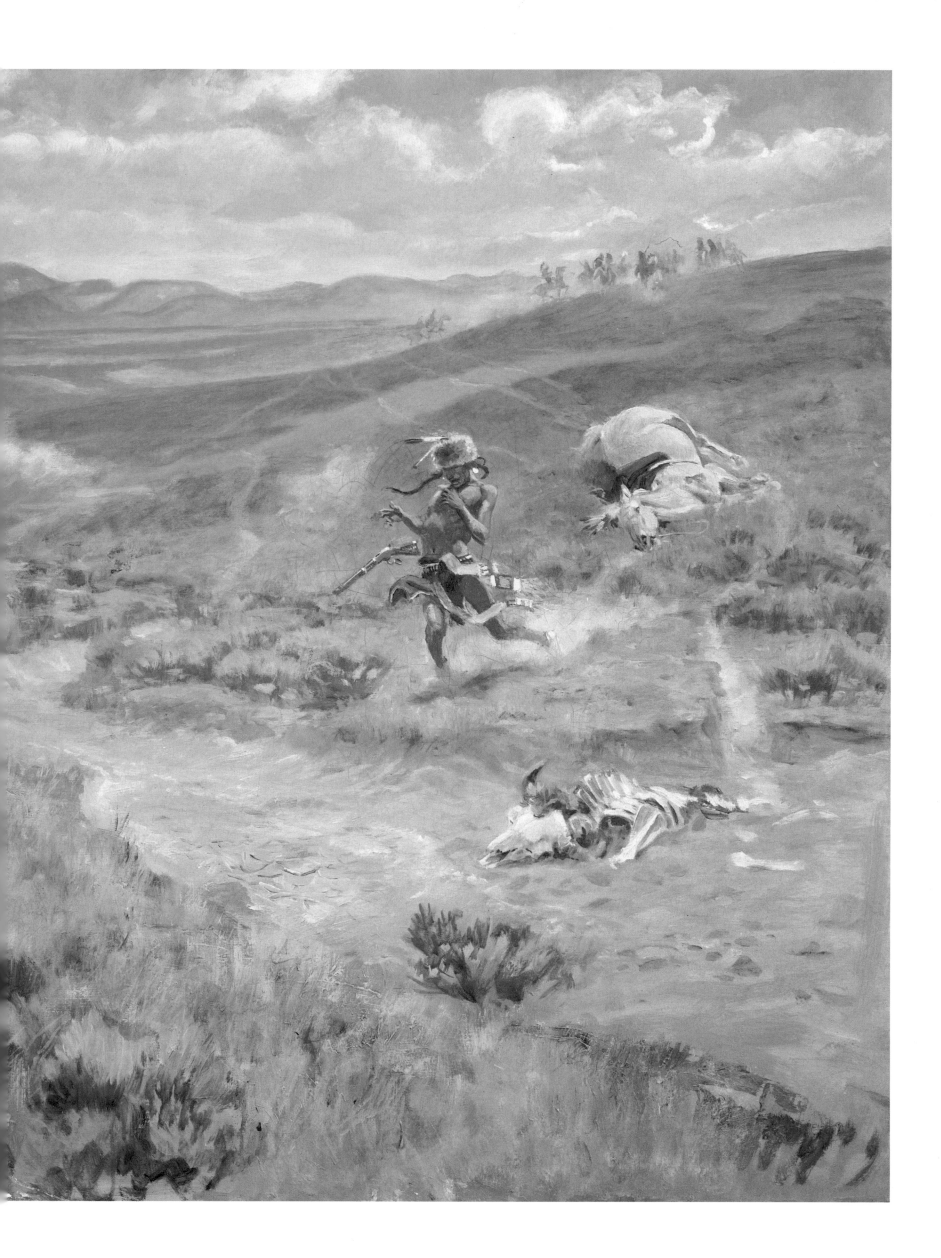

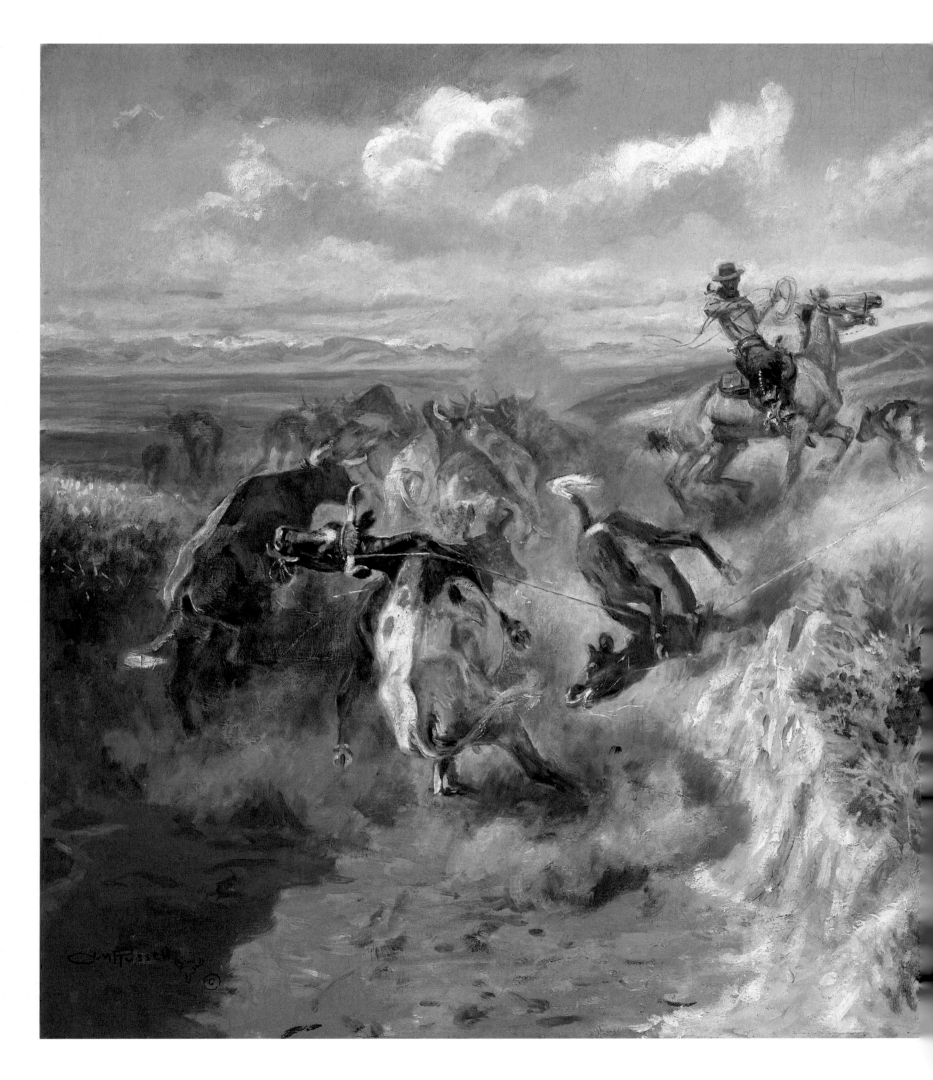

CHARLES M. RUSSELL
A Tight Dally and a Loose Latigo, 1920
Oil on canvas
30¼ × 48¼ in.
Amon Carter Museum,
Fort Worth, Texas (1961.196)

This is a wonderfully chaotic composition, with rearing, tumbling steer caught by the "dally" – a long lariat – and a cowboy being bucked off his bronc. (A latigo is a whip that is used to keep the longhorns in line.) The composition is made up of two triangles: the three steers in the left foreground form one, and the three cowboys on the right provide another. Russell skillfully uses bright color and sharp details on the cowboy in the foreground and lets the background figures corral our attention along with the cattle. The animals' expressions are superb.

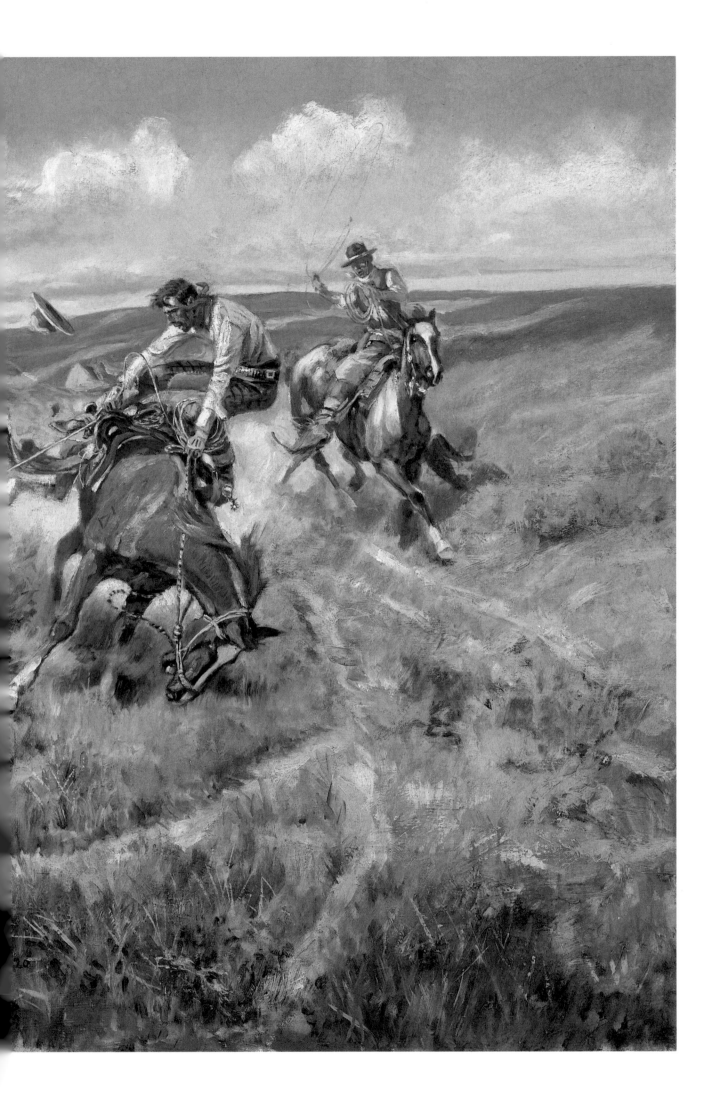

N.C. Wyeth 1882-1945
A Shower of Arrows Rained on Our Dead Horses From the Closing Circle of Redmen (Fight on the Plains), 1916
Oil on canvas
32 × 40 in.
Collection of Mr. and Mrs. Andrew Wyeth,
Courtesy of the Brandywine River Museum,
Chadds Ford, Pennsylvania

Newell Convers Wyeth was born near the Charles River in Needham, Massachusetts, on October 22, 1882. He was a farmboy who spent a lot of time riding horses and drawing them: as a teenager he sold sketches of polo ponies to their owners. He trained as a draftsman at the Mechanics Art School in Boston and, on a friend's advice, attended the Howard Pyle School of Art in Wilmington, Delaware. Frederic Remington was one of the many friends of Howard Pyle (1853-1911), perhaps the most influential American illustrator of his generation.

Although he had never been west, Wyeth sold a cover illustration called *The Bronco Buster* to the *Saturday Evening Post* in 1903. The *Post* and *Scribner's* magazine sponsored Wyeth's journey to the Rockies in 1904. He lived among Indian tribes at trading posts and worked as a range rider, a mail carrier and a stagecoach driver. Upon his return to the East he sold stories of his adventures with illustrations to a variety of magazines. He also illustrated children's books and novels by such writers as Jules Verne and James Fenimore Cooper, did advertisements and made paintings for calendars.

After five years or more of painting Western themes, Wyeth found his ardor for the subject dwindling, and he later tended to concentrate on farm scenes and landscapes closer to his home in Chadds Ford, Pennsylvania. He died there in a train accident on October 19, 1945.

Wyeth's love of action is tangible in this canvas. The perspective is highly unusual and effective. It focuses on the horse, the cowboy's ally even when fallen and wounded. Though no Indians loom nearby, the painful arrows in the horses' sides mark their presence and threat. Wyeth once watched a horse being slaughtered and it left a lasting impression on him, enhancing his ability to draw horses accurately and from a wide variety of angles.

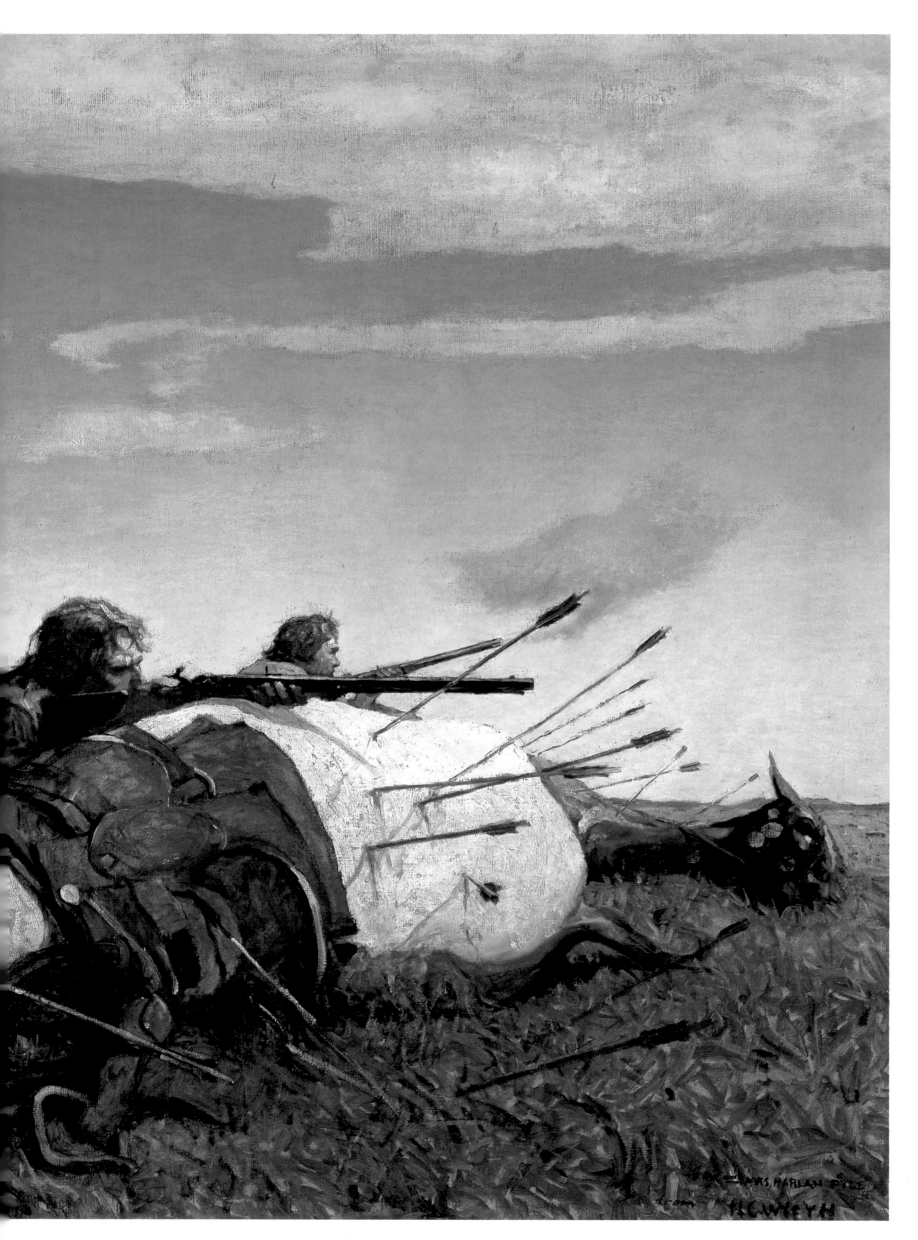

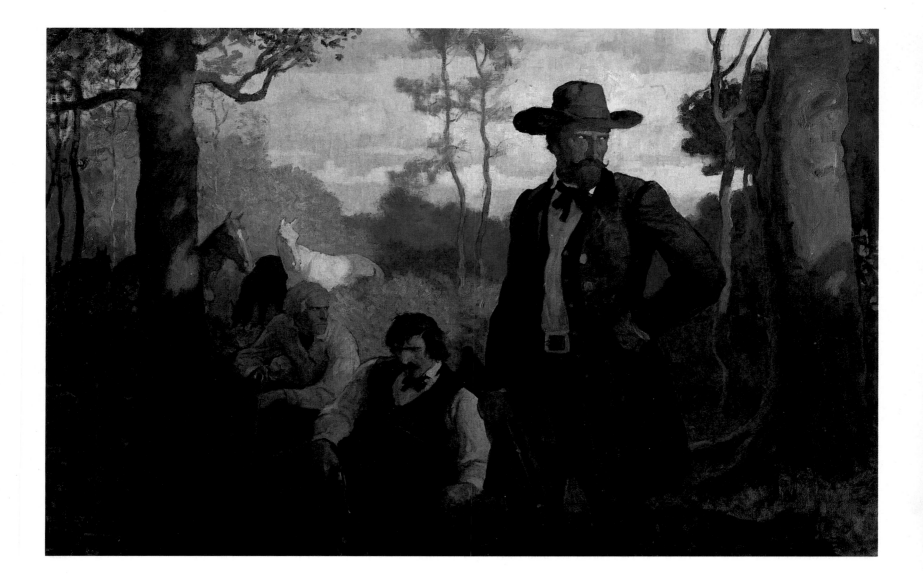

Above:
N.C. WYETH
The James Brothers in Missouri,
n.d.
Oil on canvas
25 × 40 in.
The Thomas Gilcrease Institute of
American History and Art,
Tulsa, Oklahoma (0127.1544)

In *The James Brothers* Jesse James' narrow
eyes, villainous expression and dark demeanor
assert the evil character of the outlaw. The
Pinkerton Agency, along with assorted sheriffs
and marshals, had hunted the James Gang for
over 16 years, but Jesse was ultimately shot by
a traitor in his own camp. Here, he is the
central figure, hiding out with his band of men
in the Western woods. The forms of the men,
their horses and the trees are strong and active
– there is always tremendous movement and
energy in Wyeth's paintings. Their clearly
defined outlines against the background reveal
his technical skills as an illustrator. The gentle
beauty of horses grazing in the distance
contrasts with the gang's furtiveness and shows
Wyeth's pleasure in the Western landscape.

Right:
W. HERBERT DUNTON
Rodeo Rider, 1908
Oil on canvas
30 × 20 in.
Mr. and Mrs. Roger K. Gray

W. Herbert Dunton was one of the few
Western artists to depict strong, independent
white women. He saw many female bronco
riders at the Frontier Days Fair in Cheyenne,
Wyoming, starring in events such as the Ladies'
Relay Race and the Squaw Race. Here, his rider
is a sort of Gibson girl in Western dress –
serene, pretty, feminine and wearing a clean,
neat skirt and starched white blouse, despite
the rigors of her task. In contrast, the horse is
all angry contortion and savage determination.

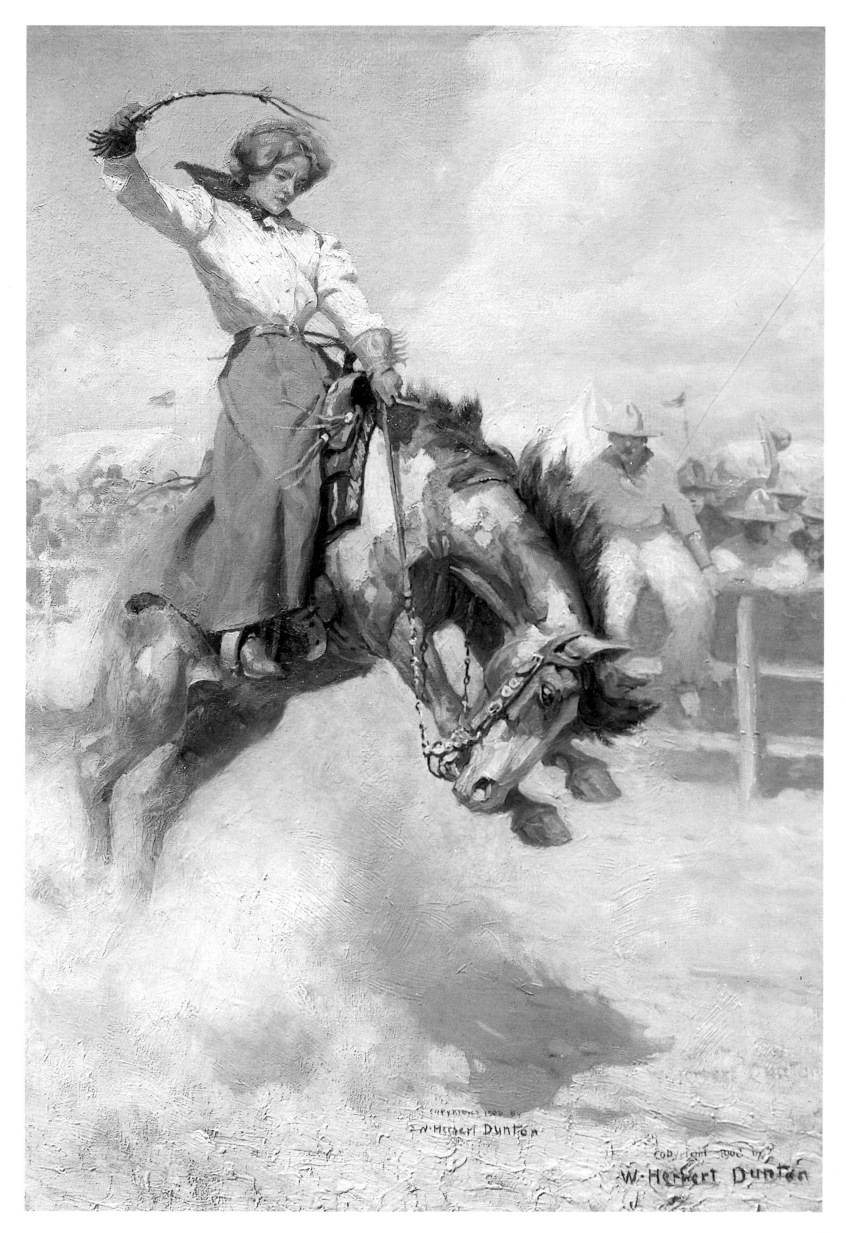

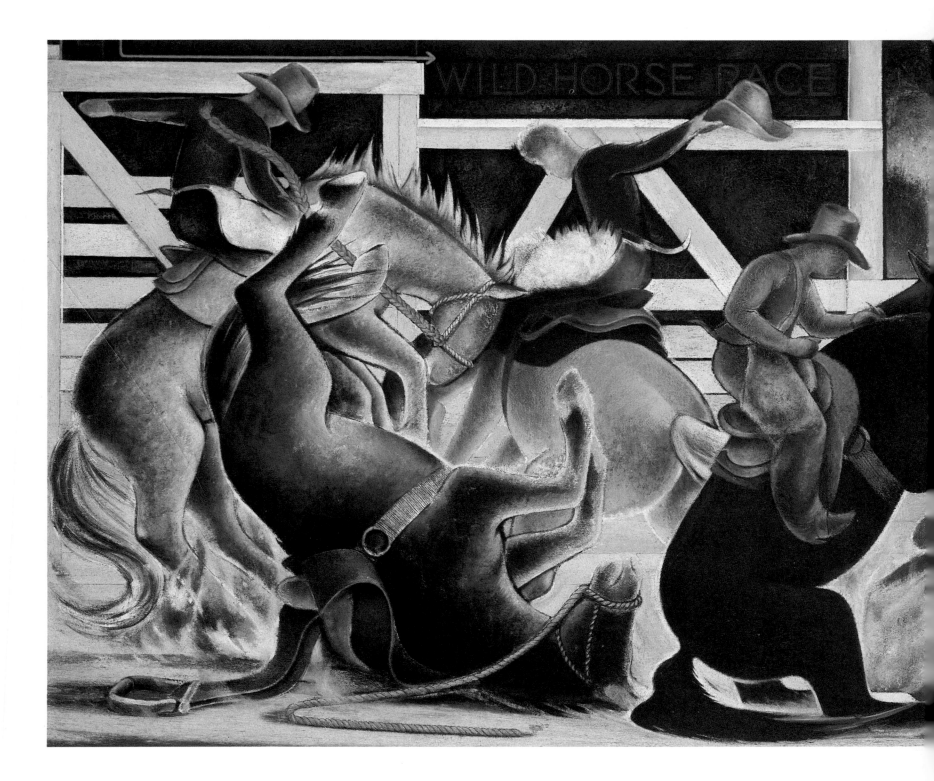

FRANK MECHAU 1904-1946
Wild Horse Race, 1935
Oil on canvas
40 × 100 in.
The Anschutz Collection

Frank Mechau was born in Glenwood Springs, Colorado. He paid for his first painting lessons by boxing and working as a railroad cattlehand. He later studied in Chicago, New York and finally in Paris, where he was strongly influenced by the Cubist movement. He returned to Colorado and in 1931 began supplying murals for the Works Progress Administration. He completed *Horses at Night* for the Denver Public Library, and seven others for federal projects. He entered and won awards in a number of competitions, including the Whitney Biennial in New York and the Corcoran International in Washington, D.C.

Wild Horse Race has a flattened picture plane and a geometric composition of horses bucking, rearing and kicking. Their shapes are a procession of circles with diagonal thrusts and counterpoints. Action, rather than detail, is primary. A nightime aura is cast by beams that seem to come from spotlights above the scene, as well as by the smoky background. In these races the cowboy is required to rope, saddle and ride unbroken horses. Despite the riskiness of these feats, the image here is soothed by soft-textured horses and the rounded, pleasingly colored forms of the careering riders.

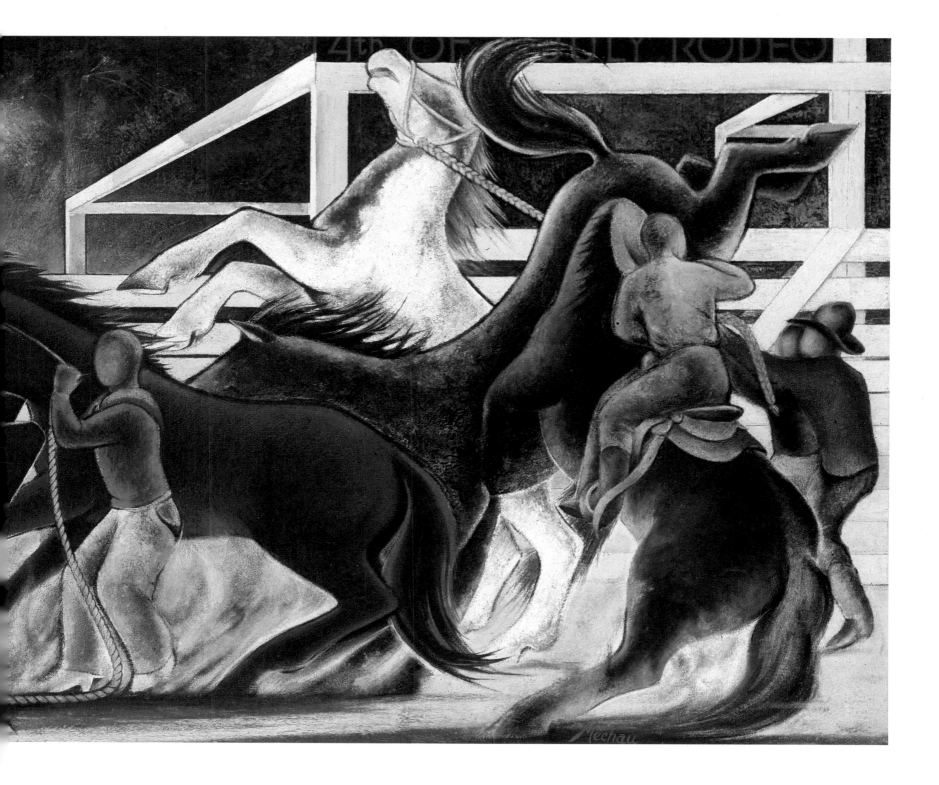

Olaf Wieghorst 1899-

Cutting Horse-The Roper, n.d.

Oil on canvas

28⅛ × 38 in.

Collection of the Eiteljorg Museum of
American Indian and Western Art,
Indianapolis, Indiana
Gift of Harrison Eiteljorg

Olaf Wieghorst is a Dane, born in Jutland,
Denmark. He was a trick rider with the circus
during his youth and has spent his entire
career involved with horses in one way or
another. After his arrival in New York at the
age of 19 he enlisted in the Fifth Cavalry and
was immediately dispatched to the Mexican
boundary as a member of the US Border Patrol.
He later worked at the Quarter Circle 2C
Ranch in New Mexico. In his late twenties he
returned to New York, married his wife, Mabel,
and joined the New York City Mounted Police.
He returned to the West following this and
now has a home and studio in El Cajon,
California.

Suspense is created in this action canvas,
Cutting Horse, by the two forms of horse and
steer almost colliding. This possibility is
reinforced by their even closer shadows on the
ground below. Together their shapes form a
strong compositional triangle in the right of the
picture. The cowboy is a classic Western hero,
boyishly handsome and wearing a white hat.
He looks completely in control, despite the
rush of the action. The background is misty
and impressionistic, lost in the heat and dust of
the moment. Realistic detail is reserved for the
horse's facial expression and his silver studded
bridle, revealing the Wieghorst's undoubted
equestrian expertise.

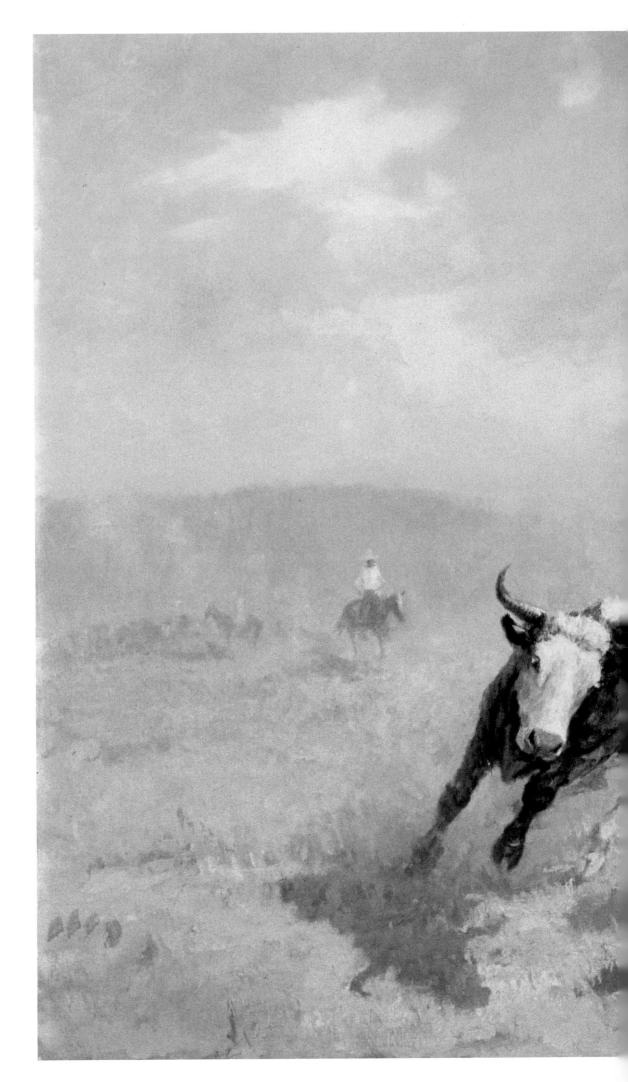

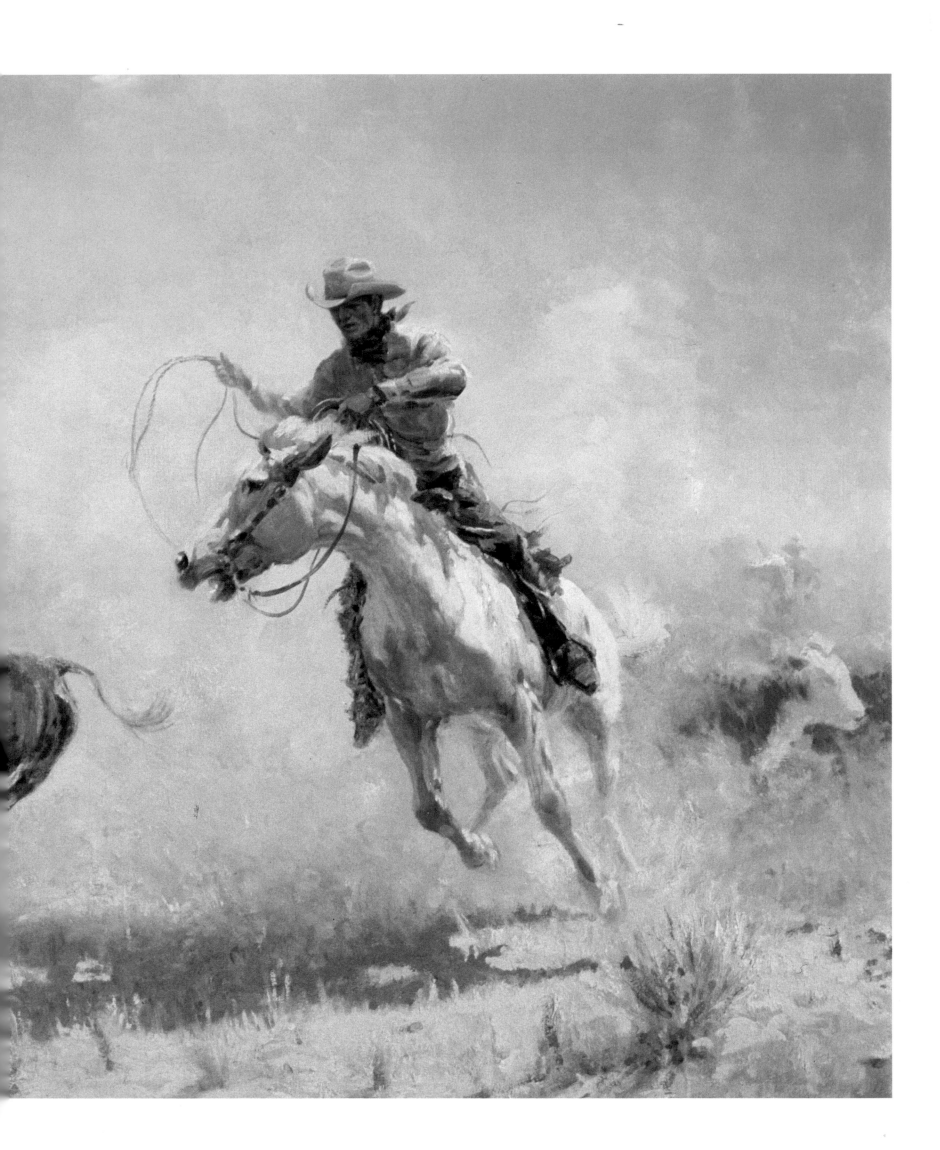

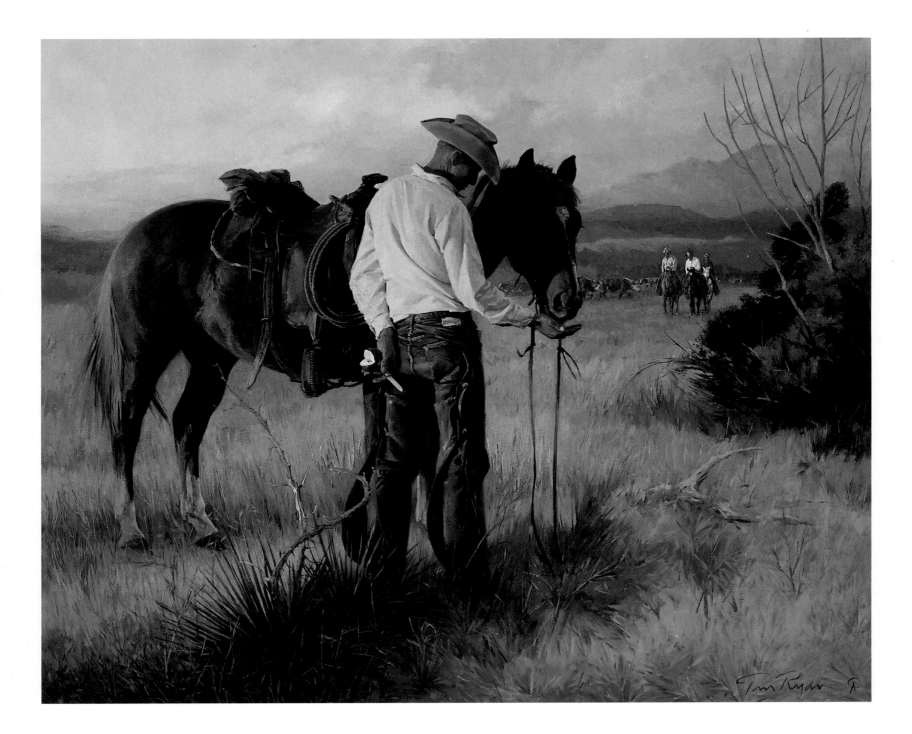

THOMAS RYAN 1922-
Sharing an Apple, 1969
Oil on canvas
25¼ × 30 in.
National Cowboy Hall of Fame
and Western Heritage Center,
Oklahoma City, Oklahoma (A.097.2)

A native of Springfield, Illinois, Tom Ryan attended the Art Students League in New York and has worked consistently as a commercial illustrator. He served as president of the Cowboy Artists of America, and his paintings have been on display at the Franklin Mint in Philadelphia, the Phoenix Art Museum and the Whitney Gallery of Western Art in Cody, Wyoming, among other places. He has received many awards for his canvases.

A carefully composed scene with photorealist details, *Sharing an Apple* exemplifies the value of a cowboy's relationship with his horse. The surrounding vista is beautifully harmonized in blues, heathers and maize, against which the cowboy's hat and chaps stand out in contrast, while his white shirt rivets our attention. The gentleness of the offering is sincerely represented and never seems mawkish, in part because of the well-defined expressions of man and animal.

FREDERIC REMINGTON
Coming Through the Rye, 1907
Bronze
27½ × 28 × 19 in.
Buffalo Bill Historical Center,
Cody, Wyoming
Gift of Barbara S. Leggett (5.66)

This is a marvelous swashbuckling piece, with a quartet of pistol-packing cowpunchers roaring into town. Their camaraderie is evident as they lean gregariously toward one another, and the vigor of their horses' poses seems to reflect their pleasure. This bronze ripples with tactile energy.

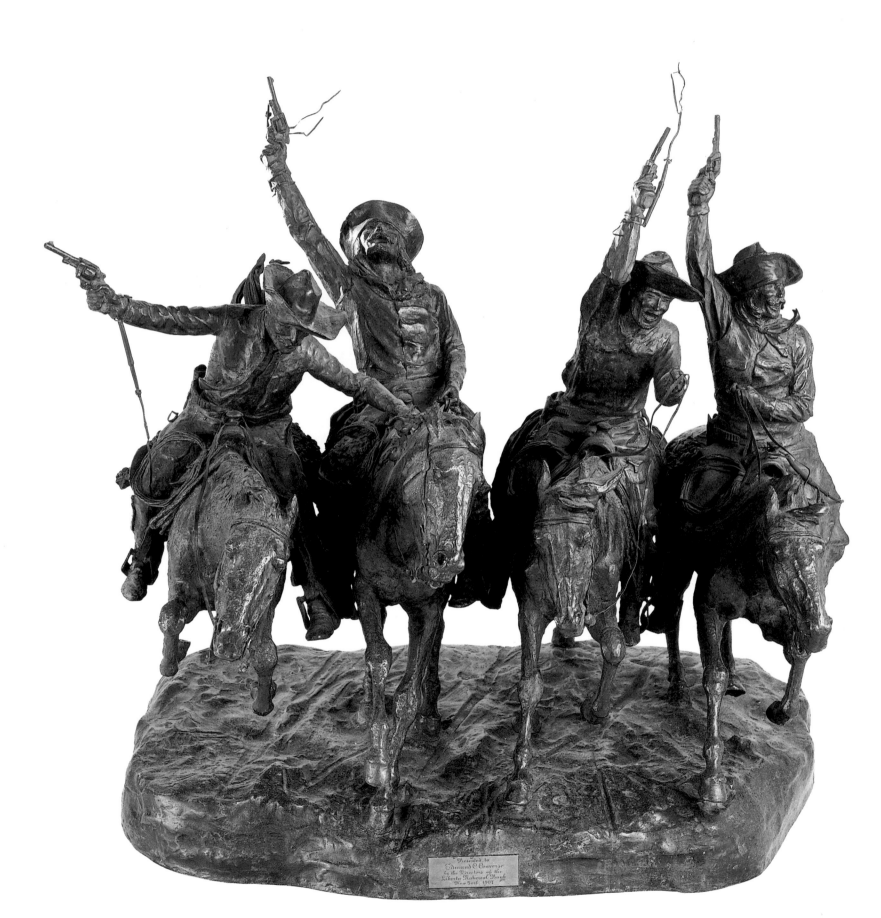

Below:
FREDERIC REMINGTON
The Stampede, 1910
Bronze
23 × 48 × 20 in.
Courtesy Frederic Remington Art Museum,
Ogdensburg, New York (66.011)

This is a counterpart to Remington's 1908
canvas of the same title, except that here the
steers, rather than the rider, are the focus of
interest. Their lean frames, bony ribs, curling
tails and sinuous longhorns are graphically
described, and the wrangler seems borne along
by their headlong rush. The turbulent texture
of the base conveys the tumult of the moment.

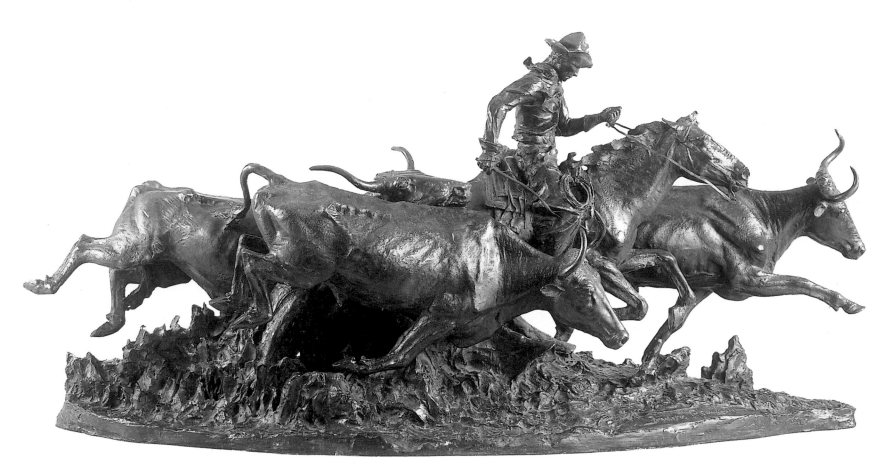

Right:
FREDERIC REMINGTON
The Rattlesnake, n.d.
Bronze
22⅝ × 22⅝ × 13 in.
Buffalo Bill Historical Center,
Cody, Wyoming
Gift of The Coe Foundation (50.61)

In his own words, Remington sculpted "to put
the wild life of the West into something that
burglar won't have, moth eat or time blacken."
In this bronze a horse's shy is curved like a
rodeo stunt, providing an opportunity to
highlight his rider's bronco skills. The two are
linked in movement and material as if made of
the same flesh.

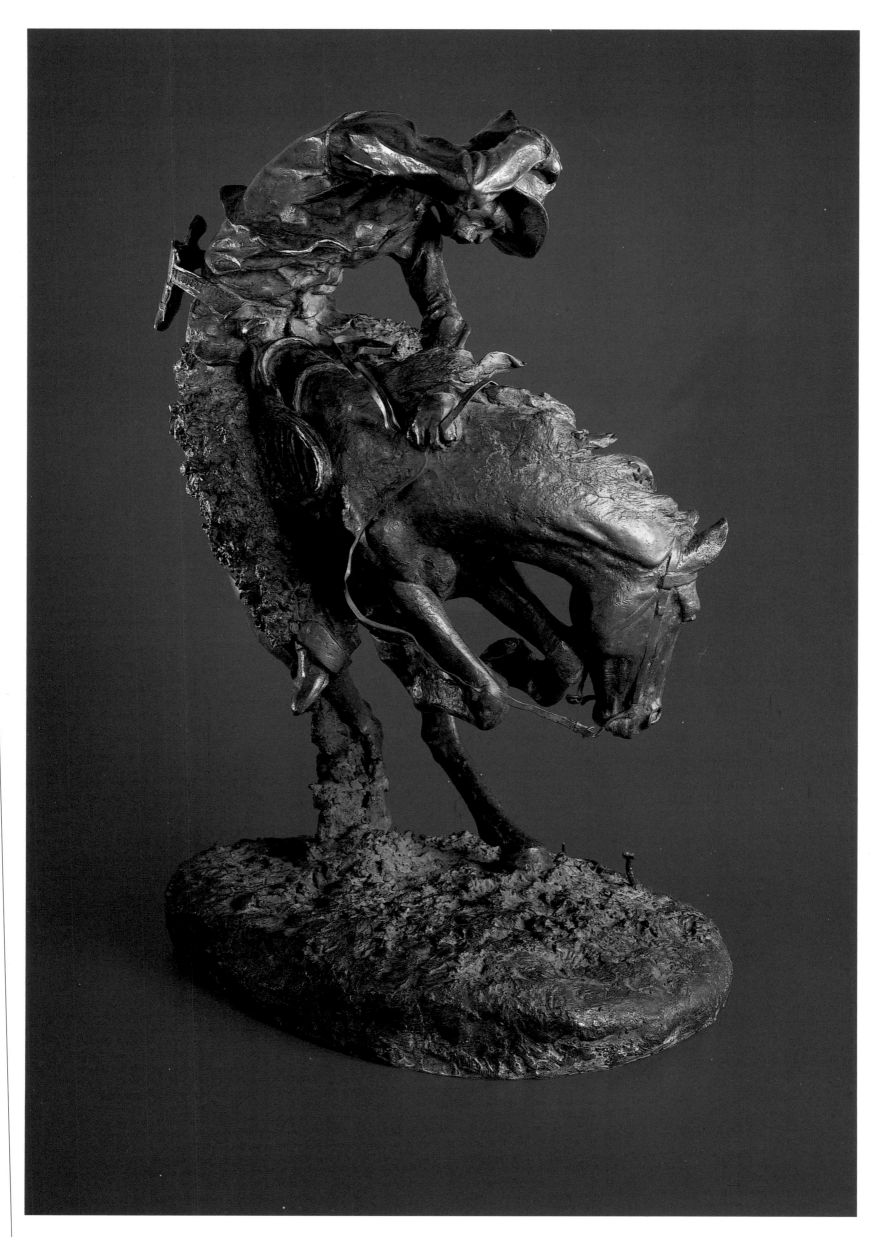

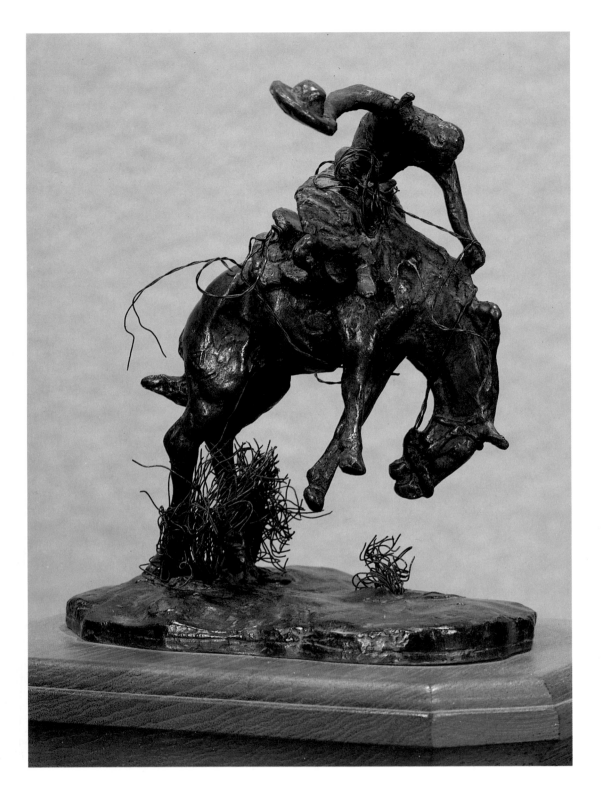

Right:
CHARLES M. RUSSELL
Jim Bridger, 1925
Bronze
14¼ × 6 × 10 in.
Buffalo Bill Historical Center,
Cody, Wyoming (21.81)

Jim Bridger was a famous trapper and
mountain man who helped construct Fort
Henry at the mouth of the Yellowstone River in
1822. He later discovered the Great Salt Lake
in Utah. Here he wears a typical, large-
brimmed hat and carries a percussion cap rifle.
The saddle is a Santa Fe model, with solid oak
stirrups adapted from a Mexican type. His
gestures match those of his mount – his hair
flying like the horse's tail and his arm angled
like the horse's hocks. Bridger doesn't even
hold the reins, a measure of the understanding
between the two.

CHARLES M. RUSSELL
Bucking Bronc, 1905
Bronze
5¼ × 4 × 3⅛ in.
Charles M. Russell Museum,
Great Falls, Montana
(967-1-34)

Although Russell often painted canvases based
on his bronzes, in this case the sculpture
resembles an earlier watercolor sketch, *The
Bucker*. This is a classic rodeo pose, with the
horse contorted so powerfully it is amazing
that the cowboy still rides. The spindly
sagebrush echoes the linear elements of the
lariat and reins. Note how the cowboy's form
follows his mount's to maintain his balance,
head down and hand forward.

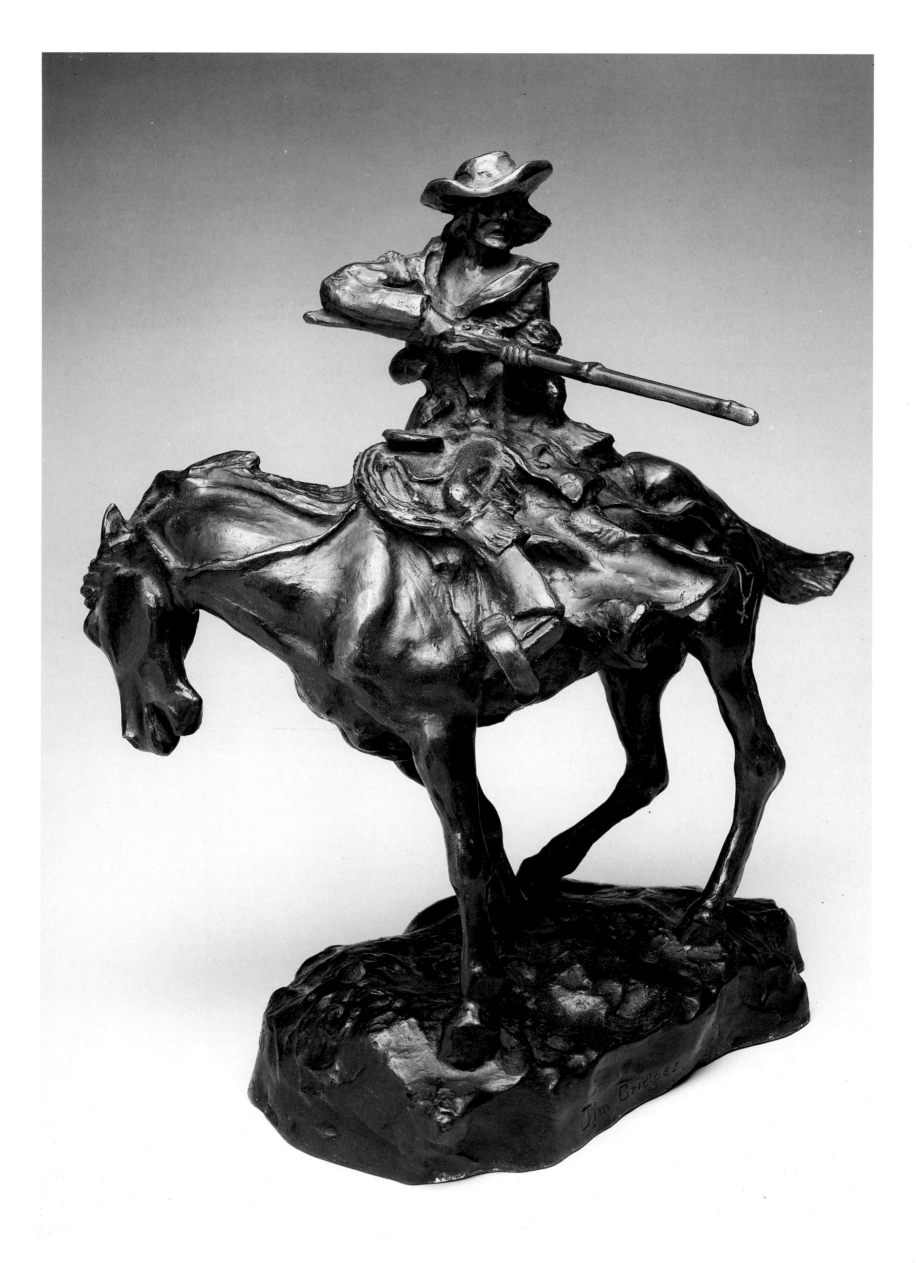

Below:

GRANT SPEED 1930-

Stampede Over a Cutbank, n.d.

Bronze

22⅝ in × 34 × 6¾ in.

Collection of the Eiteljorg Museum
of American Indian and Western Art,
Indianapolis, Indiana

Gift of Harrison Eiteljorg

Ulysses Grant Speed grew up in San Angelo, Texas, and rode on the rodeo circuit as a youth. He worked as a cowhand, moving from ranch to ranch in Arizona, Wyoming and Texas – 15 ranches in all – before he was 22. In 1952 he attended Brigham Young University, where he joined the rodeo team. After a bronco named "Big Ping" fell on him and broke his ankle he decided to give up bronco-busting in favor of becoming a sculptor. He later worked as a Mormon missionary. The self-taught artist became a member of the Cowboy Artists of America in 1966. Residing in Pleasant Grove, Utah, he

teaches school by day and sculpts whenever he has free time.

This bronze is similar in style and subject to Remington's *Stampede*, yet the steer's desperate leap adds the suspense of incipient catastrophe. The galloping cattle have a wonderful sense of pace, with a tail flying at one end and legs and hooves projecting over the bank at the other. The cowboy with lariat held high forms the center apex and focus. Tension is created by his horse being reined back as the cattle plunge forward. Sharp details of horns, the cowboy's coattails, the pommel and his boots add excitement.

Right:

HARRY JACKSON 1924-

Cowboy's Meditation, n.d.

Polychromed cast bronze and plaster

21½ × 21½ × 10 in.

Collection of the Eiteljorg Museum of
American Indian and Western Art,
Indianapolis, Indiana

Gift of Harrison Eiteljorg

A sculptor in the Remington tradition, Harry Jackson was born in Chicago, where his mother ran a lunchroom in the stockyards. At the age of 14 he ran away to be a hand at the Pitchfork Ranch in Wyoming. In 1942 he joined the Marines and, when he was wounded in action, became a combat artist. After the war Jackson returned to New York and studied with Hans Hoffman. His first interest was in abstract expressionism, but, following a fellowship to Italy in the 1950s, he developed Western themes in paintings and sculpture. He has also made an album of cowboy ballads, and he sometimes treats historical subjects in

addition to his wranglers and bronco riders. He lives on a 40,000-acre ranch in Lost Cabin, Wyoming, where he breeds horses and raises cattle. He also has a studio and foundry in Camaiore, Italy.

Cowboy's Meditation was devised to solve compositional problems in a canvas Jackson was working on. (It was later purchased by a patron, Robert Coe, the American Ambassador to Denmark.) Cowboys often spent 12 hours a day in the saddle, and in this bronze the resultant look of fatigue is shared by both horse and rider. Inseparable in spirit, the pair seems planted in the West for eternity.

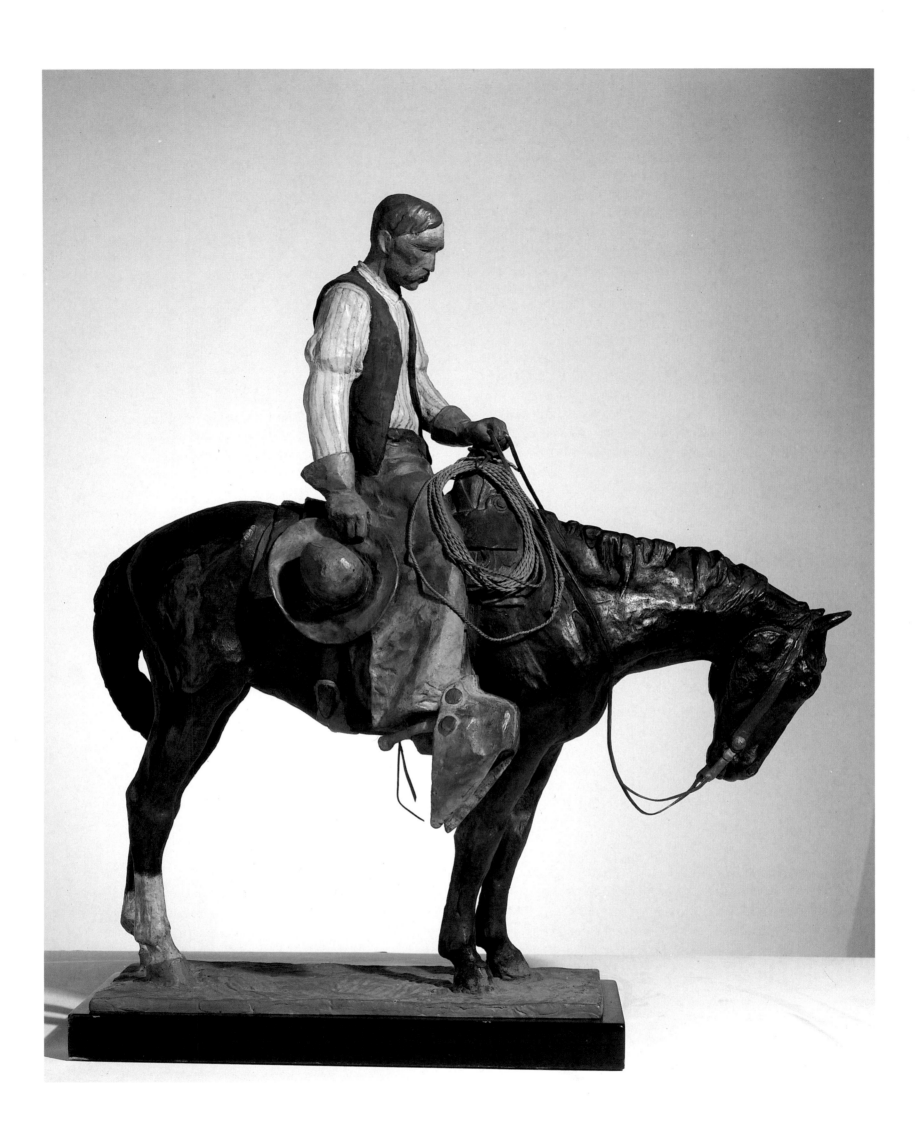

Indians

For artists providing ethnological portraits for federal agencies in the early nineteenth century, the Indians were a fabulous discovery, unmatched in costume and appearance to any prior subject. Alfred Jacob Miller, an Indian genre painter in the 1830s and 1840s, could not fathom why American artists traveled to Europe to pursue classical studies. In his opinion, the Indians were "equal in form and grace (if not superior) to the finest beau ideal ever dreamed of by the Greeks." Even after Indian portraiture became unprofitable, artists persisted in their endeavor, fascinated by these strangely admirable red men.

The earliest images convey a sense of dignity and self-possession, less savage and ferocious than pictures created during the Indian Wars that would follow in the second half of the century. Noble visages crowned with feathered headdresses were limned by notable portraitists such as Charles Bird King and George Catlin to be displayed in galleries in Baltimore, Philadelphia and Washington, D.C.

Catlin, Seth Eastman, Charles Wimar and John Mix Stanley were employed by the military to render descriptive canvases of tribal activities. They delighted in the rites, games, entertainment and hunting methods of the Indians. Thus Eastman highlights the colorful clothing and energy of native athletes in his *Lacrosse Playing Among the Sioux*.

Most of these paintings have outdoor settings, for the Indians were patronizingly considered "children of Nature." In fact, their survival and livelihood had for centuries depended upon their ability to adapt to the Western plains geography and especially upon their skills in hunting the buffalo, which provided their clothing, their dwelling and their sustenance.

The dramatic action of the buffalo hunt supplied vivid narrative material for artists, beginning with Catlin and continuing into the era of Remington and Russell. The sketchy, shorthand style that Catlin employed in his larger group scenes makes, for example, a lively episode of Indians hunting buffalo on snowshoes. The natives' cleverness at disguises is revealed in Remington's wonderful genre canvas *Indians Simulating Buffalo*.

Fresh kills were a cause for feasting and celebration by the Indians. Charles Wimar in 1860 and Gerald Cassidy in 1920 painted scenes of the buffalo dance, yet the 80-year gap merely serves to underscore how enduring was the myth and magic that surrounded this festive event.

After the Indian Wars, when the aggressive Sioux, Comanche and Apache nations were subdued by the more numerous and better armed white men, all the Indian tribes were confined to small reservations. Several artists mourned the loss of their distinctive culture, native skills and independent spirit. Henry Farney's quiet winter canvas *The Song of the Talking Wire* typically expresses the intrusion of the white man's modern technology, symbolized by telephone poles, upon the once free and untrammeled open spaces of the West.

The Indian portraits created by artists in Taos and Santa Fe, New Mexico, are almost without exception serene, gentle and proud in character. The bright dress of a Pueblo maiden suits the Impressionist palette of Nicolai Fechin in his *Indian Maid Seated*. The bounty of the harvest and the span of generations, united in sharing, is the subject of Oscar Berninghaus' rather sentimental *Peace and Plenty*.

Illustrators of the Indians in recent decades have come both from without and within the boundaries of the reservations. James Bama's detailed figure of a Crow Indian wearing a medicine bonnet hearkens back to the majestic chiefs of Charles King, updated with a photographic clarity. Richard Greeves, a contemporary sculptor, lives at an Indian trading post. His bronze *Calling the Spirits* features two owls, symbols of the spirit kingdom in Indian folklore. It echoes the Indians' belief in the intrinsic value of nature and animals.

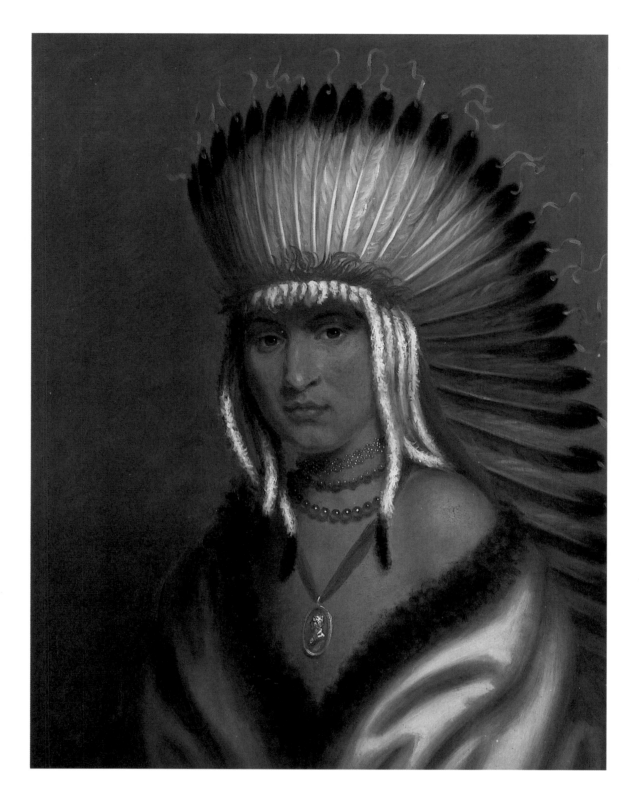

CHARLES BIRD KING 1785-1862
Petalesharro (Generous Chief), Pawnee, c. 1822
Oil on panel
17½ × 13¹³⁄₁₆ in.
© White House Historical Association,
Washington, D.C.

Charles Bird King, who was born in Newport, Rhode Island, went to London in 1805 to study with Benjamin West. When he returned to the United States he became a portrait painter in Washington, D.C., furnishing likenesses of prominent members of society and politicians. Not long after the Lewis and Clark expedition, the Superintendant of Indian Trade, Thomas L. McKinney, began bringing Western Indian leaders to Eastern cities to negotiate treaties. In a gesture of frienship and to impress them with white man's culture and power, McKinney employed King to paint their portraits.

He completed over 100 images of chieftains and braves representing 20 different tribes.

King's Indian Gallery at the Smithsonian at one time numbered 89 portraits, but a fire destroyed all but three of these. *Petalesharro* is one of the surviving gems.

Petalesharro is depicted as a handsome youth with smooth, calm and unwarlike features. In modulated tones of soft amber, rose brown and warm sienna, this Pawnee chief's formal image seems gentle, and the decorative features of his bonnet of eagle feathers stand out. Around his face are ermine tail pendants. The sparkling turquoise beads in his necklace may have been acquired by barter from some more westerly tribe. He wears a silver peace medal and a draped robe trimmed in buffalo fur. His eyes have a sweet and noble expression. Petalesharro was well-known for sparing a Comanche maiden before she was sacrificed in the Pawnee morning star ceremony.

S. Seymour del.

Kiawa encampment

SAMUEL SEYMOUR 1796-1823
Kiawa Encampment, 1819-20
Transparent and opaque watercolor over graphite
132 × 208 in.
Collection of Western Americana
Beinecke Rare Book and Manuscript Library
Yale University,
New Haven, CT

Samuel Seymour received his art training with Charles Wilson Peale at the Pennsylvania Academy of Art. He accompanied Major Stephen Long in 1819 and 1820 to explore the country between the Mississippi River and the Rocky Mountains. They traveled by riverboat into the Yellowstone region, and Seymour recorded the journey in 150 landscapes. He also painted a series of pagan rites and military councils.

Seymour went on a second expedition with Major Long in 1823, a 4500-mile trek to Lake Winnipeg. The first published portrait of the Rockies, featuring the mountain christened Long's peak in the area now known as Colorado, was Samuel Seymour's *Distant View of the Rocky Mountains.*

This watercolor depiction of Long's council meeting with two tribes is relatively straightforward. It satisfies the government's desire always to appear fair in its dealings with the "children of the prairies" while at the same time appearing invincible in establishing footholds on their land. The horizontal progression of figures echoes the geographical layout of the plains. The most important detail is the expedition's flag, the only vertical feature in the composition: it was in fact drawn and painted by another member of the expedition, Titian Peale, son of the Pennsylvania Academy of Arts founder.

GEORGE CATLIN 1796-1872
Catching the Wild Horse, n.d.
Oil on panel
12¼ × 16¼ in.
The Thomas Gilcrease Institute of
American History and Art,
Tulsa, Oklahoma (0126.2174)

George Catlin was the first American artist to
devote his entire career to painting the Western
Indians: the body of work he produced
included 1200 portraits. Catlin was born in
Wilkes Barre, Pennsylvania, and his early
source of Indian lore may have been his
mother, who was captured by the Iroquois
when she was eight. Catlin trained to be a
lawyer and practiced for a time in Philadelphia,
but in the end his interest in art proved more
compelling, and he became a society painter in
Philadelphia and Washington, D.C. A
delegation of Indian chieftains visiting Charles
Peale's museum in Philadelphia inspired him to
go west in 1830.

Catlin went first to St. Louis, where he met
the explorer William Clark. He then ventured
up the Mississippi River to Prairie du Chien
and Fort Leavenworth. In 1832 he boarded the
steamboat *Yellowstone* for a 2000-mile journey
up the Missouri River, where he painted Sioux,
Cheyenne, Assiniboin and Blackfoot Indians.

When he returned, Catlin took his "Indian
Gallery" on city tours, arriving in New York in
1837 and continuing across the Atlantic to
England. In 1845 he exhibited in Paris before
King Louis Philippe.

Catlin dedicated his life to being the Indians'
historian, foregoing his comfortable fees for
society portraits: as a result, he later became so
poor that he landed in debtor's prison. His
canvases are a tribute to his determination, as
well as to the fascinating characters he
encountered, and in sum they constitute a
priceless record of Indian life and culture at a
time before either was much affected by the
white man's ways.

Catching Wild Horses is a vivid and dynamic
canvas, interesting for its accuracy in
portraying the Indians (though not the horses,
which are presented as stock Arab types).
Catlin glories in the bright war paint
(vermillion cost the Indians $4 an ounce). The
bouffant headdress and fancy leggings the main
figure wears, as well as his powerful build. The
plump, vicious-looking pony with his wild,
tangled mane and tail is an engaging opponent.
The background chase scene is typical of
Catlin's shorthand, field-sketching style.

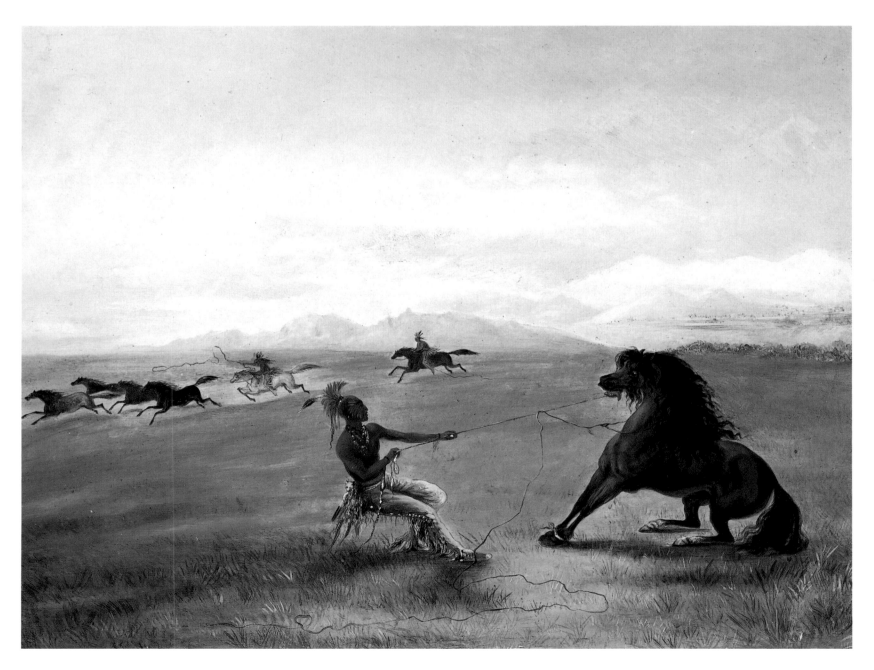

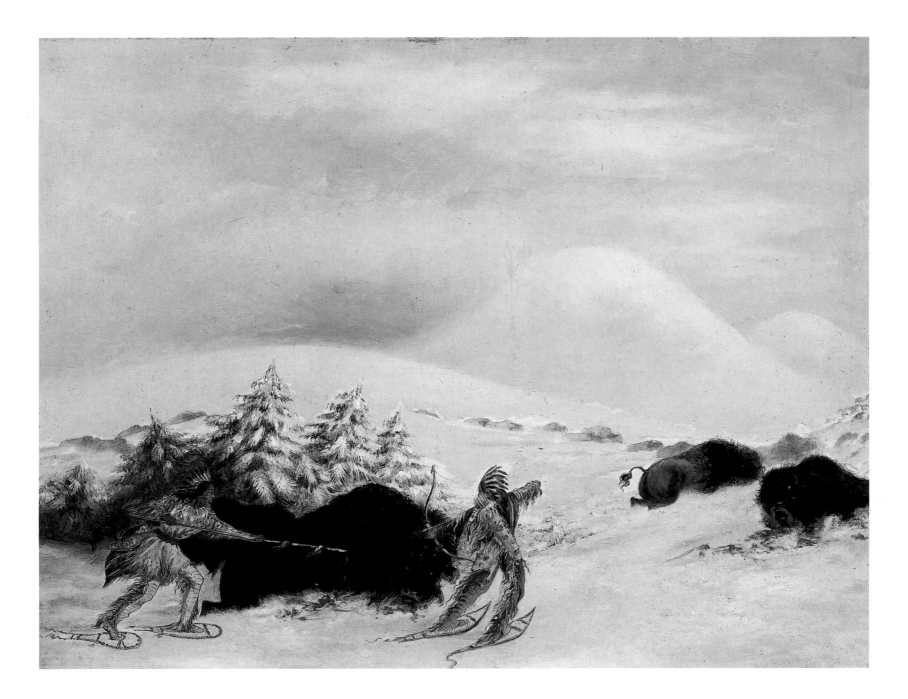

Above:
GEORGE CATLIN
Buffalo Hunt on Snowshoes, n.d.
Oil on panel
12¼ × 16⅜ in.
The Thomas Gilcrease Institute of
American History and Art,
Tulsa, Oklahoma (0126.2174)

Catlin never witnessed a buffalo hunt in
winter, yet he has provided us with a colorful
and imaginative narrative of this unique
subject. Whirling clouds in a turquoise sky
lend a poetic aura to a vast white landscape
punctuated only by a few groves of fir trees.
The Indians resemble the trees in shape and
seem to relish their pursuit of the huge black
bison which stampede off into the distance as
far as the eye can see.

Right:
GEORGE CATLIN
**Osceola, the Black Drink, a
Warrior of Great Distinction,**
1838
Oil on fabric mounted on canvas
30⅞ × 25⅞ in.
National Museum of American Art,
Smithsonian Institution
Washington, D.C./Art Resource,
New York, New York (1985.66.301)

Osceola is a testimony to George Catlin's finesse
as a portrait painter. The Indian chief is as
lavishly dressed as a European nobleman, and
his bearing is even more handsome. His
draped floral tunic appears made from silk, as
does his rich scarlet headdress. His metal-
embroidered leather sash and curved silver
pendants, looking faintly Teutonic, are
accompanied by plentiful strands of beads,
dangling silver earrings and a red and green
ribbed belt. The plume of his black-and-white
feather accentuates the way his thick black hair
frames his face. The bounty of red and rose
flourishes highlight his beautiful skin, and his
eyes are mesmerizing.

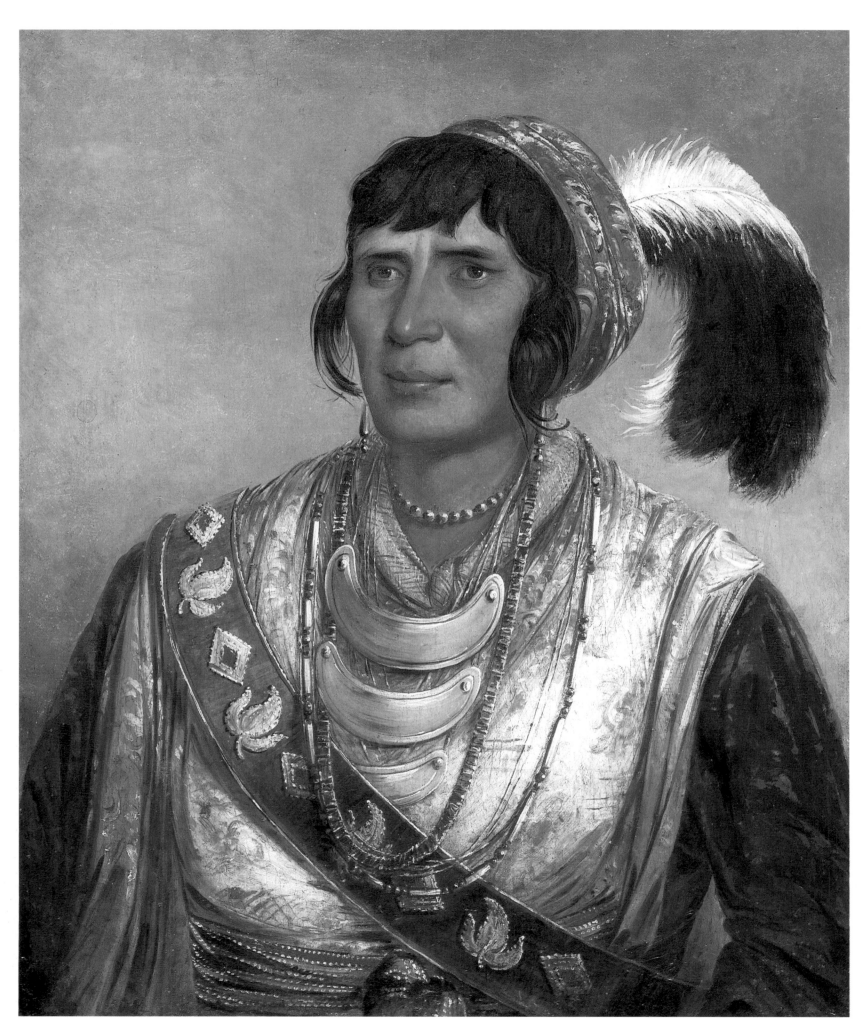

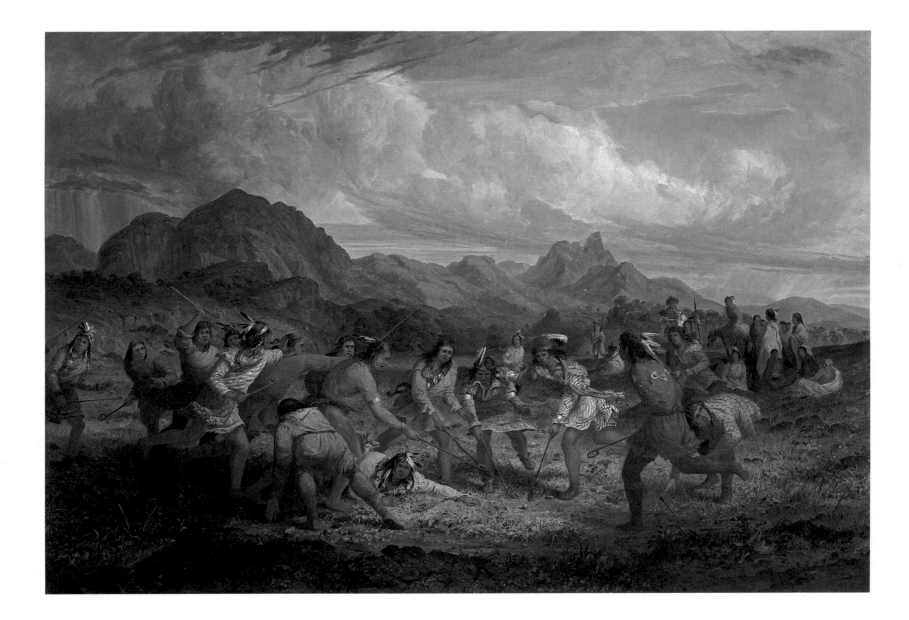

SETH EASTMAN 1808-1875
Lacrosse Playing Among the Sioux Indians, c. 1851

Oil on canvas
28³⁄₁₆ × 40¾ in.
© Corcoran Gallery of Art,
Washington, D.C.
Gift of William Wilson Corcoran
(69.63)

A soldier artist, Seth Eastman was born in Brunswick, Maine. A graduate of the West Point Military Academy, he was initially stationed at Fort Crawford on the banks of the Mississippi and kept a sketchbook of events there. He recorded the council meeting of the Sauk, Fox, Winnebago and Sioux tribes in 1829. In 1831 he was sent to Fort Snelling, and then, in 1833, he was brought back to teach drawing at West Point, where he married Mary Henderson, the daughter of the surgeon-general. He was again stationed at Fort Snelling between 1841 and 1848. He spoke Indian languages well and was said to have fathered a child by a Sioux mistress. He published a book of his experiences, *Dakotah: Life and Legends of the Sioux around Ft. Snelling*, in 1849 and went to Washington, D.C., as a captain in 1850. He served as a colonel in the Civil War, being cited for bravery, and retired as a brevet brigadier general in 1867. Congress commissioned Eastman to paint canvases for the meeting rooms of the Committee on Indian and Military Affairs in the Senate and also in House of Representatives.

This painting pictures the Indians as innocent children frolicking in middy dresses made from white men's fabrics. In fact, lacrosse was a violent and brutal sport, accompanied by war whoops. But here the colors are pretty lavenders and blues, the Rockies in the distance look serene and the striped patterns make a pleasing design composition.

JOHN MIX STANLEY 1814-1872
Osage Scalp Dance, 1845
Oil on canvas
40¾ × 60½ in.
National Museum of American Art,
Smithsonian Institution,
Washington, D.C./Art Resource,
New York, New York
Gift of The Misses Henry, 1908
(1985.66.248.930)

John Mix Stanley was born on January 17, 1814, in Canandaigua, a small town in the Finger Lakes region of western New York. As a boy he drew pictures of Seneca Indians. He later moved to Detroit, where he found work as a sign and portrait painter. In 1839 he went west to Fort Snelling to paint the Indians, but

he eventually had to return to make more money painting portraits. In 1842 he traveled to Fort Gibson, Arkansas, and attended the council meeting at Tahlequah, the capital of the Cherokee nation, in June 1843. Here a peace treaty between the red men and the state of Texas was signed, and Stanley painted all the chieftains assembled together. An exhibit of Stanley's work in Cincinnati in 1846 included 83 paintings representing 20 tribes.

On September 26, 1846, Stanley was hired as a draftsman to accompany Major Emery on his expedition to San Diego; Kit Carson was their guide. Stanley also accompanied Major Isaac Stevens in 1853 in his survey party for a transcontinental railroad line. His paintings from this journey were on display at the Smithsonian, a total of 152 Indian canvases. Stanley married and settled in Washington,

D.C., in 1854. A fire at the Smithsonian destroyed all but five of the Stanley collection.

Savagery is implied in this romantic painting, in which a white woman and her cherubic child are surrounded by strangely costumed, threatening Indians. Their plight is emphasized by their being seated amidst the towering braves. The animal head loincloths, moccasins, leggings and beads worn by the dancers are entertaining details, and the white powder on their skin accentuates their fitness and sculpted forms. The pictorial arrangement of the figures suggest the circular movement of the dance in a clockwise progression.

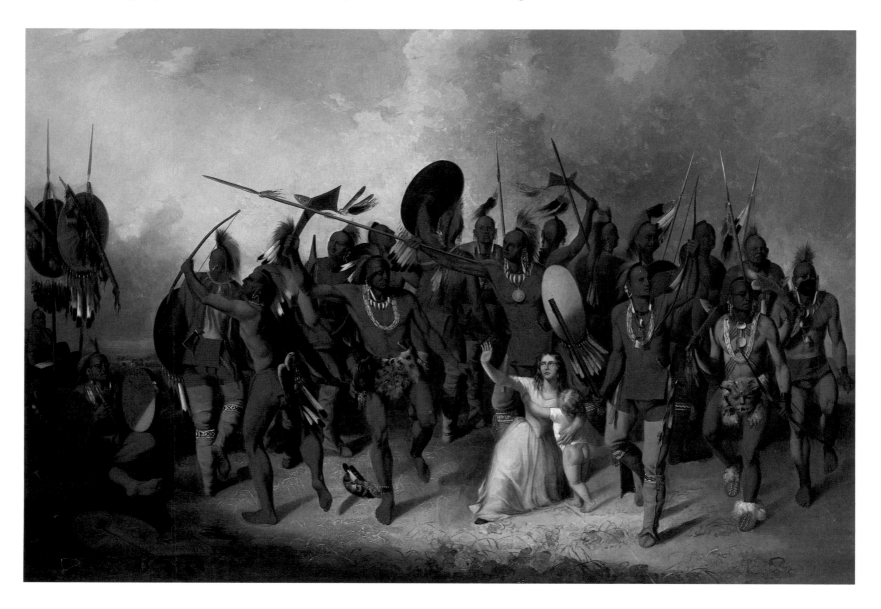

CHARLES WIMAR 1828-1862
The Buffalo Dance, 1860
Oil on canvas
24⅞ × 49⅝ in.
The Saint Louis Art Museum,
Saint Louis, Missouri
Anonymous Gift (164: 1946)

Charles Wimar was raised among the sizeable German immigrant population in St. Louis. He was born in Siegburg, Germany, near Bonn, and brought to America by his stepfather in 1839. He became an apprentice to a fresco painter in St. Louis in 1852 while doing paintings on storefronts and prairie schooners. To further his talents he returned to Europe, where he painted Western subjects while studying with Emanuel Leutze, the artist best known for his patriotic canvas *Washington Crossing the Delaware*.

Back in America, Wimar voyaged up the Missouri River, visiting various forts and sketching Indian tribes along the way. Perhaps his appearance helped him to gain acceptance, for his straight black hair made him look rather like an Indian himself. In 1861 he received a $1000 commission to paint murals for the St. Louis Courthouse. This would be his last work, for he was so weak from tuberculosis he had to be carried up the courthouse steps to complete it. He died in 1862 at the age of 34.

The Buffalo Dance is testimony to the drama of Indian rites. Under the glow of a full moon we see an amphitheater setting arrayed on a Western bluff. The campfire gives a red glow to the crowd and outlines the central dancers, graphically shown crouching and ground-stomping. A symbolic skull is set up on the hill, and the succession of red and blue robes worn by the onlookers adds color and vitality.

GEORGE CALEB BINGHAM
The Concealed Enemy, 1845
Oil on canvas
29 × 36 in.
Stark Museum of Art,
Orange, Texas (31.221.1)

Though Bingham is better known for
landscapes and folksy backwoods scenes, he
also did some Indian paintings. This is a
typical example, a dramatic scene of a lurking
brave whose features appear utterly unlike
those of any real Indian. The triangular
composition follows Bingham's standard
landscape format, which effectively focuses our
attention and directs light upon the central
narrative. The promontory behind the Indian
echoes his form, and the clarity of his figure
intensifies his avid pose. Yet one feels the
essence of the image is contrived.

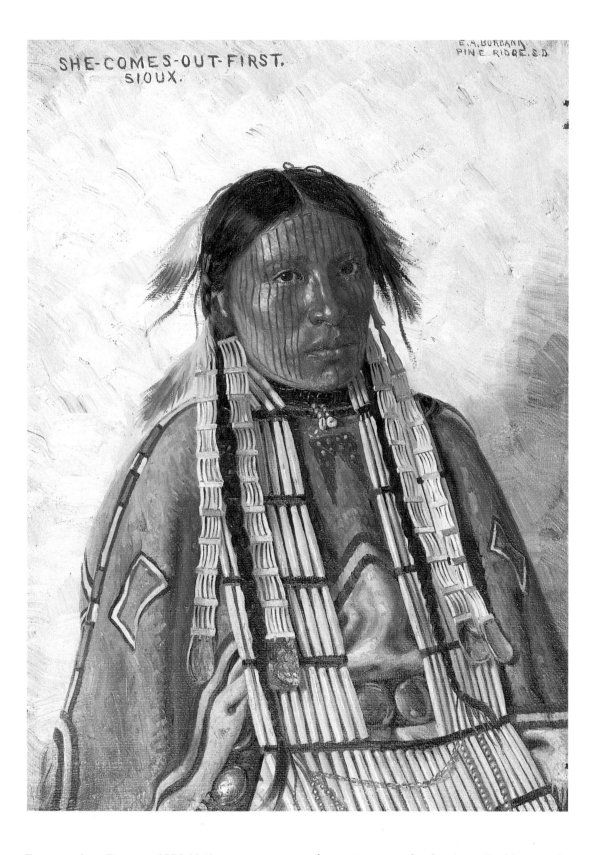

ELBRIDGE AYER BURBANK 1858-1949
She Comes Out First (Sioux),
1899
Oil on canvas
13 × 9 in.
The Butler Institute of American Art,
Youngstown, Ohio
Purchase by Butler from Burbank, 1912

Elbridge Ayer Burbank was raised in Chicago.
He was encouraged to paint Indian portraits by
his uncle, E.E. Ayer, who had a fine collection
of Indian artifacts which he eventually donated
to the Newberry Library in Chicago. Burbank
traveled west to the Pine Ridge reservation in
South Dakota in 1895, and from the notes and
sketches he made this trip he worked up a
number of impressive finished oil portraits of
Indians.

One such portrait, *She Comes Out First,
Sioux*, carefully portrays the extraordinary

decorations worn by the sitter. Her blue smock
elkskin dress is painted and beaded at the
yoke. She wears a German silver concho belt
and a hair-pipe bone necklace. The two pairs
of dentalium earrings she wears are tipped with
abalone shells. The lines of her necklace are
repeated in vermillion paint on her face, and
four eagle down feathers in her hair signify that
the Hunkaype rite was held in her honor – a
ceremony of acceptance and celebration that
conferred high status upon young men and
women. The abundant articulated designs and
sharp color are vivid and dynamic, yet the
serenity of the girl's expression gives the
portrait an overall air of gentleness and quiet.

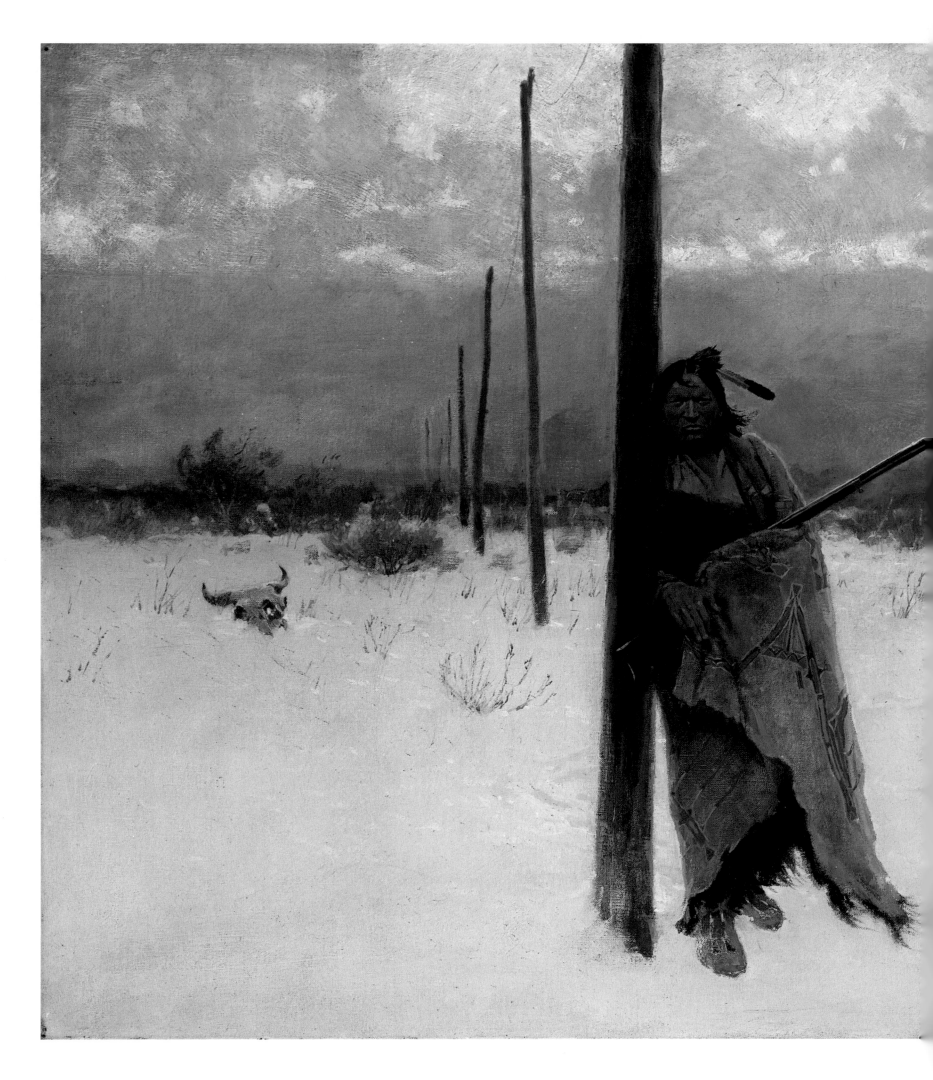

HENRY F. FARNY 1847-1916
The Song of the Talking Wire,
1904
Oil on canvas
22⅛ × 40 in.
The Taft Museum,
Cincinnati, Ohio
Bequest of Mr. and Mrs. Charles
Phelps Taft (1931.466)

Henry Farny, an Alsatian, was christened
François Henri Farny. His family emigrated to
the United States in 1852, eventually settling in
Cincinnati, Ohio. In 1865 Farny sent sketches
of Cincinnati to *Harper's Weekly,* which
published them with the byline Henry Farny.
Farny subsequently went to New York to work
as an illustrator for Harper and Brothers. He
returned to Europe in 1868 and studied in

Düsseldorf with Albert Bierstadt, who, not
surprisingly, recommended that young Farny
take a trip to the Rockies.

He did not immediately follow Bierstadt's
advice, for on his return to America, Farny
soon found himself engaged in a busy and
successful career as an illustrator. Finally, in
1881, he took his first trip to the West and was
at once enthralled by everything he found and

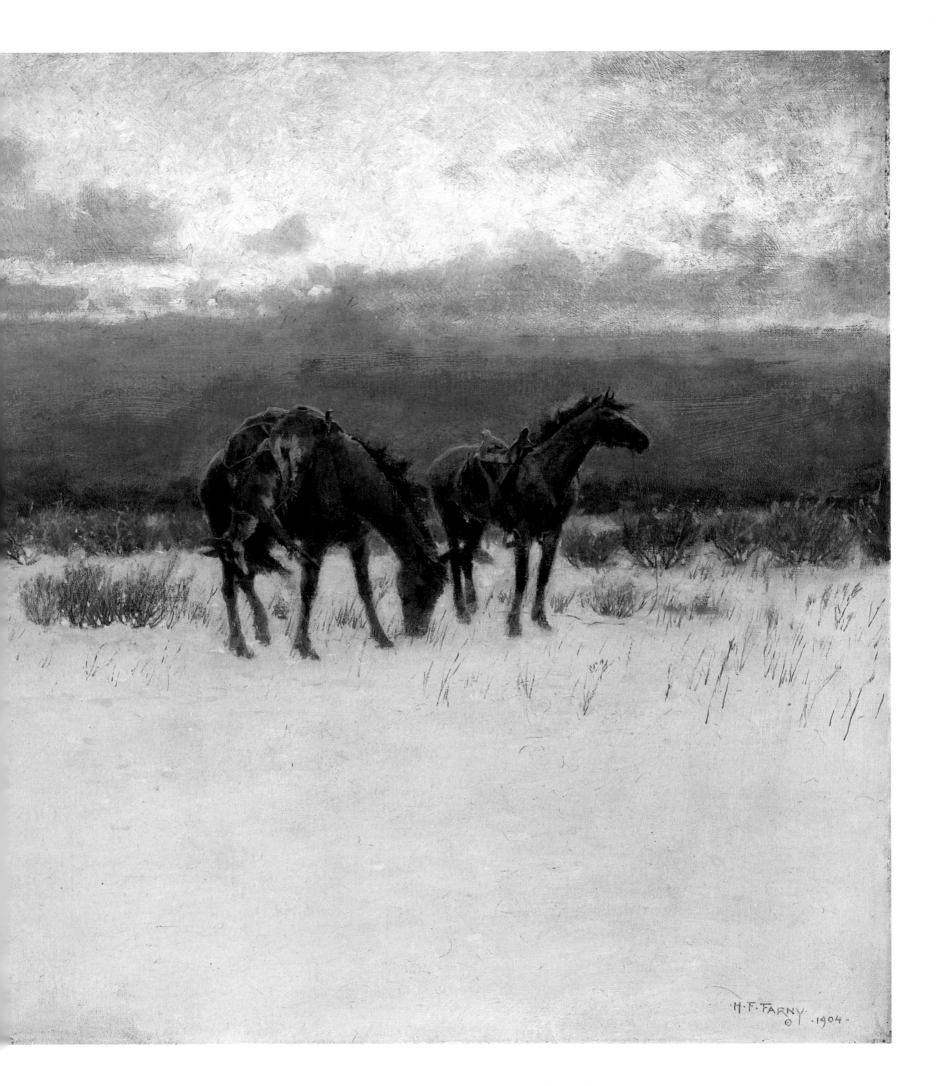

especially by the Indians, who soon became his favored subject matter.

The Song of the Talking Wire is a bittersweet composition, juxtaposing the serene integrity of the Western landscape and its native inhabitants and the inexorable claims of the white man's civilizations, represented by the apparently endless line of telephone poles stretching into the distance. Farny's delicate draftsmanship enhances the details of the old brave, who seems to be listening for messages from this strange technology. The single skull in this wintry scene almost seems an omen of the impending doom of Indian culture.

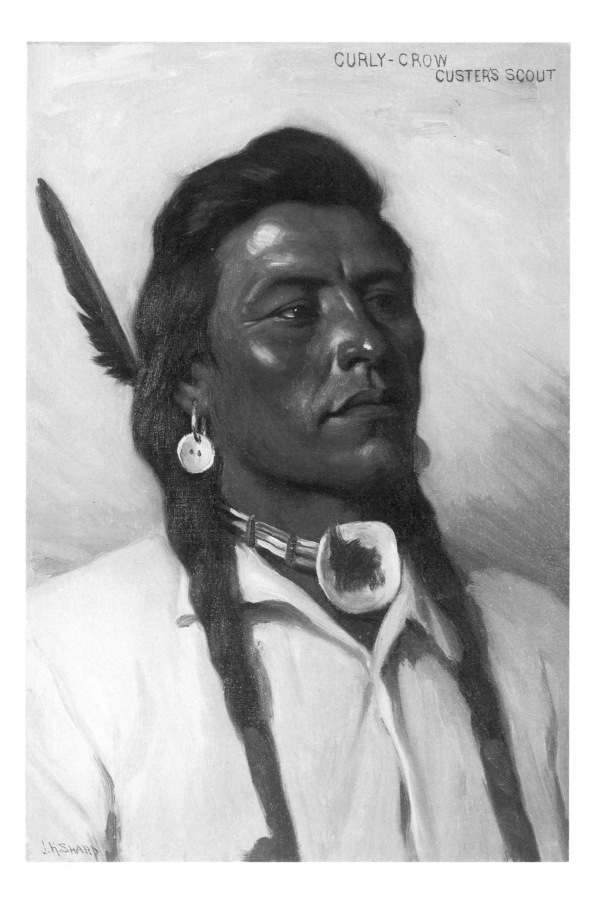

JOSEPH HENRY SHARP 1859-1953
Curly-Crow (Custer's Scout), 1905
Oil on linen
18 × 12 in.
Phoebe Hearst Museum of Anthropology,
The University of California,
Berkeley, California (17-16)

In addition to his landscapes (q.v.) Sharp also did Indian paintings. Often Sharp wrote notes on the back of his canvases, and on this one he wrote: "Custer's famous scout and the only man to escape that battle. A morose, taciturn sort of fellow. Disinclination to make friends, and rarely talks or pays much attention to anyone. He will not talk of the battle and seems to have been greatly affected by it."

That Sharp had an ethnologist's eye for detail is revealed in this portrait of a proud, handsome and moody Crow Indian. He has a broad forehead, dark heavy brows, high cheekbones and a strong nose. His white shell necklace and earrings and fine feather are tribal emblems. Many Indians were superstitious about having their portraits painted; the scout's resistance can be seen in his pose and in a certain stubbornness in his expression.

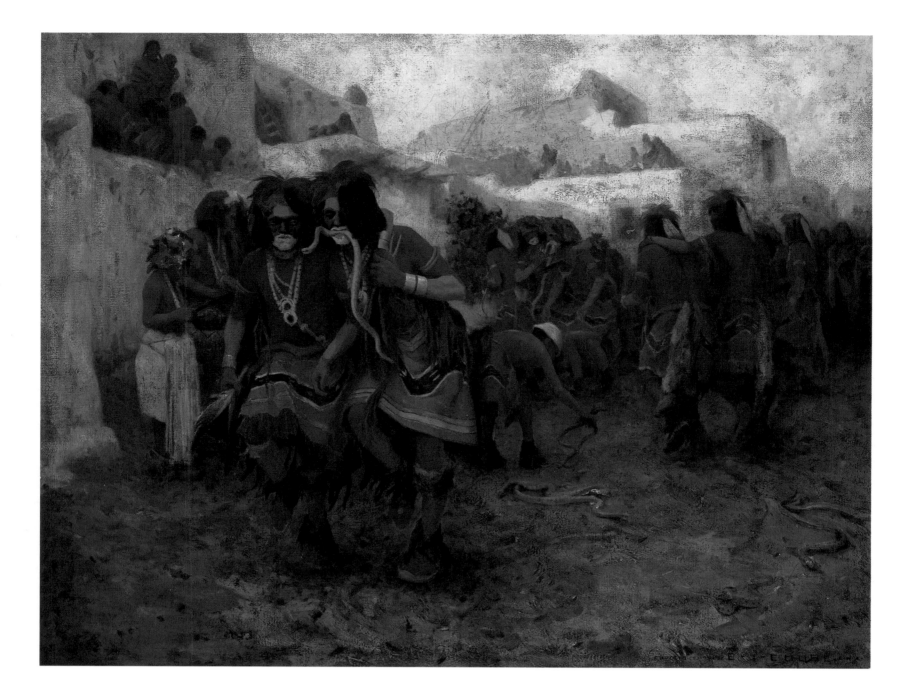

E. IRVING COUSE 1866-1936
Moki Snake Dance, 1904
Oil on canvas
36 × 48 in.
The Anschutz Collection

Of Alsatian descent, E.I. Couse was born on September 3, 1866, in Saginaw, Michigan, where there was a sizeable Indian population. He attended the Chicago Art Institute in 1883, the National Academy of Design in 1884 and in 1886 went to the École des Beaux-Arts.

Couse traveled to Oregon to paint Indians in 1891. Although he met with some resistance from braves who felt these images would sap their strength, his portraits of the Klikitat Indians are remarkable for their ethnological accuracy. When Couse returned to Paris in 1896 he met Joseph Sharp and Ernest Blumenschein, both of whom were extolling the virtues of New Mexico and Taos. Back in America, Couse followed their advice and went to a Hopi Reservation to sketch. Couse enjoyed Indian art and considered the Indians to be "natural Cubists." A devout Christian, he had great sympathy for the Indian and felt he was a tragic hero. Couse won honors from the American Watercolor Society and the National Academy. His work is represented in the National Gallery and the Corcoran, as well as in many other prestigious galleries.

The shadows that fill the foreground and the somewhat ominous poses of the main figures in *Moki Snake Dance* accentuate the sense of magic surrounding this tribal rite. The stripes in the dancers' skirts, their dangling necklaces and the writhing snakes fill the composition with complex movement. The use of a dark foreground against a bright background is disconcerting, as is the feeling that the strangely painted dancers are moving directly towards the viewer. The ceremony itself is performed to send prayers to the gods of the underworld, for whom the rattlesnake is a messenger. When released at the end of the dance, the snakes, carrying the tribe's petitions, would return to their burrows and thence to the gods below.

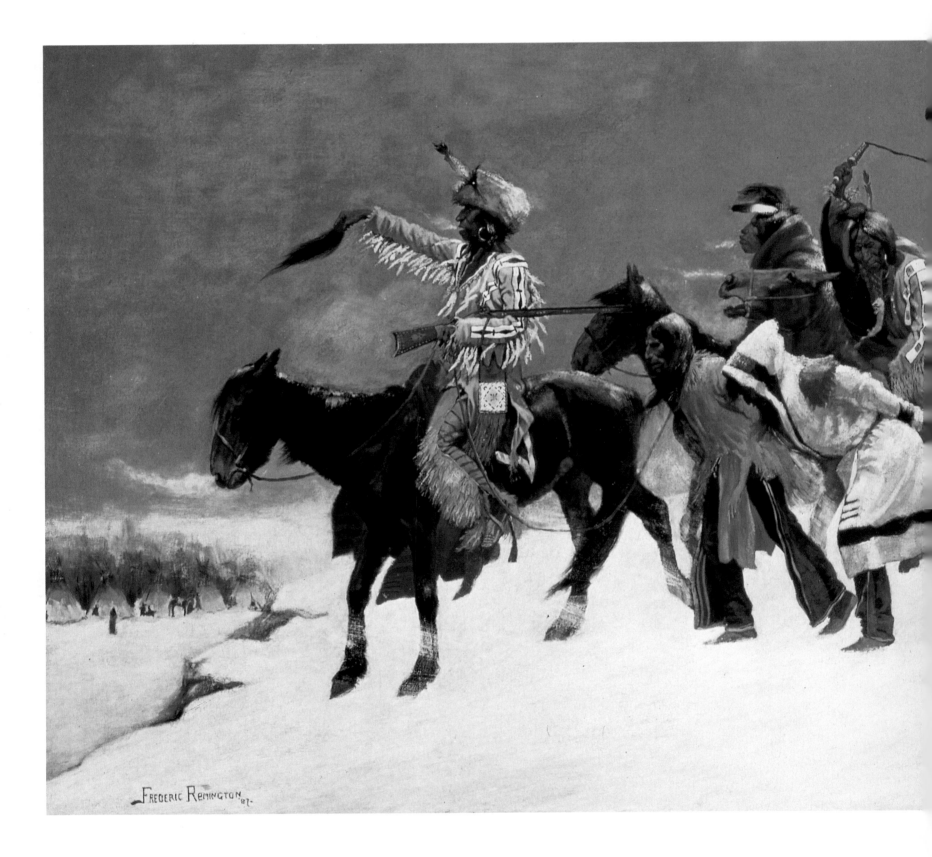

FREDERIC REMINGTON
Return of the Blackfoot War Party, 1887
Oil on canvas
28 × 50 in.
The Anschutz Collection

Remington painted Indians as skillfully as he painted cowboys, cavalrymen and virtually everything else Western. Here an extraordinary richness of color and patterning draws attention to the garments and blankets of the Blackfeet, who stand out sharply against the snowy terrain and neutral gray sky. Violence is implied by the brave's whip raised to beat the prisoner. The viewer's eye is swept down the hillside by the white brushstrokes of windblown snow. The cold permeates the expressions of the horses – noble servants in this canvas.

Above:

FREDERIC REMINGTON

Indians Simulating Buffalo, 1908

Oil on canvas

26¹⁵⁄₁₆ × 40⅛ in.

The Toledo Museum of Art,

Toledo, Ohio

Gift of Florence Scott Libbey

Here is a deft image of the singular ruses the Indians used when hunting buffalo. At a quick glance, the disguise is almost complete, yet Remington paints in a piebald pony so that we can enjoy the artifice. The stances of the ponies are perfectly aligned to conform with the bison's shape and the simple bright maize background sharpens their contours.

Right:

FREDERIC REMINGTON

The Outlier, 1909

Oil on canvas

40⅛ × 27¼ in

The Brooklyn Museum,

Brooklyn, New York

Bequest of Miss Charlotte R. Stillman (55.43)

This painting has a sculptural quality, with the Indian and his pony outlined by the light of a full moon. The staccato, pastel-hued brushwork of the landscape is reminiscent of Van Gogh, and the strong primary hues of the Indian's red skin against the soft blue horizon are dynamic. There is a resolute quality to the Indian's pose and expression, and the pony is effectively detailed with highlights to define his coat and sinews. The way the two hills in the background converge emphasizes the stature of the Indian and enlivens the formal composition of the picture plane.

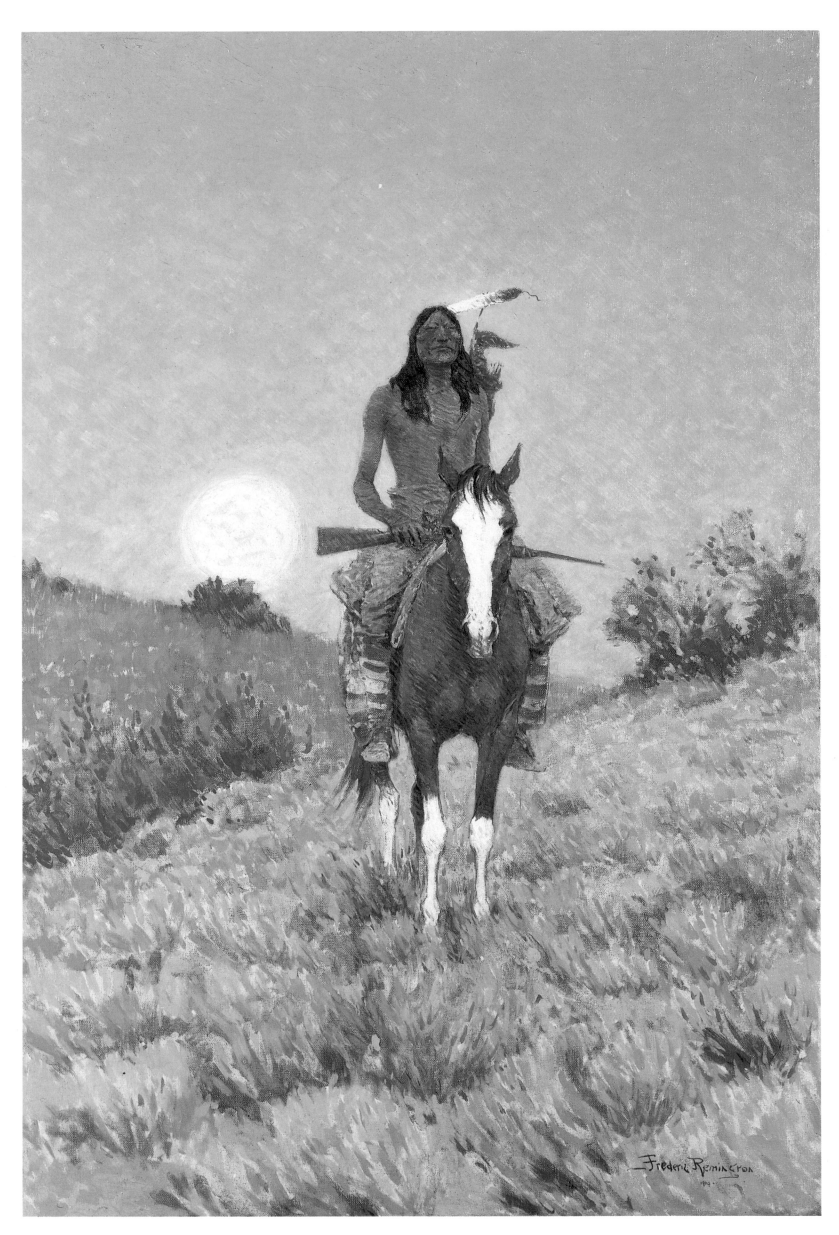

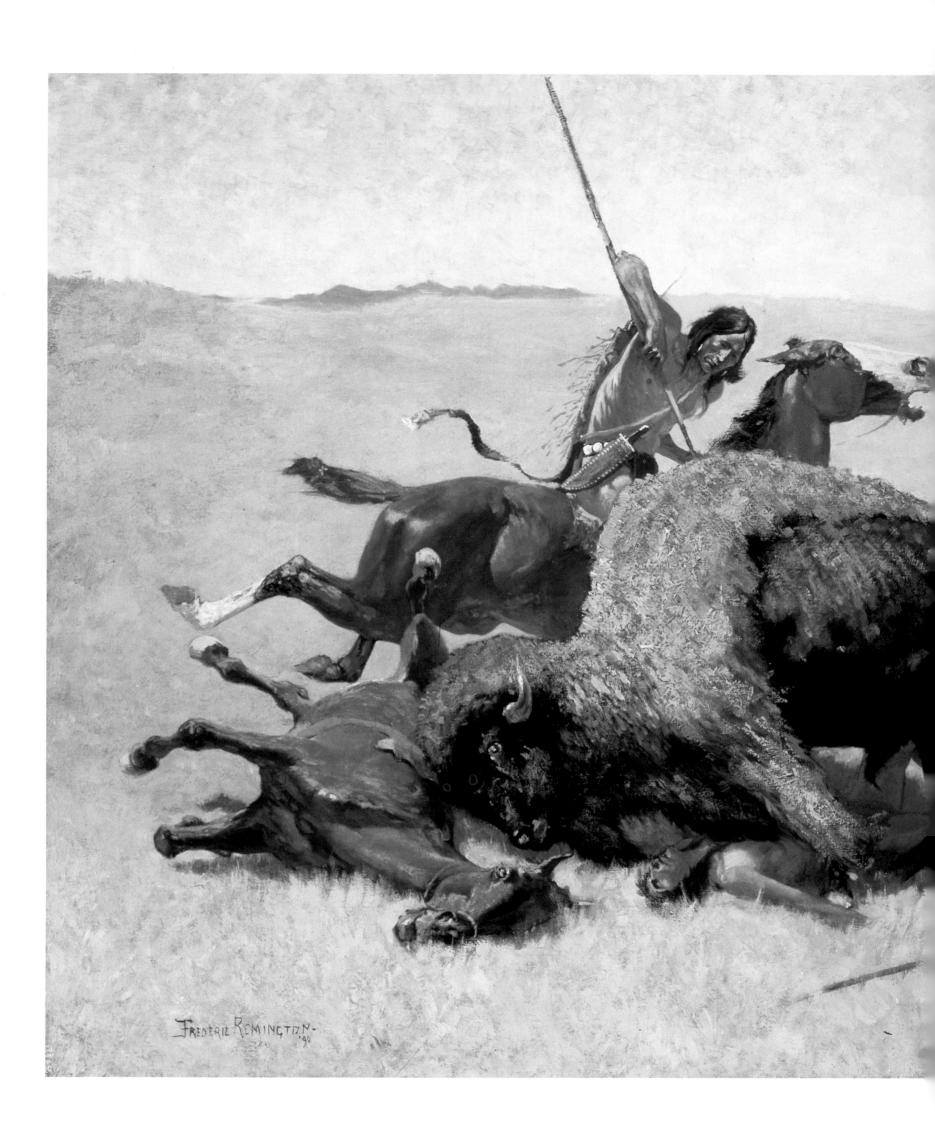

FREDERIC REMINGTON
The Buffalo Hunt, 1890
Oil on canvas
54 × 49 in.
Buffalo Bill Historical Center,
Cody, Wyoming
Gift of William E. Weiss (23.62)

Remington's passion for dramatically violent
scenes reaches a crescendo in this painting,
arranged to show a horse, a buffalo and an
Indian all in the throes of death. Remington
uses the opposed diagonals of the two
surviving Indians' spears to focus our attention
on the central action. The scale of the bison is
underscored by this placement, and the look in
his eye creates sympathy for his plight. Flying
hooves, tails and belts add movement and
pace, and the placid, empty plains in the
background never distract from the brutal
subject matter.

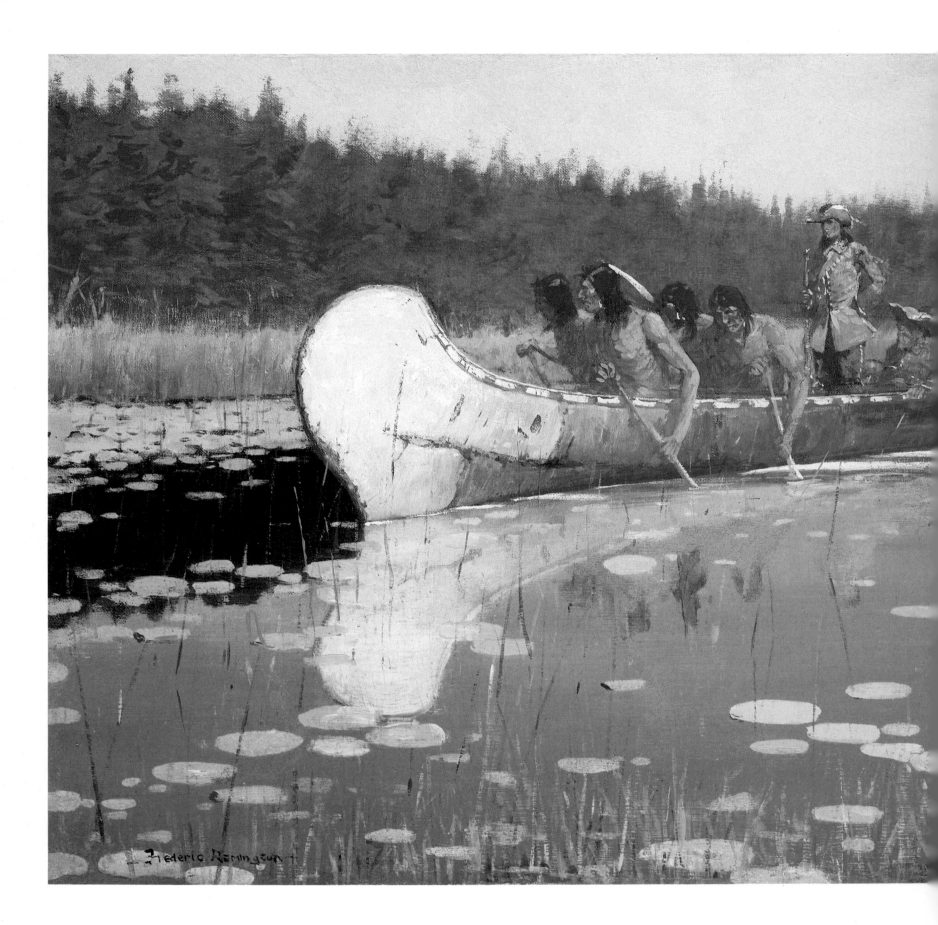

116

FREDERIC REMINGTON
Radisson and Groseilliers, 1905
Oil on canvas
17 × 29¾ in.
Buffalo Bill Historical Center,
Cody, Wyoming
Gift of Mrs. Karl Frank (14.86)

Pierre Radisson and his brother-in-law, Médard
Groseilliers, were French-Canadian explorers
who set out in 1659 in search of treasure and
wealth in North America. They traveled from
northern Michigan to the upper Mississippi
and then followed the Missouri River into
Montana. When they returned to Québec with
canoes loaded with furs and beaver pelts they
were fined by the French governor for not
having a government permit.

The luscious color in this painting divides it
into three strong, diagonal planes of green,
orange and blue, and these seem to vibrate in
intensity. The long, lean shape of the canoe is
echoed in the horizontal line of the landscape.
One explorer, standing tall in the center of the
craft, provides the primary vertical element in
the composition. This is one of Remington's
more tranquil and luxurious canvases.

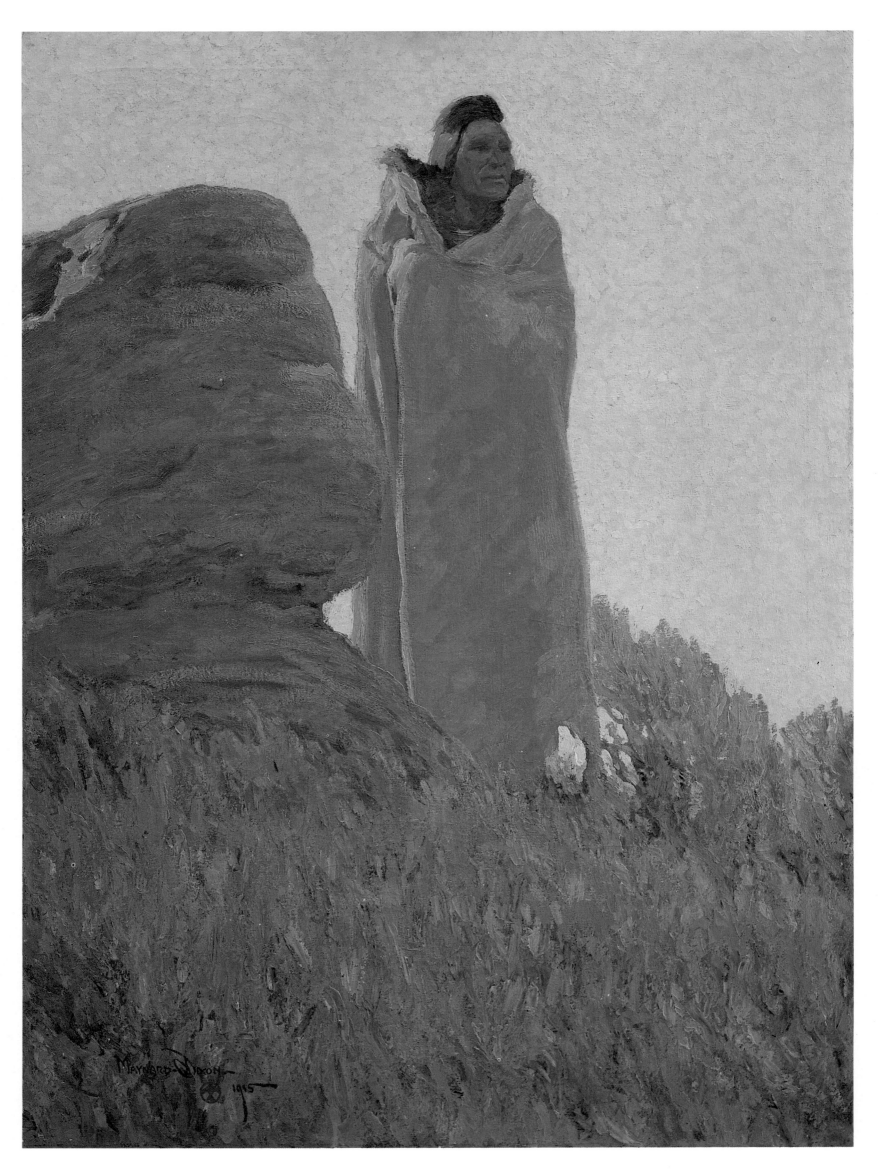

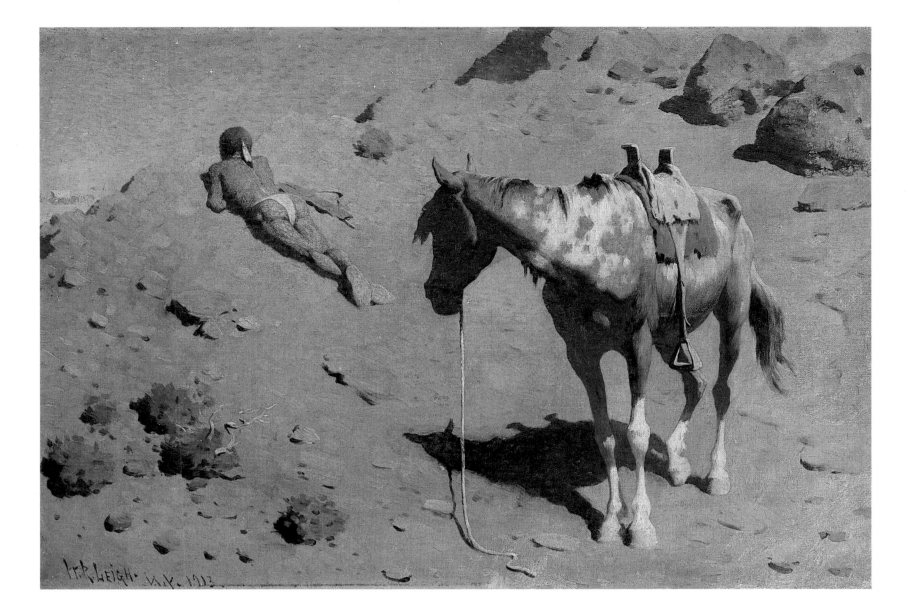

Above:
WILLIAM ROBINSON LEIGH 1866-1955
The Scout, 1913
Oil on canvas
16 × 24 in.
Collection of the Eiteljorg Museum of
American Indian and Western Art,
Indianapolis, Indiana
Gift of Harrison Eiteljorg

William Robinson Leigh, a contemporary of
Frederic Remington and Charles Russell, was
born in West Virginia and attended the
Maryland School of Art at the age of 14. He
was later financed by the art patron W.W.
Corcoran and went to Europe, where he
studied at the Royal Academy in Munich.
Upon his return he found work as a
panoramist. In 1897 *Scribner's* sent Leigh out
west to do illustrations of the wheat harvest.
He went west again, to Laguna, New Mexico,
with an art student friend whom he had met in
Munich, in 1906.

Leigh was not a popular character. He was a
bigot and was considered delusional by many.
Fellow artists called him "Buttons and
Shoestrings" because of his fussiness about the
details in his paintings: it was said that he
would return to a scene to count the exact
number of trees that should be included. But
that he was an admirable craftsman there could
be no doubt. After a trip to Africa he
supervised the habitat paintings at the

American Museum of National History. His
best-seller, *The Western Pony*, published in
1933, received critical acclaim. He was
financially secure and still painting very late in
life – he completed 32 canvases when he was
84. He was elected an Academician at the
National Academy of Design when he was 89
and died later that same year.

In *The Scout* the Indian and his pony seem
almost embedded in the rocky plains
landscape, both in color and form. The thin,
dutiful pony has haunches shaped like the
boulders around him, and the scout is
outstretched and almost indistinguishable from
the soil. He looks lean, muscular and canny as
he lies on his perch overlooking the camp of a
wagon train below, its small scale lending a
deep perspective to emphasize the scout's
elevated position. The magnificent evening is
filled with stars, and moonlight casts shadowy
hues of lavender, aubergine and deep blue.

Left:
MAYNARD DIXON
The Medicine Robe, 1915
Oil on canvas
40 × 30 in.
Buffalo Bill Historical Center,
Cody, Wyoming
Gift of Mr. and Mrs. Godwin Pelissero
(2.73)

Warm impressionistic light dapples the
horizon and the Indian figure and the hillock
upon which he stands. The composition is
simple, arranged to show the Indian's stature
by posing him next to, and taller than, a large
boulder. In hue and form he is inseparable
from his landscape. The title suggests he is a
hallowed member of the tribe, its shaman, or
medicine man.

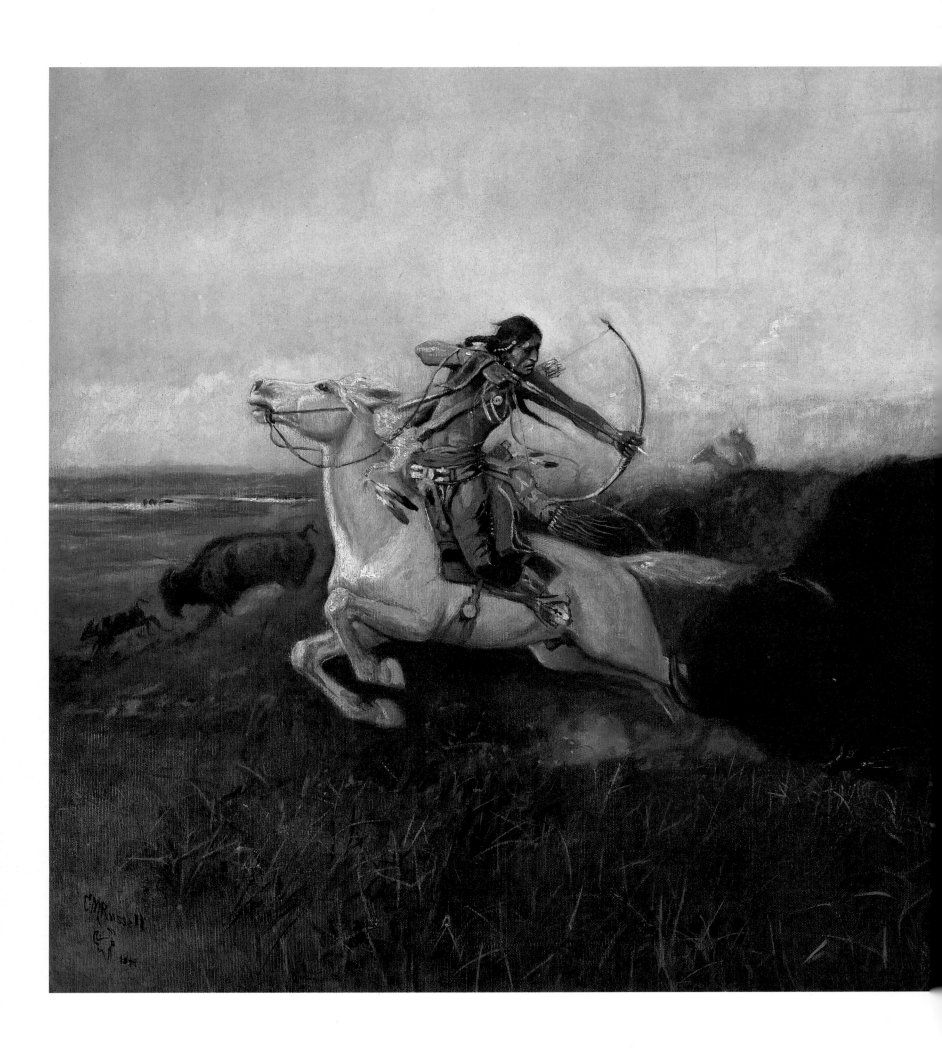

CHARLES M. RUSSELL
Indians Hunting Buffalo, 1894
Oil on canvas
24⅛ × 36⅛ in.
Courtesy Sid Richardson
Collection of Western Art,
Fort Worth, Texas (SWR 9)

In this vivid action painting the forms are
simplified, focusing on one Indian and his
prey, a massive bison. The white pony
contrasts sharply with the black bull,
heightening their conflict. The Indian's red
chaps add color, and his costume is explicitly
detailed – Russell had a fine collection of
Indian garb. The background is left simple:
grey sky meets maize fields, and a thundering
herd is roughly suggested beyond the central
players. The bull seems to be pushing the pony
along, and the force of his thrusting hooves is
powerfully evoked.

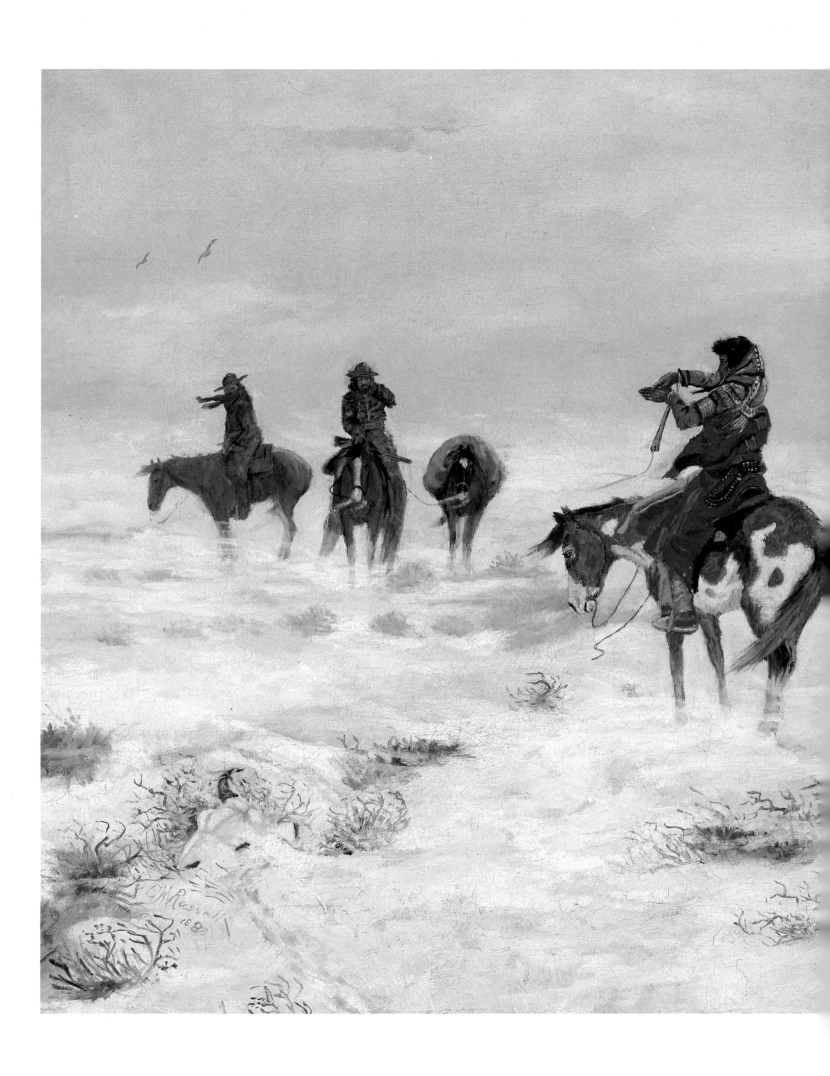

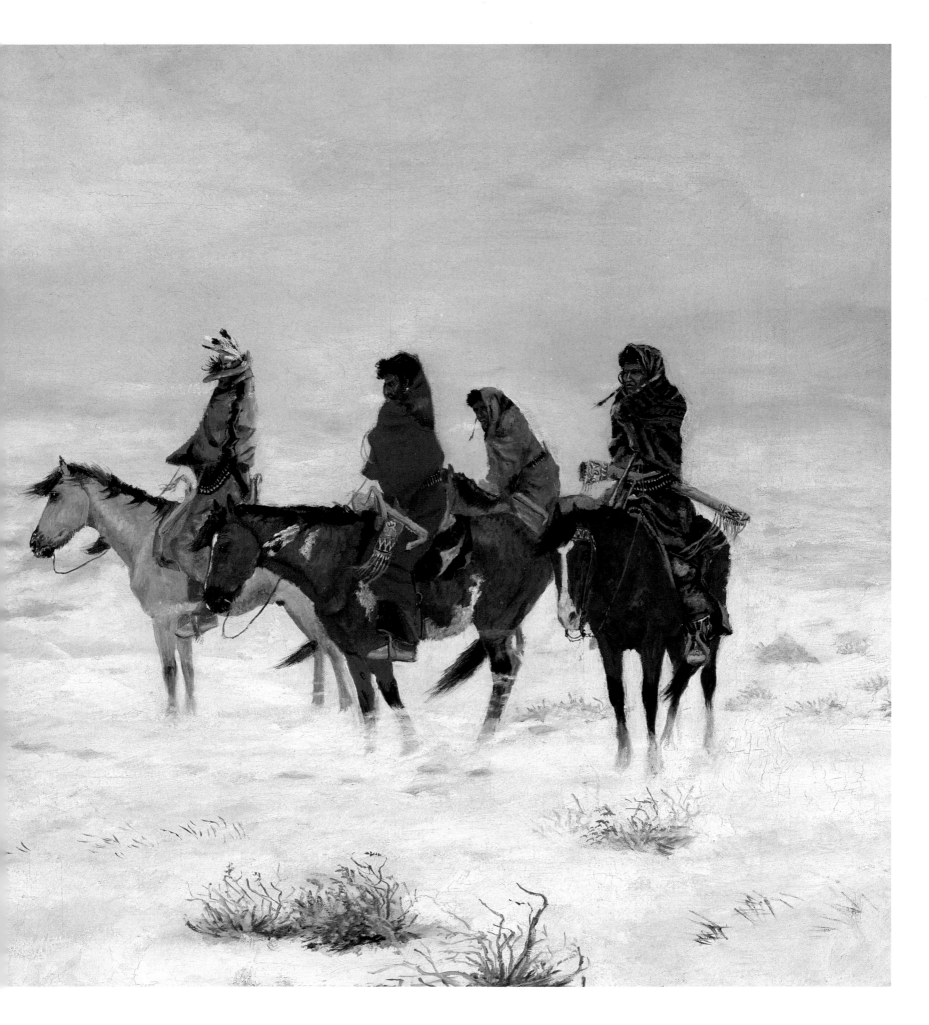

CHARLES M. RUSSELL
**Lost in a Snowstorm-
We are Friends,** 1888
Oil on canvas
24 × 43⅛ in.
Amon Carter Museum,
Fort Worth, Texas (1961.144)

One of the prettiest, quietest and least complicated canvases Russell painted, this work exmplifies his sympathetic feelings for the Indians. Here cowboys and Indians are united against a natural foe, the elements, and the buffalo skull in the left foreground symbolizes their danger. Russell employs brilliant red blankets and the most colorful paint, dun and bay ponies to stand out against the white-gray background.

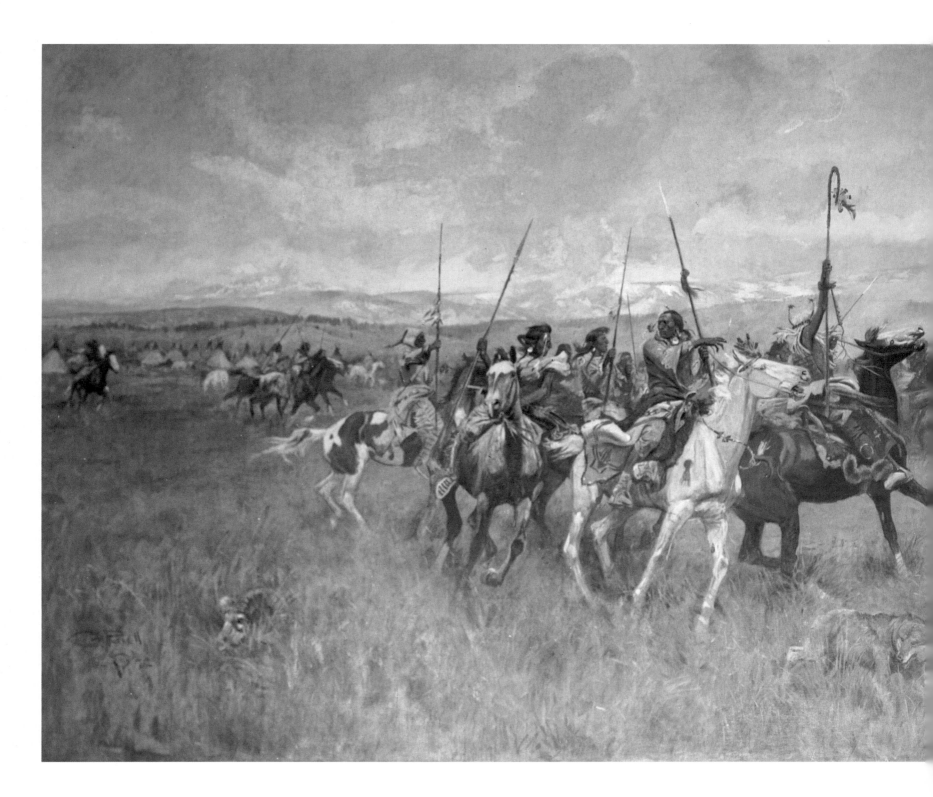

CHARLES M. RUSSELL
**_Lewis and Clark Meeting Indians
at Ross' Hole,_** 1912
Oil on canvas
144 × 300 in.
Courtesy of Montana Historical Society,
Helena, Montana (952.797)

This is a wonderful historical panorama, filled
with a dynamic swirl of riders, howling wolf-
like dogs and distant snow-capped mountains
against a sunset sky. The mission of Lewis and
Clark, whose diminuative figures are relegated
to the far right of the canvas, seems almost
secondary to the awesome spectacle they
witness here on their arrival. The leather
costumes of the Indians and their aquiline, red-
hued features command our attention. The
bleached antelope skull in the grass on the left
is a detail so often found in Russell paintings
that it is almost a trademark. (Indeed, he
frequently drew an outline of such a skull next
to his signature.)

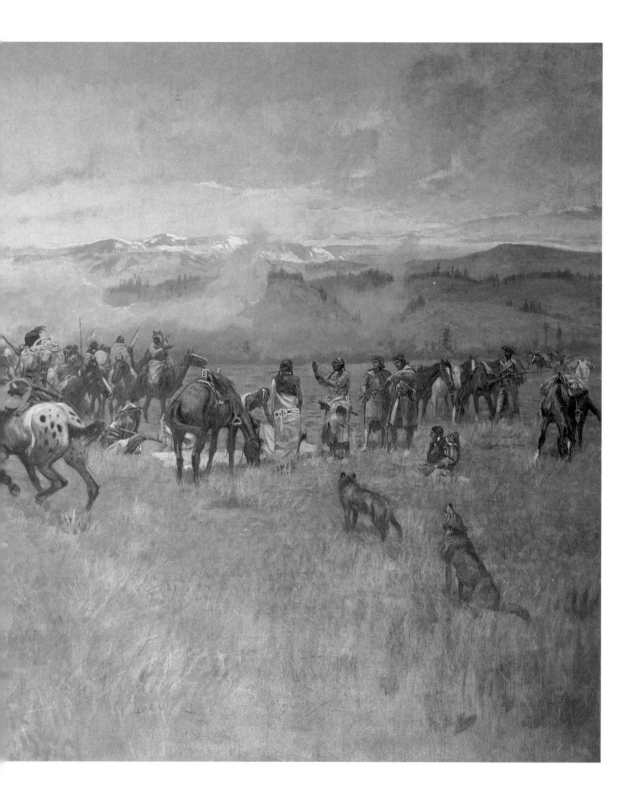

CHARLES M. RUSSELL
The Fireboat, 1918
Oil on canvas
14½ × 23½ in.
Charles M. Russell Museum,
Great Falls, Montana

Russell yields nothing to Remington in his skill
in portraying Indians. The rich color and
dappling of light in this late Russell canvas
reveals an Impressionist influence, and
Russell's feeling for the rugged beauty of the
West pervades the scene. The composition is a
semicircle beginning from scrub trees at the
lower left and following the path of the
Indians' spears and the shape of the hillock
beneath them. The ponies are painted in colors
and patterns that almost camouflage them
against the rocks below their hoofs. The
warpaint hand imprint on the white pony, the
fox headdress on his rider and the rearing
horse painted on his canteen are lively and
authentic details. The Indians appear both
delighted and mystified watching the tiny
steamer, which they called a "fireboat," making
its way along the river.

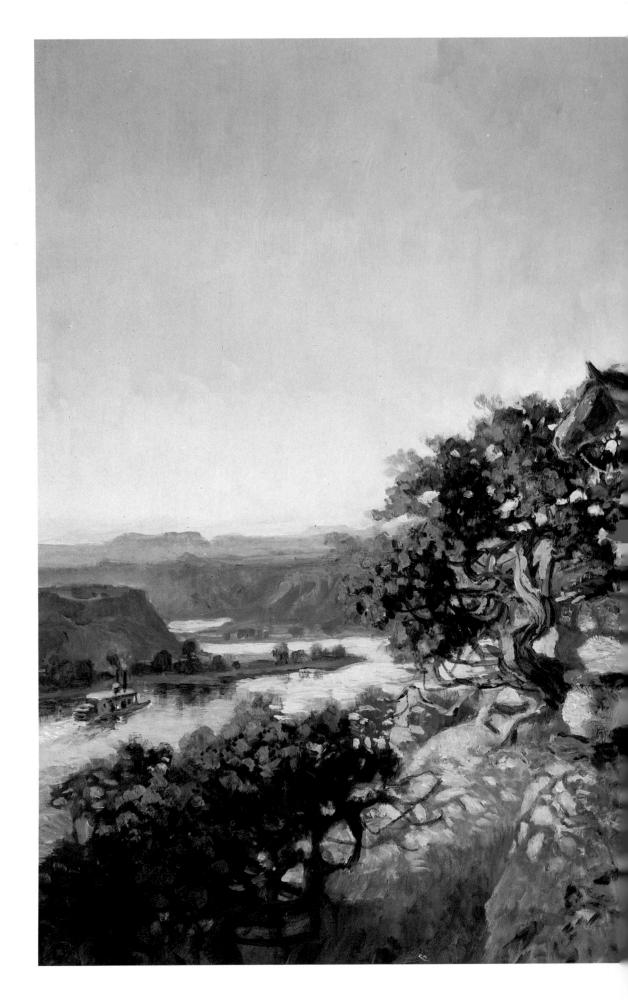

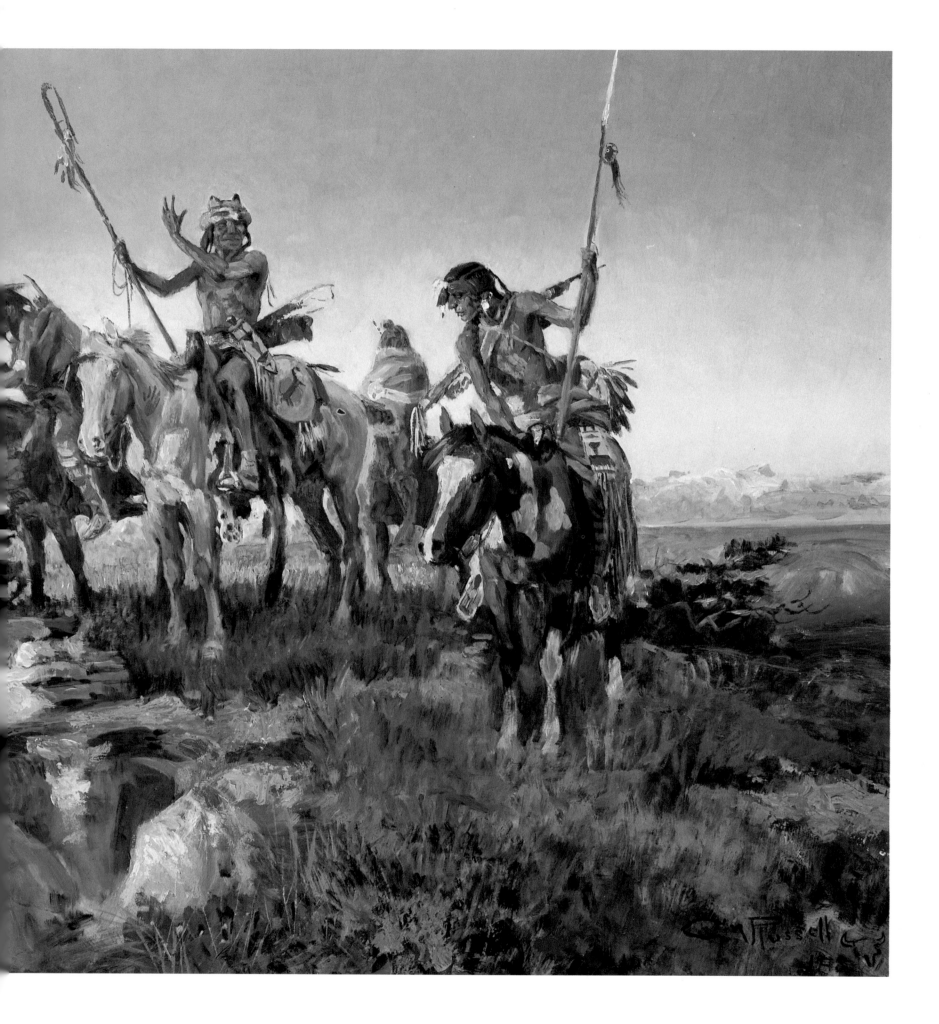

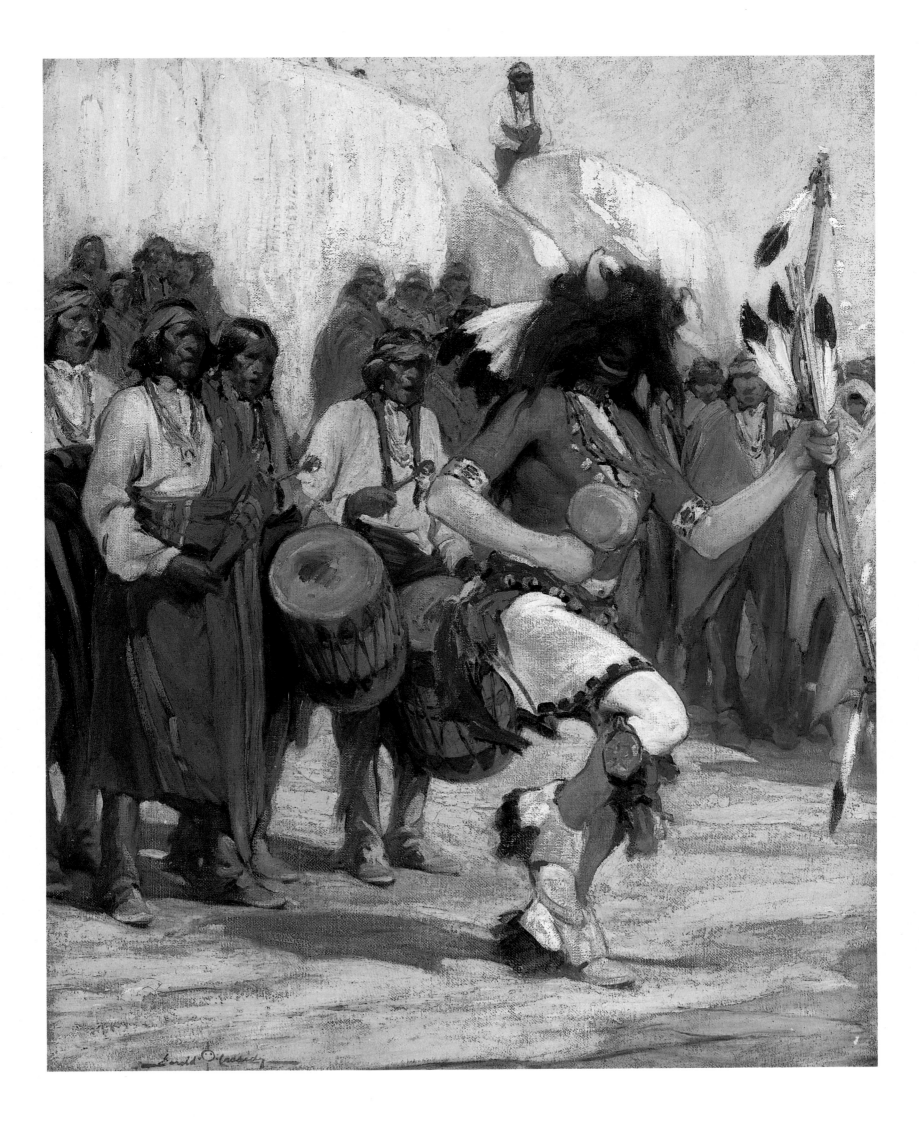

128

Left:
Gerald Cassidy 1879-1934
The Buffalo Dancer, c. 1924
Oil on canvas
57 × 47 in.
The Anschutz Collection

Gerald Cassidy was born and raised in Cincinnati, Ohio. Extremely talented in drawing, he was the head of a New York lithography firm by the time he was 20. But he contracted pneumonia, which so weakened his lungs that in 1899 he was obliged to go to a sanitorium in Albuquerque, New Mexico, for a cure. During this period he produced numerous illustrations with Western motifs and adopted a signature that had the sun symbol of the Tewa tribe between his initials.

When Cassidy recovered he stayed in the West and worked as a commercial artist in Denver. He settled in Santa Fe permanently in 1912 and was one of the founders of the Santa Fe art colony. He painted many murals and won recognition at the California International Exposition for his painting *The Cliff Dwellers of the Sun.* During the 1920s he received many commissions both for large historical works and for portraits, Mrs. Herbert Hoover and Dr. William Mayo being among his patrons. He died while working on a federal building commission in Santa Fe.

In *The Buffalo Dancer* the saturated hues of the war paint and fanciful accessories of the central figure set the tone for the canvas. The tribesmen stand on golden ground, against which the reds, ochres and blue-browns of their costumes seem to vibrate. They are huddled in front of a great kiva, the sacred stone chamber of the Pueblos. The main figures loom large and potent, and there is a rhythmic quality to the painting, as if the music of the tom-toms could be heard.

Above:
Nicolai Fechin 1881-1955
***Manuelita with Kachina
(Indian Maid Seated),*** c. 1926-1930
Oil on canvas
20¼ × 16⅛ in.
San Diego Museum of Art,
San Diego, California
Gift of Mrs. Henry A. Everett
(1938:025)

A Russian native, Nicolai Fechin first attended art school there at the age of 13 and enrolled at the Imperial Academy at 19. His primary training was as a portrait painter. In 1923 he emigrated to New York and later settled in Pittsburgh. During his first year he won the award for best portrait from the National Academy of Design, but he soon contracted tuberculosis and went to Taos for a cure. There he painted local Pueblo tribe members. After a bitter divorce he went to California, where he earned sizeable commissions for his portraits of wealthy patrons.

A bold, spontaneous technique was Fechin's hallmark. One critic claimed "he works with the savage, violent temperament of his Tartar ancestry." In addition to lively brushwork, Fechin used his spatula freely in his canvases, often building a heavy impasto. In this painting, *Manuelita with Kachina*, the girl's face is far more finished than her clothing or surroundings, a common Fechin device. He sets the darkest form, her black hair, against a white wall, the texture of which drifts into abstraction. Fechin employs a rich Indian palette for the woven cloth textiles and the Kachina doll, both of which are rendered with vivid, impressionistic strokes of brush and spatula.

Oscar Berninghaus
Peace and Plenty, 1925
Oil on canvas
35 × 39½ in.
The Saint Louis Art Museum,
Saint Louis, Missouri
Museum Purchase (6:1927)

In this serene painting a lusciousness of color
highlights traditional American themes of
Thanksgiving and piety. The cross reflects the
influence of the Christian culture upon the
Pueblo Indians, and the bountiful array of
pumpkins and corn signifies a good harvest, as
well as providing dynamic patterning to
contrast with the neutral tones of the figures.
The couple is in harmony, and the formal
drapery of their robes adds a classical flavor to
this quietly sentimental canvas.

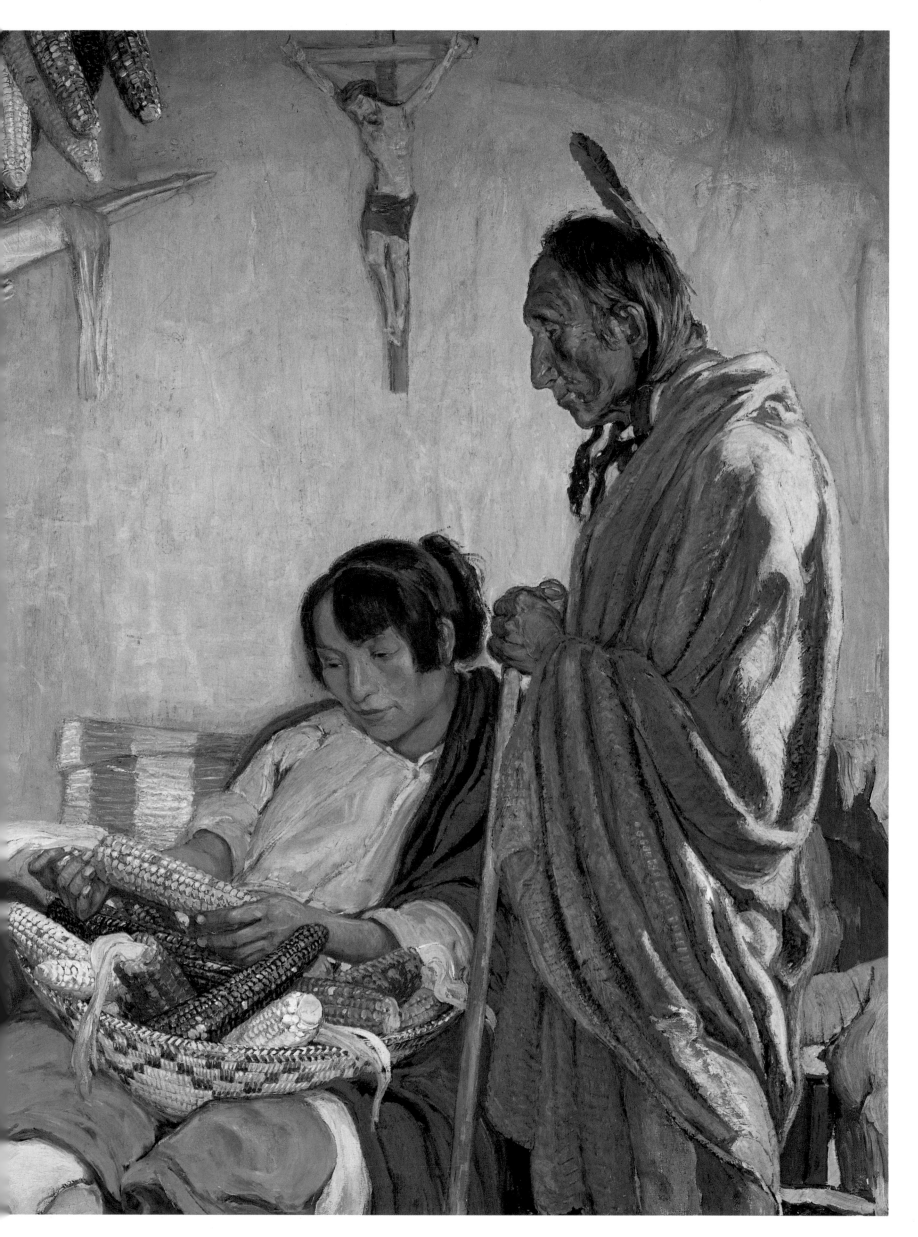

131

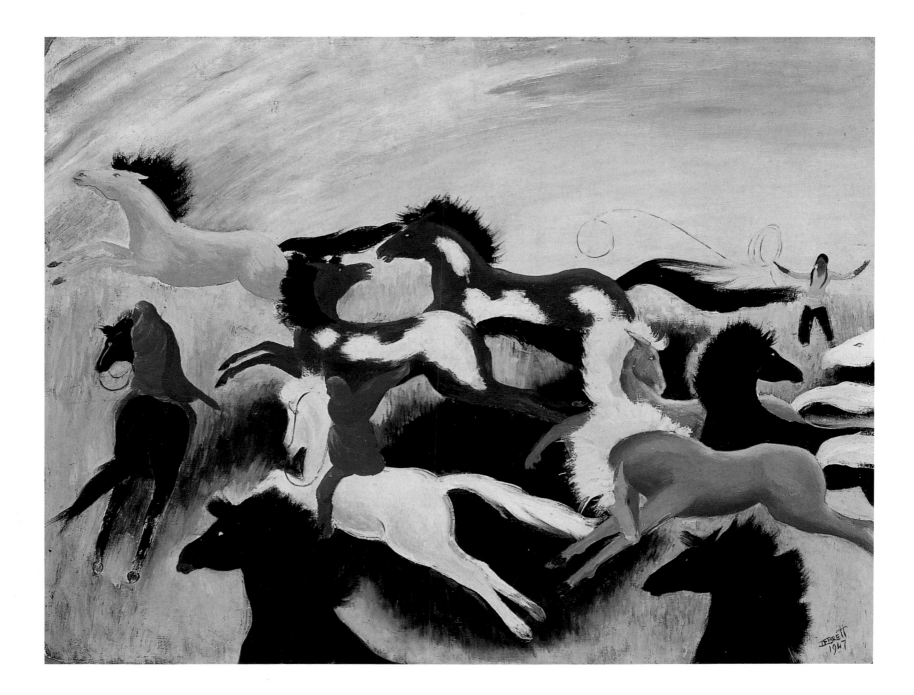

Dorothy Brett 1883-1977
Taos Indians, 1947
Oil on masonite
16½ × 22 in.
Collection of the Eiteljorg Museum of
American Indian and Western Art,
Indianapolis, Indiana
Gift of Harrison Eiteljorg

A member of Mabel Dodge Luhan's coterie in the 1920s, Dorothy Brett accompanied D.H. Lawrence and his wife Frieda to Taos. She was born in London in 1883, the daughter of a viscount, and she attended the Slade School of Art there. Her friends were members of the bohemian Bloomsbury set rather than the aristocracy. Her first interest in the American Indian was inspired by Buffalo Bill's Wild West Show, which she saw in London.

Upon arriving in America, Brett contributed articles to the *New Yorker* magazine. In Taos she was fascinated by the rhythms of the Pueblo dance ceremonies and was strongly influenced by the nervous, telegraphic and semi-abstract style of John Marin. She painted from memory, and her technique was consciously primitive. A colorful character and quite deaf, she carried a large ear trumpet around with her at social gatherings.

The wild mustangs in *Taos Indians* symbolize the freedom and zest of the Western landscape. They are rendered in a simplified, naive manner with a palette of orange, yellow, red, black and white. The lime green background energizes the work, and the horses' wavy manes and tails are echoed by the cloud patterns. The Indians are in the thick of the action, yet they seem small in comparison with the careering herds.

Fritz Scholder 1937-
Posing Indian, 1974
Acrylic on canvas
80 × 68 in.
Collection of the Eiteljorg Museum of
American Indian and Western Art,
Indianapolis, Indiana
Gift of Harrison Eiteljorg

Born in Breckenridge, Minnesota, of Indian
heritage, Fritz Scholder was only nine when he
won first prize for a Veteran's Day poster. He
later enrolled at Sacramento State College,
where he studied with the pop artist Wayne
Thiebaud. Afterward, he taught painting at the
Institute of American Indian Arts in Santa Fe
and in 1967 began a series of Indian paintings.
A trip to London introduced the artist to
Francis Bacon's work, whose influence can be
noted in many of the physical distortions in
Scholder's paintings. In the 1970s he also
branched out into lithography. He was featured
in the PBS documentary "Three Indian Artists"
in 1975. He now lives in Scottsdale, Arizona.

Posing Indian resembles the jazzy, silkscreen
images of pop artist Andy Warhol. The figure
is larger than life and projects out of the
picture plane. He is outlined in blue against a
brilliant orange background, which lends a
neon effect to his contours. Detail is simplified,
and the overall effect is dramatic and
impressive.

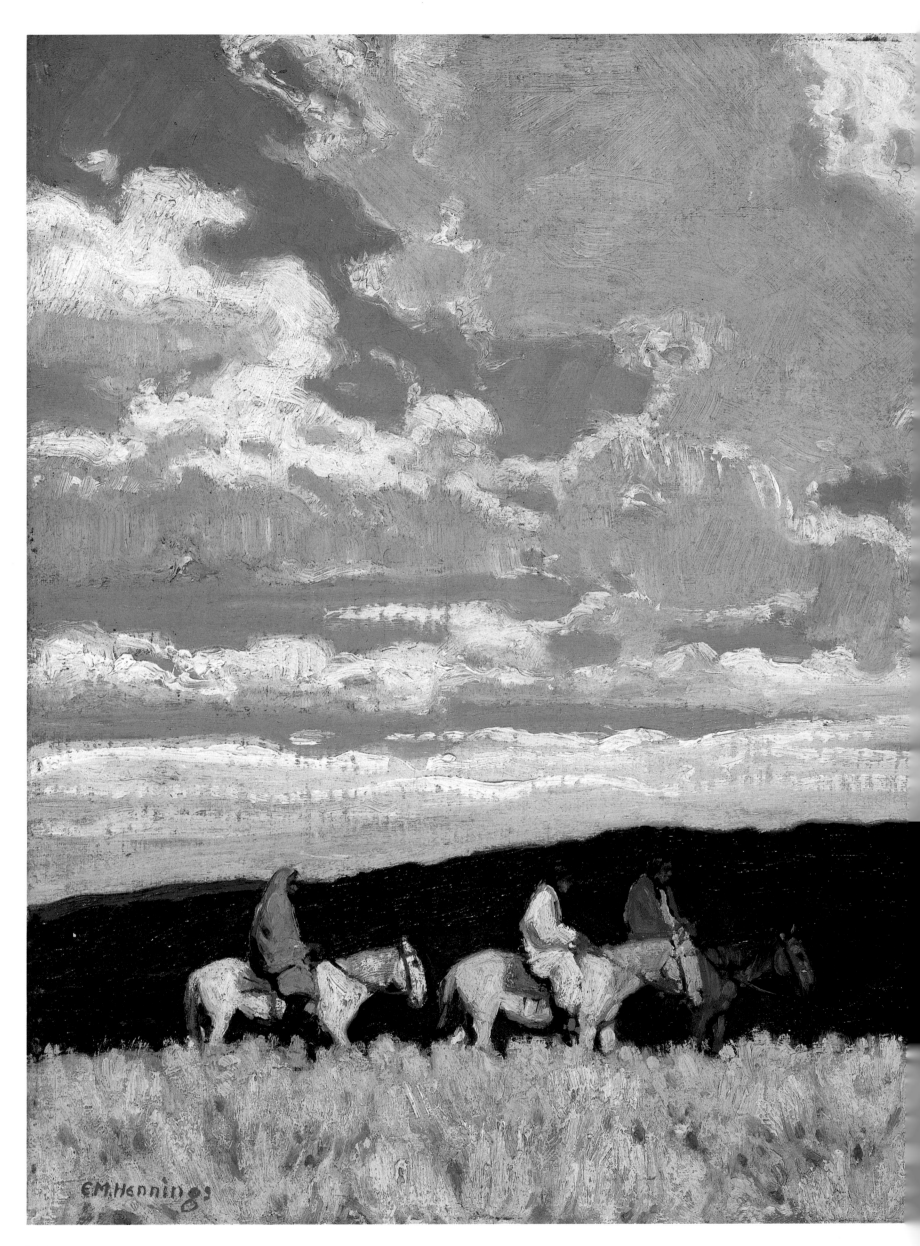

E. Martin Hennings 1886-1956
Indians in the Sage, n.d.
Oil on academy board
12 × 14 in.
Collection of the Eiteljorg Museum of
American Indian and Western Art,
Indianapolis, Indiana
Gift of Harrison Eiteljorg

Ernest Martin Hennings was born in Penns
Grove, New Jersey, on February 5, 1886, the
son of German immigrants. He developed an
early interest in drawing and was attending the
Chicago Art Institute by the time he was 15.
This was followed by three years of study at
the Munich Art Academy in Germany. Among
the patrons whom Hennings acquired after his
return to Chicago in 1915 were Oscar Mayer,
founder of the meat packing company, and the
Mayor of Chicago, Carter Harrison, and it was
at Harrison's suggestion that Hennings made
his first visit to Taos in 1917. He fell in love
with the place and moved from Chicago to
settle permanently in Taos in 1921.

Hennings joined the Taos Society of Artists,
and in subsequent years his work won many
prizes and honors – from the Art Institute, the
Pennsylvania Academy of Fine Arts and the
National Academy of Design, among others. He
married Helen Otte, a buyer for Marshall
Fields, in 1926, and the couple lived in a
spartan adobe home in Taos. He painted a
WPA mural for the post office in Van Buren,
Kansas, did lithographs and calendar
illustrations for the Santa Fe Railroad and had
many portrait commissions in Houston, Texas.
He died of a heart attack on May 19, 1956.

Indians in the Sage is a small gem, measuring
only 12 inches by 14 inches, with rich colors,
impressionistic brushwork and a fine sense of
the peaceful open beauty of the Taos
landscape. The Indians are bright maize against
the blue-black foothills, which seem to protect
their procession. The white horses and yellow
robes worn by the Indians are echoed in the
sunlit clouds about them.

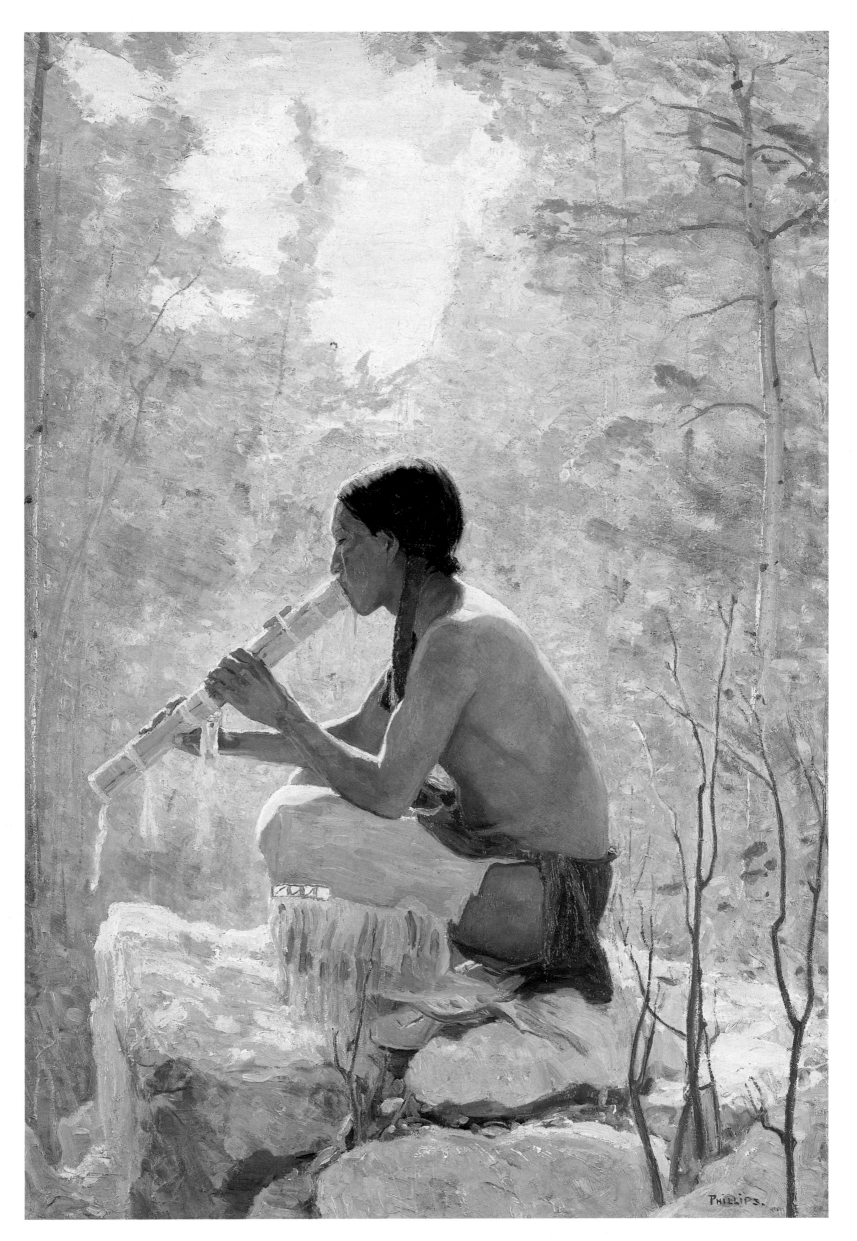

136

Left:
Bert Geer Phillips 1868-1956
Song of the Aspen, c. 1926-1928
Oil on canvas
40 × 27⅛ in.
Collection of the Eiteljorg Museum of
American Indian and Western Art,
Indianapolis, Indiana
Gift of Harrison Eiteljorg

A prominent member of the Taos Society, Bert
Phillips was born in Hudson, New York. He
enrolled at the Art Students League and later
the National Academy of Design in New York.
He went to England in 1894 and then to Paris,
where he met Joseph Sharp and Ernest
Blumenschein. In 1897 he exhibited his
Western paintings in New York, the models for
which were members of Buffalo Bill's Wild
West Show. He traveled by railroad to Denver
in 1898 and went on to Taos in a horse-drawn
wagon. He married and settled there in 1899.

When Phillips injured his eyes painting by
firelight he required four years of healing time,
during which he could not paint. He worked
as a forest ranger instead, and many of his
finest canvases celebrate the beauty of the
woodlands. Phillips later produced several
public murals and painted until the end of his
life, most of which was spent in Taos.

Phillips idealized the Indian and favored
poetic landscapes with one dominant color,
such as the brilliant yellow in *Song of the Aspen.*
The Indian is portrayed in a nearly classical
study, with his black hair and dark skin
constrasting strongly with his surroundings.
The mood is peaceful and contemplative, and
the sweet sounds of the flute pervade the
atmosphere. Phillips wrote that as a forest
ranger, ". . . the value and beauty of the forest
grew upon me . . . summer greens, and
autumn yellows. These messages of beauty, like
lyrical and symphonic music."

Above:
James E. Bama 1926-
**Crow Indian Wearing 1860's
War Medicine Bonnet,** 1983
Oil on masonite
30 × 24 in.
© James E. Bama

A native of New York City, James Bama
attended the Art Students League. He was a
prosperous commercial illustrator for 20 years
in New York before moving to Wyoming. His
focus is portraiture of Western cowboys and
native Indians, painted with contemporary
details and trompe l'oeil realism. His characters
are gentle and strong.

The precise style and palette of Andrew
Wyeth come to mind on viewing this painting.
Every wrinkle of the Crow's timeworn face is
exposed, as are the gnarls of his hands. These
marks of age, however, are wholly venerable,
and the subject's social stature is confirmed by
his wearing a precious heirloom war bonnet.
The split-horn headdress was worn only by the
bravest warriors, whom its special powers
would protect from harm in battle. It is
graphically portrayed here, along with the
creased and battered buffalo hide on the
Indian's shoulders. The stately Crow seems to
have enclosed himself within the history of his
tribe, and the artist conveys this feeling with a
reverence that transcends the photographic
realism of his style.

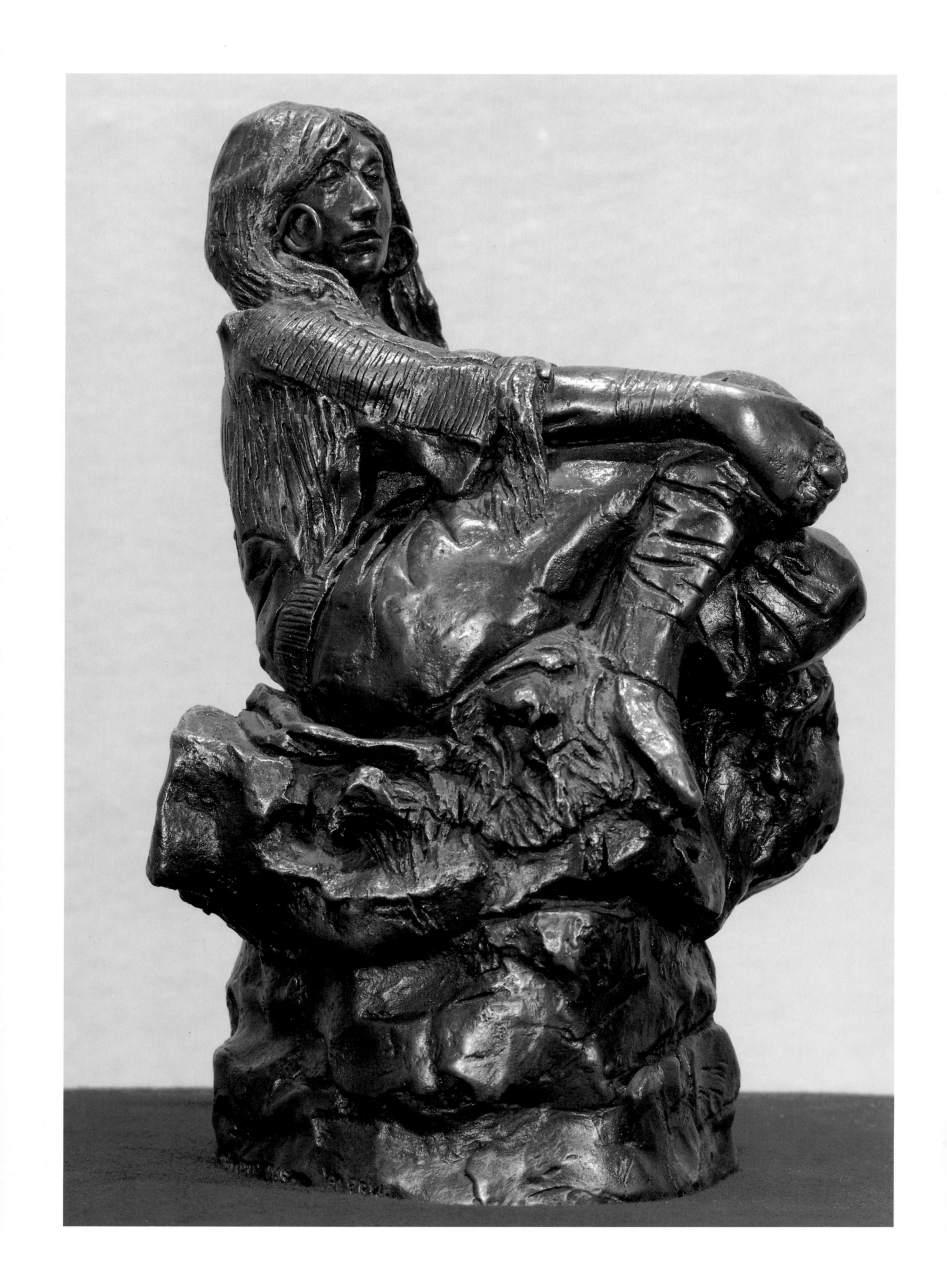

Left:
CHARLES M. RUSSELL
Piegan Maiden, c. 1910
Bronze
10¼ × 5¼ × 6¼ in.
Charles M. Russell Museum,
Great Falls, Montana

The color of the bronze describes both the rich
hue of the maiden's skin and of her leather-
fringed dress and leggings. She seems
materially wed to her surroundings, in this
case the rocky tor upon which she sits. She
looks serene and noble. Her great, bright hoop
earrings are a single (but rather glamorous)
accessory.

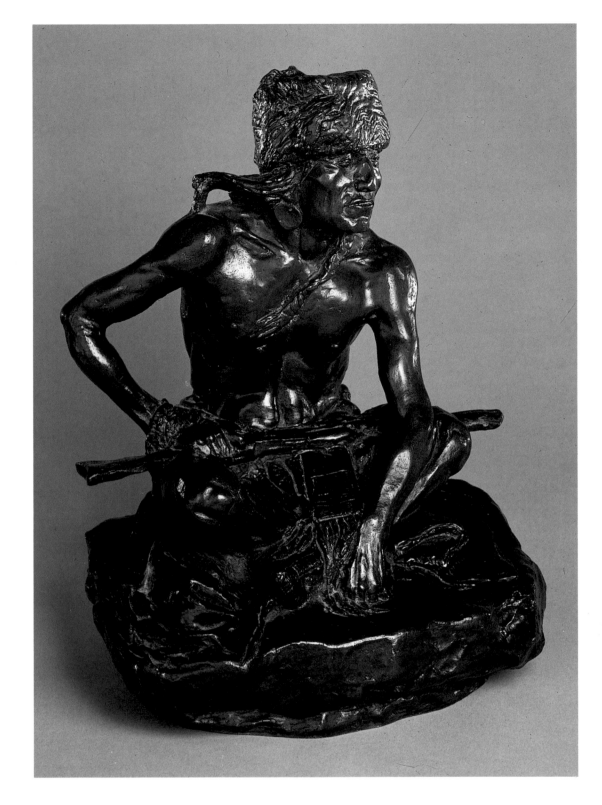

Above:
CHARLES M. RUSSELL
Watcher of the Plains, n.d.
Bronze
10¾ × 6⅞ × 8¼ in.
Buffalo Bill Historical Center,
Cody, Wyoming (3.85)
Gift of William E. Weiss Foundation

Russell often used his sculpture as models for
figures in his paintings. The pose, expression,
sinewy limbs and hat of this Indian resemble
those of a figure mounted on a horse in
Russell's canvas *Trouble Hunters.* The figure
blends into the rock beneath, which is finished
smooth, like his skin. We are aware of his taut
muscles, his fitness and his calm, vigilant
readiness. His braids, hat and fringed satchel
add linear interest, and the triangular voids
created by his pose allow one to appreciate his
contours in the round.

FREDERIC REMINGTON
The Cheyenne, 1902
Bronze
21⅛ × 14½ × 7¼ in.
Buffalo Bill Historical Center,
Cody, Wyoming
Gift of Mrs. Henry H.R. Coe (17.71)

The Indian's spear creates the plane of
movement in this piece, thrusting forward on a
diagonal axis. The bronze is shaped like wave
crests to describe the horse's main and tail, as
well as the Indian's hair, headdress, shield and
feathers. Even the base of the sculpture is
wave-like, thus maintaining a thematic unity
and an overall pace. The horse's expression is
intelligent and intense – the most finely
detailed aspect of the piece.

FREDERIC REMINGTON
The Buffalo Horse, 1907
Bronze
36 × 24½ × 11 in.
The Thomas Gilcrease Institute of
American History and Art,
Tulsa, Oklahoma (0827.51)

Despite the improbability of this dramatic
conjunction of buffalo, horse and Indian, the
sculpture is successful as a homage to the
bravery and tenacity of all three subjects. The
athleticism of the Indian, who appears as if he
will land on his feet, is particularly stressed.
The composition is highly original, and the
surface of the bronze is expertly varied
to reveal different textures of fur,
horsehair and skin.

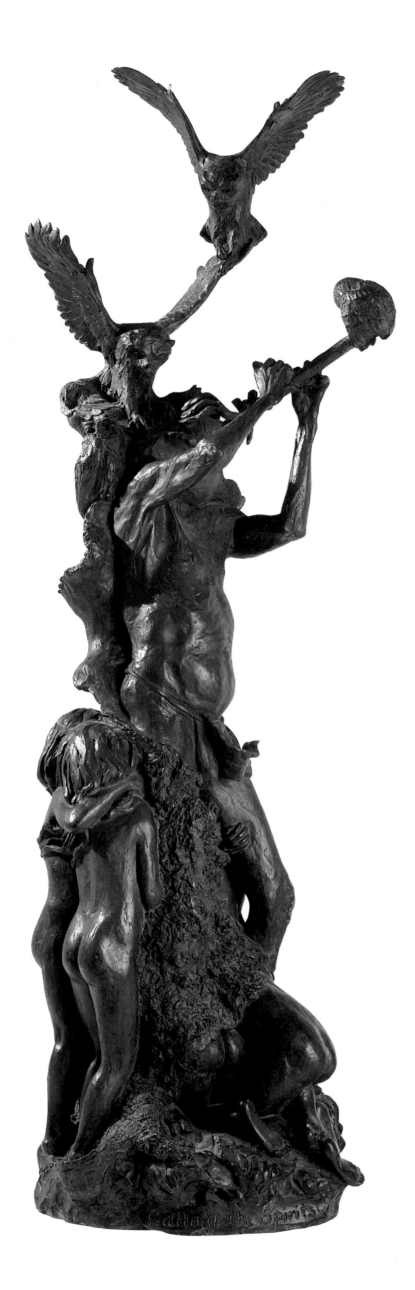

RICHARD GREEVES 1934-
Calling the Spirits, 1975
Bronze
40 × 12 × 12 in.
Collection of the Eiteljorg Museum of
American Indian and Western Art,
Indianapolis, Indiana
Gift of Harrison Eiteljorg

Richard Greeves was born in 1934 in a small
town near St. Louis, Missouri. At the age of 15
he went to live with an Indian family at Fort
Washakie on the Wind River Reservation in
Wyoming. He currently lives on the Arapaho
and Shoshone reservation with his wife, Jeri, a
Kiowa, and runs the grocery, the art gallery
and the craft shop at the Fort Washakie
Trading Company. Greeves observes Indian
customs and is an accomplished war dancer.

This sculpture won the first prize at the
1979 National Academy of Western Art exhibit
held at the Cowboy Hall of Fame. Greeves's
approach is an emotional one: he feels a
sculptor must "get the inside right before you
get the outside right." The naked children are
symbols of Edenic innocence, portrayed with
their arms around each other and a tree of life.
Two owls, a species which represents the spirit
and wisdom in Indian myth, are landing. One
touches down upon the other's wing, another
gesture of harmony. The arrangement is
complex, and the textures are varied, from
smooth skin to rough bark.

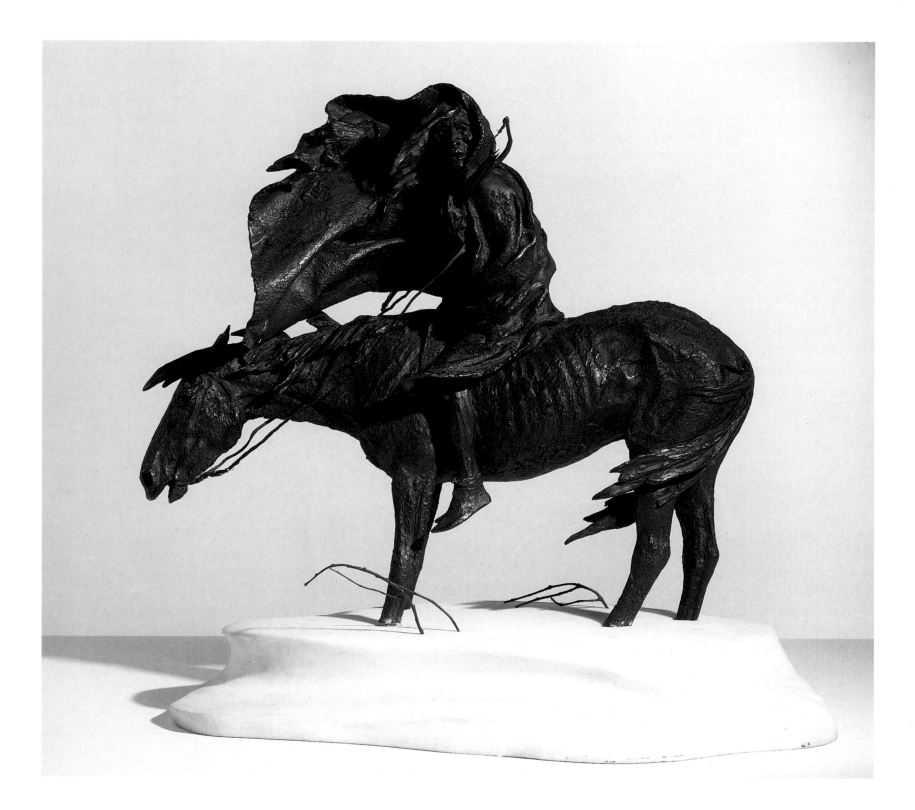

ERNEST BERKE 1921-
January, *A Hard Month,* 1973
Cast bronze and marble
18 × 19 × 13 in.
Collection of the Eiteljorg Museum of
American Indian and Western Art,
Indianapolis, Indiana
Gift of Harrison Eiteljorg

Ernest Berke was born in New York City, the
son of Russian and Rumanian immigrants.
Serving in the Army Air Corps in World War
II, Berke discovered his aptitude for painting
and drawing, and after the war he worked as a
commercial artist, doing animated films and
fashion art.

When Berke first turned to Western themes
he began with paintings of Indian life that
show the influence of Harold Von Schmidt. In
1973 he moved to Santa Fe, New Mexico, and
began sculpting, and by 1980 he had produced
55 bronzes. His work is clearly inspired by that
of Remington and Russell – essentially realistic,

yet striving for dramatic situations and based
upon thorough historical research.

In *January, A Hard Month*, the windswept
mane and tail of the pony and the Indian's
blanket lend a tangible sense of cold to the
piece. The white base creates an illusion that
the pony is standing in snow – a few forlorn
twigs poke through. The Indian's thin legs and
gaunt cheeks, like the pony's prominent ribs,
suggest privation. The Indian and his mount
are kindred souls, allies against the bitter
winter weather.

Military Scenes

The military became an important presence in the West soon after the Louisiana Purchase in 1803, when President Thomas Jefferson commissioned Meriwether Lewis and William Clark to explore the newly-acquired territories of the United States. Imaginative narrative canvases based on accounts of their exploits (for no illustrator accompanied their party) were later furnished by artists as diverse in style as Charles Russell and Thomas Hart Benton.

Following the forays of Lewis and Clark, a network of forts and trading posts was established along river routes and overland trails throughout the West. Artists visiting these oases on the frontier described their architecture and inhabitants. Alfred Jacob Miller, for example, was commissioned in the 1830s by a Scottish aristocrat, Captain William Drummond Stewart, to supply Western paintings for his castle in Scotland. Miller's sketches and oil canvases of Fort William on the Laramie River, in what is now Wyoming, depict its wood plank structure as a singular feature upon the empty plains, surrounded by teepees and protected by cannon-armed block houses. The Swiss artist, Karl Bodmer, even records a battle he viewed at Fort McKenzie while accompanying a Prussian prince, Maximilian Alexander Philip zu Wied, on his Western journeys.

The most impressive military canvases involve the cavalry, whose mounted troops were originally organized as the First US Dragoons in 1833 and later produced such famous regiments as the 4th, 7th and 10th Cavalry. Their campaigns were effective police actions aimed at curbing hostility from aggressive members of Comanche, Kiowa, Apache and Sioux tribes, who attacked wagon trains, settlers, railroad workers and others who sought to "civilize" the western frontier.

Frederic Remington was the foremost illustrator of the "pony soldier." Along with Charles Schreyvogel, also a master of historical detail, Remington is the primary source of our contemporary image of the typical cavalryman. The fact that Remington's father was a cavalry officer during the Civil War and that Remington himself had a passion for equestrian activities of all sorts helped to make his work particularly authoritative and dynamic.

A marvelous perspective of a parade of mounted soldiers approaching from distant mesas is the subject of Remington's *Pony Tracks in the Buffalo Trails*. An Indian scout in the foreground pointing out footprints made by the enemy provides the main narrative element, but the tallest and otherwise most noteworthy figure is a handsome officer riding square and straight in the saddle, his horse heading directly at the viewer.

The discomforts of the trooper's life led Remington to remark to a commanding officer, "Captain, I've got the heart of a cavalryman, but the behind of a nursemaid." The only time Remington actually witnessed battle first-hand was during the Spanish-American War in Cuba in 1898, and he glorifies his friend and patron, Theodore Roosevelt, leading *The Charge of the Rough Riders at San Juan Hill*. In this picture, wholly Western in spirit, if not in subject matter, the soldiers' uniforms make a picturesque pattern against the maize battleground.

Remington's maturing talents, as well as the influence of the French Impressionists, are reflected in a later canvas of 1907, *On the Southern Plains*. Shimmering light dapples the galloping forms of horses and riders, who are somewhat indistinct in this diffused rendering. The horses appear to be all bays in this troop. A commander would often deliberately select a particular color for particular units, which might then be known as "the grey troop" or "the bay troop."

Charles Schreyvogel, a contemporary of Remington, was equally exacting and precise in his depiction of the cavalry's uniforms, equipment and battles. In his heroic scene of a trooper saving the life of his comrade entitled *My Bunkie* the figures are suspended in a stop-action frame so the viewer can examine each aspect of their attire, arms and saddlery. An interesting counterpart to this canvas is Remington's bronze *The Wounded Bunkie*. Indeed, artists mining the subject of the cavalry in the late twentieth century have never really ceased to employ the vernacular of Remington and Schreyvogel.

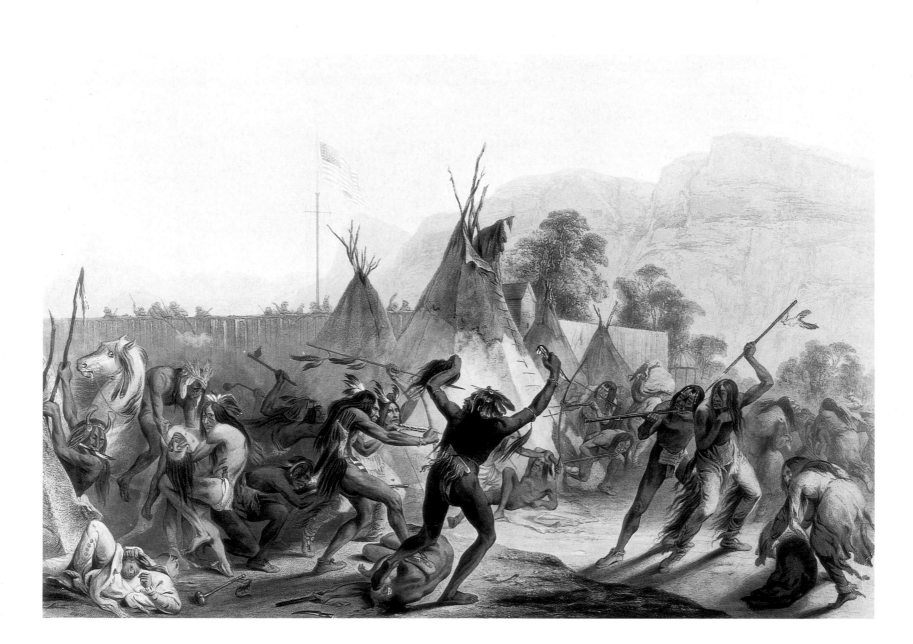

Above:

KARL BODMER 1809-1893

Fort McKenzie, 1843

Illustration for *Travels in the Interior of North America. . . ., by Maximilian Alexander Philip, Prinz zu Wied-Neuwied, published London: Ackermann and Co., 1843*

Rare Books and Manuscripts Division

The New York Public Library,

New York, New York

Astor, Lenow and Tilden Foundations

Never a US citizen, Karl Bodmer was born in Riesbach, Switzerland. He studied in Paris and arrived in America at 23 years of age with the explorer Maximilian Alexander Philip zu Wied, a Prussian prince, for the purpose of supplying paintings of the West for the nobleman. The two men and their party arrived in St. Louis in March 1833 and took the steamer *Yellowstone* up the Missouri, stopping at several forts along the way. They stayed at Fort McKenzie for a month.

There Bodmer witnessed a sharp battle between a party of Blackfeet and a band of Assiniboins and Crees. The soldiers assisted the Blackfeet, and Bodmer produced this canvas of the event. Following this stay, Bodmer and the Prince continued on to Fort Clark and Fort Union. In 1834 the pair returned to Europe, and Prince Maximilian later published a two-

volume folio atlas, *Travels in the Interior of North America*, for which Bodmer supplied 81 pictures. Bodmer later settled in France and became an influential member of the Barbizon School. One of his students was François Millet, who was also an assistant engraver for the artist. Millet actually produced many Indian pictures from Bodmer's sketches.

The Blackfeet tribe considered Fort McKenzie its private domain and was prepared to fight off any aggressive interlopers such as these. Bodmer's rendering of the encounter is appropriately gory: bloody scalps are much in evidence, and one Indian steps on the dead body of another. The Indians are all accurately portrayed, though their horses are stylized, resembling European dressage mounts rather than plains ponies. The US flag is the uppermost element in the composition, establishing the preeminence of the army. In the battle itself, messengers rode out to the main Blackfeet camp 10 miles away from the fort, and reinforcements were sent to defeat the attackers.

Pages 146-147:

ALFRED JACOB MILLER

Fort Laramie, 1851

Oil on canvas

18 × 27 in.

The Thomas Gilcrease Institute of American History and Art,

Tulsa, Oklahoma (0126.727)

Miller's romantic oil of Fort Laramie (William) presents the outpost as an oasis in the plains. Bright light shines on the wood planks of the fort's exterior, and Indians camp peacefully in their teepees nearby. Our perspective is the Indians', looking up towards a symbol of benevolent power. Many important council meetings were held at Fort William, which was originally built by William Sublette and Robert Campbell as a trading post in 1834. Fort William was re-named Fort Laramie and became a US military post in 1849.

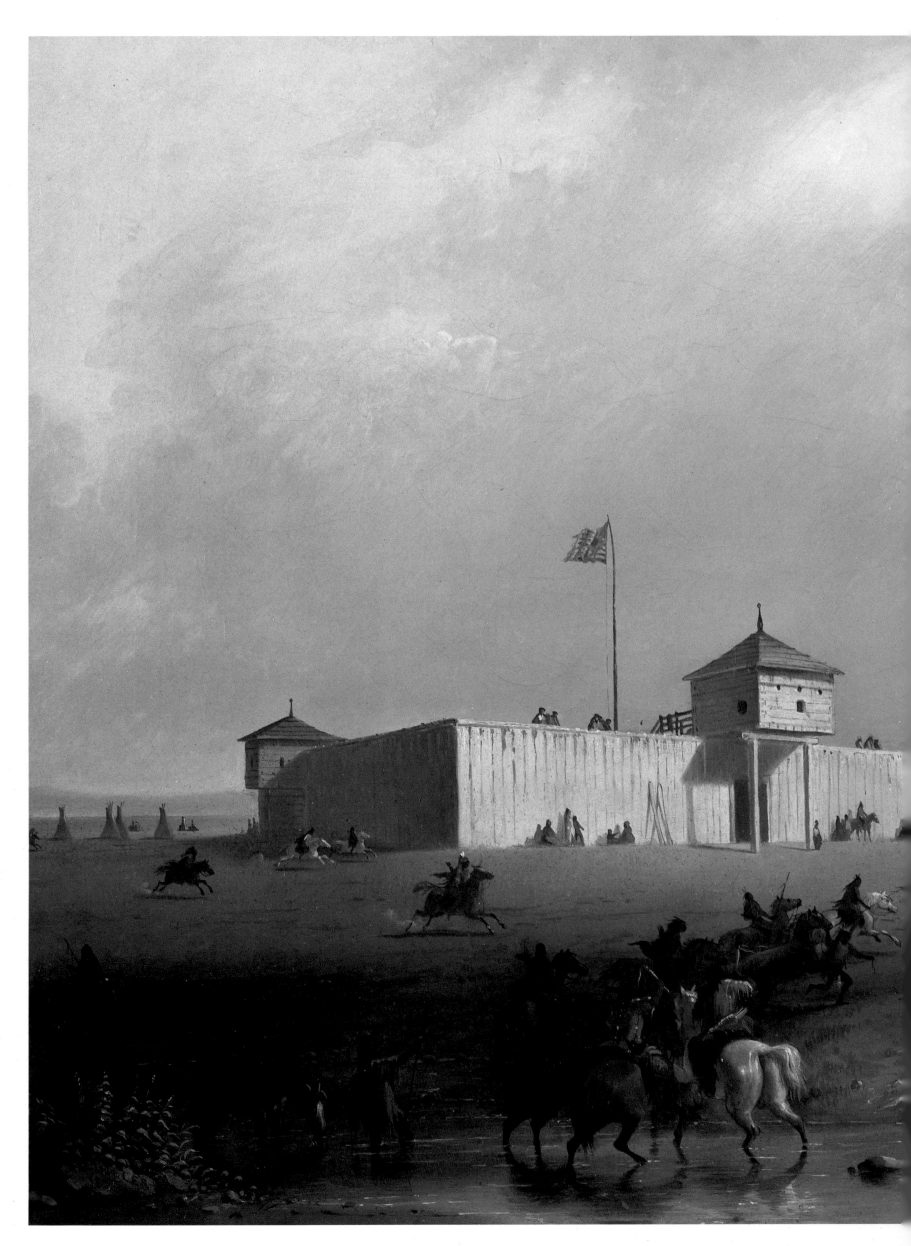

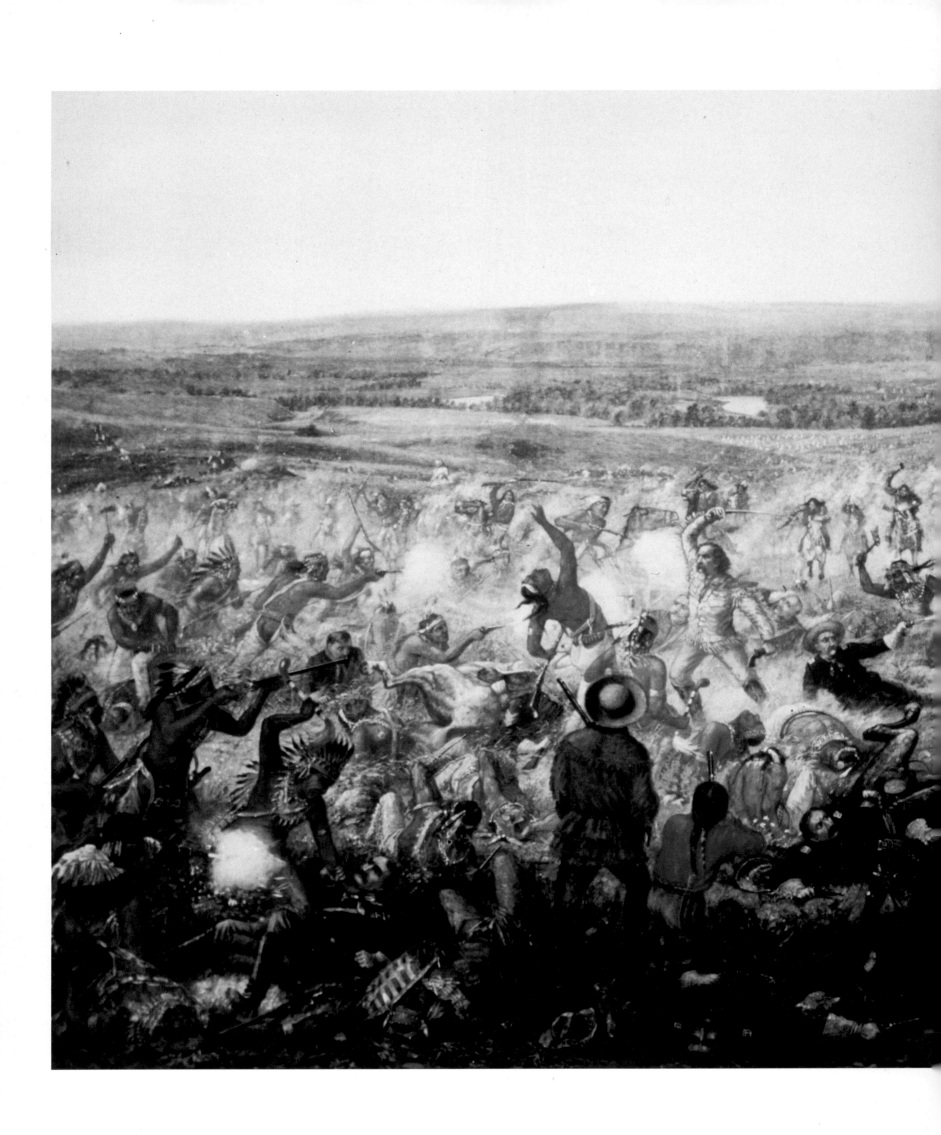

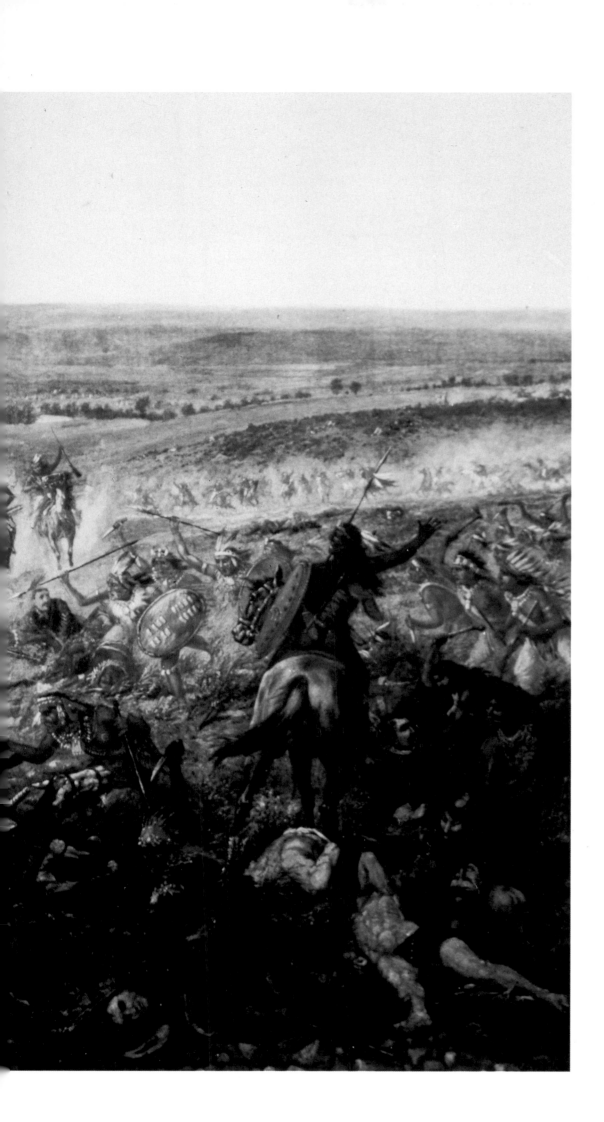

CASSILY ADAMS 1843-1921
OTTO BECKER 1854-1945

Custer's Last Fight, 1896
Oil on canvas
24¼ × 38¼ in.
Anheuser-Busch Co., Inc.,
Saint Louis, Missouri

Cassily Adams was born in Cincinnati, Ohio, and attended the Boston Academy of Arts and the Cincinnati Art School. He lived briefly in St. Louis before settling permanently in Cincinnati and establishing a studio there. His huge original painting of the Battle of The Little Big Horn, completed in 1886, was at first exhibited in various cities for an admission fee and then was hung in a fancy St. Louis saloon frequented by local politicians and visiting · officials. At the time it was insured for $50,000. The saloon and the painting were acquired in a foreclosure by Anheuser-Busch, Inc., in 1890.

Otto Becker was a native of Dresden, Germany, where he enrolled at the Royal Academy of Arts. He emigrated to New York in 1862 and found employment there as a lithographer and later worked in Philadelphia, Boston and St. Louis, finally settling in Milwaukee.

Becker painted a smaller version of *Custer's Last Fight* from Adams's original and made 150,000 lithographs of his new work. These were hung behind the bars of saloons throughout the country. From a strictly historical point of view, the picture leaves a good deal to be desired. The soldiers did not in fact wear sabers, the Indians did not carry Zulu shields or charge the soldiers on horseback and Custer's hair was cut short before this battle. More essentially, by dwelling on the doomed gallantry of the defenders, the picture effectively glosses over the fact that Custer, through his own rashness, was mainly responsible for having gotten himself into this predicament in the first place.

Taken solely on its own terms, however, the lithograph is an effective evocation of panic and pandemonium in the midst of a violent confrontation. Horizontal bands of action stretch out actross the scene like the plains themselves. Horses thrown to the ground stab the air with their legs. Fallen officers are at the mercy of Indians armed with guns, spears and tomahawks, and the sheer hopelessness of the defenders' position is manifest.

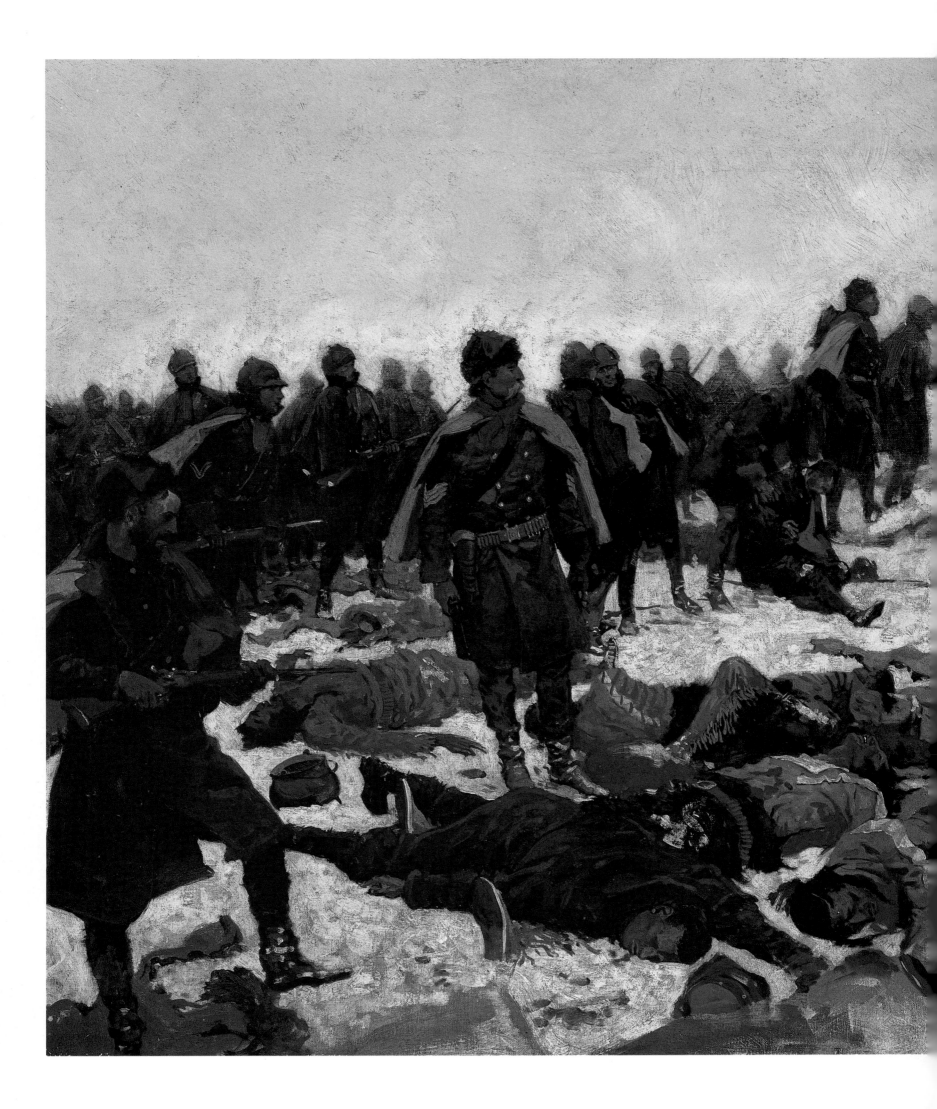

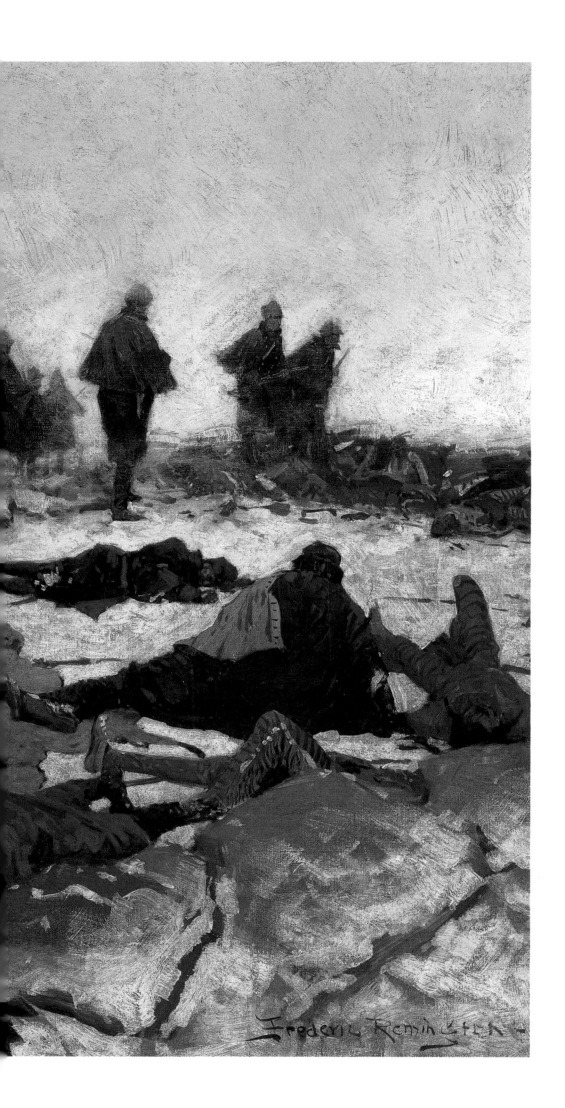

Left:
FREDERIC REMINGTON
Battle of War Bonnet Creek, n.d.
Oil on canvas
27 × 40 in.
The Thomas Gilcrease Institute of
American History and Art,
Tulsa, Oklahoma (0127.2310)

The scrabbled and flurried brushstrokes in the
foreground and sky make almost abstract
patterns in this canvas, and the fallen Indians
and soldiers are lifeless extensions of the
craggy boulders. A sense of victory can be
clearly seen in the officer's face and stance, but
the most interesting aspect of the painting is
the sense of confusion and disarray produced
by combat. A limited palette of gray, ochre and
navy transmits the wintry cold.

Pages 152-153:
FREDERIC REMINGTON
**Charge of the Rough Riders at
San Juan Hill,** 1898
Oil on canvas
35 × 60 in.
Courtesy Frederic Remington Art Museum,
Ogdensburg, New York (66.052)

This canvas is a tribute to Remington's patron,
friend and fellow frontiersman, Teddy
Roosevelt. He is the only mounted soldier,
leading his troops into battle. The men's black
shirts and red leather trousers stand out
sharply against the maize-colored field, and the
movement of their surging ranks is accentuated
by the jagged line made by the trees in the
background. Remington's early realist style is
evident here, with clearly delineated forms and
precise details of pistols, rifles, ammunition
belts, canteens and clothing.

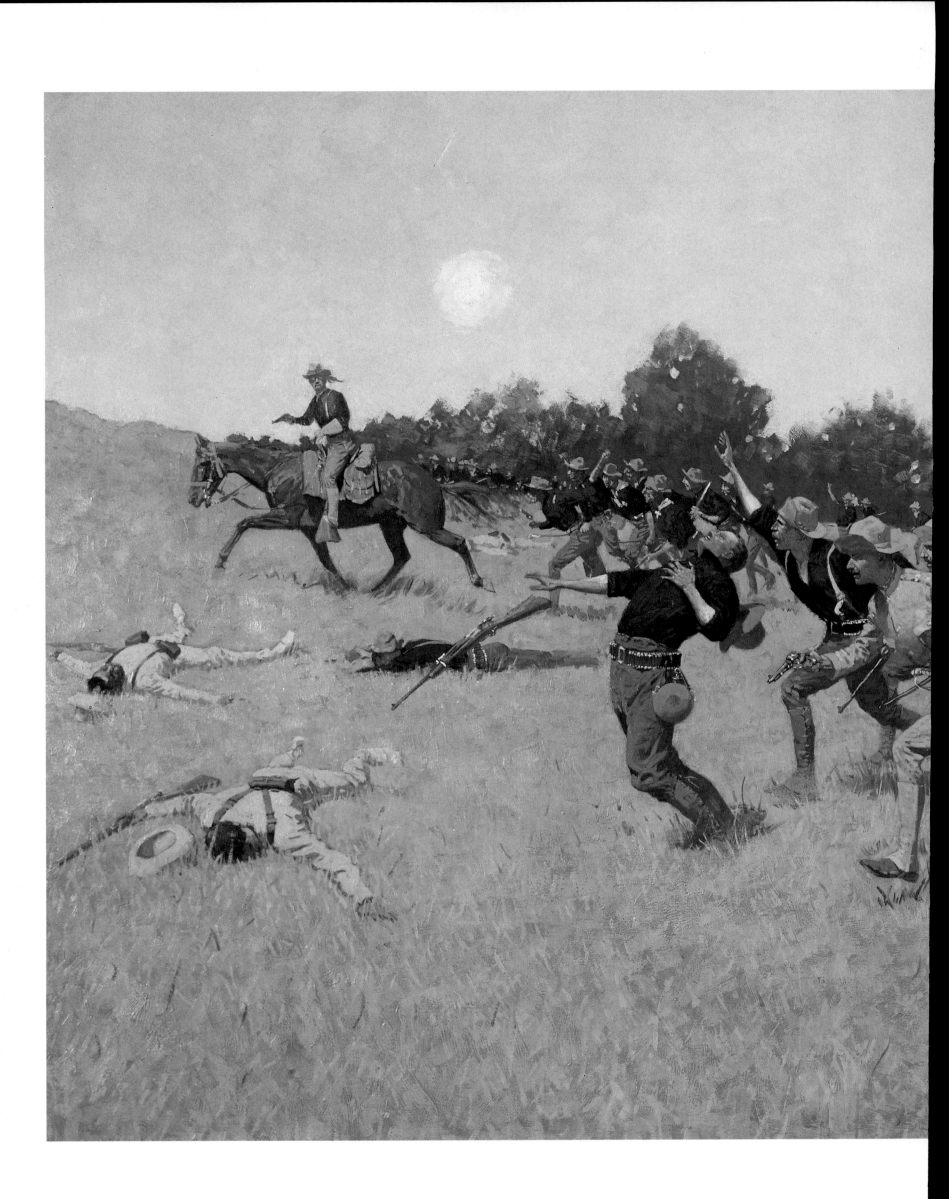

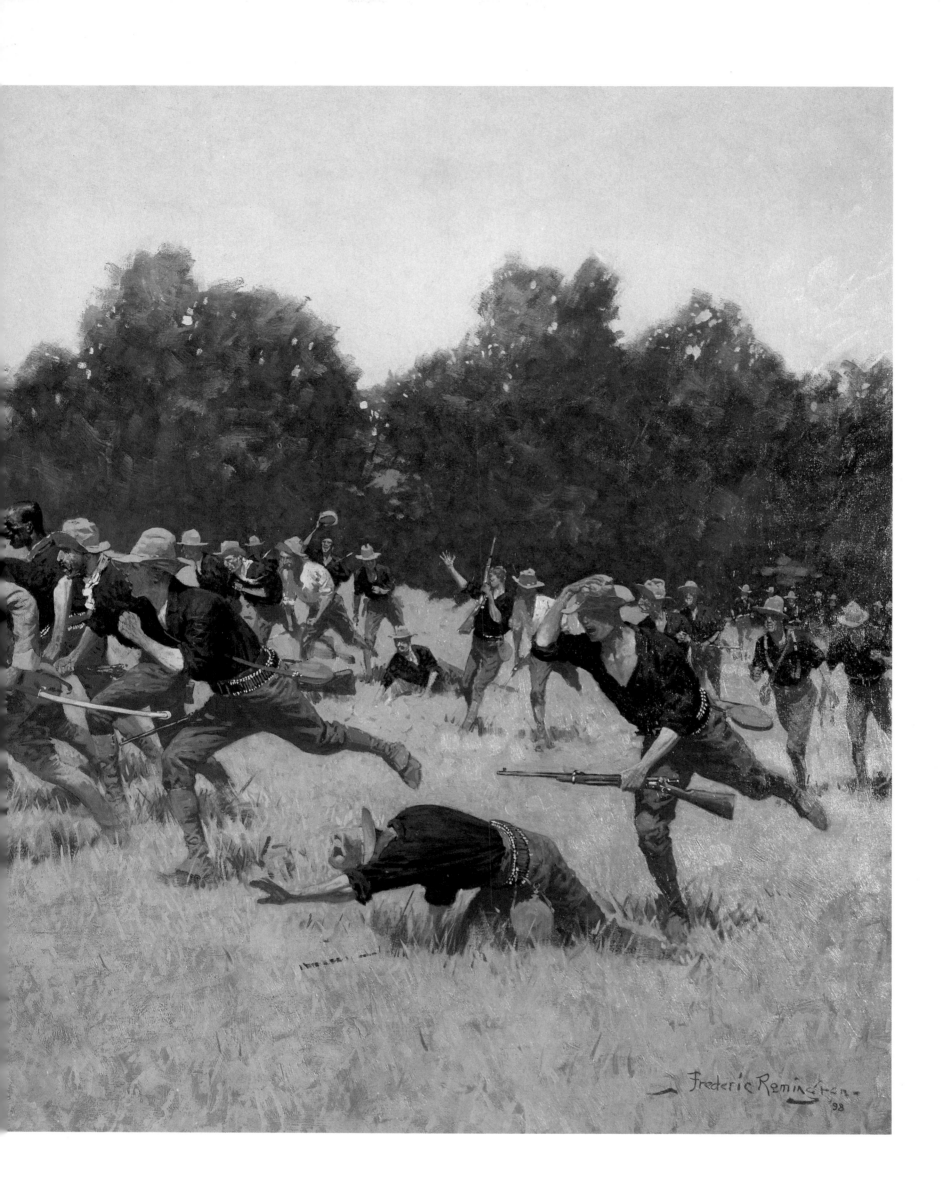

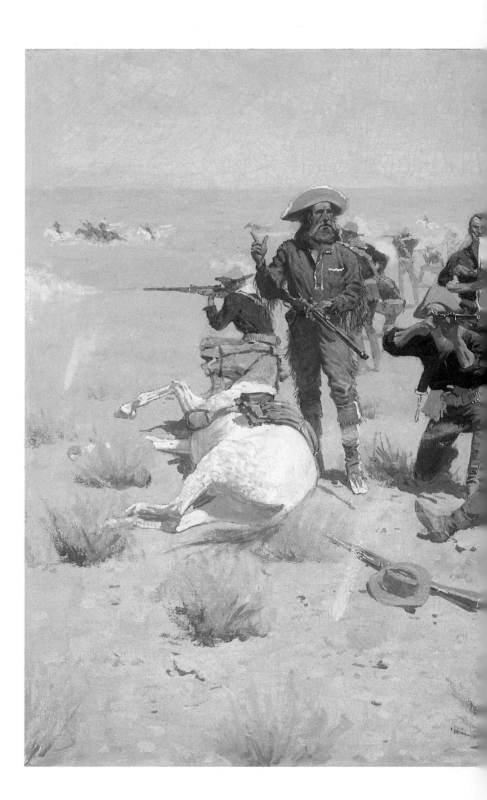

FREDERIC REMINGTON
Rounded Up, 1901
Oil on canvas
25 × 48 in.
Courtesy Sid Richardson
Collection of Western Art,
Fort Worth, Texas (SWR 85)

The unpredictable and lethal nature of Indian
ambushes is well communicated in this
painting, but the too obviously contrived poses
of the figures weakens the picture's overall
impact. The composition may also be a little
too static for the subject: the horses and figures
fit into a fairly neat triangle, with the dead
soldier and his fallen mount bleeding from the
mouth forming its peak. The most dramatic
figures are the guide on the left and the two
Indian scouts.

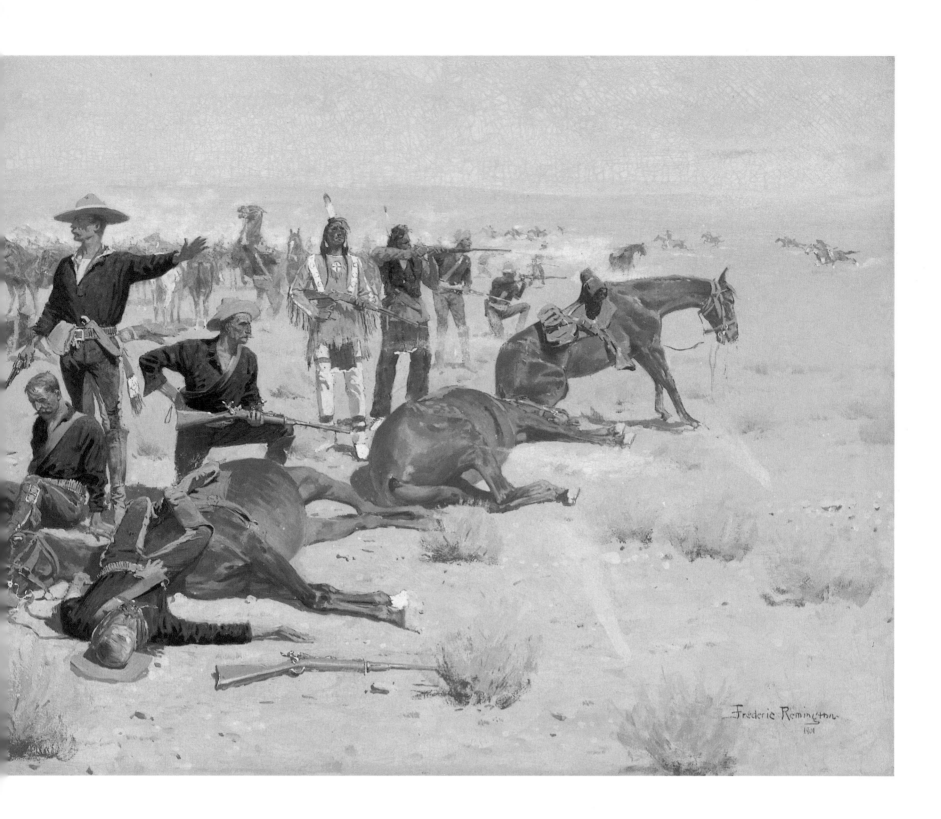

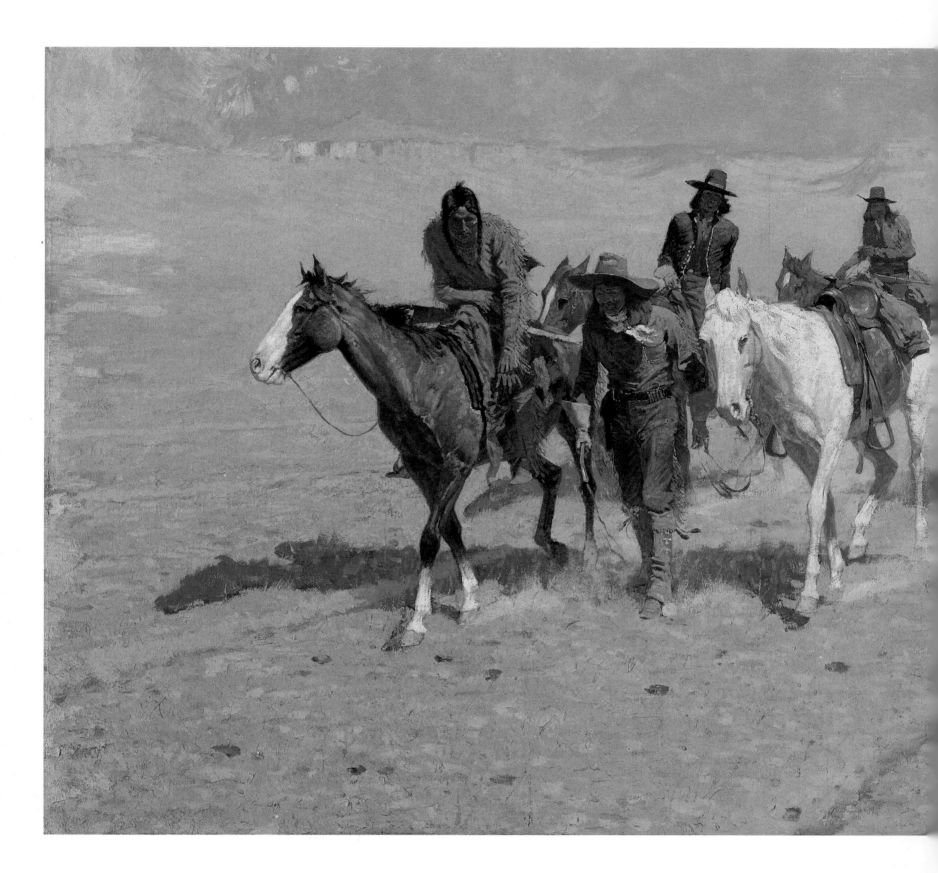

FREDERIC REMINGTON
Pony Tracks in the Buffalo Trails, 1904
Oil on canvas
30⅛ × 51⅛ in.
Amon Carter Museum,
Fort Worth, Texas (1961.223)

A diagonal procession of troops plodding across vacant plains leads our eyes directly to the narrative focus of this canvas: the Indian scout and the cavalry guide. Of the two, it is the Indian who is the more important to the story, for it is he who has spotted evidence that a hostile tribe may be nearby. Remington makes sure that we understand his central role by rendering him in much sharper detail and in more vivid colors than any other figure in the scene.

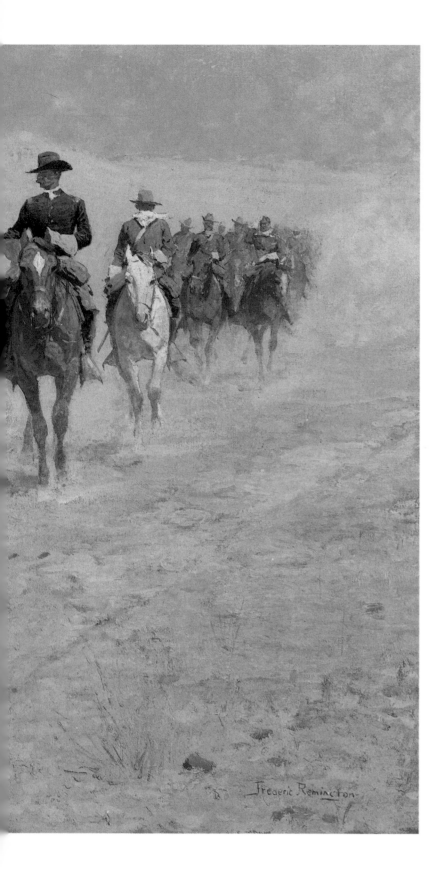

Pages 158-159:
FREDERIC REMINGTON
On Southern Plains, 1907
Oil on canvas
30⅛ × 51⅛ in.
The Metropolitan Museum of Art,
New York, New York
Gift of Several Gentlemen, 1911
(11.192)

Fierce flecks of bright paint furnish a kind of
electric energy in this dynamic and
impressionistic canvas. Their rhythmic patterns
punctuate the headlong charge of the troopers,
who hurtle towards the viewer with grim
expressions and upraised pistols. The powerful
forelegs and neck of the horse at the far left,
and the wildly determined thrusts of the other
steeds, carry the action forward across the
diagonal plane of the painting.

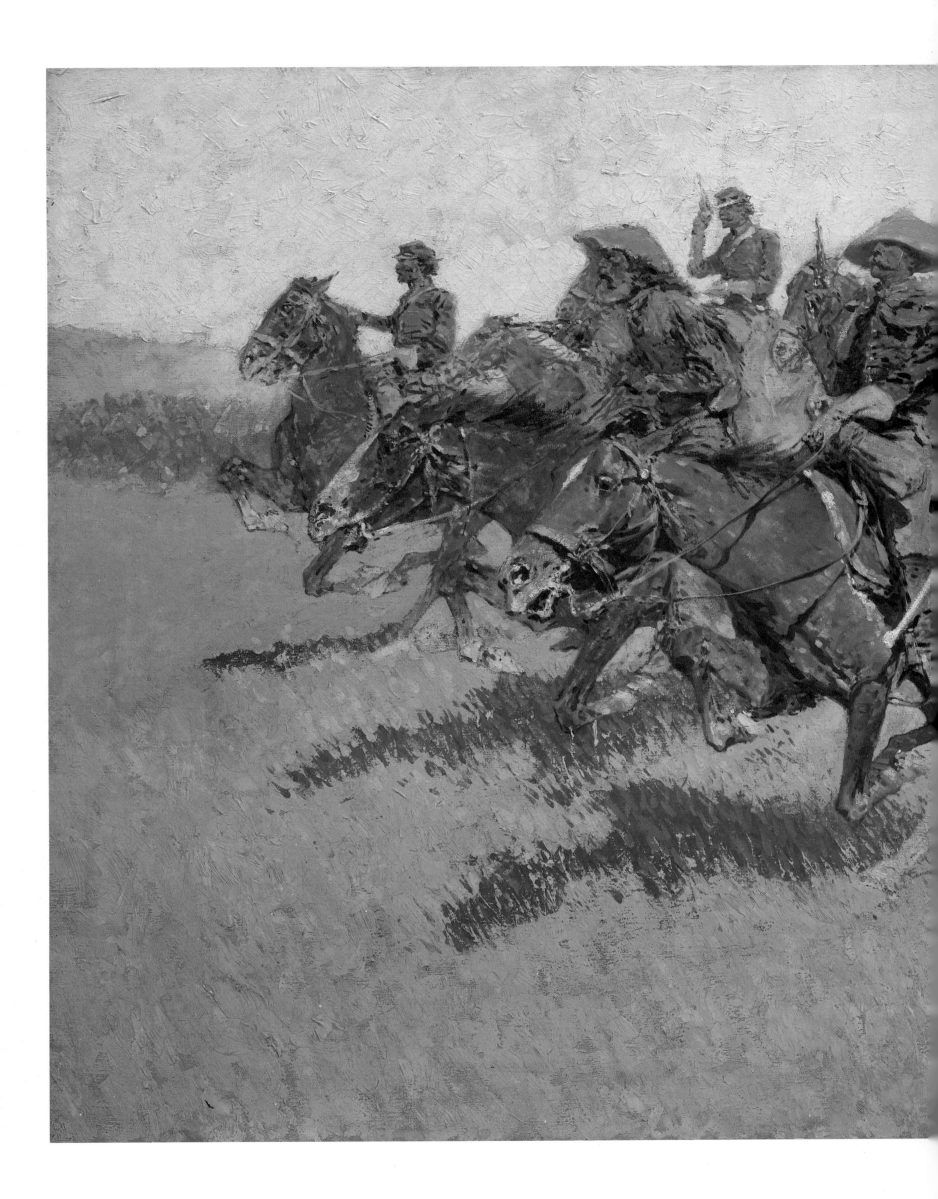

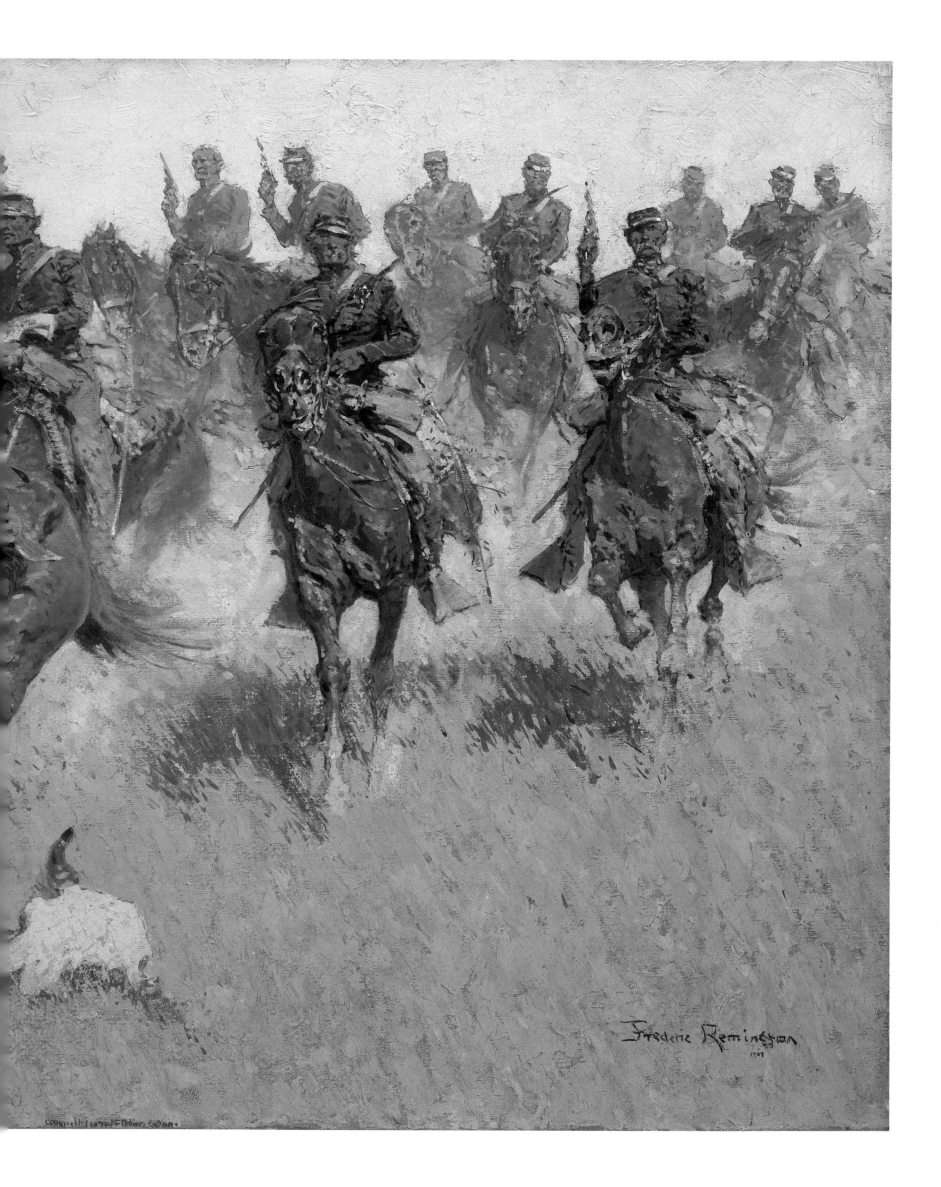

Frederic Remington
1907

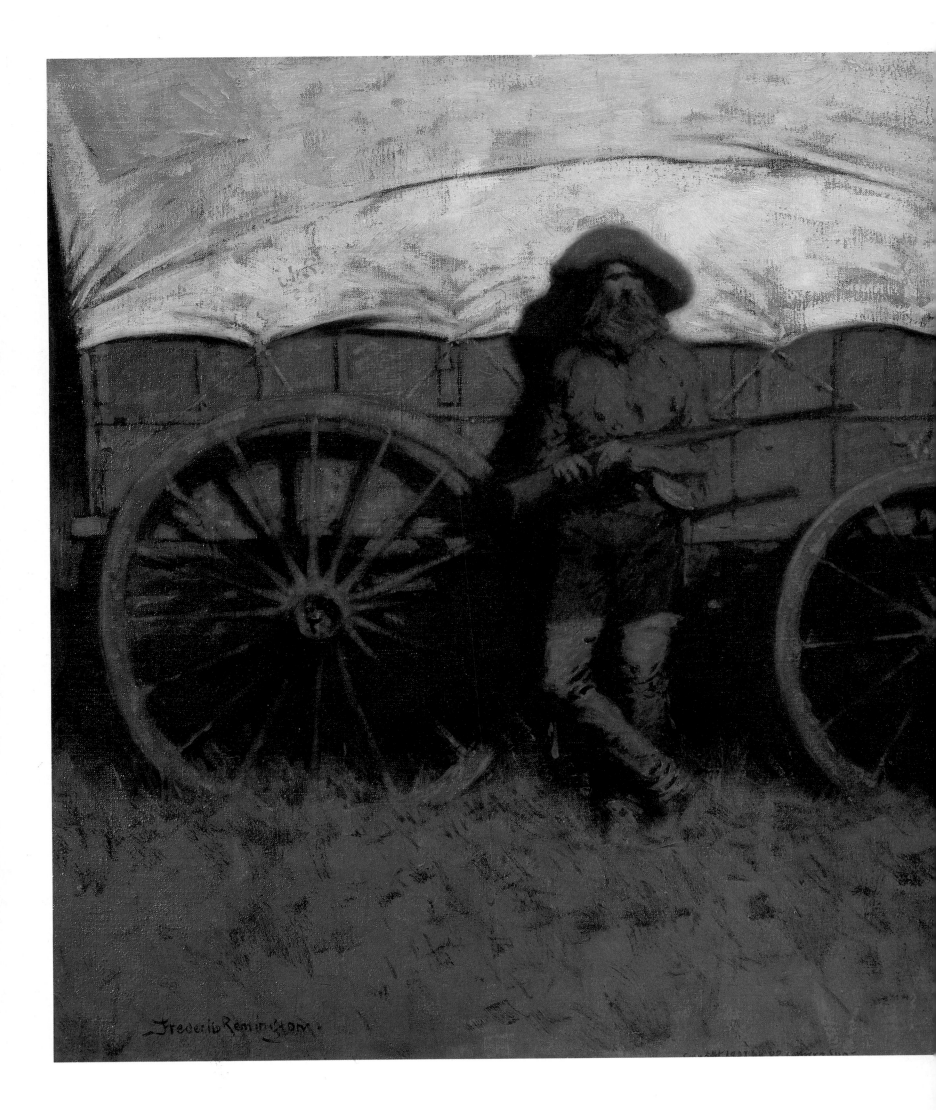

Frederic Remington.

160

Frederic Remington
The Sentinel, 1907
Oil on canvas
36 × 27 in.
Courtesy Frederic Remington Art Museum,
Ogdensburg, New York (66.046)

A nocturnal twilight suffuses this portrayal of
the lonely vigil of a wagon train's night
watchman. The half-light virtually drains the
scene of color distinctions, making the drab
olive green of the sentinel's dress much the
same as that of the planks of the schooner and
the shadowy brown grass he stands on. The
patterns of the huge wheels and their slim
spokes and the scalloped edges of the wagon's
canvas cover are graceful notes.

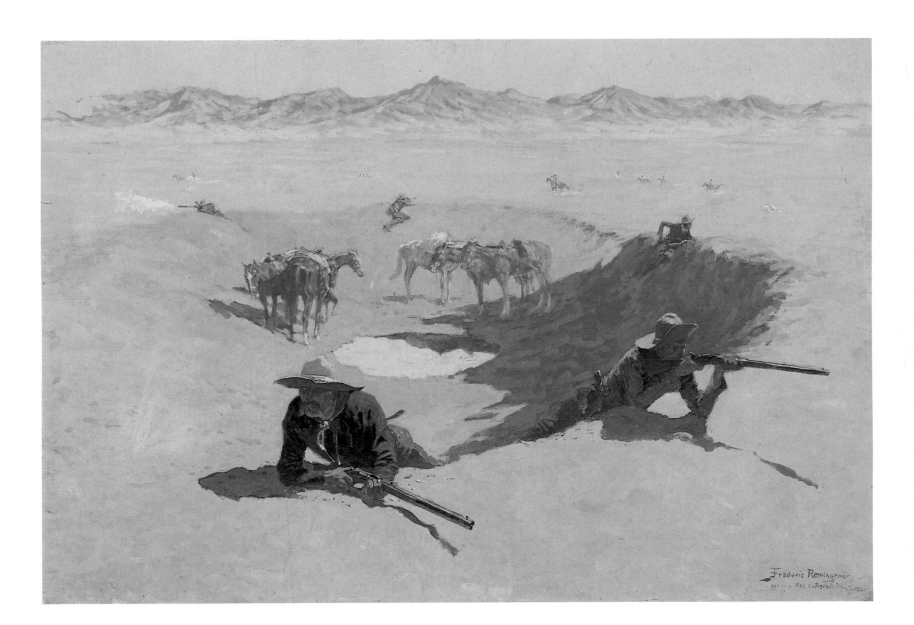

FREDERIC REMINGTON
Fight for the Waterhole, 1903
Oil on canvas
27¼ × 40⅛ in.
The Museum of Fine Arts,
Houston, Texas
Hogg Brothers Collection,
Gift of Miss Ima Hogg (43.25)

The intensely wary expression of the trooper in the foreground sets the tone of the canvas: we immediately scan the painting for danger. The circular arrangement of the figures and their horses focus our attention on the subject, and a scattering of Indians and the towering Rockies in the distance complete the narrative.

CHARLES SCHREYVOGEL 1861-1912
The Fight for Water, 1909
Oil on canvas
53 × 40 in.
The Thomas Gilcrease Institute of
American History and Art,
Tulsa, Oklahoma (0127.1253)

Charles Schreyvogel was born January 4, 1861, in Hoboken, New Jersey, the son of prosperous, middle-class German parents. He was a student at the Newark Art League and later went to Europe to study in Munich. He suffered from asthma and went west to ameliorate his condition. In 1893 he got an invitation to stay with the Army post surgeon at the Ute Reservation in Ignacio, Colorado, in

the southwestern part of the state. Schreyvogel rode and shot, learned sign langauge and collected boxes of props. He subsequently also traveled to an Army post in San Carlos, Arizona, adding still more to his growing fund of knowledge about cavalry life.

When Schreyvogel returned to Hoboken he dedicated himself to painting scenes of the US Cavalry fighting Indians. He devoted a great deal of time to historical research into the details he liked to put in his canvases, and this may in part account for the fact that his output was relatively small – only 60 canvases compared to 3000 works by Remington – yet his technical accuracy is superb. Schreyvogel remained both poor and unrecognized until 1900, when he sent *My Bunkie* to the annual exhibit at the National Academy of Design. There it won a medal and a $300 award,

setting the artist on a path that would provide him with commissions, eventual financial security and an associate membership in the Academy. Perhaps the most telling evidence of his success – though not one that Schreyvogel wanted – was the fact that Remington became furiously jealous of him.

This theatrically violent scene is on a par with Remington's dramatic massacres. In spite of the fearsome rearing leap of the soldier's horse, the trooper is calmly able to take exact aim at the enemy. Not a wrinkle of his uniform is out of focus, allowing one to admire his accoutrements. The Indian is as graceful as a ballet dancer in his death throe, with arms and torso that evoke Renaissance drawings. The running Indian pony heads at us as well as at the fallen pony. The three horses set up the painting's composition in a dynamic pyramid.

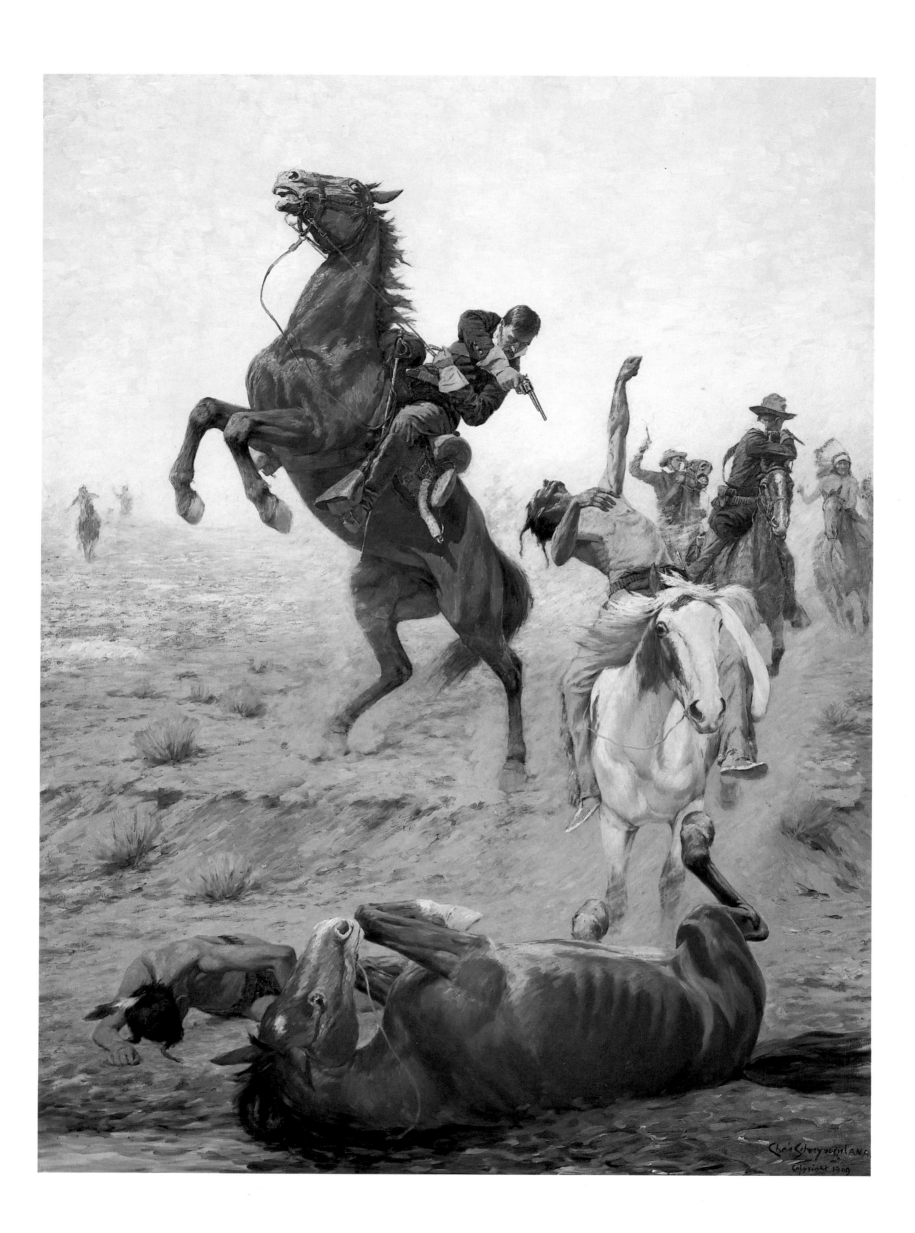

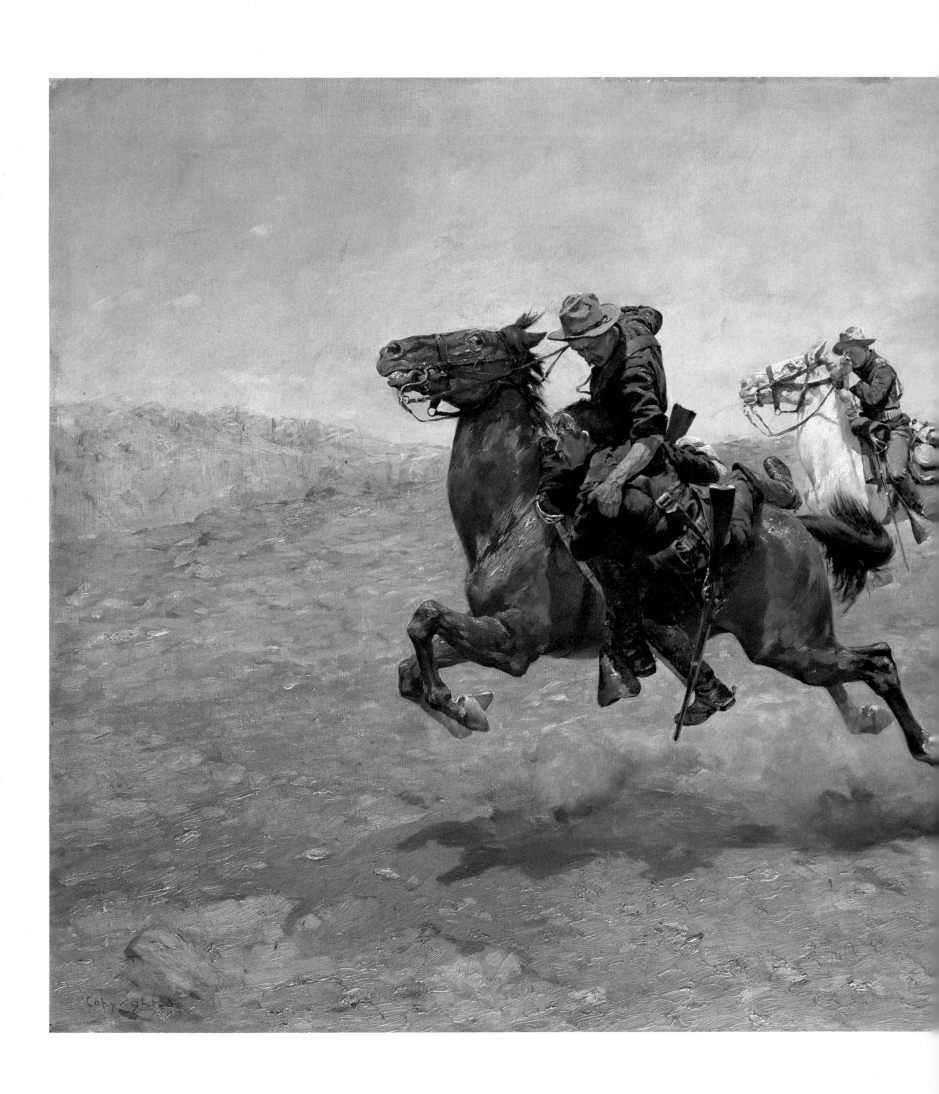

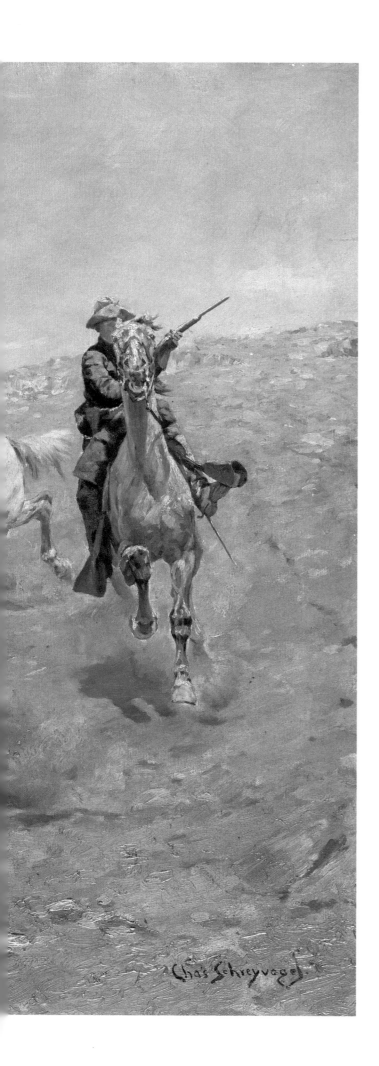

Left:
CHARLES SCHREYVOGEL
My Bunkie, 1899
Oil on canvas
25³⁄₁₆ × 34 in.
The Metropolitan Museum of Art,
New York, New York
Gift of Friends or the Artist, 1912
(12.277)

The situation depicted in *My Bunkie* is similar to that in a Remington sculpture, *The Wounded Bunkie,* though here the wounded soldier is no longer mounted and the action is more focused and intense. Note the careful detail lavished on the soldier's rifle, holster, boots and spurs and on the horse's bridle. The horse's galloping leap adds suspense to the dismounted soldier's precarious position. To add to the viewer's worries, Schreyvogel has another soldier apparently aiming a gun directly at him. So as not to detract from the foreground action, the background is kept simple and impressionistic.

Pages 166-167:
CHARLES SCHREYVOGEL
Custer's Demand, 1903
Oil on canvas
54 × 79 in.
The Thomas Gilcrease Museum of
American History and Art,
Tulsa, Oklahoma (0127.1254)

Unlike the plethora of dramatic and wholly contrived paintings of Custer's Last Stand, this canvas of Custer's meeting with the war chief Satanta in 1869 is based on actual events and costumes. Schreyvogel obtained the soldier's gear from Custer's widow and reconstructed the composition from the recollections of Custer's aide-de-camp, Schuyler Crosby. When Remington publically wrote letters attacking the painting as incorrect, Mrs. Custer confirmed Schreyvogel's accuracy, prompting an amused Theodore Roosevelt to remark, "What a fool my friend Remington has made of himself."

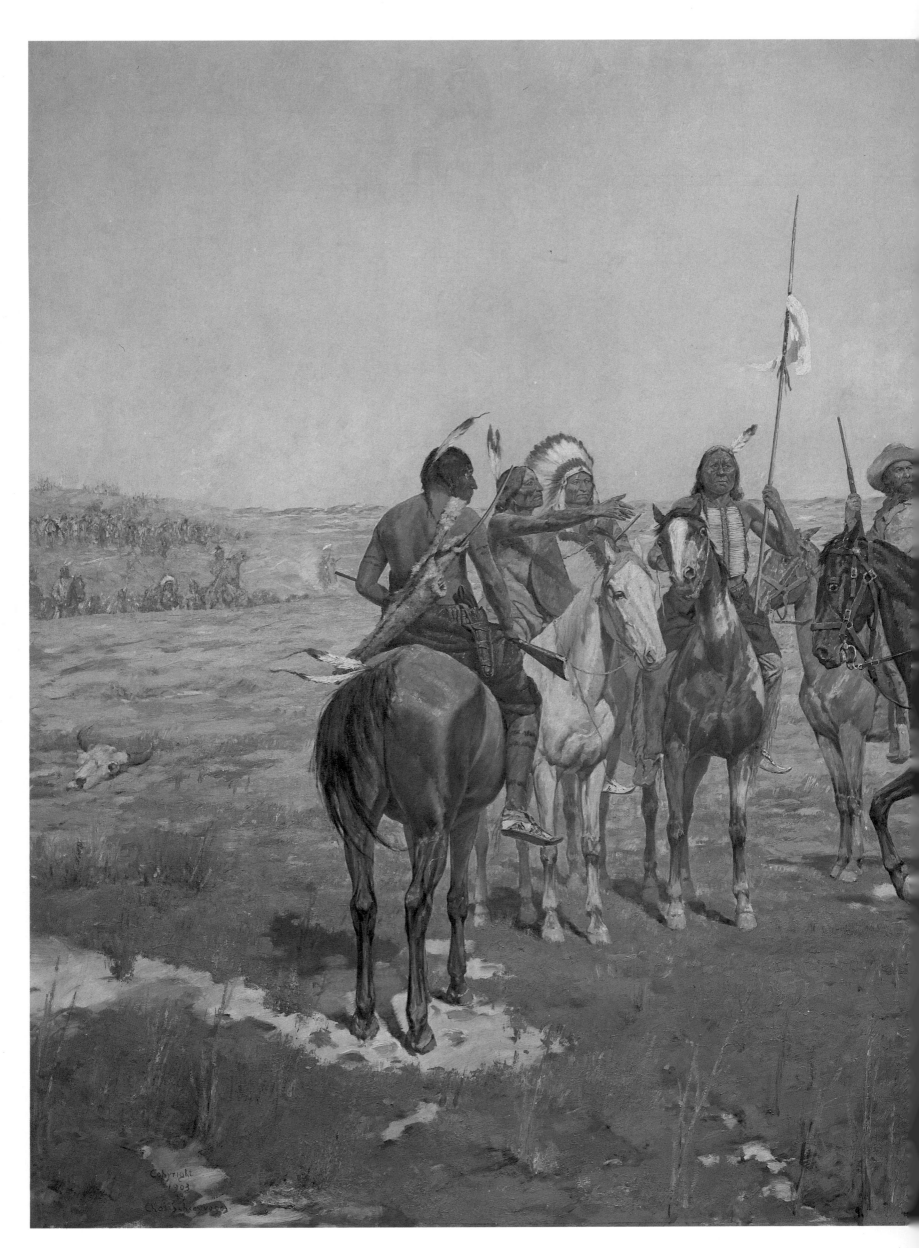

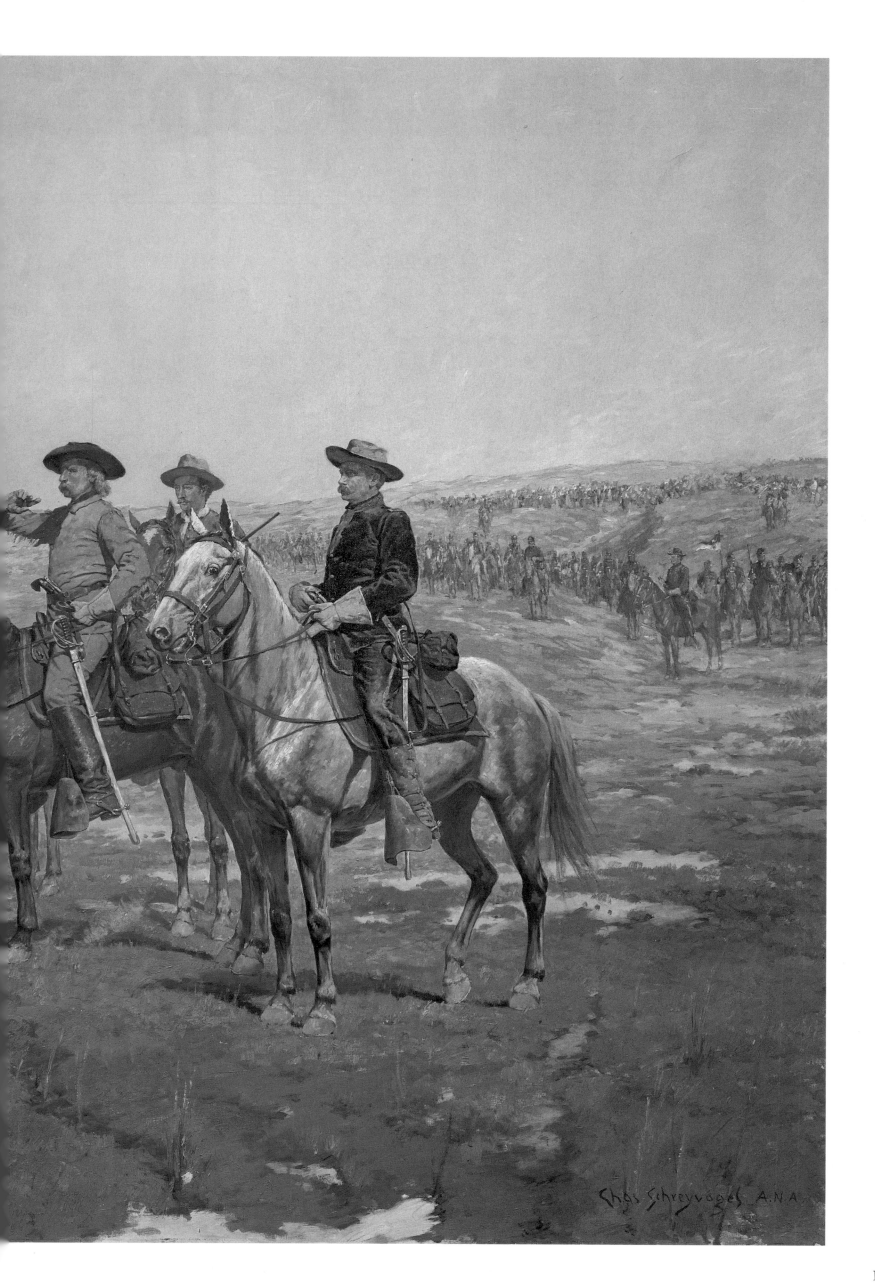

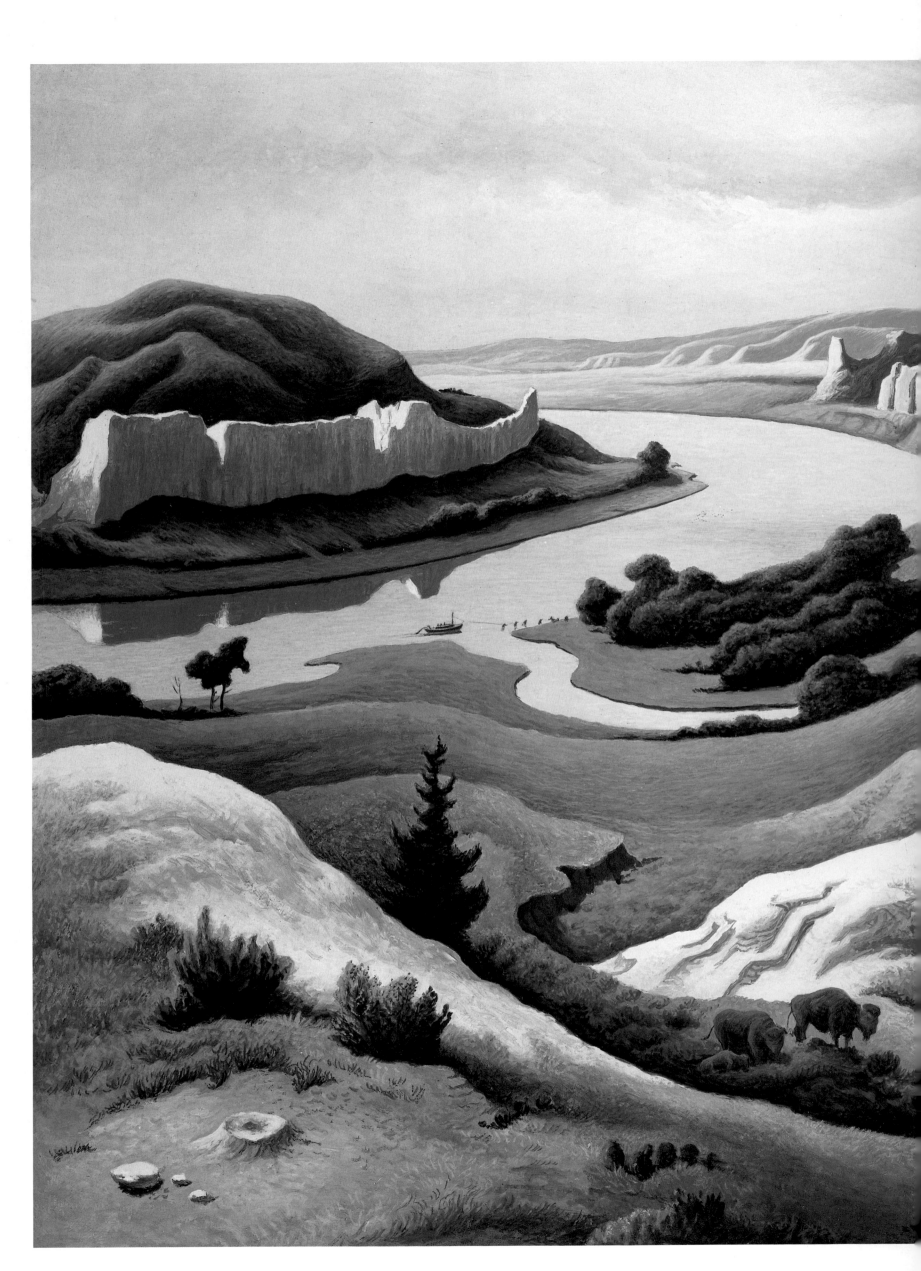

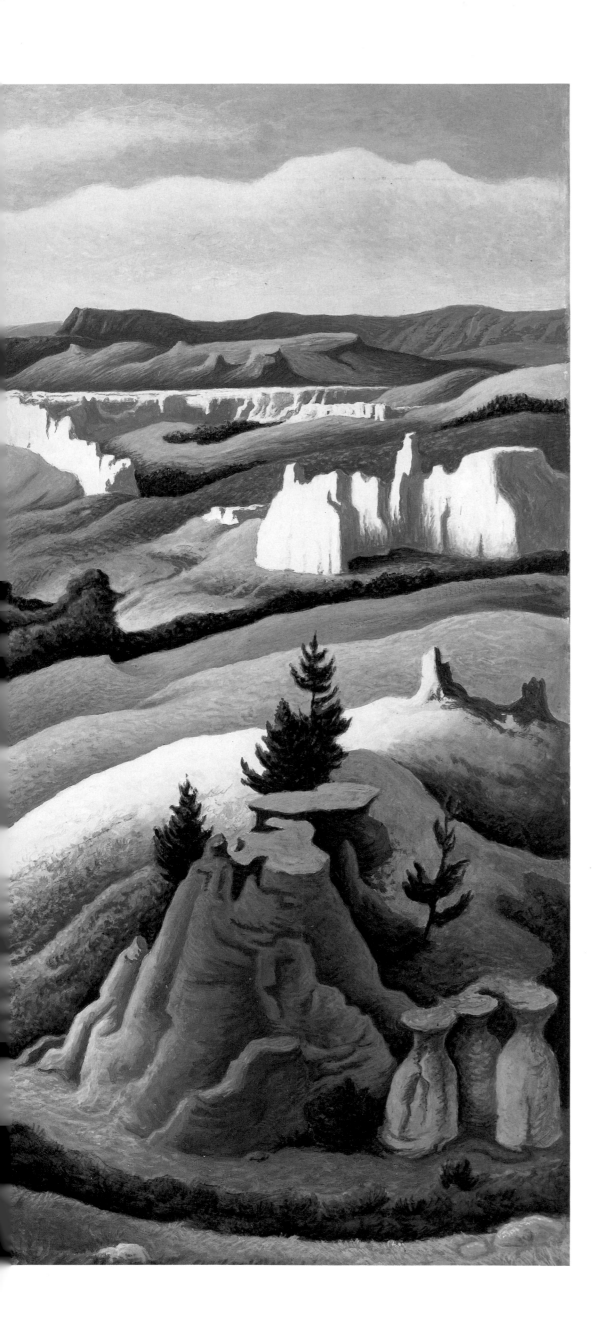

Thomas Hart Benton 1889-1975
Lewis and Clark at Eagle Creek,
1967
Polymer/tempera on masonite
31 × 38¼ in.
Collection of the Eiteljorg Museum of
American Indian and Western Art,
Indianapolis, Indiana
Gift of Harrison Eiteljorg

Thomas Hart Benton was born in Neosho,
Missouri, and studied at the Art Institute of
Chicago and the Académie Julien in Paris
between 1908 and 1911. He was to some extent
affected by cubism and synchronism, and the
distorted figures of El Greco were a significant
influence as well. By the 1930s he was
producing highly distinctive canvases that
dwelt heavily on rural and backwoods scenes,
often infused with mythic overtones. Though
his reputation has diminished somewhat of
late, in the 1930s and 1940s he was regarded as
one of America's foremost painters.

Benton's unique style of writhing forms and
panoramic landscapes of undulating bands of
color is richly apparent here. The tones are
almost surreal, bright Fauve hues of pink, lime,
forest green and persimmon. By treating the
subject of the explorers more as part of
American folklore than of American history
Benton is free to glorify the grand expanse of
the West in his inimitable vernacular. His
brushwork is very smooth, with no defined
source of light and no blending of the colors.
There is a feeling of undisturbed calm to this
wilderness territory.

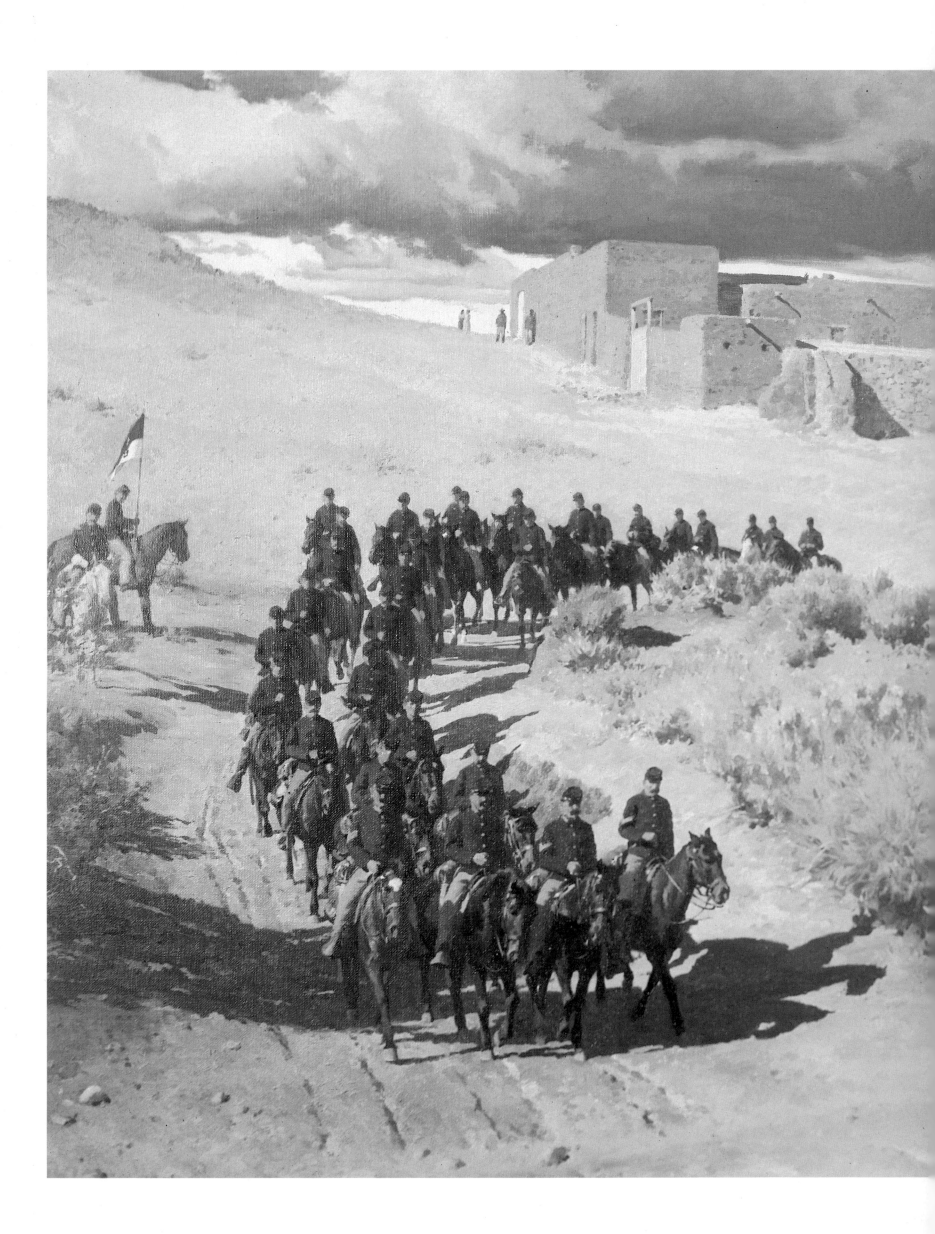

Francis Beaugureau 1920-
B Troop Leaving San Carlos, n.d.
Oil on canvas
26 × 36 in.
Collection of the Eiteljorg Museum of
American Indian and Western Art,
Indianapolis, Indiana
Gift of Harrison Eiteljorg

Francis Beaugureau was born and raised in
Chicago and first took classes at the Chicago
Art Institute when he was eight years old. After
high school he studied at the Mizen Academy,
and his primary focus was even then on Indian
portraits and horses. In 1939 he enlisted in the
US cavalry, later switching to the USAAF and
serving as a B-17 pilot during World War II.
He was an illustrator for the United States Air
Force during the Korean War. He moved to
Arizona as a permanent resident in 1954 and
lives in the town of Tubac. His canvases often
explore the period of the nineteenth-century
Indian Wars in Arizona.

This canvas, commissioned by Harrison
Eiteljorg, glories in the pageantry of the
cavalry. There is a sense of an expanding
procession created by the perspective, which
shows the troopers in single file in the distance
but gradually increasing their front until they
ride four abreast in the foreground
approaching the viewer. The men, a
handsomely-mounted bay troop, are active,
kinetic forms as opposed to the blockish fort in
the background, and their crisp, dark blue
uniforms are set off by the orange-hued turf.
The dark, overcast sky is dramatic, and the
clouds part to allow bright, sharp light to be
cast on the soldiers from the right.

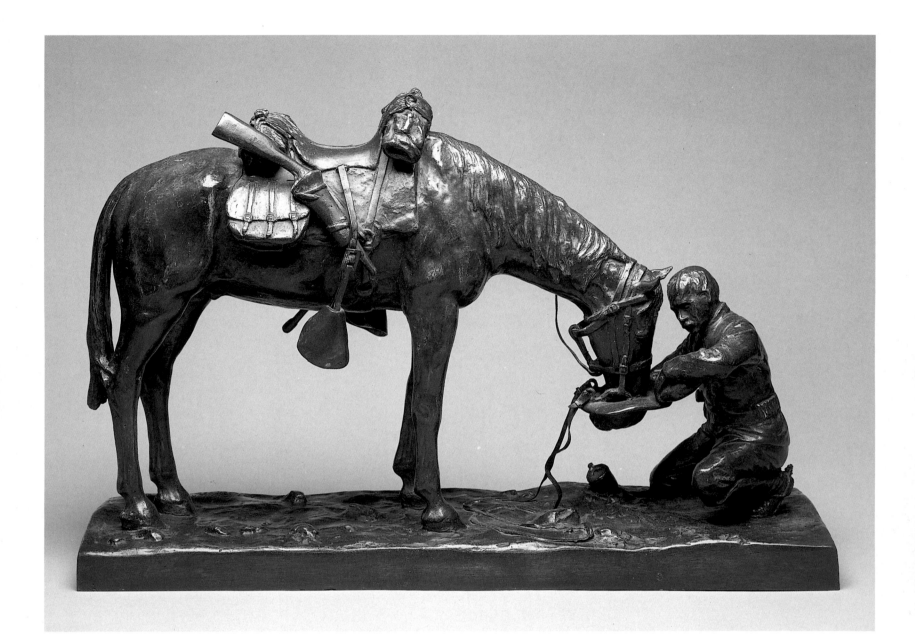

Above:
CHARLES SCHREYVOGEL
The Last Drop, 1903
Bronze
11¾ × 17⅞ × 4⅞ in.
The Thomas Gilcrease Institute of
American History and Art,
Tulsa, Oklahoma (0827.2174)

This bronze expresses the warm sentiment
between a trooper and his horse and is notable
for its accurate details. The bridle is a
hackamore, which easily converts to a halter,
and the saddle is a McClellan, the type used
from the Civil War till 1954. At the back of the
saddle is a blanket roll, and a dog tent lies
across the pommel. A Springfield single-shot
carbine is planted in a "boot" on the right side
of the saddle, and a saber is on the left. The
saddlebags held horseshoes, a currycomb, a
brush and ammunition. The trooper has a
pistol tucked into his waistband, and the
stirrups have leather-styled covers called taps.
The best equine temperament for a cavalry
steed – quiet, obedient and hardy – is
embodied in the form and expression seen in
this horse.

Top right:
FREDERIC REMINGTON
**The Old Dragoons
of 1850,** 1905
Bronze
24 × 46 × 19 in.
Courtesy Frederic Remington Art Museum,
Ogdensburg, New York (66.005)

This bronze portrays an action in the early
days of the Indian wars. The cavalry officers
and the Indians are locked in combat, their
swords and spears raised to form the apex of a
triangle. The complex pose of the officer's
horse, which appears simultaneously to be
falling backward and galloping foward, is
emblematic of the tangled dynamics of the
piece – passionate energy simultaneously
forging ahead and being held in check.

Bottom right:
FREDERIC REMINGTON
The Wounded Bunkie, 1896
Bronze
20¼ × 32¼ × 13½ in.
Amon Carter Museum,
Fort Worth, Texas (1961.7)

Not only the soldiers but the horses, too, seem
in partnership in this bronze. Their galloping,
almost interlocking, forms are expertly
delineated, from flaring nostrils to flying
hooves and flexed tendons. The wildly looping
reins on the bridle of the wounded soldier's
horse accentuate his plight, and the anxious
expression on his comrade's face suggests a
still-present foe.

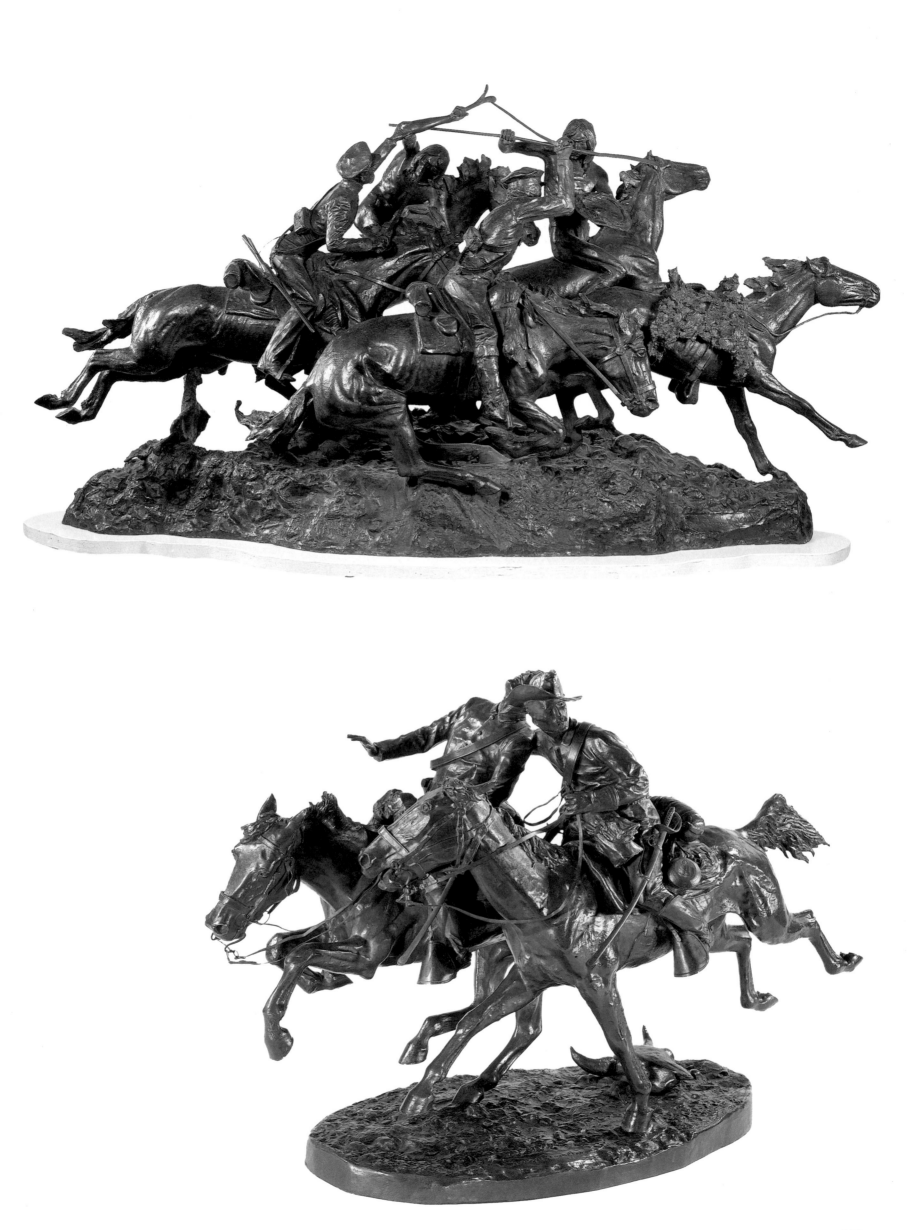

List of Plates

ALPHABETICAL BY ARTIST

The artist's biography appears with the first plate of his or her work to appear in the text.

Acknowledgments

The publisher would like to thank Alan Gooch of Design 23, who designed this book and Sara Dunphy, who did the picture research. Thanks are due as well to the following, who provided illustrations other than plates:

The Bettmann Archive, Brooklyn, NY: pages 7 (both), 11, 13, 19 (bottom), 20 (top right), 21 (top).

Ernest Blumenschein House, Taos, NM: page 23.

Brompton Picture Library: page 15.

The Brooklyn Museum, Brooklyn, NY, John B. Woodward Memorial Fund: page 24 (bottom).

Buffalo Bill Historical Center, Cody, WY: page 16 (bottom).

Kansas State Historical Society, Topeka, KS: pages 12 (top left), 17.

Montana Historical Society, Helena, MT: pages 20 (top left, bottom).

National Archives, Washington, D.C.: pages 14, 18 (top).

National Cowboy Hall of Fame and Western Heritage Center, Oklahoma City, OK: pages 22 (right), 25.

National Museum of American Art/Art Resource, New York, NY: page 8.

National Portrait Gallery, Smithsonian Institution, Washington, D.C.: pages 9 (top), 16 (top).

New Bedford Whaling Museum, New Bedford, MA: page 12 (top right).

New York Historical Society, New York, NY: page 6 (bottom).

R.W. Norton Art Gallery, Shreveport, LA: page 18 (bottom).

Courtesy Frederic Remington Art Museum, Ogdensburg, NY: page 19 (top).

C.M. Russell Museum, Great Falls, MT: page 21 (center).

Museum of Texas Tech University, Lubbock. TX: page 22 (left)

UPI/Bettmann Newsphotos, New York, NY: page 24 (top).

Walters Art Gallery, Baltimore, MD: page 10.